Themes of Contemporary Art

Themes of Contemporary Art

visual art after 1980

JEAN ROBERTSON

HERRON SCHOOL OF ART AND DESIGN
INDIANA UNIVERSITY-PURDUE UNIVERSITY INDIANAPOLIS

CRAIG McDANIEL

HERRON SCHOOL OF ART AND DESIGN
INDIANA UNIVERSITY-PURDUE UNIVERSITY INDIANAPOLIS

New York Oxford

OXFORD UNIVERSITY PRESS

2005

Oxford University Press

Oxford New York
Auckland Bangkok Buenos Aires Cape Town Chennai
Dar es Salaam Delhi Hong Kong Istanbul Karachi Kolkata
Kuala Lumpur Madrid Melbourne Mexico City Mumbai
Nairobi São Paulo Shanghai Taipei Tokyo Toronto

Copyright © 2005 by Oxford University Press, Inc.

Published by Oxford University Press, Inc. 198 Madison Avenue, New York, New York 10016 www.oup.com

Oxford is a registered trademark of Oxford University Press

All rights reserved. No part of this publication may be reproduced, stored in a retrieval system, or transmitted, in any form or by any means, electronic, mechanical, photocopying, recording, or otherwise, without the prior permission of Oxford University Press.

Book design by Cathleen Elliott

Library of Congress Cataloging-in-Publication Data

Robertson, Jean, 1950-

Themes of contemporary art: visual art after 1980 / Jean Robertson, Craig McDaniel.

p. cm.

Includes bibliographical references and index.

ISBN-13: 978-0-19-516215-8

ISBN 0-19-516215-3

1. Art, Modern—20th century—Themes, motives. 2. Art, Modern—21st century—Themes, motives. I. McDaniel, Craig. II. Title.

N6490.R5487 2004 709'.04'5--dc22

2004050135

Printing number: 987654321

Printed in the United States of America on acid-free paper

Frontispiece: Detail of color plate 18

FOR KARIN, JAMIE,
EDIE, AND SUSAN

Contents

PREFACE | xi

INTRODUCTION

Themes of Contemporary Art: What, Why, and How | 4 A Brief Orientation | 7

CHAPTER ONE

The Art World Expands | 9

Overview of History and Art History, 1980–2004 | 11
Old Media Thrive, New Media Make Waves | 14
A Spectrum of Possibilities Emerges | 19
Theory Flexes Its Muscles | 22
Art Meets Contemporary Culture | 27

CHAPTER TWO

Time | 33

Time and Art History | 35

Representing time | 36

Embodying time | 40

Changing Views of Time | 45

Changing Views of the Past | 49

Exhibits about Time | 50

Exploring the Structure of Time | 50

Fracturing time | 51
Real time | 52
Changing rhythm | 53
Exploring endlessness | 55

Revisiting the Past | 56

Recovering history | 56 Reshuffling the past | 58 Reframing the present | 59

Commemorating the Past | 60

PROFILE: Brian Tolle | 63

CHAPTER THREE

Place | 69

Places Have Meanings | 69
Places Have Value | 71
Exhibits about Place | 72

History's Influence 72

(Most) places exist in space | 73 The work of art exists in a place | 75

Looking at Places | 78

Looking Out for Places | 80

Constructing (and Deconstructing) Artificial Places | 84

Placeless Spaces | 89

What's Public? What's Private? | 90

In-between Places 93

PROFILE: Janet Cardiff | 96

CHAPTER FOUR

Identity | 103

Identity in Art History | 106

Identity Is Communal or Relational | 107

Social and cultural identities | 107 | Identity politics | 108

Identity Is Constructed | 110

Essentialism | 111

Difference | 111

Identity Is Not Fixed | 114

Sexual Identity Is Diverse | 116

Hybridity | 118

Reinventing Identities | 120

PROFILE: Jaune Quick-to-See Smith | 122

CHAPTER FIVE

The Body | 129

Past Figurative Art | 131 A New Spin on the Body 133 The body is a battleground | 135 The body is a sign | 135 People are bodies | 137 The Body Beautiful | 139 Different bodies | 139 Body parts | 140 Mortal Bodies 141 Sexual Bodies | 143 The gaze | 145 Sexual pleasure and desire | 147 Sex and violence | 149 Posthuman Bodies | 150 PROFILE: Shirin Neshat

CHAPTER SIX

Language | 161

Words with Art: A History | 162
Art with Words: A History | 164
Recent Theories of Language | 166
Reasons for Using Language | 168
Exhibitions and Publications Concerning
Language in Art | 171
Language Makes Meaning | 171
Language Takes Form | 174

Transparency and translucency | 175
Spatiality and physicality | 178
Books made by artists | 179
Art made with books | 180

Wielding the Power of Language | 183
Confronting the Challenge of Translation | 186
Using Text in the Information Age | 189
PROFILE: Ken Aptekar | 192

CHAPTER SEVEN

Spirituality | 199

A Short History | 201 A Few Strategies | 204

Manipulating forms, materials, and processes | 204
Manipulating meanings and minds | 206
Finding Faith and Harboring Doubt | 210
Expressing Religious Identities | 213
Facing Death, Doom, and Destruction | 215
Mingling the Sacred and the Secular | 217

PROFILE: José Bedia | 221

TIMELINE | 227

SELECTED BIBLIOGRAPHY | 235

INDEX | 241

Color plate section follows page 112.

Preface

Contemporary art is a vast arena of diverse styles, techniques, materials, subjects, forms, purposes, and aesthetic traditions. Viewers of the art of today and the recent past find themselves in the presence of objects and images that can range from the lighthearted to the soul-searching, from the monumental to the ephemeral, from the highly recognizable to the strangely alien. To provide a cohesive gateway for those who are encountering this art with little advance knowledge or experience, we offer an approach that concentrates on six themes that have been widespread in artistic practice during the past twenty-five years: time, place, identity, the body, language, and spirituality. After an initial chapter that provides an overview, the six themes are explored in as many chapters.

We chose to write about six themes rather than ten or fourteen or twenty because we want to provide a sufficient analysis of each theme so as to reveal something of the depth of thinking and intensity of practice within that arena. More themes, within a compact-size publication, would necessarily have meant curtailing our treatment of any one theme. As the chapters will document, each of the themes we selected has received significant attention by contemporary artists, critics, curators, and art historians. Furthermore, each theme we chose to examine has an enduring lineage in art history as well as widely recognized importance in daily life. Thus, we believe our choices for thematic topics are valid, enduring, and vital, even though not exhaustive of all possible significant themes.

But why use themes as the structure for this book? An introductory text on recent art could have been organized around media disciplines (painting, sculpture, and so forth); in our view, however, such a treatment would tilt the discussion too heavily toward materials, techniques, and formal concerns. Of course, media distinctions remain important, and no more so than in the academy, where most studio art programs still offer a media-specific focus in the range of courses and majors in the curriculum. We believe a balanced view of artists' diverse approaches to materials and techniques can be presented by discussing examples from virtually all the major media (as well as some that are idiosyncratic) within the structure of a thematic focus. Furthermore, by

focusing on thematic content, the structure of this volume fosters a cross-disciplinary approach that reflects an increasing trend in how artists and curators of new art function today.

Arguably an emphasis on theoretical concerns could also provide the structure for a text on contemporary art. Indeed, edited collections of theoretical writings by artists and critics already exist. (Of course, an instructor with a strong interest in theory might opt to assign one of these collections of writings in tandem with our volume.) However, in terms of an introductory text on contemporary art, if just one text is used, one organized into theoretical chapters strikes us as a less-effective choice than one organized by theme. Theory directly propels some but not all artists. Still, we recognize the influential role of theory in the art of our time, and a concise assessment of some of the theoretical underpinnings of each theme is provided in every chapter, while a brief overview of the influence of theory vis-à-vis art after 1980 is provided in chapter 1.

A thematic approach, it seems to us, provides a judicious balance between discursive thinking and careful looking. By emphasizing the analysis of artworks thematically, our volume prioritizes the process of cognitive interpretation alongside attentive perception. The interpretations we offer are never construed as the only possible interpretations. On the contrary, a primary pedagogical principle of our book is that meanings of any artwork are flexible: the same work can be presented so as to reveal alternative interpretive stances. Interpretations, mirroring the culture at large, are constructed by an interweaving of factors brought into play by the artist, society, and the viewer.

Within the analysis of the six themes, we introduce artists working in a diverse range of media disciplines. Disciplines include those that are ancient (painting, sculpture), those that became central to the work of advanced artists during modernism (photography), those that have gained widespread attention within the last several decades (installation, performance), and disciplines that depend on recently developed technologies (computer art, video). Within the examination of themes, we also introduce broad issues that are significant topics of current debate (for example, beauty, censorship, and the construction of gender). The variety of approaches to analyzing meaning offers different analytical frameworks, while cross-references among them will add up to a fluid understanding of the multilayered, multifaceted experience of recent art. The book promotes critical thinking rather than a passive reception of the listing of who, what, and where.

The presiding context of the book is contemporary art in the West. The book is informed by our understanding that current art in the West is indebted to and embedded in heritages from many cultures around the world, and that numerous influential artists working in the United States and Europe are immigrants. This introductory text provides a look at the vigorous involvement in contemporary art by artists from a wide variety of cultural and geographic backgrounds, including some artists living outside the West who are engaged in exhibitions, publications, and/or events that are finding an international audience.

Themes of Contemporary Art is not a traditional survey in the sense of providing a chronological history of art since 1980. We feel that trying to sort the most recent art into "movements" or "styles" is premature and most likely impossible at this point. Many present tendencies are just commencing or are in midstream, and we cannot see their full shape clearly nor predict their future course and significance. It is not even certain that the old-style linear narrative of one movement influencing and leading into

the next is adequate anymore. In the wake of Conceptual Art, art became increasingly theoretical and idea driven, and began to sprout increasingly difficult and obscure branches. In our view, attempting to sort these positions and counterpositions into a chronological structure would be confusing for our readers and needlessly arcane. Instead, what we provide is an extended look at themes that are prevalent right now (and, in looking at themes, we provide a context for examining an assortment of the issues and practices that are currently vital). We also provide focused studies of a range of recognized artists, thereby offering students insights and a critical perspective on the rapidly evolving state of contemporary art. Our book is a kind of snapshot of where artists and critics are today in their thinking and activities.

Structure of the Book

The introduction orients the reader to the primary focus of the book: a thematic engagement with contemporary art. The term *theme* is defined and then applied immediately as a framework for analyzing two works of art, a photograph by Richard Misrach and a sculpture by Roxy Paine.

Chapter 1, "The Art World Expands," provides an overview to key aspects of contemporary art using broad strokes (concepts, issues, terms of engagement) and an introduction to a (brief) history of the United States and the world, 1980–2004. The chapter clarifies four characteristics of artistic practice over the last two and a half decades: old media have thrived while new media made waves; a spectrum of diverse artistic strategies emerged within the context of increasing global interconnectivity; theoretical writings provided strong influence; and art met (at times melded with) contemporary popular culture in all its manifestations. Furthermore, each of these four developments continues to define the present.

Chapters 2 through 7 form the core of this intellectual project: to chart contemporary artistic practice through the lens of key themes. Each of these chapters follows a similar format, including an introduction to the thematic topic, a concise look at historical precedents and influences, and a detailed analysis of key points that characterize how contemporary artists have responded to and embodied aspects of the theme in specific works. The chapter closes with a more in-depth profile of one artist who, we argue, has devoted significant energy within the parameters of the theme under discussion.

Artists who came of age in the 1980s and 1990s tend to be conceptually oriented. Readers of this volume will gain insights into how and why many contemporary artists place great emphasis on creating meaningful work that connects to the world outside of art, including intellectual debates from a wide array of discourses. An emphasis on thematic meaning has not come at the expense of the importance of form. Indeed, the analyses of specific artworks throughout these chapters will reveal that form remains a potent carrier of content. By providing a clearly structured approach, the student/reader will *learn how to learn* about new art, including artworks that are not discussed.

A range of issues and influences that are pervasive in current art discourse are examined, including the impact of social agendas and the rise of new media. A look at these topics within the context of artworks exploring the themes under review should give readers insights into the current dialogue that surrounds the creation, exhibition, and discussion of new works of art. Theoretical concepts—including feminism, postmodernism, structuralism, and multiculturalism—are introduced at appropriate junctures as powerful

analytical tools. Issues involved with our potential aesthetic engagement with art (including a discussion of the concepts of beauty and the grotesque) are raised as well. Within the discussion of the thematic categories, and in the artists' profiles, the various roles artists assume—including the artist as visionary and the artist as social activist—will provide students with an opportunity to consider how, when, and why art can be created.

The Audience for the Book

Themes of Contemporary Art: Visual Art after 1980 is designed to be a core text in introductory-level courses in the recent history of contemporary art. It can serve as the text for introductory courses that begin with art of the 1980s, perhaps supplemented by a published collection of edited writings on contemporary art or by a packet of readings selected by the instructor. We hope that this volume will serve as a resource that is intellectually engaging without being intimidating for a diverse student population.

Themes of Contemporary Art could also be used as a resource to supplement instruction in art appreciation courses at the university level (in order to provide a way to extend the discussion of art appreciation concepts to the art of our own era). Indeed, many art appreciation texts include substantial discussion of themes in art over time, with only a cursory examination of the art of the present. The structure of our book would parallel how students are learning about art of the past while introducing them to current practices.

Additionally, this book is designed to function as a pedagogical resource for introductory, intermediate, and advanced undergraduate-level studio art classes, since the discussion of thematic content can be utilized as a springboard for studio projects in virtually any media. Studio art instruction is challenged increasingly to offer systematic approaches to conceptualizing content, in order to engage students in the kind and quality of thinking that underpins the studio practice of professional artists. This volume can serve as a text to supplement in-class instruction in techniques, tools, materials, and formal concerns.

We also wrote this volume with the aim that general readers, not enrolled in a university class, would find it to be a useful, thoughtful, and thought-provoking guide to undertaking an exploration of the curious and often challenging landscape of contemporary art.

Features of the Book

Themes of Contemporary Art: Visual Art after 1980 emphasizes the analysis of works of art within thematic groupings. By stressing interpretation, we seek to engage the reader in actively considering how ideas, forms, materials, processes, and purposes all contribute to meaning. The book examines how art in the contemporary period reveals a redefined spin placed on themes that were addressed by artists in earlier eras.

Artist profiles: An in-depth analysis of an artist who has developed a sizable body of work that can be analyzed from the perspective of a chapter's theme is included at the end of chapters 2 through 7. The profiled artists are ethnically and culturally diverse, with origins from a range of locations. Our intention in the profiles is to examine at some length what a selection of contemporary artists are actually doing: how and why they are making art; and the materials, techniques, and ideas they are engaging with.

The profiles are positioned at the end of every chapter, to let readers know which profile meshes particularly well with the ideas presented in that chapter.

Illustrations: Eighty-seven artworks are illustrated, including nineteen in color. The illustrations have been carefully selected for their individual visual appeal as well as to provide a rich sampling of the diversity that characterizes today's visual arts. The illustrated works feature a wide variety of materials, techniques, theoretical viewpoints, and stylistic approaches and include examples by artists from diverse ethnic, cultural, and geographic backgrounds.

Timeline: A concise spreadsheet of the quarter century, 1980–2004, presents a year-by-year listing of significant, memorable, and prototypical events in three categories:

art, pop culture, and world events.

Index: An index provides readers with an easy-to-access method for looking up key artists, terms, and events analyzed in the text. Boldface listings signify the initial occurrence of a term and can thereby be used as a glossary.

Alternate Paths Through the Book

The chapters may be read in sequence, following the order they appear. Alternatively, each chapter may be approached individually and in any order. Some teachers may prefer to have their students read all or some of the six thematic chapters prior to the first chapter. Chapter 1, offering a condensed analysis of key developments that characterize the entire twenty-five-year period, including the role of theory, may be taken up after students have explored some (or all) of the thematic chapters. Teachers of studio art may wish to select those chapters—in any order—that dovetail with the content of studio projects that are being explored during a particular semester. Teachers of art appreciation may wish to assign chapters in the order in which thematic topics are being studied in the overall course.

Acknowledgments

This book would not exist except for the support we received. Our efforts were aided by the many individuals who generously shared with us their encouragement and expertise and those numerous institutions that provided us with resources.

Professional peers from the United States and England reviewed the text in manuscript form at several stages in the process of its preparation. We thank the following for insightful criticism that strengthened our thinking as well as our writing: Terry Barrett, Ohio State University; Claude Cernuschi, Boston College; Kathleen Desmond, Central Missouri State University; Cecilia Dorger, College of Mt. St. Joseph; Paul E. Ivey, University of Arizona; Pamela Fletcher, Bowdoin College; Dana Leibsohn, Smith College; Tim van Laar, University of Illinois; Jean Miller, Marshall University; Mary Francey, University of Utah; Jo Ortel, Beloit College; Kristine Stiles, Duke University. We benefited from the expert assistance of a fine staff at Oxford University Press and thank the following for their contributions: Leslie Anglin (Production Editor), Cathleen Elliott (Art Director), Elyse Dubin (Director of Editing, Design, and Production), and Talia Krohn (Assistant Editor).

We extend our appreciation to our talented colleagues at Herron School of Art and Design, Indiana University–Purdue University Indianapolis, whose professional lives—devoted to art—are a daily source of inspiration. We extend particular thanks to

Dean Valerie Eickmeier at Herron for her ongoing encouragement of faculty research projects, including her support of a sabbatical for Jean Robertson during which the preliminary stage of planning and researching this book was conducted. An Indiana University President's Arts and Humanities Initiative Award and a Clowes Fellowship from the Vermont Studio Center provided valuable support for work on this project for Jean and Craig, respectively. We also thank our students for helping us hone many of the ideas presented in this volume during class discussions.

The artists and their dealers who made available the materials and permissions for illustrations have added an invaluable component to this volume. We thank them, and we are confident our readers will thank them as they have the opportunity to discover the visual qualities, via the reproductions, of some amazing artworks tucked into the pages that follow. Thanks to the Indiana University Press for permission to reproduce, in altered form, sections of a previously published essay by Jean Robertson, woven into sections of chapters 4 and 5 in this volume.

Finally, we want to thank three individuals who have made irreplaceable contributions to the preparation and completion of this book project. First and foremost, we thank Janet Beatty, Executive Editor at Oxford University Press, for her acumen in shepherding us wisely through the development of our writing. Significant changes in approach and conception occurred along the way, and Jan was there at every step, pinpointing ways to bring greater clarity to our writing and to steer us to a more effective organization of the entire book. Second, we thank Martha Morss, a longtime friend of ours who just happens to be an expert editor. Martha tightened our writing in its penultimate draft stage and, in doing so, helped us produce a book that, we hope, will be thought-provoking without being mind-boggling and full of needless jargon. Last, we owe our fond gratitude to Ana Radovanovic, who worked closely and cheerfully with us in key capacities: as research assistant, illustration and permissions researcher, timeline author, and general assistant in preparing the project for submission to our publisher. We are proud that the completion of this project coincides with the start of Ana's own professional career.

A world without art is unimaginable.

J.R. and C.Mc.

Themes of Contemporary Art

Introduction

In writing *Themes of Contemporary Art: Visual Art after 1980*, we aimed high: to offer you, our readers, an accessible, engaging, and wide-ranging introduction to the world of recent art. Within these pages we explore work by hundreds of contemporary artists who, we believe, have succeeded in giving memorable substance to their creative visions. The artworks illustrated and discussed in the chapters that follow function in a plenitude of ways, arousing our curiosity, delighting our senses, evoking our emotions, and provoking questions and debate. In the pages that follow you should expect to find some of your notions about art—about its definitions, its purposes, and its manifestations—turned in new directions, perhaps, at times, even topsy-turvy. This learning won't come without effort. We need you to engage actively in your pursuit of fresh knowledge; don't expect to read this book the way you might sit on a sled, simply holding on and trusting gravity and momentum to carry you to the end. No, you must climb with us if you are to enjoy the viewpoint of new ways of thinking. And, in so many words, that is what the best in contemporary art offers: viewpoints for new ways of thinking and seeing.

This book explores a segment of history—a history of some significant achievements in visual art over the past twenty-five years. However, you will discover that this volume avoids one of the usual routes taken in the study of history: the march in step with chronology. Rather than proceeding through the period under discussion in strict linear fashion, we prefer to concentrate primary attention on a selection of six prominent themes that have recurred in art during recent decades: time, place, identity, the body, language, and spirituality. Each chapter considers artworks made throughout the entire period from the point of view of that chapter's theme.

What do we mean by a theme in a work of art? A theme is a clustering of ideas around a particular topic. In discussing a theme, we are concerned with the overarching ideas embodied and expressed by the artwork's totality. Looking at themes we focus on the meaning of a work of art examined as a whole, including the impact that materials, techniques, form, and subject matter make on content.

A thematic approach provides a judicious balance between discursive thinking and careful looking. By emphasizing the thematic analysis of artworks, this text gives priority to the process of interpretation. While we offer interpretations of the artworks presented, we recognize that the meanings of any artwork are multiple and complex. and that all interpretations are negotiable.

We believe that an engagement with thematic ideas will prepare the reader to face both familiar and unfamiliar works of art with intellectual excitement. Indeed, our goal is to empower the reader/viewer with an enlarged mental perspective. The future will offer much that is unfamiliar. Learning to think about new art will provide tools for adapting to all manner of future events and can be a pleasure in and of itself.

Themes of Contemporary Art: What, Why, and How

Imagine you are an art critic whose mission is to compare the meanings you find in a wide variety of individual artworks. How would you proceed with this task? One way to begin is to examine the materials each artist selected in making an object, image, video, or event. The decision to cast a sculpture in bronze, for instance, inevitably affects its meaning; the work becomes something different than if it had been cast in gold or plastic or chocolate, even if everything else about the artwork remains the same. Next, you might examine how the materials in each artwork have become an arrangement of shapes, colors, textures, and lines. These, in turn, are organized into various patterns and compositional structures. In your interpretation, you would comment on how salient features of the form contribute to the overall meaning of the finished artwork.

The meaning of most artworks, however, is not exhausted by a discussion of materials, techniques, and form. Most interpretations also include a discussion of the ideas and feelings that the artwork engenders. For example, a photograph of a stretch of landscape in the American West by Richard Misrach [I-1] is defined only partially by the fact that it is a color photograph carefully composed to accentuate the sense of deep space in the view. The meaning is also in the subject matter of the photo, an orderly arrangement of tables and chairs within a barren landscape. But what does all this mean? Why did the photographer select this view to capture on film, and what effect does the photograph have on you as a viewer?

By examining other photographs by the same artist and reading some of the literature on his work, you would discover that this particular artwork is one in a series that Misrach calls his Desert Cantos series. Like all the works in the series, this one focuses on an outdoor location in the American West. Entitled "Outdoor Dining, Bonneville Salt Flats, Utah" (1992), this photo records the strange beauty in a scene of empty chairs and tables. Photographs in the series show how the Western landscape has been transformed by human actions, including bomb craters produced by explosions at nuclear test sites. Every work in the Desert Cantos series appears to stem from one basic idea: that humans have made nature subservient to our needs and wishes and that continuing to do so endangers not only nature's health but our own. Variations on this theme are explored throughout Misrach's Desert Cantos.

This text looks at art after 1980 in terms of selected themes that have been prevalent in the period. In many works of art, the artist conveys a theme by investing a subject with emotional significance or implying a moral value. In some works of art, the theme is expressed by a set of symbols (e.g., a rose might symbolize romantic love

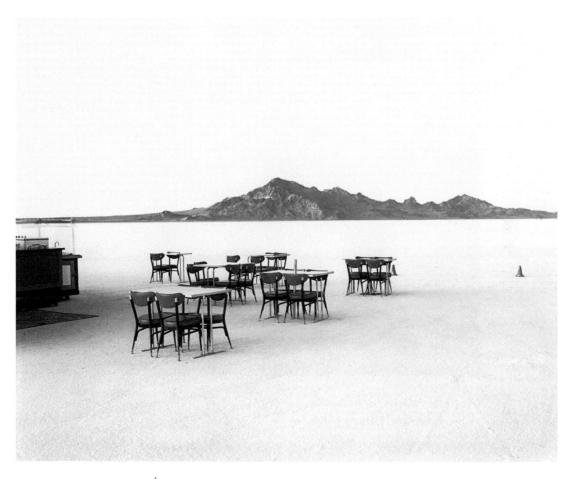

I-1 Richard Misrach | "Outdoor Dining, Bonneville Salt Flats, Utah," 1992 Color photograph, 40 x 90 inches

Courtesy of Fraenkel Gallery, San Francisco, and Pace/MacGill Gallery, New York

while thorns represent pain). In the study of art history, an interrelated, conventional set of symbols is called *iconography*. When using a thematic approach, we construct a mental framework for making sense of the ideas expressed in the artwork and their embodiment in certain materials and forms.

It is important to note that while the subject matter of a work of art contributes to the overall cognitive content, the subject matter is not necessarily equivalent to the theme. For example, artist Roxy Paine's *Crop* (1997–98) [I-2] is a sculptural recreation of a six-by-eight-foot plot of garden soil. Appearing to grow out of the soil are Paine's painstakingly rendered simulations of poppy plants. In addition to its literal subject matter—a patch of poppies—*Crop* is freighted with meaning that derives from our recognition that the poppy plant ultimately becomes saleable as opium or heroin. We might interpret the artwork as a metaphor for a world full of dangers and tensions, temptations, and condemnations and define its theme as having something to do with the health of the planet. (The artwork may take on an additional level of meaning for

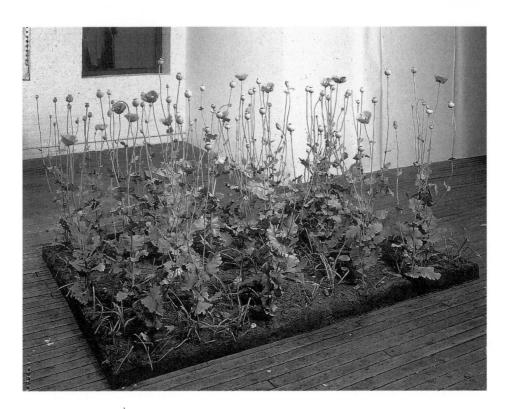

1-2 Roxy Paine Crop. 1997-98 Lacquer, epoxy, oil paint, pigment, 58 x 96 x 72 inches Photo by John Lamka Courtesy of James Cohan Gallery

viewers who recognize that much of the world's heroin supply originates in the poppy fields of Afghanistan.)

Exploring the chapters in this volume, you should bear in mind that our selection of six primary themes does not exhaust the broad range of content found in contemporary art. Furthermore, these thematic categories do not necessarily reflect those that the artists who made the works would name. Artists' intentions regarding content are complex, reflecting both conscious and unconscious ideas, and often involve more than one theme. Moreover, while contemporary artists are engaged in thinking about the content of the works they create, not all artists think about themes in a precisely defined manner.

These six thematic categories allow us to present a sample of artworks from which you can grasp influential concepts that stretch across much of the art of our time. Each theme functions as an interpretive lens, an analytical tool for exploring the various levels of meaning that artworks embody. Ultimately, almost all works of art can be viewed from the perspective of more than one theme. As you may have observed, the two artworks we just discussed—the photograph of the Salt Flats in Utah by Misrach and the sculpture of a poppy patch by Paine—are related to each other in that both involve aspects of our (human) relationship to the land. Both works would fit easily into chapter 3, in which we focus on the theme of place. But both could be analyzed in terms of other themes as well. It might be appropriate to explore the works in terms of spirituality, the topic of chapter 7, discussing them as metaphors for an apocalyptic end to human life and the loss of ability to find spiritual renewal. That an artwork can be approached from multiple interpretive contexts does not diminish the relevance or value of any one of them.

A Brief Orientation

Chapter 1 provides a broad introduction to important developments in art and to ideas and events that influenced art in the period from 1980 to 2004. Chapter 1 introduces ideas that apply to all the themes discussed in subsequent chapters. Chapters 2 through 7 delve into the themes themselves, one theme to each chapter in the following order: time, place, identity, the body, language, and spirituality.

Chapters 2 through 7 follow a similar format. An introduction situates the theme within a broad social and cultural matrix; a brief historical overview discusses artistic approaches to the theme and related concepts in earlier eras; recent artists' treatments of the theme are evaluated in terms of key theories and strategies of art production; and the theme is examined in terms of subcategories that have received critical attention in contemporary exhibitions and publications. Alongside an in-depth discussion of the theme, each chapter incorporates an artist's profile. Each profile provides a concise examination of the ideas and approaches of an artist who has devoted a substantial portion of his or her creative energies to exploring aspects of the theme under discussion.

By approaching the landscape of contemporary art from the perspective of the six themes selected for this text, we believe that our readers will benefit from two familiar footholds. First, these themes of art overlap in significant ways with the concerns of contemporary living. Each reader already possesses knowledge, ideas, and terms for thinking about topics such as place, time, and the body. To this degree, each chapter starts on familiar ground that is inherently meaningful to everyone. Second, the themes demonstrate that the achievements of contemporary artists have a historical context. Readers can see that the art of our own period connects with and draws from the rich traditions of past art. We expect that all our readers possess at least a modicum of knowledge of the traditions of art (e.g., they can recognize a landscape painting or a portrait), and so we build on this as a way of anchoring new learning to the bedrock of previous knowledge.

Note

1. While numerous themes are prevalent in the discourse on contemporary art, it is a curious fact that other themes that are important to the public, such as sports and marriage, are examined only rarely by notable contemporary artists and the art critics and historians who focus on contemporary art.

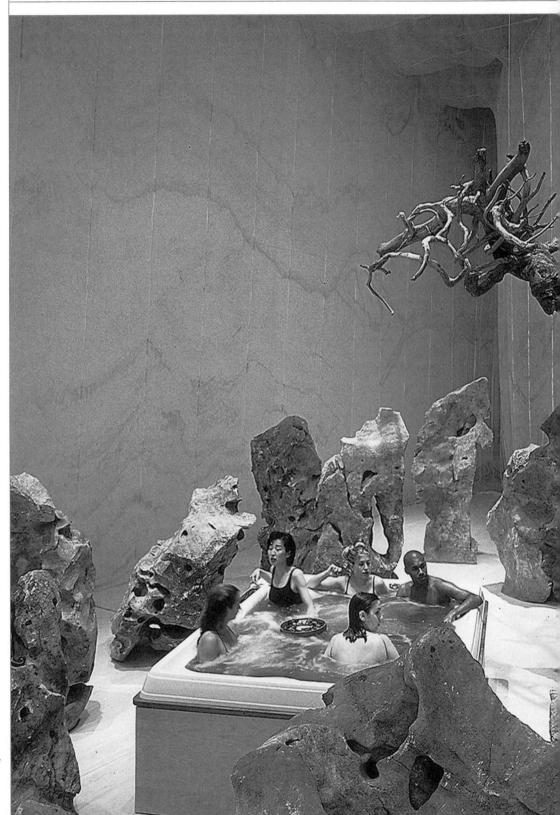

Detail of 1-3

The Art World Expands

In our travels and visits to exhibitions of contemporary art over the past several years, we've encountered many unusual and challenging works of art. Here is a sampling:

- The Eighth Day (2001), a "transgenic" artwork by Eduardo Kac, brought together living, bioengineered, glow-in-the-dark mice, plants, and fish and a biological robot ("biobot") in an environment housed under a clear four-foot-diameter Plexiglas dome (seen at the Institute for Studies in the Arts, Arizona State University, Tempe).¹
- Listening Post (2002) by Bell Labs statistician Mark Hansen and sound designer
 and artist Ben Rubin consists of an assortment of random messages gathered by
 a computer program that searches unrestricted Internet chat rooms and relays
 them as they are being typed on two hundred small screens and ten loudspeakers (seen at the Whitney Museum in New York City).
- Marsyas (2002) [1-1] by Anish Kapoor was a 508-foot-long, 115-foot-high structure made from a single span of blood-red PVC (polyvinyl chloride) membrane pulled taut over three steel rings, which filled the entire length of the massive ten-story-tall Turbine Hall in London's Tate Modern.
- An impressively large painted triptych by Li Tian Yuan (2001), based on a satellite image, shows progressively closer views of the artist and his infant son on the Great Wall of China (included in an international exhibition of art dealing with the interface of art and science at the National Museum, Beijing, China).

As these examples hint, the world of contemporary art is rich, diverse, and unpredictable. While painting, photography, sculpture, drawing, and the crafts still attract a large number of practitioners, these familiar forms of art no longer subsume the field. Film, video, audio, installation, performance, texts, and computers are common media today, and artists are often fluent in several media. Artists freely mix media, or they

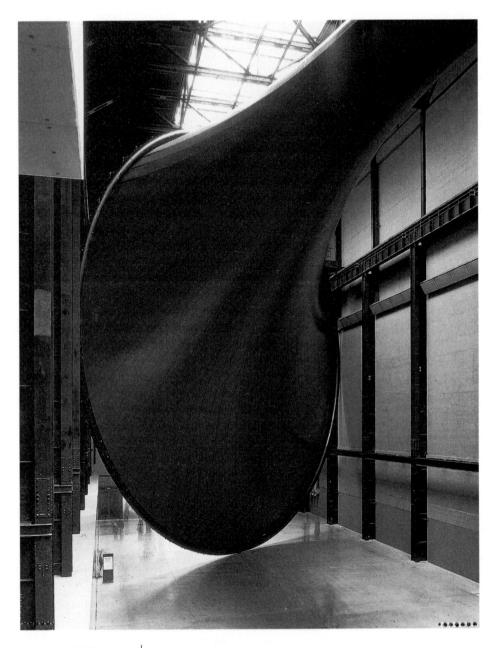

1-1 Anish Kapoor | Marsyas, 2002 Installed October 2002–April 2003, Tate Modern PVC, steel Photo by John Riddy Courtesy of Barbara Gladstone

may practice a medium with a long lineage in an unconventional way, such as making paintings that look like photographs or pixilated computer images.

Contemporary art is in flux. Old hierarchies and categories are fracturing; new technologies are offering different ways of conceptualizing and producing visual art; established art forms are under scrutiny and revision; an awareness of heritages from

around the world is fostering cross-fertilizations; and everyday culture is providing both inspiration for art and competing visual stimulation. The diversity and rapid transformations are intriguing but can be daunting for those who want to understand contemporary art and actively participate in discussions about what is happening.

Along with the dynamic nature of contemporary art, content still matters. Looking back at the history of modern art, it is debatable whether the idea of "art for art's sake" truly took over the thinking of modernist theorists and artists. But certainly there were periods in the twentieth century, especially just after World War II, when critics (famously the American Clement Greenberg, who died in 1994) and some influential avant-garde artists advocated *formalism*, an emphasis on form rather than content when creating and interpreting art. Those invested in formalism were and are concerned mainly with investigating the properties of specific media and techniques, as well as the general language of composition (the role of color, for instance). But formalism is inadequate for interpreting art that expresses the inner visions of artists or art that refers to the world beyond art. When Pop Art appeared in the 1960s, with its references to cartoons, consumer products, and other elements of shared culture, the limitations of formalism became evident and broader theories surfaced, including postmodernism in the 1980s, as we discuss later in this chapter.

Throughout the period we discuss—1980 to the present—artists have engaged deeply with meaningful content. Artists active after 1980 are motivated by a range of purposes and ideas beyond a desire to express personal emotions and visions or display a mastery of media and techniques. Political events, social issues and relations, science, technology, mass media, popular culture, literature, the built environment, the flow of capital, the flow of ideas, and other forces and developments are propelling artists and providing content for their artworks.

Overview of History and Art History, 1980-2004

The past two and a half decades have been eventful in virtually every area of human activity, including politics, medicine, science, technology, culture, and art. In the 1980s fax machines and compact-disc players entered widespread use, the first laptop computers were introduced, and cordless telephones became available. Also in the 1980s, for the first time in the United States, a woman was appointed to the Supreme Court, a woman traveled in space, and a woman headed a major party ticket as a candidate for vice president. The Berlin Wall was dismantled and Germany reunified in 1989, presaging the collapse of communism in Eastern Europe. In the 1990s numerous controversies raged over threats of global warming and genetic engineering of plants and animals; a sheep was successfully cloned in 1997; also in the 1990s a brutal civil war led to the breakup of Yugoslavia into several independent republics, ethnic massacres devastated the African state of Rwanda, nationalist conflicts broke out in the new states of Georgia and Azerbaijan in the former Soviet Union, and the IRA resumed its campaign of violence in Northern Ireland. Early in the 1990s apartheid officially ended in South Africa. By the mid 1990s the Internet system linked millions of users. In 1995 the Federal Building in Oklahoma City was destroyed by American terrorists. In September 2001 the World Trade Center in New York was destroyed and the Pentagon in Washington, D.C., attacked by Islamic terrorists. The U.S.-led invasion of Afghanistan commenced later that fall, and in 2003 the United States led an invasion of Iraq that toppled the government of Saddam Hussein. In general over the past ten years,

while the United States experienced enormous economic growth and prosperity, "in the poorest nations, famine, AIDS, and religious fundamentalism often reversed decades of progress."²

The demographics of various parts of the world have changed dramatically since 1980. Just in the United States, "the US experienced a profound demographic shift in the 1980s, with an influx of over 7 million immigrants from Latin America, the Caribbean, and Asia. By 1990, 25 per cent of Americans (population 247 million) claimed African, Asian, Hispanic, or Native American ancestry." Every year, across the globe, the relocation of vast numbers of people occurs in response to wars, famines, ethnic violence, and economic pressures and opportunities. Alterations in national boundaries and distributions of power are commonplace.

The art world itself underwent major changes during the period covered in this text. Major art centers lost some of their dominance as art activities became more decentralized. While New York City remained a primary destination on the contemporary art world map, other urban centers—including London, Los Angeles, Tokyo, Berlin, and Cologne—ratcheted up their support and presentation of new art to such a degree that anyone who expected to remain knowledgeably informed felt pressure to research current activities in these locations. Other cultural centers—such as Johannesburg, Beijing, Milan, and Sydney—also demanded frequent attention. The changed artistic landscape led to a significant cross-fertilization of ideas among major cities across the globe.

The art scene exploded after 1980, with a marked increase in artists, dealers, collectors, publications, and exhibition spaces. The formation of new institutions, as well as new or revamped facilities at existing institutions, expanded the number, size, and quality of locations where the latest in visual art could be seen by the public. Of these projects, several are notable not only for offering intriguing possibilities for the exhibition of art but because the architectural structures assert themselves as works of art in their own right. Topping the list in terms of publicity was the Guggenheim Museum's new branch in Bilbao, Spain, designed by architect Frank Gehry and built in 1997. Other notable new venues include the spectacular transformation of an enormous power station along the Thames River in London into Tate Modern (2000), and the more modestly scaled but boldly designed Wexner Center (1989) on the campus of Ohio State University in Columbus, a project by Peter Eisenman.

The fortunes and misfortunes of contemporary artists take shape, to a large degree, within the sphere of the commercial galleries that present new art. Reputations are built by the support of prominent gallery dealers and the approval of the critics, curators, and collectors who carefully monitor and judge the quality of the art featured in highly publicized exhibitions. For example, in the United States the 1980s saw the dizzying rise to fame of the American Neo-Expressionist painter Julian Schnabel, orchestrated with canny expertise by his New York gallery dealer. During the era, there were frequent shifts in the zones of concentrated art activity (such as the reduction of galleries located in New York's SoHo area and the dramatic influx of galleries into the historic meat-packing district known as Chelsea by the mid-1990s), as well as numerous gallery openings and closings, which reflected fluctuations in national economies. The rise of Neo-Expressionism in the early 1980s, for instance, was tied to a boom in the U.S. stock market, while an economic recession later in the decade was responsible in part for retrenchment and attention to more modestly scaled artistic projects. All of this, of course, is not without precedent. General forces at work in society, including politics, demographics, and economics, have always influenced the history of art.

In addition to an enormous range of activities, especially exhibitions, performances, film and video screenings, and lectures, presented by public institutions within facilities devoted to contemporary art, the contemporary period witnessed a surge of visual arts activities in public settings, such as city streets, plazas, and commercial facilities. Public dollars funded many of these activities, a fact that turned out to be something of a double-edged sword. The support of contemporary art with government dollars was a crucial means of enlarging the funds available to artists and institutions; in the United States and Britain such support was often a percentage of the amount budgeted for new government-funded public construction projects.

The use of public dollars increased attention to contemporary art (taxpayers were interested to know how their money was being spent), but the increased attention also resulted in more controversy whenever a vocal core trumpeted their outrage over a specific project. Maya Lin's Vietnam Veterans Memorial (1981–84), located on the Mall in Washington, D.C., Richard Serra's *Tilted Arc* (1981), installed in a public plaza near a government office building in Manhattan, and Rachel Whiteread's *House* (1993), constructed in an empty lot in London's West End, are examples of public art projects that galvanized public opinion, both pro and con. The Vietnam Veterans Memorial ultimately was embraced even by its original opponents. In the latter two cases, a more conservative outlook prevailed: Serra's work was removed in 1989 after a lengthy legal battle; and Whiteread's was demolished only a few short months after its creation.

Ultimately, however, the surge of public art activity resulted, on balance, in a growing recognition that contemporary art increased the economic well-being and cultural vitality of the entire community. Perhaps nowhere could this pattern be traced more clearly than in London, where a number of forces came together to contribute to the burgeoning notoriety and energy of the contemporary British art scene during the 1990s. Support, opportunity, and resources coalesced into a critical mass thanks to such developments as Artangel (a foundation that commissioned works of public art), the Saatchi Collection (a private institution devoted to the purchase and exhibition of cutting-edge works of contemporary art), and the influx of talented artists to London (to pursue educational and career goals).

Public controversies over contemporary art erupted regularly throughout the period. In the United States, art by feminists, gays, and nonwhite artists were particular targets, fueling the so-called culture wars that erupted in the late 1980s and early 1990s over public funding and freedom of expression. Highly publicized controversies accompanied a traveling exhibition of photographs by Robert Mapplethorpe that included some photos showing homosexual activities, the exhibition of *Piss Christ* (1987) by Andres Serrano, a photographic image of a plastic crucifix submerged in urine, which was deemed blasphemous by some religious spokespersons, and the offer in 1990 by feminist artist Judy Chicago to donate her monumental collaborative creation *The Dinner Party* (1979) to the University of the District of Columbia, a plan blocked by conservative members of Congress who called the work pornographic because some interpreted the imagery as representing female genitalia. Also under pressure from Congress, the National Endowment for the Arts (NEA) eliminated fellowships to individual artists in 1995.

Political considerations influenced some contemporary artists to engage in institutional critiques. Such critiques took aim both at art institutions, with artists attempting to reveal how museums, commercial galleries, and other organizations control how art is produced, displayed, and marketed, and at institutions within the wider society; for

example, feminists critiqued the social structures and hierarchies that limit female potential. Politically motivated art projects were particularly prevalent in the late 1980s and first half of the 1990s.

Activist art addressed social realities heard and seen in the news and experienced directly by the artists involved. Art about AIDS provides a key example. AIDS began its destructive growth in the early 1980s, when the disease was first recognized and named. In the 1980s, before treatments had been developed and refined, an AIDS diagnosis was like a death sentence. "Life was lived with that bell tolling all the time," recalls writer Stephen Koch. The association of AIDS with gays at that time brought forth a wave of virulent homophobia. In response to the crisis and to massive losses from AIDS within the arts community, numerous artists, including David Wojnarowicz, Keith Haring, and the art collective known as Gran Fury, put their art in the service of AIDS activism. Other arenas that provided serious political content for contemporary art included feminist politics, issues of race, homelessness, corporate capitalism, issues of consumerism, and militarism.

The history of contemporary art is not entirely a story of young artists bursting onto the scene with new ideas. While many previously unknown artists emerged after 1980, the presence and influence of older artists was important as well. For example, Joseph Beuys died in 1986, Andy Warhol in 1987, Louise Nevelson in 1988, and Roy Lichtenstein in 1997. Warhol and Lichtenstein were making vital work up until their deaths, so that even an art movement such as Pop Art, which we normally associate with the 1960s, was evolving within the ongoing production of these artists' oeuvres. British critic Richard Cork, discussing art in the 1990s and pointing to octogenarian artists such as British painter Francis Bacon and Franco-American sculptor Louise Bourgeois, observed: "The identity of a decade is not, of course, solely defined by the work of its emergent artists. More senior practitioners . . . can further enrich their own achievements, or even redefine themselves by exploring new directions. Their previous work can also take on a new pertinence in the light of interests explored by younger artists."

Themes of Contemporary Art is not a traditional survey in the sense of providing an in-depth chronological history of art since 1980. The history of art over the past twenty-five years is fantastically rich and involves many diverse stories, motivations, influences, ideas, and approaches. Attempting to map recent art into a tight chronological structure of movements or even of collections of major artists would be premature and, in fact, would misrepresent the contemporary period. Whereas the art world before 1980 is distant enough that we can perceive some sequence of trends (really multiple intersecting and interacting trends), more recent art practices are much more pluralistic and amorphous in character. Many of the artists we discuss are still active and still defining their practices. Artist Haim Steinbach said (remembering the 1980s, although his statement applies to the entire contemporary period), "I see [the period] as an archipelago, in which different things were going on, on different islands. They were going on concurrently but not always moving in the same direction."

Old Media Thrive, New Media Make Waves

If we cannot place contemporary art into neat compartments or a series of movements, we can still make a few broad observations about developments and tendencies in art since 1980.

Painting didn't die in contemporary art, despite predictions to the contrary made in the 1970s. Indeed, painting enjoyed something of a rebirth in the United States in the early 1980s, during the heyday of Neo-Expressionism, "an international movement dominated by oversized canvases and emotional gestures, and by a bustling commercial market." Young Americans making bold, gestural paintings, including Julian Schnabel, David Salle, and Eric Fischl, were celebrated and compared to dramatic painters who had emerged in Europe in the 1970s, such as the German Neo-Expressionist Anselm Kiefer. While enormously popular, Neo-Expressionism had its detractors, who saw the artists as opportunists who simulated emotion in order to appeal to the market. By 1990 the Neo-Expressionist momentum had died down, but in its wake painting continued to attract critical attention, although with some rising and falling in its influence (especially when examined on a regional basis) and changes in the concerns of its practitioners.

Like other traditional media, such as drawing and sculpture, the practice of painting saw its boundaries stretched and took on new life in the contemporary period. What defines a painting? Can we still recognize one when we see one? Thousands upon thousands of paintings are created each year in the familiar portable, rectangular, paint-on-canvas format. But exciting work has pushed painting into areas where it appears to overlap with sculpture and installation art. Guillermo Kuitca and Fabian Marcaccio, two artists from Argentina, exemplify the push to open the venerable queen of the arts up to new possibilities. Kuitca has painted maps on full-size mattresses, while Marcaccio trusses his paintings at odd angles between the walls and floor.

Photography became a player. Even as brushy Neo-Expressionist painting garnered headlines, the 1980s saw the rise of photo-based art. Photography gained respect in the "high" art world as an important medium in its own right, increasing in scale and in price in the art market. Artists had used photography as a medium from its invention in 1839, but it was in the 1980s that photography decisively escaped its secondary status and "moved to the very centre of avant-garde art practices rivalling painting and sculpture in size, spectacular effects, market appreciation, and critical importance."8 Photography also exerted a noticeable influence on other forms of art, particularly some genres of painting, which sometimes seemed to be playing catch-up in striving to create a convincing illusion of the way the world "really" (i.e., photographically) looks. Photography also expanded its own boundaries as artists gave free rein to experimentation. For instance, the Starn Twins, from the United States, composed artworks by overlapping and affixing multiple photos together using informal means such as masking tape. More and more photographers turned to elaborate fabrications, constructing staged scenes they then photographed or manipulating negatives and altering photographic prints.

The themes and subject matter pursued by individual photographers expanded, building on the work of earlier photographers, such as the mid-twentieth-century Americans Diane Arbus and Ralph Eugene Meatyard, Robert Frank from Switzerland, and Henri Cartier-Bresson from France, who intensely set about the business of capturing images of the world in all its surprising diversity. Nan Goldin, a contemporary American photographer, provides us with snapshotlike glimpses into the underbelly of life as she witnesses and lives it, often showing her friends at their most vulnerable moments—making love, bruised from domestic violence, or shooting up drugs. Canadian Jeff Wall portrays his staged subjects, such as dead Russian soldiers stuck in the muck of their failed war in Afghanistan or an aged, nude giantess dominating a

landing inside a shopping mall, so that they look like illustrations from a breaking news story. The effect of Wall's art, which seems weirdly familiar, can be attributed in part to his presentation format. Wall transforms his images into transparencies that are illuminated from the reverse side and displayed in light boxes up to six feet on a side, so that his art resembles photographs mounted for maximum impact at trade conventions.

Sculpture as an art form widely expanded its sphere of influence, and the range of content and forms within the genre expanded as well. In the 1970s, during the reign of Minimalism, pared-down abstract sculpture predominated. Such Minimalist sculpture emphasized simplified, abstract volumes (what some critics referred to as "primary forms"). In the 1980s and extending into the present, sculptors dramatically diversified the forms, techniques, and materials they selected. In the early 1980s strong work was produced by a particularly vital group of young sculptors working in Britain, including Richard Deacon, Anish Kapoor, and Tony Cragg. In addition to creating sculptures from traditional materials, such as bronze, marble, and wood, artists made sculptures from a wide array of materials as well as found objects. Tony Cragg, for instance, became widely known for his wall-mounted, multipart figurative sculptures created by arranging found plastic objects (e.g., packaging materials, throw-away plates, and plastic containers) into pictographic patterns. Furthermore, while sculptors continued to carve, cast, and construct discrete, unique objects, others expanded their practice so that sculpture overlapped with other art forms. Artists such as Robert Gober in the United States and brothers Dinos and Jake Chapman in England produced work that incorporated multiple sculptural objects within their multimedia installations.

No medium dominates. Many contemporary artists do not limit their efforts to a single "signature" medium. Instead, artists may move between various media and even move between the world of fine art and commercial fields such as fashion, design, and music.

New media attract artists. Video technology attracted experimenters within the field of art, notably Nam June Paik, as soon as it became available in the 1960s. During the 1990s video became a prominent medium, in part because its time-based character supports a contemporary interest in exploring narrative structures. Also in the 1990s numerous artists adopted digital technologies as small, powerful computers became affordable and software programs facilitated sophisticated graphic manipulations. Artists used digital tools both in the service of traditional media, designing the structure for a sculpture on a computer, for instance, and as a new formal and conceptual arena in itself. With the widespread use of DVD recording technology in the early 2000s, artists, and the gallery system that derives its profits from the sale of artworks, gained an important means of controlling the sale of video and computer artworks in limited editions to collectors. Of course, DVDs are easily copied, and in spite of copyright protection, bootleg versions of artists' original recordings are now traded and downloaded on the Internet.

Meanwhile fast-paced developments in digital video production and editing, holography, light art, and interactive computer sites have spawned new arenas for artistic exploration. These new media have also spilled over into the practice of other media; for example, new media are often incorporated into installation and performance art events.⁹

New technologies produce new paradigms. The invention, adoption, and adaptation of new technologies create new modes of representation, new ways of perceiving and thinking about the world. Photography appeared to offer its nineteenth-century

viewers a quality that no other form of visual art could match: visual truth. A photograph of the battlefield at Gettysburg was accepted, prima facie, as a bona fide representation of the scene one would have beheld had one stood in the same place that the Civil War photographer stood. Unless obviously altered in the darkroom, photographs were understood to be recordings of the way light reflected off actual subjects at a specific moment in time and place. To the public, this meant that photos were accurate in a way that drawings, paintings, or sculptures could not equal. Furthermore, the public was often willing to equate accuracy with truth.

Of course the so-called truth factor in photography should always have been suspect. Staged photographs, to cite just one strategy, are constructions of events that never took place, although their representation photographically allows them to appear real. Indeed, the camera is unparalleled in its capacity to duplicate the myriad nuances of the material world, and thereby to explore in endless detail the tensions and border zones separating the real and the fictive, nature and culture, one culture from another, and the public from the private. No matter what happens before or after the picture is taken, when the photo is snapped the camera is functioning as a recording instrument. This provides the photographer (and the viewer) with a baseline authenticity against which other concerns are articulated, fabricated, and highlighted. An example of photography's use as a tool for fabricating convincing portrayals of imaginary realms is Japanese photographer Yoshio Itagaki's intriguing concoction "Tourists on the Moon #2" (1998) [1-2].

Highly skilled darkroom manipulations, such as those made by photographer Jerry Uelsmann since the 1960s, can produce convincing representations of unreal places, people, and events. Today, digital technologies have the potential to alter images even more dramatically. Paradigms of the nature and structure of perception and conception are shifting again. Particularly in the last half of the period this book covers, the availability of desktop computers and the increasing sophistication and ease of using

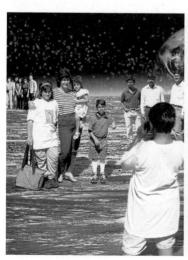

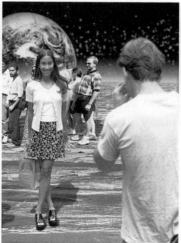

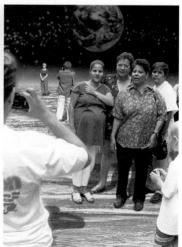

1-2 Yoshio Itagaki

"Tourists on the Moon #2," 1998

computer graphics programs are bringing about "a transformation in the nature of visuality probably more profound than the break that separates mediaeval imagery from Renaissance perspective," in the words of art historian Jonathan Crary. We are experiencing an epochal shift from an analog world, a world of everyday perceptions with infinite gradations, to a digital world rendered in binary code.

The computer stores vast quantities of detailed information digitalized into a binary code. It enables an image of any subject to be manipulated, duplicated, transformed, and transmitted to a degree that is unprecedented in human history. Digital images, of subjects both real and imaginary, can look so convincing that the distinction between the actual and the made-up is almost impossible to detect. At the same time, unlike early viewers of photographs, today's audiences know that images are manipulated and manufactured all the time; they allow themselves to suspend disbelief in order to enjoy the illusion of reality. Crary argues that during the contemporary period "there has been a progressive depreciation of the reality 'value' of manufactured images of all kinds.... Most images (whether film, video, or photography) still function as though their referentiality were intact but with a vaguely defined reduction in their truth value." 11

Virtual reality blurs boundaries. The blurring of the boundaries of fact and fabrication is epitomized by the development of virtual reality as a field of investigation. The term virtuality refers to "an image or space that is not real but appears to be. In our own time, these include cyberspace, the Internet, the telephone, television and virtual reality." The term virtual reality generally refers to a simulated, computer-generated environment. A viewer wears special goggles and earphones and interacts with the environment by moving her head or manipulating controls. Throughout the 1980s and early 1990s the promise of virtual reality outstripped the actual achievement, but since then, advances in software and technology have made forays into virtual reality more satisfying for viewer and artist/designer alike. Experiments in virtual reality have been conducted widely in the realm of computer gaming, but it is only a matter of time before designers/authors of interactive computer games create works in that medium that are embraced by an expanded definition of contemporary art.

Visual culture is duplicated and shared worldwide. In addition to enabling rapid, radical manipulation of imagery, the computer now makes possible the almost instantaneous dissemination of images. Since the mid-1990s the growth of the Internet and World Wide Web has allowed users to transmit and receive images and other information instantly all over the world. The digitalization of information is a powerful force in speeding up the sharing of artist-generated images in all media, as well as the appropriation by computer-savvy artists of information streams from other arenas of culture. In our role as viewers we no longer are dependent on being in a specific place. We can plug into the Web or into our computer's memory anywhere we have access. Acknowledging this trend, the Whitney Museum included Internet art for the first time in its Biennial Exhibition in 2000.¹³

In addition to the accelerated exchange of information and images, another significant quality of mass visual culture is the uniformity of imagery that is disseminated by the media. Through this process, many more people share an identical storehouse of mediated experiences. Such high uniformity of memory never occurred prior to the invention of the Internet, television, radio, cinema, and photography. With each new technological breakthrough, the capacity of pop culture to overwhelm the sphere of

private experience expands. Today's information culture is channeled into formats that tend to homogenize the structure of information. Contemporary artists, however, have found ways to counteract this phenomenon. Christian Marclay combined snippets from over a hundred movies to create *Video Quartet* (2003), which is projected simultaneously on four oversized screens; and David Byrne, widely known as a musician, utilizes Microsoft's PowerPoint software to produce imaginative illustrations and animation that are a far cry from the staid sameness of most PowerPoint presentations seen in the business or academic world.¹⁴

Although the languages of digital media are in their infancy, they are bound to have a radical impact on visual art in the twenty-first century. Artists who are concentrating on this area are pioneers in helping us to confront what it means to live in a world of accelerated information flow from multiple channels, and to find ourselves entranced by manufactured virtual worlds.

A Spectrum of Possibilities Emerges

Pluralism, multiculturalism, internationalism, globalism, diversity, difference. These are just a few of the terms that have been used to describe and discuss the ever-expanding variety of cultures and regions on our globe and the transformation of art that is occurring in a rapidly mutating, increasingly interconnected world.

In the United States in the period from the late 1960s to the start of the 1980s, the rebellions and successes of the women's movement and civil rights movement impacted art by opening up the stage to more voices. These newly visible participants brought new ideas to the field as well as new ideas about means, media, and techniques for expressing those ideas. Since 1980 the highly visible activism of gays and lesbians has added more voices to the mix. Although they have yet to achieve full equality in terms of income, influence, prestige, and recognition, women and minority artists in the West have become empowered and have had a major impact on who makes art, what art is about, and how art is viewed and interpreted. Artists of color, women artists, and gay artists have been at the heart of discussions about contemporary art in the 1980s, 1990s, and today. The collective imagination of what is possible in art has opened up to acknowledge diversity.

Over the past twenty-five years, artists have become more conscious of diversity internationally as well as in their midst. For example, beginning about 1980 the American art world in general turned its attention to artistic developments in Western Europe, particularly to the Neo-Expressionists—including Germans such as Anselm Kiefer and Georg Baselitz and Italians such as Sandro Chia, Francesco Clemente, and Enzo Cucchi. Subsequently, as a result of shifts in national borders, regimes, and political and economic structures, artists from all over the world have become widely known in Western Europe and North America. Among these are Eastern Europeans such as the Russians Ilya Kabakov and the collaborative duo Vitaly Komar and Aleksandr Melamid, Central and South Americans such as Chilean Alfredo Jaar and Brazilian Adriana Varejão, Middle Eastern artists such as Iranian Shirin Neshat and Palestinian Mona Hatoum, Africans such as Zairean Chéri Samba and South African William Kentridge, and Asians such as Xu Bing, Wenda Gu, and Wang Guangyi of China, and Yasumasa Morimura, Yukinori Yanagi, and Mariko Mori of Japan. Many of those named have immigrated to the West, contributing to their visibility.

Artists and audiences outside the West likewise are paying attention to developments far beyond their borders. From 1980 onward, with increasing complications, artists in Africa, Europe, the Americas, Asia, and the Pacific are influencing each other to varying degrees. We live in a multicultural, internationalized world, where people with different cultural knowledge are meeting, mixing, and negotiating histories, definitions, and boundaries. Artists use visual means to convey positions or paradoxes about where cultures draw boundary lines, and what belongs on one side or the other. Immigrant artists, in particular, frequently use art to comment on the places and cultures they have left and to reveal their perspectives on their adopted countries.

To cite just one example of a complicated path followed by a contemporary artist: Cai Guo-Qiang was born in Quanzhou City, China, in 1957 and grew up during the Cultural Revolution. He studied stage design in Shanghai, then left China in 1986 to study in Tokyo. In 1995 he relocated again to New York City. His art production includes large-scale drawings, installations, and performance events and has involved gunpowder, fireworks, and Chinese herbal medicines, among many other materials and means. Cai's elaborate installation *Cultural Melting Bath*, which has been installed in various locations including the Queens Museum in New York in 1997 [1-3], provides a symbol of the therapeutic cultural mixing Cai hopes that his art fosters. The installation includes a Chinese rock garden, banyan tree roots, and a Western-style hot tub infused with Chinese medicinal herbs, in which a multicultural array of museum visitors are invited to bathe together.

Awareness of international developments in art has made the art world more exciting and well rounded. But internationalism is not an unequivocal good, particularly when art production comes under market pressure from international institutions and corporations who support the production and display of contemporary art. Increasingly, the world is becoming linked by a global economy, a development that is inevitably impacting the production and reception of art. Consumer capitalism, especially the approach developed most aggressively in the United States, made huge strides during the contemporary period in extending its reach to global markets. The emergence of new telecommunications technologies, specifically the continued spread of television throughout the world and the rapid development of the computer and Internet for both personal and business use, has significantly promoted globalization. The collapse of the communist system in the former Soviet Union and the economic rise of countries of the Pacific Rim, especially China with its steps toward a more capitalist-style economy, have opened up portions of the world that had been significantly insulated from capitalist business practices.

The global economy has impacted the entertainment and culture markets. The number of international art fairs, biennials, and triennials has increased to the point where they are nearly impossible to keep up with. Geographic mobility has become important, and artists who have the resources to participate in international events are more likely to succeed. In 2001 there were more than sixteen international biennials; in 2002 there were seventeen in fifteen countries. Cultural scholar Homi Bhabha has argued that market forces, including goals such as enhancing tourism and attracting international corporate investment, and a desire for civic or regional status drive the biennial trend. "Having a biennial reveals a desire to be seen as a region of modern culture. Even in countries of economic and political hardship, they provide a virtual sense of being part of a technologically connected world."

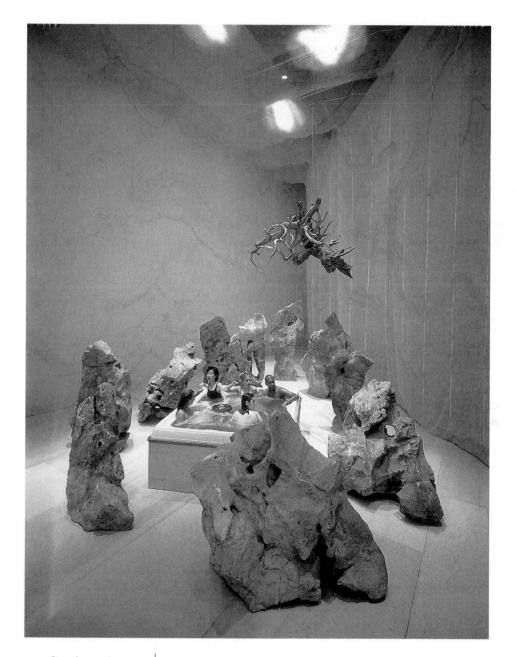

1-3 Cai Guo-Qiang | Cultural Melting Bath: Projects for the 20th Century, 1997 Taihisu rocks, hot tub, live birds, and herb medicine, 24 x 67 x 80 inches Courtesy of the artist

The value, meaning, and impact of the international art market are matters of debate in the art world. Some decry the trend as promoting uniformity, maintaining, for instance, that Western influence dominates and that expensive video and multimedia installations are ubiquitous in biennials because they are eye-catching while also

portable and reproducible. In contrast, others see the international events held outside Europe and the United States as an important means for other areas to assert themselves as players in the art world. The emergence of a linked global society (linked both technologically and economically) apparently has not resulted in the international unity predicted by earlier theorists and historians. According to Jonathan Crary, "the planetary circulation of images, information, and data of all kinds over telecommunication networks is not even remotely leading toward a unified global society but only toward a superficially homogenized consumer environment. Instead, there has been a proliferation of relatively self-sufficient micro-worlds of meaning and experience, between which intelligible exchange is less and less possible."

Theory Flexes Its Muscles

Numerous artists and critics active since 1980 have been heavily invested in theory and critical analysis. In the wake of Conceptual Art, art became increasingly theoretical and idea-driven and began to sprout difficult and obscure branches. The direct embrace of theory seemed to crest midway through this period; by the early 1990s influential art graduate schools in Europe and the United States were advocating the acquisition of theoretical knowledge and teaching analytical and interpretative skills. Discussing master of fine arts degree programs in the United States, writer and curator Bennett Simpson maintained, "Employing conceptual, post-minimal, video and performance artists from the sixties and seventies, schools such as CalArts, UCLA, Art Center, Yale and the Whitney Museum's Independent Study Programme tended to privilege intellectual and critical study over the more traditional training in manual skills like drawing, figure painting and sculpture. 'Knowledge work' became detached from its antecedent, technical work." ¹⁷

Concepts from a range of theoretical perspectives, including postmodernism, semiotics, poststructuralism, feminism, and postcolonialism, to name several of the most influential, have shaped the creation and reception of art produced since 1980. The theoretical critique of the period examined many arenas of visual culture, including the structure and biases of art history, the nature and operation of art-market economics and how reputations are built, the visual means through which mass media influence ideas and taste, and the representation in visual media of all kinds of identities revolving around gender, race, sexuality, religion, and nationality.

The term *postmodernism* cropped up in art criticism in the 1970s but became more commonly used in the 1980s. Writers and thinkers engaged with postmodernism include Jean-François Lyotard, Jean Baudrillard, Julia Kristeva, Charles Jencks, and Umberto Eco. The term is vague and open-ended, initially implying an opposition to some of the tenets of modernism, including the belief in social and technological progress, faith that history unfolds in a rational, linear direction, and belief in individual self-determination. Postmodernists are skeptical about progress, tend to be anti-elitist (for example, embracing kitsch as readily as the art of museums), think that the forms of culture are hybrid, eclectic, and heterogeneous rather than pure and easily defined and contained, and believe that individuals are inevitably molded by culture. Postmodernists believe we are all prisoners, to some degree, of identities constructed for us by artistic and popular media. Moreover, the contemporary world is becoming increasingly more artificial because secondhand images filtered through television, film, and other

media now substitute for direct experiences and exert a powerful influence on how we perceive and understand the world. In addition, more and more mediated images and experiences are manufactured illusions with no basis in tangible reality—simulacra, to use Baudrillard's term. Baudrillard, according to art historian John Rajchman, "took the words 'simulation' and 'simulacrum' to describe the 'Beaubourg effect'—no longer able to distinguish model from copy, we had lost any sense of reality, leaving us only with 'irony,' hyperrealism, kitsch, quotation, appropriation." 19

There is no single style associated with postmodernism; instead any and all styles and visual vocabularies are valid, and pluralism rules. In the 1980s, in line with up-to-the-minute theories of postmodernism, visual artists adopted appropriation, quotation, and pastiche as tactics. Appropriation artists comb both art history and vernacular culture for styles, images, subjects, and compositions and recombine details borrowed here and there into eclectic visual pastiches. Schlock and kitsch borrowings are readily combined with details from high art, architecture, and design. Most appropriationists mine the distant and recent past in a nostalgic fashion, usually with little historical consciousness of what visual representations meant in their own past context. In addition to evoking nostalgia, postmodernists also often quote from the past and vernacular culture with an attitude of irony or even parody.

Many postmodern artists use appropriation uncritically, simply adopting the approach as a contemporary artistic fashion. But some artists attend to the conceptual implications of appropriation, using the strategy as a tool to raise philosophical questions about whether it is possible for artists to be original or express authentic feelings and beliefs. Such artists include German Gerhard Richter, Russian team Komar and Melamid, and American Cindy Sherman. The most politically motivated appropriationists, including American Sherrie Levine, also challenge as elitist the modernist identification and celebration of a handful of supposedly innovative artists. By appropriating, such artists imply that originality does not matter.

Influenced by the ideas of Swiss linguist Ferdinand de Saussure and the American philosopher Charles Sanders Peirce, both active in the late nineteenth century, complex permutations of *semiotics* (the science of signs) were applied to the visual arts in the late twentieth century. While linguists analyze the structure of (verbal) language, semioticians open up virtually any field of human activity as a potential subject for an analysis of the signs that function within that field. Clothing styles, rules of etiquette, codes of conduct for men and for women—all of these and countless other realms of experience can be analyzed in terms of semiotics. As scholars (and artists) surmised, all of the arts also function on the basis of the conventional use of signs, and so semiotics is a powerful tool for the analysis of the practice of art. Art topics such as styles of representation, the rules of linear perspective, and the metalanguage of various media (painting, for instance, signals "tradition" in a way that video does not) are ripe for analysis through the magnifying glass of semiotics.

For example, some contemporary artists knowingly engage with the language of abstract art in a semiotic manner. Abstraction is intimately associated with modernism (the period in Western art directly before postmodernism), which is often a target and devalued in contemporary theory. The "heroic" generation of post–World War II American abstract painters, including Abstract Expressionists such as Jackson Pollock, believed fervently in art as self-expression and maintained that artists should work intuitively as much as possible, relying on the subconscious to stimulate vital, uncensored

gestures and marks. They believed that every artist has a unique, "authentic" touch, as identifiable as a person's handwriting, which will emerge if the artist creates in a free process. They also believed that receptive viewers have a visceral response to the resulting paintings, echoing the passion of their creator. In contrast, many in our postmodern age are skeptical that genuine self-expression is possible and argue that our "individual" expressions and responses are really just reflections of cultural conditioning. Maybe at one time a painter could make a fluid gesture that was sincerely spontaneous, but today's painters must be self-consciously aware that a gestural style is supposed to be a sign of freedom, and thus they can no longer make gestures in an unself-conscious manner.

Artists today who engage with abstraction in a semiotic way might adopt characteristics of the Abstract Expressionists or Minimalists precisely because they know those devices have become conventions that a knowledgeable audience recognizes. One artist might make obviously contrived gestures to subvert the notion of painting as spontaneous expression; another artist might choose a grid or another convention of geometric abstraction to critique an earlier generation's dreams of social utopia and "encode" a warning about ideological rigidity. For example, American painter Peter Halley used rectangular motifs reminiscent of Piet Mondrian and other painters of geometric abstraction to design images that hint at diagrams for a network of passages, perhaps in a prison ward or underground bunker. American Rachel Lachowitz's lipstick-coated copies of Minimalist sculptures mock the supposed "masculine" objectivity and logic encoded in those impersonal, hard-edged structures.

Even in the face of skepticism, however, some contemporary artists choose to work abstractly with heartfelt commitment rather than irony. Those who argue that art is valuable when it provides a focus for perception and contemplation often prefer abstraction. The reductions of abstraction yield a strong contrast to the visual overload of mass-media images. And without recognizable images or narrative to occupy their thoughts, viewers are not distracted from the immediate sensory experience of looking. But today's artists who are sincere about abstraction are not necessarily returning to the Abstract Expressionists' notion of abstraction as self-expression. As painter Laurie Fendrich writes, abstraction "is also about ideas—the complex struggle between order and chaos, for example, or how the flux of the organic world modifies the rigor of geometry." ²¹

Theories associated with *poststructuralism* are closely identified with postmodernism and semiotics. What poststructuralism added to the mix was the concept that the underlying structure of a language or any other symbolic system is not fixed and permanent.²² With individual variations, these poststructuralist thinkers argued that any symbolic system or cultural artifact (e.g., a language, a work of literature, a painting, a social system)—what they called a *text*—can be shown to have internal contradictions and hidden ideologies. Poststructuralists use a strategy developed by French philosopher Jacques Derrida known as *deconstruction* to analyze visual and verbal texts. Deconstruction looks at a text or symbolic system in terms of the underlying worldview that gave rise to it, exposing contradictions and hidden biases in order to challenge the validity of the worldview as well as the text. Derrida also argued that the meanings of texts are unstable because different readers (or viewers, in the case of visual texts) bring their own worldviews to their reading and looking, which skew interpretation. No text has any single, correct interpretation; meanings change with the reader, the time, and the context.

According to postmodernists and poststructuralists, truth and reality are not as truthful and real as they may seem; in fact, there are many truths and many realities. All truths and realities are relative and contingent, constructed by culture, dependent on context, and subject to negotiation and change; none is inherent in the natural order of things. Moreover, today the contradictions are more apparent because the cultural landscape is filled with texts that express competing worldviews, simultaneously available and bleeding over into each other's domain because of the rapid flow of information from numerous sources constantly bombarding us. These texts interact and compete with one another (creating a condition of intertextuality, to use the term favored by Derrida and Roland Barthes, another influential French theorist). Poststructuralist thinkers believe that the onslaught of information in our media-saturated societv has made it impossible for any single worldview to dominate. Instead, boundaries and divisions between categories of all kinds are eroding. In particular, the dualities, or binary pairs, so common in Western thinking and culture no longer are convincing as polar opposites. Male and female, gay and straight, white and black, public and private, painting and sculpture, high art and low art—distinctions between these and other categories dissolve in a postmodern world and the elements merge into hybrids.

Under the banner of poststructuralism, a significant core of contemporary artists aligned their studio practice with theoretical positions that emphasized the deconstruction of meaning within ever-shifting relationships of power and symbolic signage. Among the many artists influenced by these theories are Sonia Boyce and Helen Chadwick from England and Barbara Kruger and Lorna Simpson in the United States.

The perspectives of *feminism* and *postcolonialism* have profoundly affected contemporary visual culture. Feminists and postcolonialists challenge artists, art historians, critics, and audiences to consider politics and social issues. Feminists look at experience from the perspective of gender and are particularly concerned to ensure that women have the same rights and opportunities as men. Feminist theoretical critiques analyze hierarchical structures that contribute to male dominance, what feminists call *patriarchy*, that is, the cultural beliefs, rules, and structures that reinforce and sustain masculine values and male power. A key area of feminist analysis in the visual arts is *the gaze*, a term used to refer to how categories of people are stereotyped in visual representations by gender, race, sexuality, and other factors.

Postcolonialists are interested in cultural interactions of all kinds (in politics, economics, religion, the arts, philosophy, mass media, and so on) among peoples of different nations, regions, and communities. Postcolonialists examine how peoples' histories and identities demonstrate the economic, political, social, and psychological legacy of colonialism in particular locations, which oppressed indigenous peoples and resulted in *hybridity*, or a mingling of peoples and cultures. They also analyze migrations and displacements of peoples (*diasporas* and *nomadism*, to use two of the current terms) and highlight the diversity of cultures that coexist in contemporary communities. Postcolonialists' attention to the visual cultures of Africa, Asia, the Americas, and the Pacific has helped foster the internationalization of the contemporary art world.

Many different theories have influenced feminism and postcolonialism, and ideas and positions are constantly mutating. ²³ The perspectives are usually interdisciplinary, drawing from literature, history, sociology, anthropology, and other disciplines. Since 1980 poststructuralism has been highly influential, and critics and artists have used deconstructive strategies to analyze, or "decode," how power functions to limit the

achievements and potential of women and postcolonial people around the world. Feminists and postcolonialists have applied other theories as well, including Marxism and psychoanalysis, and have contributed theories of their own. Postcolonialists have promoted the use of theoretical models that attempt to understand the visual arts of various cultures on their own terms rather than in comparison to art traditions in Europe and the United States.

The positions of feminists and postcolonialists, at their most ideological, propel art with an activist agenda. Thus feminist artists might make art about reproductive rights or body image or other social issues important to women. Postcolonial artists might make art about racism, disparities between rich and poor nations, or the blending of cultures among immigrant groups. Feminists and postcolonialists question and challenge many core values of Western civilization, such as some of the ideologies, practices, and effects of the capitalist economic system. In the eyes of its critics, capitalism centralizes power and money in the hands of a few and leads to the poverty and oppression of many, including minorities in the Western world and large populations in many countries outside the West. Feminists and postcolonialists also challenge Western dualistic thinking, arguing that the underlying logic is hierarchical and privileges one of the binaries as superior and relegates the second to the margins as inferior and "Other." Hierarchical thinking built on dualities puts male over female, white over black, Western over non-Western, youth over age, order over chaos, and so on.

The theories discussed above, as well as others not discussed such as Marxist and psychoanalytic theories, permeate the production, reception, and interpretation of contemporary art. But the explicit embrace of theory has not been universal or constant over the past two and a half decades, and its influence is often diffuse and unacknowledged rather than systematic. For example, there has been a widespread cultural backlash against feminism; as a result, younger women artists are often reluctant to call themselves feminists, even when their art and ideas support feminist tenets.

Artists didn't seem to pay attention to theory as much after 1990, and the debates of the previous decade over modernism and postmodernism died down. According to curator Toby Kamps, in "an ideologically uncertain moment, artistic strategies of the 1980s—appropriation, critiques of commodification, deconstruction—seemed empty or calculating. Instead, artists took up accessibility, communication, humor, and play. As a style, Postmodernism, positing stylistic eclecticism, social criticism, and end-of-history irony, appeared bankrupt; as an attitude, however, it was the definitive zeitgeist. The art of the 1990s, with its interest in complexity, multivalency, and ambiguity, mirrored an uncertain, transitional period."²⁴

Although in general over the past ten years artists seem less committed to strong political positions and not as well versed in academic theories, that does not mean that art has lacked meaningful content. To the contrary, a preoccupation with deep moral and ethical questions and resonant themes, such as spirituality, beauty, violence, sexuality, transience, extinction, memory, and healing, is a powerful current in the most recent art. The real world is treacherous and volatile. According to Richard Cork, the question posed by Joseph Beuys's 1985 work *The End of the Twentieth Century* still resonates: "Is [our era] about to terminate prematurely in a nuclear apocalypse, or will it be succeeded by an era which asserts a less destructive set of values?" Or as Homi K. Bhabha wrote: "The '80s inaugurated a dream of difference which is now being haunted by horror and doubt: abhorrence of the 'deterritorialized flows' of global terror

networks; doubts about the feasibility of global politics with the increase in 'homeland' security and international surveillance; doubts about preemptive strikes; doubts about war; doubts about our rights and responsibilities for the world and ourselves. What happened to the dream?"²⁶

Art Meets Contemporary Culture

One of the leitmotifs of art over the past hundred years has been the blurring of distinctions between the realm of art and other categories of culture. Before World War I, while developing Cubism, Georges Braque and Pablo Picasso produced the first high-art collages, combining scraps of newspaper and other materials from the everyday world with traditional art materials. At about the same time, Dada artist Marcel Duchamp famously exhibited unaltered found objects such as a urinal and a snow shovel as what he called *readymades*, or found sculptures. Numerous artists since have experimented with found objects, including other Dada artists, the Surrealists, the so-called junk sculptors of the 1950s, Pop Artists, and a range of artists interested in techniques of assemblage or the conceptual implications of the readymade. Performance artists likewise have mixed everyday movements, sounds, props, and behaviors with more conventionally theatrical elements.

In the contemporary period, the dissolution of boundaries between art and life has continued in a number of directions. There continues to be cross-fertilization between high and low art. The use of found objects and the readymade remains a significant direction, frequently involving appropriations from consumer culture. Americans Jeff Koons and Ashley Bickerton and Israeli-born Haim Steinbach have each in their own idiosyncratic way referenced the slick refinement and packaging of mass-produced consumer products in the creation of their art. Koons's gleaming *Rabbit* (1987) [1-4] is an appropriation of a novelty Mylar balloon, now cast in polished stainless steel. Koons knowingly fuses, and confuses, commercial glitz with the polished forms of earlier modern art and the everyday subjects of Pop Art sculptures. Like many of his other sculptures in which the artist appropriates actual consumer objects (e.g., kitsch statuary, toys) and remakes them in a new medium as highly crafted luxury objects for wealthy collectors, Koons's *Rabbit* appears to warmly embrace our consumer lifestyle while, at the same time, coolly appraise the shallowness of a civilization devoid of deeper meaning.

This bifurcated stance toward contemporary reality, in which many of us are simultaneously attracted to and repelled by the tidal wave of rampant consumerism, is reflected in the alternative use of comic book and cartoon imagery and styles. Now a thriving subculture of visual culture as a whole, the comic and cartoon format is seen in the work of Raymond Pettibon, Laylah Ali, Glen Baxter, and Christian Schumann, among numerous others. Japanese *anime* (animation films) and *manga* comics, with their super-cute, super-violent, and super-sexualized imagery done in an insistently flattened style, have exerted a particularly strong influence on the younger generation of Japanese visual artists. The painters Takashi Murakami and Yoshitomo Nara, for instance, are known internationally for their characteristic approach to painting in the *Superflat* style (a term coined by Murakami). The early 1990s also saw the beginnings of the "abject" or "pathetic" art trend, when artists such as the Americans Mike Kelley and Candyass evoked adolescent bad-boy behavior by using materials such as soiled stuffed animals and techniques such as rude graffiti.

1-4 Jeff Koons Rabbit, 1987
Stainless steel, 40 15/16 x 18 15/16 x 11 3/4 inches (104 x 48 x 30 cm)
Courtesy of Sonnabend Gallery

Distinctions between art and the larger visual culture are dissolving and even disappearing. Artists bring nonart experiences into the sphere of art; they also introduce art into the larger visual culture. Artists mingle their works with other products of visual culture by electing to exhibit their work in certain kinds of sites and choosing not to limit their display opportunities to art venues only. This phenomenon is not

1-5 Jenny Holzer

Selection from The Survival Series, 1983-85

Signboard
Nelson Mandela 70th Birthday Tribute
Wembly Stadium, London, 1988
Courtesy of Artists Rights Society (ARS), New York, © 2004 Jenny Holzer

new: earth artists and artists involved in site-specific public art have been positioning their art in locations outside the museum since the 1960s. The trend has expanded and mutated since 1980 in response to entertainment culture and new technologies of electronic communication. American Jenny Holzer, for example, inserts ambiguous messages into public places, using posters, T-shirts, baggage carousels, electronic bill-boards [1-5], and park benches as sites to display her texts. Artists, according to curator Benjamin Weil, "have been exploring approaches akin to an ambient strategy, focusing on ways to insert their projects within the chaos of an overmediated public sphere. Billboards, usually designed to advertise commercial products, have been used by artists such as the late Felix Gonzalez-Torres to 'sell' ideas. Marquees of abandoned theaters are ideal surfaces for the placement of inconspicuous messages; stickers, posters, and other forms of street culture become compelling instruments in the hands of artists."

Art more and more appears to be in competition with the bold graphics, seductive objects, and lively stories of commerce and entertainment. Some artists adapt by making art that has become more like entertainment, adopting strategies of display and production from popular culture, installing multimedia spectacles in exhibition sites, crossing over into the domains of film, music, and fashion, and serving professionally as consultants and even entrepreneurs in commercial enterprises such as restaurants and magazines. Examining the trend, photographer Jeff Wall said, "I think a new kind of art has emerged since the '70s, a kind that is easier to appreciate, more like entertainment, more attached to media attitudes. . . . It's much closer to entertainment and depends on production value and on spectacle in a way that serious art never did before."

The pervasive influence of popular culture, including Hollywood action films, British rock, interactive computer games, and so on, which has been embraced enthusiastically by young people around the world, is a powerful influence on the production of contemporary art in countries from Korea to Nigeria. The world appears to be changing so rapidly that artists may feel they have no choice but to get onboard and create

works that embody the ride. More rare but equally welcome are those instances in which artists succeed in stopping the world in its tracks, so to speak. Such was the case with the design and installation of their monumental *Bottle of Notes* (1993) by Claes Oldenburg and Coosje van Bruggen in a public space in England. Appearing like an enormous bottle containing a message that has washed ashore, this work of public art brings the potential for meaning to passersby going about their daily lives. The message the sculpture brings only verges on legibility (in fact, the bottle itself is formed by the nonsense script that comprises its surface), yet the sculpture holds out the hope for communicating meaning.

This last point in our reconnoitering mission through the past twenty-five years of art reasserts this chapter's initial premise: *content matters*, even if the content is multilayered and open-ended. It is with this fundamental idea in mind that we turn to an examination of contemporary artworks that embody six resonating themes: time, place, identity, the body, language, and spirituality.

Notes

- 1. For more information, see Eduardo Kac's website, at www.ekac.org, or the recently published book about the project: *The Eighth Day: The Transgenic Art of Eduardo Kac* (Tempe: Institute for Studies in the Arts, Arizona State University, 2003).
- 2. Toby Kamps, "Lateral Thinking: Art of the 1990s," in *Lateral Thinking: Art of the 1990s* (La Jolla, Calif.: Museum of Contemporary Art San Diego, 2002), p. 14. An exhibition catalog.
- 3. Erika Doss, Twentieth-Century American Art (Oxford: Oxford University Press, 2002), p. 203.
 - 4. Stephen Koch, "Andy Warhol, 1928–1987," Artforum, April 2003, p. 94.
- 5. Richard Cork, "Introduction," in *Breaking Down the Barriers: Art in the 1990s*, by Richard Cork (New Haven: Yale University Press, 2003), p. 10.
- 6. Haim Steinbach, "Haim Steinbach Talks to Tim Griffin," interview by Tim Griffin, Artforum, April 2003, p. 230.
- 7. Neal Benezra and Olga M. Viso, *Distemper: Dissonant Themes in the Art of the 1990s* (Washington, D.C.: Hirshhorn Museum and Sculpture Garden, Smithsonian Institution), p. 10. An exhibition catalog.
 - 8. Doss, Twentieth-Century American Art, p. 217.
- 9. Some active practitioners within the expanding field of new media include Rebecca Horn, Jon Kessler, Alan Rath, Laurie Anderson, Margot Lovejoy, Pipilotti Rist, Mariko Mori, Jeffrey Shaw, and Michal Rovner.
- 10. Quoted in Liz Wells, *Photography: A Critical Introduction* (London and New York: Routledge, 1997), p. 257.
- 11. Jonathan Knight Crary, "Perceptual Modulations: Reinventing the Spectator," in John B. Ravenal, Outer and Inner Space: Pipilotti Rist, Shirin Neshat, Jane and Louise Wilson, and the History of Video Art (Richmond: Virginia Museum of Fine Arts, 2002), p. 23. An exhibition catalog.
- 12. Nicholas Mirzoeff, An Introduction to Visual Culture (London and New York: Routledge, 1999), p. 91.
- 13. In the age of mechanical reproduction, such processes as photolithography allowed newspapers and magazines to duplicate and disseminate images. The electronic age, however, is different in degree as well as in kind from preceding eras, as imagery is now sent around the world at the speed of light.
- 14. For descriptions of Byrne's work, see David Byrne, *Envisioning Emotional Epistemological Information* (New York: Steidl and Pace-McGill Gallery, 2003).

- 15. The statistical information and the quote from Homi Bhabha appeared in Ann Wilson Lloyd, "Rambling round a World That's Gone Biennialistic," *New York Times*, March 3, 2002, p. 34 and 36.
 - 16. Crary, "Perceptual Modulations," p. 25.
- 17. Bennett Simpson, "Pushing an Open Door: The Artist as Culture Broker," in *The Americans: New Art* (London: Booth-Clibborn Editions, 2001), p. 296. An exhibition catalog.
- 18. Prior to postmodernism, various artists including the Dadaists and many Surrealists also were interested in kitsch.
- 19. John Rajchman, "Unhappy Returns," *Artforum*, April 2003, p. 61. "Beaubourg" is a nickname for the Centre Georges Pompidou, a cultural center that opened in Paris in 1977.
- 20. Artists working with appropriation in the 1980s and after include Sigmar Polke in Germany, Jeff Koons, Mike Bidlo, and Louise Lawler in the United States, Carlo Maria Mariani in Italy, and Wang Guangyi in China.
- 21. Laurie Fendrich, Why Painting Still Matters (Bloomington, Ind.: Phi Delta Kappa Educational Foundation, 2000), p. 16.
- 22. Influential theorists of poststructuralism include the French intellectuals Michel Foucault, Jacques Derrida, Roland Barthes, and Jacques Lacan.
- 23. The many feminist thinkers influencing the visual arts include Julia Kristeva, Luce Irigaray, Hélène Cixous, Gayatri Chakravorty Spivak, Craig Owens, Laura Mulvey, Lucy Lippard, and Griselda Pollock. Thinkers associated with postcolonialism include Homi K. Bhabha, Edward Said, Rasheed Araeen, Paul Gilroy, and Olu Oguibe. Intellectuals involved with both feminism and postcolonialism include bell hooks, Trinh T. Minh-Ha, and Ella Habiba Shohat.
 - 24. Toby Kamps, "Lateral Thinking," p. 15.
 - 25. Cork, "The End of the Twentieth Century," in *Breaking Down the Barriers*, p. 628.
 - 26. Homi K. Bhabha, "Making Difference," Artforum, April 2003, p. 76.
- 27. Benjamin Weil, "Ambient Art and Our Changing Relationship to the Art Idea," in 010101: *Art in Technological Times* (San Francisco: San Francisco Museum of Modern Art, 2001), pp. 58–59. An exhibition catalog.
- 28. Jeff Wall, "Jeff Wall Talks to Bob Nickas," interview by Bob Nickas, Artforum, March 2003, p. 87.

Detail of 2-6

Time

Time is a vital topic in contemporary art, addressed in a rich range of works that involve a variety of media, approaches, and concepts. In this chapter we will look at the prevalence of the theme of time in art after 1980, as well as some definitions, historical contexts, artistic strategies, and subthemes that begin to map aspects of this far-reaching topic.

To begin exploring the complexity and variety of artists' reflections on matters of time, let's look at two works of art: a film by a team of Swiss artists, Peter Fischli and David Weiss, and a sculpture by American Heide Fasnacht. In Fischli and Weiss's entertaining thirty-minute film, Der Lauf der Dinge (The Way Things Go) (1985–87) [2-1], the camera pans the long floor of a warehouse, along which are arrayed makeshift conglomerations of simple props, such as buckets of water, rubber tires, Styrofoam cups, string, and balloons. Through the action of fire, gravity, chemicals, and gunpowder, each object spills, falls, rotates, ignites, or explodes in turn. Each object's demise triggers what happens to the next object in line. The chain reaction embodies time in its absurd kinetics: one thing is engineered to lead to the next in what appears to be a continuous thirty-minute sequence in real time. (In fact, though, Fischli and Weiss had to film some of the micro-events separately and splice segments of film together to achieve the appearance of a seamless chain of events.) Fischli and Weiss do not structure time as a narrative in this film: there is no plot with a beginning, middle, and end, and the chain reaction has no ultimate goal or final outcome. Rather, their approach to time favors sequencing without narrative. In the view of curator Amy Cappellazzo, "Since the objects are set up to have a domino effect but rely on time, rather than a story line, to dictate their next move, the entire work can be viewed as a kind of timepiece or clock."¹

Besides coming close to representing a real-life experience of time, *The Way Things Go* may also have a moral subtext. Fischli and Weiss devoted months of tinkering to achieve their house-of-cards effects. The implication is that there is value in time spent making something essentially useless that only exists for a short time, simply for the joy of seeing an idea come to life. This devotion to time spent in creative play generally contradicts how time is valued in day-to-day life in industrial societies.

2-1 Peter Fischli and David Weiss | Still from Der Lauf der Dinge (The Way Things Go), 1985–87

Courtesy of Matthew Marks Gallery, New York, © Peter Fischli David Weiss

Heide Fasnacht's sculpture *Demo* (2000) [2-2] conveys a sense of time that is more instantaneous yet paradoxically more permanent than the sequence of time expressed in Fischli and Weiss's film. In a highly unusual approach to sculpture, *Demo* freezes a split second in time, suspending the explosion of a building in midair (much like in a stop-action photograph). To create *Demo*, Fasnacht referred to black-and-white photographs made during the detonation of an actual building. Working at a scale slightly larger than a standing human and using nontraditional materials (Styrofoam and neoprene), Fasnacht suspended the myriad shards of an exploding building flying outward into space. What would normally occur in the blink of an eye is frozen for us to peruse at our leisure, unlike the constantly changing mini-events in Fishli and Weiss's film. A key difference between these works is that Fischli and Weiss's film *embodies* time, whereas Fasnacht's sculpture *represents* the explosion of a building as a suspended moment in time.

Demo is one in a series of stop-action sculptures that Fasnacht began in 1997, when she first introduced a human sneeze as a subject. Since then, in numerous drawings and sculptures, the artist has represented a range of eccentric events—including sneezes, geysers, fires, and military explosions—that, according to Nancy Princenthal, "fall at the threshold of visibility, in the realm of things that, while not imperceptible, are more or less impossible to visualize in any stable, conventional way." Intriguingly, *Demo* manipulates the dimension of time on multiple levels. First, there is the (rapidly moving) time of the actual explosion; second, the (stopped) time of the artwork's depiction;

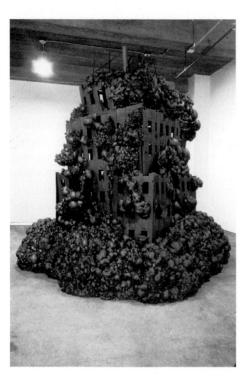

2-2 Heide Fasnacht D

Demo. 2000

Neoprene, Styrofoam, pigment, approximately 9 1/2 x 10 1/2 x 10 feet Courtesy of the artist and Kent Gallery, New York

and third, the (much slower but still moving) time of the viewer's experience walking around and looking at the artwork. Additionally, the subject of the artwork provides a fourth, metaphoric level of meaning. The sculptural simulation of an explosion, with its unreal quality of suspended animation, expresses the futility of any belief that we can control time. Moreover, the sculpture, made in 2000, has taken on another, prophetic meaning. After the September 11, 2001, terrorist attacks on the World Trade Center towers, Fasnacht's fellow Americans can regard *Demo* as a metaphor for the traumatic attack and a cautionary symbol of a possible future apocalypse.

Time and Art History

Concepts of time vary from culture to culture, from the cyclical philosophies of time taught in Hinduism, Buddhism, and other traditional Asian philosophies to the linear view of time that the Judeo-Christian tradition of the West teaches to the ideas of relativity and simultaneity that modern science proposes and modern culture with its new technologies fosters. Thus, the sense of time that different works of art express can vary widely.

The means that visual artists use to make time visible are also varied. Historically visual artworks were most commonly static forms—paintings, sculptures, tapestries, ceramics, and the like—physical objects that were not intended to move or change. (Among the exceptions were artworks designed for use in performances and rituals; these artworks generally did not change in form, but performers moved the objects about.) Artists making static works who aimed to express concepts of time could only represent time through symbolization and suggestion. For example, a Hindu artist

might incorporate a wheel in his art as a symbol for the cycle of birth, death, and reincarnation. A Christian artist with a linear view of time might paint three different scenes from a biblical story to imply a progression forward through time.

Alternatively, time can manifest itself in visual artworks through the use of actual movement, since our experience of time often depends on our movement in space. Kinetic (moving) sculpture shows time through the motion of its parts. The modern visual media of performance art, film, and video likewise rely on motion as a major element. Change (which relates closely to movement) is also a condition that reveals time. We become aware of the passage of time if a work of art changes perceptibly as we observe it. Of course, the process of change affects all works of art, even when unwanted. For example, we read time and aging into the cracks and darkened varnish of an old master painting, even though the process of decay is so slow that we do not see it happening at any given moment. Artists who want to make time an intentional element in their works might build observable physical change into their works by using fragile or volatile materials such as cut flowers, snow, or melting wax as art materials.

In the next two sections, we'll look at some ways in which static forms of art represent time and then we'll consider how moving and changing forms embody time. As we will see, some works of art are hybrids that both represent and embody time. Imagine, for example, an installation that juxtaposes a painting of a clock and an actual clock.

Representing Time

What do we mean when we say that time is represented in a work of art? Representation is the symbolic process by which an artwork refers to a subject beyond itself. For example, a painting or drawing that includes an image of an hourglass in the composition is representing time through an obvious symbol. Similarly, a depiction of a sunset signals the ending of a day. The passage of time is also implied by depicting an arrested motion or showing a series of actions in a temporal sequence. Artists who wish to represent time must deal with an inherent contradiction: while many visual artworks are static (paintings and sculptures don't usually move), time is measured and made manifest by change.

Many ideas about time and strategies for representing it in art can be traced back through the history of art. We can never be certain of the exact meaning of the animal images painted on prehistoric cave walls or the specific purpose of ancient fertility figures, of which the Venus of Willendorf is a famous example. But based on present-day knowledge, anthropologists theorize that these visual symbols may have represented ritualistic moments or attempts to control the future. Perhaps, the cave paintings were a way to ensure success in a hunt and the Venus a way to ensure a successful pregnancy.

One of the main reasons that artists throughout history have engaged time in their works is the desire to record and recount events. These might be ones within the artist's lifetime, but more often the events came from mythology, religion, legend, and literature. In some cases, the visual record of an event acknowledges the event without depicting it directly, as in a monument with dates and inscriptions. The monument itself is usually a figurative or abstract sculpture that interprets an event in an allegorical way. In other cases, artists depict an event in a *narrative* form; that is, they visualize a story by representing a key moment or moments in an event as it is

unfolding. Today, artists interested in narrative might choose to work in a moving form, especially film or video. But artists working in a static medium such as painting or carved sculpture need devices other than actual movement to mirror the passage of time in a story.

A *multi-episodic* format is one ancient method used in narrative visual art. A multi-episodic narrative represents two or more scenes from the same story. For example, wall reliefs and paintings from ancient Egypt depict a succession of scenes from a story in a sequence of vignettes running in outlined bands across and down a wall. Court painters in ancient China, who produced hand scrolls with images of imperial processions, also employed a kind of multi-episodic format. As a scroll is unrolled, the progress of the emperor on horseback or by boat is revealed in successive scenes. (The scenes are not framed separately but flow into one another.) Multi-episodic formats in Christian art range from two-panel diptychs and three-panel triptychs to artworks with numerous individual panels that were displayed below religious altarpieces.

The multi-episodic forms seen most frequently today are comic books and comic strips, which use single static drawings framed and arranged in a sequence to represent a narrative. The sequencing of events may not be strictly chronological; flashbacks can occur, and the main storyline can split into more than one subplot. In the art world, a use of multi-episodic imagery influenced by cartoons is thriving as well. In the 1980s American painter Ida Applebroog began to make large multicanvas works that often include sequences of cartoonlike figurative images to suggest fragmented stories with a powerful feminist edge. Emerging in the last few years, Americans Laylah Ali and Kojo Griffin likewise quote the graphic style and often the multi-episodic format of comic books to suggest narratives that are parables of contemporary human behaviors, including unsettling acts of xenophobia and hate crimes.

In contrast to the multi-episodic approach, most Western painting since the perfection of linear perspective during the Renaissance has represented a narrative within the unified pictorial space of one composition. Artists are able to imply a narrative by rendering figures and objects engaged in a variety of actions that appear coherent within the convincing illusory space, "leading the viewer to perceive a narrative sequence when, in fact, all events depicted are present on the picture plane at the same time. The here-and-now of the image [thus encompasses] the past and the future." Sometimes artists combined different episodes from one story in a single composition. A well-known example is *The Tribute Money* (c. 1427) by the early Italian Renaissance painter Masaccio, which includes within one composition three episodes from an event involving Saint Peter.

More often, however, artists have used linear perspective to render a single important scene within a story, in which the characters are frozen at a dramatic moment. In this convention, the tableau implies what preceded and what will follow. (Or, alternatively, the artist relies on the viewer's preexisting knowledge of the storyline to place the event depicted within a context of past and future events.) Since 1980 numerous artists have continued to represent illusionistic space in order to heighten the drama of a suspended moment in time.⁴

Implying a narrative through a single dramatic scene became the favored format in *history painting*. This grand style of figure painting illustrating important events from ancient history, religion, or literature was promoted as the highest form of art by European art academies in the seventeenth and eighteenth centuries. Strongly indebted

to Italian Renaissance art, academic history painting blended an illusionistic pictorial style and idealized subject matter, often glorifying dramatic events performed by gods, heroes, and leaders. In the nineteenth century artists introduced a more realistic approach by painting historic genre scenes in addition to grand events; some artists also took the then unusual step of painting current events. After a long period in the twentieth century when narrative art fell out of critical favor, interest in representing time as narrative revived in the early and mid-1980s, notably in the work of the Neo-Expressionists, who were creating contemporary versions of history paintings. Other artists working with narrative structures were interested in recovering the neglected or forgotten histories of women, ethnic minorities, and other marginalized groups. The radical revision of history in contemporary art, and the process of deciding which events of the past are to be valued, is explored in greater detail later.

Of course, narrative is not the only way that artists engage with time. Artists working in static media might want to imply movement and change without being interested in telling a story. Any work of art that appears to halt movement at a dynamic moment creates an impression of arrested time. A few examples are *Discobolus (The Discus Thrower)* (c. 450 BC), a Greek sculpture by Myron showing an athlete who has just brought his arm back and is poised momentarily before swinging the discus forward, Edgar Degas's nineteenth-century sculptures of ballet dancers poised on one leg, and the twentieth-century high-speed photographs by Harold Edgerton that show bullets and other rapidly moving objects "stopped" in midflight. (Edgerton was an engineer not an artist, but his unusual photographs are often included today in art books.)

Indeed, from the mid-nineteenth century on, motion and speed are increasingly important aspects of the representation of time in art. J. M. W. Turner's dynamic painting of an oncoming steam-engine locomotive, *Rain, Steam and Speed* (1844), is an early example of the representation of speed as an emblem of the modern age, which equated speed with progress. Later in the nineteenth century, the ability to render the momentary effects on color and form of the rapidly changing conditions of light was central to the achievements of the Impressionists. Claude Monet's series showing haystacks and the facade of Rouen Cathedral at different times of day are remarkable efforts to represent moments in time.

Photography, an invention of the Industrial Revolution, has a special capability for using motion and speed to represent time. By recording the exposure of a light-sensitive surface to the pattern of light at a specific moment, the photograph records the actual appearance of the subject, from the viewpoint of the camera's lens at the time the shutter was open. As photographic technology advanced, that moment became shorter and shorter; cameras achieved exposure times of less than a second in the 1870s, and today exposures can be measured in milliseconds. A photograph can represent the accelerated pace of modern life by recording in sharp, frozen detail a minute slice of a movement far too quick for the human eye to perceive.

Photography suited and supported the modern era's preoccupation with time measured through movement, which was more valued the more rapid it was. (People today who drum their fingers impatiently when a Web page takes more than a few seconds to appear on a computer screen are the latest to value time in terms of speed.) The use of still photography to record rapid movement led to the invention of cinematography, or moving pictures, the temporal medium par excellence of the

twentieth century. First, photographers (notably Eadweard Muybridge and Etienne-Jules Marey) began taking sequences of still photographs to study movement in space. Next, inventors figured out how to project sequences of still images in rapid succession, so that the eye was fooled into thinking the sequence of frames reproduced real motion. By the turn of the twentieth century, film was attracting practitioners in the arts and popular culture.

The experiments in sequential still photography and in film, which linked the perception of time with movement in space, paralleled new concepts of time emerging early in the twentieth century, as seen in the physics of Albert Einstein, the psychology of Sigmund Freud, the philosophy of Henri Bergson, and the literature of James Joyce and Marcel Proust. Meanwhile, artists involved in Cubism and Futurism tried to represent the new, more complex concepts of time in static forms, particularly painting. The Cubists fractured time by melding different views of a subject, seen at different times and from different angles, into one static composition. In contrast, the Futurists painted a sequence of movements sweeping across a single composition, with the various phases of movement linked by geometric color structures. The Futurists believed that the past did not hold any value or importance for those in the present, and their imagery evoked the speeded-up tempo of urban life in the young twentieth century, made possible by new inventions such as the automobile and airplane.

In contrast to the Futurists, the Surrealists slowed time down. They often depicted time standing still with images of frozen clocks signifying a dream state or creating a dreamlike ambience. A frozen clock watches over the plaza of Giorgio de Chirico's *The Soothsayer's Recompense* (1913), and in Salvador Dali's famous painting *The Persistence of Memory* (1931), limp pocket watches, their hands useless, are draped within an eerie landscape, hinting at the futility of culture. The representation of a time-madestrange occurs repeatedly in Surrealist art. We find ourselves peering into a dollhouse-sized world in Alberto Giacometti's tabletop sculpture *The Palace at 4 A.M.* (1932–33). In René Magritte's *The Empire of Lights* (1954), an ordinary afternoon sky floats above an evening scene of a house nestled in dark trees. This simple juxtaposition of daytime and nighttime produces a mystery that resists explanation, and this unexpected juxtaposition of elements is a typical Surrealist strategy.

A dreamlike surrealistic approach to representing time, which conflates past and present or the mythic and the prosaic, occurs in contemporary art as well, as seen in the paintings of Neo Rauch of Germany and Chatchai Puipia of Thailand, to name just two examples. Moreover, the Surrealists' bag of temporal tricks—speeding time up, slowing it down, stopping it, making it double back on itself—can be seen, in altered fashion and for different aesthetic reasons, in contemporary works that embody time such as the videos of Bill Viola.

One final strategy that artists employ to represent past time is to appropriate and recycle found materials in their art. *Found objects, readymades, appropriations, relics, collections*—these related terms are part of the vocabulary and conceptual apparatus of modern, and now postmodern, art. Julian Schnabel's incorporation of broken crockery into the surfaces of his epic-scaled paintings in the early 1980s, which caused a sensation in the New York art world, evoked powerful emotions (violence, rage) and also signified the passage of time (decay). Schnabel's creative process relied to a great extent on using used things as large-scale collage material.

Found materials do not have to be old to evoke time. For example, the use of dolls and toys, even new ones, makes viewers think about the time of childhood. For example, in the 1990s American artist Mike Kelley produced a well-known series of sculptures combining tattered stuffed animals to represent childhood, a distressing time of life in Kelley's vision. But recycled materials that are truly old are tied to the past in a direct way. They are a form of relic, an actual piece of a thing made and used for some purpose in the past, and thus these materials have strong associations with a specific historical time (and embody that time in their physical presence). Relics have the power to evoke memories and temporal reflections. American Whitfield Lovell, for instance, combines charcoal portraits (based on vintage photographs of African Americans from the early years of the twentieth century) with found historical objects. Lovell draws the portraits [2-3] on worn wood planks, similar to the floorboards or wallboards found in older homes. The artist "wants the viewer to connect with a phenomenon of time past being time present. . . . We can, he suggests, consider these people either as ciphers in a large historical continuum or as individuals who have attained fulfillment with honor and grace.5

Lovell's art exemplifies a curious feature of some art that uses aged materials to represent the passage of time. Using distressed wood with peeling paint as a support for the artist's drawn portraits reproduces the frayed and faded look of an antique photograph, but these qualities of wear were not present in the objects when they were seen by people in the past. Originally, the wood was smooth and freshly painted, and the photograph was in mint condition. The worn qualities we see now signify the distance separating our time from the bygone era. A time traveler to today would say, "Look at how these objects and photos have aged. I hardly recognize them."

The representation of time through used and worn materials is an example of a symbol or sign, known specifically as an *index*. To function as an index, a symbol requires more than an abstract or arbitrary relationship to that which it signifies. (Smoke, for example, is an index of fire; the English word "fire," on the other hand, is not an index of an actual blaze.) Such an indexical embodiment of time relates to (overlaps with) the embodiment of time discussed in the following section.

Embodying Time

A static art form can represent time by containing physical evidence of the protracted length of time that was required to make it. Examples would be a work of installation art that is created through a process of slow accumulation or a work of embroidery with tens of thousands of tiny stitches. Other forms of art embody time; that is, time itself is an integral component of the work. In these cases, artists manipulate time much as they manipulate any other malleable material (such as wood, paint, or bronze) and give it form (including texture, color, mass, and shape). Indeed, the term *time arts* is commonly used today to refer to art forms in which temporality is central, such as performance art and video art. Of course, works that manipulate time as an integral element do not necessarily otherwise address time as a theme. A video can be about the body or language or any number of other themes, for example. We are particularly interested here in the subset of works that embody time and also express additional thematic ideas about time.

Although much less common than static visual artworks, works of visual art that embody time have occurred throughout history. Two examples are the large wooden

2-3 Whitfield Lovell | Epoch, 2001
Charcoal on wood, found objects, 77 1/2 x 55 x 17 1/2 inches
Collection of the Flint Institute of Arts, Michigan
Photo courtesy of DC Moore Gallery, New York

masks made by Native Americans of the Northwest Coast, which were crafted with hinges and strings so that one mask opened to reveal another mask, and the Navajo sand paintings of the American Southwest, which were ritually destroyed after completion. But the embodiment of time has become increasingly significant over the past

one hundred years, because of philosophical and scientific changes in how time is understood and because of the invention of new technologies (film, then video, then digital media) that enable artists to produce images that viewers perceive as moving. In this section we will look at materials, techniques, and forms that artists use to embody time as an element. Generally speaking, there are three basic ways of embodying time: the artwork actually moves, the artwork uses media that create the illusion of movement, or the artwork is one where the creative process counts for more than a finished object, and materials and forms are intentionally in flux during the life of the artwork.

Kinetic art, art that contains moving parts, and performance art, live art activities that encompass elements of theater and visual art, are two types of art that actually move. Versions of kinetic art and performance art have existed in some form in many cultures. The masks used by Northwest Coast peoples were both kinetic and used for ceremonial performances. It is recorded that Leonardo da Vinci designed and fabricated elaborate kinetic pieces to entertain guests at a patron's festivals. Modern precursors of today's performance art include the Dada and Futurist events of the early twentieth century, and the Happenings and Fluxus activities of the 1960s. Forerunners of contemporary kinetic art include the Constructivist machines of Naum Gabo and Laszlo Moholy-Nagy, the mobiles of Alexander Calder, the kinetic sculptures of George Rickey and Jean Tinguely, and the collaborations between artists and engineers at the Center for Advanced Visual Studies (CAVS) at the Massachusetts Institute of Technology, which were ongoing after CAVS was founded by Gyorgy Kepes in 1967.

A fundamental concept underlying performance and kinetic art was that one had to be there in person to watch the work unfold in "live" time to get the full effect. In their embrace of real time, such artworks resembled works of music or theater. However, the "live" idea is sometimes modified today; hybrid temporal approaches have evolved that combine real-time elements with other elements, for example, live performances on a stage that include projections of videos in the background. In addition, performance and kinetic art pieces are routinely filmed today and hence have a recorded life beyond their real-time existence.

Nevertheless, live art continues to be made. In a recent performance, *The House with the Ocean View* (2002), Serbian Marina Abramovic lived for twelve days on a balconylike structure at New York's Sean Kelly Gallery in full view of a gallery audience, without eating, speaking, or engaging in any mental activities such as reading or writing; a metronome ticked off the passage of time in seconds. The real time of life and the time of art coincided exactly. Other contemporary artists involved in performance projects that involve life in real time include Tehching Hsieh, Linda Montano, and Gilbert and George. (The proliferation and popularity today of "reality shows" on television, which supposedly show ordinary people doing things in real time, have made the art-life efforts of visual artists seem less unusual.)

Contemporary instances of kinetic art include the sculptures of German Rebecca Horn. Her *Concert for Anarchy* (1990) features a grand piano suspended upside down in the air, whose lid opens and closes by means of hidden electronics, with an accompanying crash of dissonant noise that is far from the harmonic progressions of classical music. American Roxy Paine's artistic inventions include computer-driven machines such as *Painter Dipper* (1997) and *SCUMAK (Auto Sculpture Maker)* (1998) that mechanically produce unique artworks in assembly-line fashion. Jonathan Borofsky,

Tim Hawkinson, Tom Sachs, and Arthur Ganson are a few of the other artists making kinetic sculptures today.

Kinetic and performance art projects have become more complicated since 1980 because of new technologies, particularly advances in robotics and computer-based interaction (although some artists continue to embrace a low-tech approach). For example, for the past twenty-five years San Francisco—based Mark Pauline and his Survival Research Laboratory (SRL) have been creating remote-controlled, self-propelled machines and robots that run amok and destroy one another in loud performance spectacles that satirize modern technology and military exercises. Since 1997 SRL has added new information technologies to its toolbox. During performances, devices for operating the machines are available on the Internet for anonymous, remote controllers to activate, and live, wireless, streaming video of SRL shows is broadcast over the Web.

Timepieces designed by artists comprise a subgroup of kinetic artworks that deal explicitly with the theme of time. Contemporary American woodworkers, including Wendell Castle and Tommy Simpson [2-4], produce clever, beautifully crafted, functional variations on the traditional grandfather clock. Other artists have produced various clocks that serve as social metaphors. A well-known example by Cuban-born Felix Gonzales-Torres, *Untitled (Perfect Lovers)* (1987–90), consists of two clocks that appear to keep time in perfect synchronicity. The pairing offers a metaphor of same-sex romance. Only upon careful scrutiny does the viewer realize that the two clocks are not exactly the same, and, in the appreciation of that difference—the foundation of all liberal thinking—the sculpture points to a more open sense of time.

Time can also be embodied in a work of art through optical illusions of movement. With the invention of cinema in the late nineteenth century, artists finally had the capability to produce a convincing illusion of moving images. (Flipbooks and lantern slide shows existed earlier than film but were much more limited and far less convincing in their portrayal of movement.) In films and other media showing moving images, time appears to flow as it does in the actual world of the viewer. As explained by Irene Netta, "In motion pictures the individual moment dissolves in a continuous narrative, whereas the narrative in a fixed image emerges from the individual moment depicted." 6

Film, like its precursor, still photography, is one of the most popular art forms. It is used for both mass entertainment and for visual art efforts with a more limited audience. The same is true for video; the medium encompasses works made for popular consumption (particularly for television) and for the world of art museums and galleries. In 1965 Sony Corporation started to sell the first portable videotape recorder, making video technology affordable and accessible. With this tool, artists such as Korean-born Nam June Paik began to use video as an art form. Today video is ubiquitous in the art world (increasingly relying on digital rather than analog equipment). A video presentation in a gallery can be complicated and layered, with simultaneous projections of moving images that don't necessarily connect with one another in a logical way.

Cinema and television became the dominant means for creating visual narratives for mass audiences over the past century. Although the plots in commercial films tend to be conventional, the way stories are told visually is extremely sophisticated because of the development of editing and montage techniques that can carefully shape a story shot by shot. We also have witnessed the proliferation of a highly condensed visual

2-4 Tommy Simpson | Boy with Fish, 1994
Carved and painted wooden clock and cabinet, 73 x 32 x 11 inches
Courtesy of the artist

narrative form that Vicki Goldberg characterizes as "the stroboscopic story, told in a flash," evidenced in movie trailers, music videos, and television commercials.⁷

Fine artists, too, use film and video to create narratives, although their stories are far from conventional. To create their narratives, artists sometimes choose the simplest technique of using a single camera and filming a continuous event in one take; in other

instances they use editing and montage techniques from commercial films and advertising to create narrative complexity. Visual artists also use film and video technologies to create temporal works that are non-narrative, such as the plotless perpetual-motion sequence captured in Fischli and Weiss's video [2-1], discussed earlier. American Andrea Bowers takes a different but also non-narrative strategy in her video *Waiting* (1999), which shows a young figure skater kneeling on the ice, perfectly still until she suddenly lifts her cold hands off the ice; the forty-five-second segment replays over and over in a continuous loop. The audience waits for a narrative that never begins, and so little changes that it is almost as if the video is a painting rather than a moving image.

A third approach to embodying time in visual art is encompassed in works that we can loosely characterize as *process art*. The term was first used in the late 1960s to refer to art made from mutable materials such as asphalt, wax, plants, felt, latex, ice, and water that took form as a result of processes or forces such as gravity, weight, flexibility, expansion, warming, cooling, and pressure. Process art was part of a larger, radical new concept of art that Lucy Lippard and John Chandler called the "dematerialization of art," referring to the new emphasis on ideas rather than art objects.⁸

A wide range of artists active after 1980 continued to discover creative possibilities in working with ephemeral materials and natural processes. Such art does not have a fixed form but bends, flows, melts, decays, and in other ways changes over time. Observing the materials in flux is the heart of the artistic experience. Indeed, if the materials are truly perishable, over time the work of art ceases to exist. The work's existence is temporary. For example, American Ann Hamilton chooses mutable (often organic) materials such as leaves, insects, corn husks, soybeans, moth larvae, and dried algae to make installations that embody time by incorporating processes of decay. In her piece *Dominion* (1990), created at the Wexner Center in Columbus, Ohio, thousands of moths went through their entire life cycle in an enclosed space. *Offerings*, her installation at the 1991 Carnegie International Exhibition in Pittsburgh [2-5], included a vitrine filled with hollow wax heads slowly melting through the bottom. German Sigmar Polke also experimented with a latter-day conception of process art when he made some paintings in the 1990s that mixed synthetic paints with minerals in a chemical combination that is changing the imagery unpredictably over time.

Works of art that include time as a theme may be hybrids that both represent and embody time. The films of South African William Kentridge are a case in point. In a series begun in 1989 chronicling the life of a fictional character, Soho Eckstein, Kentridge employs a unique form of stop-action animation that combines drawing and film. For each film Kentridge makes around twenty drawings, erasing and redrawing parts of each drawing repeatedly and photographing each alteration. The photos become the frames of an animated sequence, "resulting in dreamlike images merging from one into another, with traces of previous forms and configurations lingering in the background. . . . His technique metaphorically parallels the acts of effacement and remembrance that characterize South Africa's postapartheid state—a nation erasing, drafting, and redrawing itself."

Changing Views of Time

Transience, permanence, change, moment, now, then, duration, pause, minute, hour, year, past, present, future, eternity. These are just a few of the multitude of words related to time that occur in everyday speech. These words identify some of the concepts

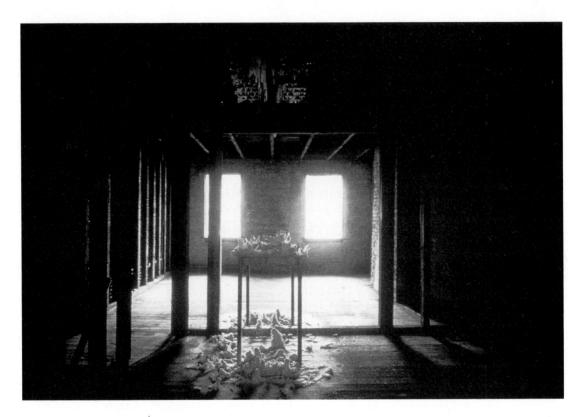

2-5 Ann Hamilton | Offerings, 1991

Installation
Courtesy of the artist and Sean Kelly Gallery, New York

we use as we think about time. Within the syntax of language, the tense of verbs is another concept that is part of people's general understanding of time. In fact, markers of tense, which distinguish events in the past, present, and future, are universal features of all Romance languages. While some of our ideas about time seem stable, social and technological changes as well as changes in our understanding of the physical and psychological universes we inhabit are reshaping the ways we perceive and conceive of time. Additionally, conceptions of time in other places and in earlier eras contrast markedly with our own beliefs. This point is significant because contemporary artists are increasingly avid "borrowers" of the images (and, thereby, parts of the concepts) of other cultures. Moreover, learning about the various guises of time in history's broad sweep leads us into a broader perspective of the inevitability of change.

In its most common cultural manifestations, time is conceived as cyclical, linear, or simultaneous, and time may be predictable or unpredictable. The recurring seasons and other natural cycles (such as the rise and fall of the moon) produce experiences of cyclical time. In contrast, linear time flows in one direction. With the invention of mechanical devices such as the metronome, clock, and wristwatch, linear time became regulated, or marked off in standard increments. Linear time provides a view of history as a progression, an improvement over the past. (This view was characteristic of modern

art, whose theorists and historians described art as progressing forward, with one style evolving out of and finally supplanting its immediate predecessor.) Simultaneous time is both the oldest and the newest conception of time; simultaneity encompasses all that happens in the duration-less present. This idea encompasses the time of primal myths (e.g., the dream time of *the Dreaming* stories of the Australian Aboriginals) and the time of the Internet, when the flow of information is everywhere and nowhere, all at once.

Other conceptions of time, of course, are available. Take the metaphor of a bicycle wheel; its spin combines cyclical (recurring) time within the context of linear time, as the bicycle moves forward through time and space. In this conception, the cyclical pattern of the seasons occurs simultaneously with the forward flow of years. Alternative conceptions of time (often referred to as the fourth dimension) can be found in the imaginary worlds of artists who envision the far-off future, parallel universes, the deepest reaches of the past, mythic times, and the strange alterations of time in science fiction. American Matthew Ritchie's ongoing project is a cycle of interrelated paintings and graphics involving complex diagrams of an entire universe of his own invention [2-6]. Some charted events that Ritchie imagines occurred at the dawn of time. Other artists and writers on art posit that time does not exist outside our own world of

2-6 Matthew Ritchie | Self-Portrait in 2064, 2001

Oil and marker on canvas, 80 x 100 inches
Photo by Oren Slor
Courtesy of Andrea Rosen Gallery, New York,

Matthew Ritchie

history. Rosalind Krauss commented, "The Imaginary is the realm of fantasy, specified as a-temporal, because disengaged from the conditions of history." 10

No matter what shape time appears to take—cyclical, linear, simultaneous, or some other form—the pace at which time moves within its structure can seem to fluctuate subtly or dramatically. For a child anticipating a major holiday, days can drag on one after the other at a snail's pace, while the holiday itself may pass in a flash. In pastel drawings and paintings produced in a faux naive style, American Hollis Sigler gave poignant expression to her own changed relationship to time—why can't the future stay in the future? she appeared to ask—as she contemplated her existence after her diagnosis of breast cancer.

Not all of our emotional feelings are linked directly to our consciousness of time. We may, for example, be so swept up in joy or anger that we are not aware of the passage of time. Living in the moment, paradoxically, might mean that we lose track of our awareness of time. But whenever our experience of duration is linked to our awareness of our feelings, we experience time as having an emotional quality. When we are in suspense, our emotional life is bound up with an acute sensitivity to the passage of time (When will it happen? Soon?). Time is also linked to emotion when we feel nostalgia or regret, emotions that focus on events or qualities that we sense are far away from us in time. When an emotion persists over time, the emotion becomes a mood, meaning a recognizably consistent coloring of our perceptions ("He was in a funk."). Some moods are so powerful that even to call them a mood would seem to diminish their significance, which may border on the ineffable. Colombian artist Doris Salcedo creates sculptures, some formed by locking pieces of household furniture into cement blocks, that embody the trapped feeling of a victim of torture (Will it *ever* end?).

The specific passage of time represented or embodied in an artwork may refer to a different subject than what is actually shown. For example, in a still life painting, the representation of change (the decaying fruit) might symbolize the inevitable frailty and aging of human beings. Such a painting, called a *memento mori*, imbues time with metaphorical meaning. The sequence of changes that we see in Fischli and Weiss's video [2-1], discussed earlier, changes that appear purposeless, can be interpreted as a metaphor for the directionless course that, to some observers, Western civilization seems to be taking. American Gary Simmons draws in chalk on a black surface, half erasing the drawings so they are on the verge of disappearance. His images reflect the concept that the experiences of black people in the United States are in danger of erasure when not written in a permanent form in historical records. The drawings can also be interpreted as a metaphor for the fleeting, evasive character of memories in general, which are so easily lost or altered.

Our notions of time keep changing. In *The Special Theory of Relativity* (1905), Albert Einstein dramatically challenged long-standing Western paradigms of physical science, including some basic notions of temporality. In Einstein's scheme, "man cannot assume that his subjective sense of 'now' applies to all parts of the universe. For, Einstein points out, 'every reference body . . . has its own particular time; unless we are told the reference body to which the statement of time refers, there is no meaning in a statement of the time of an event.'"

Einstein proved what seems counterintuitive to the ordinary (thunderstruck) reader: "Lightning flashes which are simultaneous relative to the stationary observer are *not* simultaneous relative to the observer on [a moving] train."

Table 1905.

Einstein's theory that our universe is a time-space continuum, that it makes no sense to dissociate time from the dimensions of space, exerted a wide influence. Today, we realize that time's flow is not a fixed constant, and because of the relativity of time we always face a decision of what frame of reference to use. According to artist Victor Burgin, "Locations . . . are fixed by definition, but the actual spaces to which they refer are in continual flux and so impossible to separate from time." 13

Since 1980 our concepts of time have been greatly influenced by newly emerging networks that offer instantaneous information (cell phones, CNN, the World Wide Web). Arguably, we are losing our ability to put events in any temporal or historical context. Curator Douglas Fogle has commented, "It is by now almost a cliché to state that the current generation has no sense of memory whatsoever. Subject almost from birth to the ahistorical temporality of cathode ray transmissions, ours has been labeled an amnesiac culture. . . . In effect, one could argue that we are caught up in a crisis of memory and an epidemic of forgetting."¹⁴

Changing Views of the Past

Art exploring the theme of time includes art about history and memory. Visual representations of history have changed dramatically, reflecting profound shifts in how the past is remembered and interpreted. Today it is widely recognized that the choices of where and whose actions we select to focus on are open to constant negotiation. The history of the West, for example, is not the history of everyone or of everywhere. Likewise, interpretations of actions are not neutral; a historical event that one society celebrates may register as a tragedy somewhere else. At the same time, even the simplest statement of historical fact requires documentary and physical evidence to support it. For anyone engaged in writing, telling, or visually representing history, the search for a convincing "why" seems the most problematic because motives are always subject to varying interpretations.

Our views of the past have changed because of changes in our technological capacity to record or represent the past. An important quality of popular visual culture is the standardization of imagery that is multiplied and repeated by the media. Through this process, many more people have an identical storehouse of mediated past experiences; such uniformity in collective memory never occurred prior to the invention of photography, cinema, radio, television, and the Internet. With each new technological breakthrough, the capacity of popular culture to overwhelm private, idiosyncratic memories and the memories of subcultures expands.

Our views of the past have also changed because mental attitudes about the *present* have changed, in ways that reflect attitudinal shifts in the culture at large. Throughout the modern period in the West, an allegiance to the idea of historical truth remained paramount. Historians, politicians, the public, and artists may have lacked the data needed to confirm historical truth, but there was a tacit agreement that if sufficient information were available, the truth about history could be established. Today a singular truth of history is no longer assumed.

The factors contributing to the dismantling of the idea of a "grand narrative" are numerous. Certainly, by the 1960s the influence of minorities, who felt that their stories were not accounted for in mainstream history, led to a recognition that historians needed to expand their scope dramatically. Henceforth, not one history but multiple

histories demanded exploration and expression. French historian Michel Foucault, who strongly influenced postmodernist thinking in the 1970s and 1980s, theorized a condition of multiple histories. According to Foucault, legitimate "official" histories existed alongside the excluded histories of those who lacked sufficient power to control the formation of knowledge. Also recognized was that history as a discipline used symbols that reflected power relationships in the wider social structure.

Exhibits about Time

Aspects of the theme of time have been explored in a range of individual and group exhibitions in the contemporary period. Numerous exhibitions have presented contemporary works within the "time arts" (performance, film, and video). One show that directly addressed how film and video artists understand time itself was Making Time: Considering Time as a Material in Contemporary Video and Film, 2000, at the Palm Beach Institute of Contemporary Art, Florida. Another exhibition, Tempo, 2002, at the Museum of Modern Art, New York, featuring a range of works, focused on "distinct perceptions of time that are phenomenological, empirical, political, physiological, and fictional" and examined "cultural differences in the construction of time."

Group exhibitions presenting artists' works that concern the significance of history or memory have included The Art of Memory / The Loss of History, 1985, at the New Museum of Contemporary Art, New York, a group show of fourteen international artists; Doubletake: Collective Memory and Current Art, 1992, at the Hayward Gallery, London, which used memory as a theme to examine works by diverse artists; New Histories, 1996–97, at the Institute of Contemporary Art, Boston, which brought together nine artists from Brazil, England, Japan, Poland, and the United States and considered how the construction of identity is enmeshed in global histories; Distemper: Dissonant Themes in the Art of the 1990s, at the Hirshhorn Museum and Sculpture Garden, Washington, D.C., 1996, which showed ten international artists whose works, in the curators' view, share a sense of moral discomfort with current events; and Mirroring Evil: Nazi Imagery / Recent Art, 2002, at the Jewish Museum, New York, featuring works by thirteen artists, one or two generations removed from the Holocaust, who make new use of imagery taken from the Nazi era.

Exploring the Structure of Time

Time has structure; its everyday elements include duration, speed, rhythm, and direction. In this section we'll examine some of the ways that a number of contemporary artists are controlling, altering, fracturing, and dissolving the structure of time in their work and why. While artists working in a range of media have dealt with this theme, video artists have explored the structure of time most intensively in the contemporary period. They have the technological ability to manipulate the temporal structures embodied in their works, such as speed, sequence, and direction.

A significant way in which artists manipulate time is by breaking down a chronological sequence. Instead of clearly distinguishing past, present, and future events and mapping them in a linear or cyclical fashion, artists may present moments out of chronological order. This approach goes beyond the flashbacks and flash-forwards that

are a staple of commercial films. Contemporary visual artists often depict fragments of time coexisting in a state of collision or confusion. Conceptually, this approach is particularly associated with postmodernism and the deflation of the modernist view that history is progressive and has a coherent, knowable shape. Moreover, postmodern artists show temporal fragments in collision, an approach that provides a metaphor for how our high-tech age presents information and events. Vast quantities of information are stored in data banks and can be accessed rapidly at any moment in any order using digital technologies, but this synchronicity and continual overload of information can make it nearly impossible to piece together coherent explanations of cause and effect. The fracturing of time can also be an artistic tool for metaphorically conveying the processes of memory and dreams, where the temporal structure is perpetually breaking down and meanings are fleeting and transient.

Fracturing Time

In painting, photography, and installation art, artists often create temporal dislocations by juxtaposing or layering images, objects, and styles from different contexts without setting up a logical flow or relationship among them. German Sigmar Polke and American David Salle are two painters who became closely identified with postmodernism in the 1980s for this strategy. The Mexican painter Julio Galán also fractures temporal structure; in his case the layering achieves "the hallucinatory precision of involuntary acts of memory. . . . [Galán] assembles complex rebuses with no solution, their elements drawn from sources as diverse as his personal past (and even future), children's illustrations, Catholic icons, and pre-Columbian creation myths." ¹⁶

Artists working in video have an array of tools at their disposal to alter the structure of time. They have built on strategies pioneered by photographers and filmmakers in the late nineteenth and early twentieth century—flashback, jump cut, fade-in and fade-out, and speeded-up time—which are now readily recognized by most viewers. While the earliest films were shot in real time and remained that way in the finished product, it wasn't long before editing allowed the narrative structure to be shaped. For instance, if the word "Meanwhile . . . " flashed between segments of a silent film, the audience understood that events were happening simultaneously, even though they were presented sequentially.

Due in part to a desire to distinguish their work from Hollywood and mainstream television, many video artists have avoided any attempt to tell traditional narratives in linear time. Single-channel videos dominated most of the work done in the 1960s and 1970s, but by the 1980s multichannel videos gained favor, largely because the technology for such projects had become more available and affordable. Making use of multiple projections and sophisticated equipment and editing software, video artists began to use techniques such as synchronization, slowing down the speed of movement, reversing the flow, and fracturing and multiplying sequences. For example, Mary Lucier's Wilderness, from the mid-1980s, incorporates three synchronized videotapes that are interwoven as they are projected on seven large television monitors. Like other works by Lucier, Wilderness is an investigation of how historical time conflicts with mythic time. The forward march of American progress stands in conflict with the dream of an untrammeled wilderness. The conflict is embodied implicitly in the contrasting images that are shown simultaneously.

Real Time

Ironically, one way that artists manipulate the experience of time is by creating works that *appear* to unfold in real time; the audience experiences the work as if the events shown are happening in the present without any editing or restructuring. Fischli and Weiss's video *The Way Things Go* [2-1] has the quality of a real-time sequence, although the artists actually achieved this seamless effect through deceptive editing. Marina Abramovic's twelve-day performance, described earlier, was an attempt to merge real time and the time of an artwork's duration. Various artists are working with real-time live video projections on monitors or on the Internet (so-called streaming video), an approach pioneered by Nam June Paik early in his career. For example, Spanish-born Inigo Manglano-Ovalle's *Nocturne (tulipa obscura)* (2002) is a night-vision-enhanced real-time video projection relayed from a camera filming an Afghan tulip. American Julia Scher works with standard security-industry equipment to spy on gallery goers in real time; her work is a critique of the increasing surveillance of our public lives by means of security cameras.

The interest in real time is partly a reaction to the artificial time structures we have become accustomed to as a result of watching commercial films and television. According to critic Amy Cappellazzo, "television and movies have trained modern viewers to expect life in condensed narratives, with scenes of heightened action and sound accompaniments that echo our emotions." Paradoxically, part of the appeal of the "reality shows" that have sprung up over the past few years on television can be attributed to the unexpected difference in temporal rhythm and pace such shows have compared to the packed plotlines of typical television dramas and comedies. Unlike either fictional stories on television or reality TV, everyday experiences of time are more likely to be taken up with nonevents, meandering activities that have no obvious drama or tidy conclusion.

Contemporary artists have approached the recording and representation of our experience of real time in many unexpected and novel ways, including using the static arts of painting and still photography. Japanese conceptual artist On Kawara, for example, marks time one day at a time in his ongoing production of "date" paintings. Each consists of a flat background and carefully painted text stating the date on which the painting was executed (e.g., August 24, 1988). Kawara keeps to a rigorous set of rules: each painting must be made entirely within the twenty-four-hour period of the day named on the painting itself. The artist adds newspaper clippings from that particular day to complete the artwork.

British artist David Hockney pioneered an approach to photography in which multiple individual snapshots are arranged together into one artwork, producing a representation of the subject that, according to the artist, more closely parallels the way we really see. In Hockney's *The Scrabble Game* (1983), several dozen snapshots (some butting and some slightly overlapping) show various gestures that players made during the slice of time Hockney photographed. In analyzing his achievement, Hockney recalled that one of the subjects declared *The Scrabble Game* is "better than a movie." Hockney explained that "a movie must traffic in literal time and can only go forward. Even when it pretends to go back, the spool is moving forward, forcing us to keep to an established, dictated pace. There's no time for looking, as there always is in the world. . . . I've been trying to figure out ways of telling stories in which

the viewer can set his own pace, moving forward and back, in and out, at his own discretion." 18

Many artists who work with real time emphasize the element of duration (an interval of time) rather than narrative (storytelling and drama). In this, they follow the experiments in musical composition made by the American John Cage, who since the 1950s maintained that duration is the most fundamental structuring idea in music, as opposed to the concept of harmony, which has dominated musical composition, especially in the West, since the time of Bach. Andy Warhol was another important precursor of today's artists who explore time as duration. In the 1960s Warhol made several films in which he recorded static (non-narrative) imagery over an extended time. His most famous film, Empire (1964), recorded from a distant, stationary view eight hours and five minutes in the "life" of the Empire State Building. Not much happens except lights occasionally go on and off, and the sky changes color. The length of these films challenges any viewer's patience. American Bruce Nauman and Tacita Dean of England are two artists who have worked more recently in filming scenes of protracted duration in real time. The length and slowness of their videos make viewers exceptionally aware of the passage of time, both the time portrayed in the videos and the time needed to watch them.

Building on Warhol's work, Scottish artist Douglas Gordon videotaped the movement of people coming and going as Warhol's *Empire* was being shown in a gallery. Gordon's resulting two-hour video, *Bootleg (Empire)* (1997), thus appropriates Warhol's film and wittily highlights the problem of its length and static content. Because we have been conditioned by the rapid-fire cadence of television, pop music, and action films, a filmed work of art that fails to stimulate and compress experience to a similar degree is bound to try our viewing patience. This tension can be felt strongly even in the case of viewing a painting; because no optimal time of viewing is specified or mandated, viewers increasingly tend to give paintings short shrift.

Changing Rhythm

Another way that artists in the "time arts" alter the structure of time is by speeding up or slowing down the tempo of a program. English artist Sam Taylor-Wood used time-lapse photography to film *Still Life* (2001) at an accelerated pace. The resulting film shows an elegant bowl of fruit decaying before our eyes, ending in a mass of rotten fragments infested with maggots. More than speed, however, artists are interested in exploring slowness, perhaps as a contrast to the frenzied pace of contemporary society. "Why has pleasure in slowness disappeared?" asked Czech novelist Milan Kundera. Probing the degree to which our sense of time has accelerated from previous generations, philosopher Walter Benjamin once noted that some strollers in the shopping arcades of nineteenth-century cities walked with a tortoise on a lead. "When tempo is radically slowed down, the resulting conflict with a viewer's inner clock is palpable. By altering the clocklike rhythm of time, an artist explores time much as a composer explores rhythm in music.

Over the past decade, the slowed-down video has become something of a genre all its own, with an exceptional variety of aesthetic results. Well-known practitioners include Douglas Gordon, James Coleman of Ireland, and American Bill Viola. These artists work from the assumption that slowness can be an intensification of experience.

2-7 Douglas Gordon 24 Hour Psycho, 1993
Video installation, single screen, 300 x 400 cm; duration 24 hours
Private collection, London and Kunstmuseum Wolfsburg
Courtesy of Douglas Gordon Archive

Our attention as viewers becomes so focused that even the slightest movement or change in a facial expression appears to have momentous significance. Watching events happen in extreme slow motion, we are caught up entirely in the present moment and lose track of any overall cohesive structure. In 24 Hour Psycho (1993) [2-7], Gordon replays a video copy of Alfred Hitchcock's 1960 thriller at one-thirteenth of its original speed. Even the dramatic stabbing scene in the shower is slowed down to the point that the mystery of the plot drains out of the scene; a new mystery—the mystery of time made palpable—takes over.

Continuing his interest in altering and partially dissolving the narrative structure of existing film footage, in $D\acute{e}j\grave{a}$ vu (2000) [2-8], Gordon simultaneously projects three video copies of D.O.A., a 1950 Hollywood film noir directed by Rudolph Matee. From left to right, the three projections play at one frame per second faster than normal, at normal speed, and at one frame per second slower than normal. Thus the three identical narratives diverge over time, inducing feelings of disorientation in spectators as scenes repeat and soundtracks overlap.

In discussing Gordon's slow-motion videos, one writer explained that the moment "is allowed to flourish in extravagant excess." The point is just as pertinent in looking at some recent rear-projection color video installations by Bill Viola. These are presented in such extreme slow motion that encountering one in a museum, an unsuspecting viewer momentarily may believe the image is static, like some form of electronic painting. For example, in *The Quintet of the Silent* (2001) [color plates 1 and 2]

2-8 $Douglas Gordon \mid D\acute{e}j\grave{a} vu$, 2000 Video installation, dimensions variable Courtesy of Lisson Gallery and the artist

an action that was filmed in one minute is presented over a fifteen-minute period. (Unlike Gordon, Viola does not work with appropriated footage but with a scene he staged and filmed himself.) The incorporation of actual time in the work becomes almost secretive; part of the attraction of the work stems from gradually being let in on the secret as we see how time almost imperceptibly unfolds, and we become absorbed in watching the subtly changing facial expressions and hand gestures.

Exploring Endlessness

Finally, contemporary artists sometimes deal with a concept that, at first glance, may appear to involve the infinite but that in fact is significantly different: endlessness. This quality occurs in sculptures that repeat a certain movement over and over, such as Charles Ray's *Rotating Circle* (1988), and in paintings that depict a subject with inherent repetitiveness, such as Guillermo Kuitca's painting *Terminal* (2000), which shows one of the familiar rotating carousels found in the baggage claim area of a modern airport. The endlessness found in such works has nothing to do with the transcendent infinity of the universe contemplated by the spiritually awakened; this is an endlessness founded in extreme boredom, in the dull repetition of meaningless details in contemporary (postspiritual) life. This is the endlessness of the treadmill or of a neurotic obsession.

In investigating the concept of endlessness, some artists have used the strategy of looping a video or film so that a fragment of it continuously repeats. Typically, the beginning and end meld seamlessly together, so that there is no starting or stopping. Rodney Graham's *Vexation Island* (1997), filmed in Cinemascope, for example, presents,

in an endless loop, a nine-minute scene in which a character (the artist in a pirate's costume) is out cold under a palm tree. He wakes up, only to have a coconut fall on his head, which knocks him back into unconsciousness. Ironically, while repetition often serves to fix an event in memory, in this case the falling of the coconut knocks the incident out of the poor pirate's head, and when he wakes up again, it's as if it were the first time. Michael Rush explains that *Vexation Island* is a "retelling of the Robinson Crusoe story which Graham, in the manner of other Conceptual artists . . . associates with theories on violence by French philosopher Gilles Deleuze." A similar strategy of looping action in a way that frustrates any sense of forward progress can be seen in Irish artist Willy Doherty's video *At the End of the Day* (1994). In this video, we see from a passenger's viewpoint as a car following a series of roads is repeatedly stymied by barricades. The roadblocks bring to mind the conflicts that are preventing any way out of the troubles in Northern Ireland. The repetition leaves us wondering, How long can the cycle of blame and retaliation in Ireland's troubled history go on repeating itself?

Revisiting the Past

Art that looks back in time to the historical past or remembered events has been common in the period this book covers. In the 1980s Neo-Expressionists such as Anselm Kiefer in Germany and Mimmo Paladino in Italy focused on their respective national histories and cultural origins, referring to history, literature, mythology, landscape, and religion in their heavily symbolic paintings. Kiefer was particularly concerned with overcoming Germany's repression of its actions during World War II; his works were attempts to get Germans to come to terms with the rise of Hitler and Nazism and exorcise their collective feelings of guilt. The Russian artist team of Vitaly Komar and Aleksandr Melamid (who immigrated to the United States in 1978) appropriated the old-fashioned official style of socialist realism to satirize the glorification of Stalin and Soviet history.

A key quality in the Neo-Expressionists' work (and in the work of the artists they admired and appropriated) was that they "seemed to face the future by looking to the past," as Irving Sandler has commented.²² Elizabeth Baker remarked that "tradition is no longer a burden, but a newly discovered resource. [Neo-Expressionists seek] reentry into the realm of allegory, history and myth that the dominant styles of the modern period so decisively discarded."²³

Other contemporary artists who look to the past seek to understand the nature of history—who and what is remembered, and how and why. They scrutinize the content and approaches of historical study and remembrance.

Recovering History

Contemporary artists want to tell the stories of people who for centuries were left out of history books and the visual record, particularly if they themselves belong to a disenfranchised group. Michel Foucault coined the phrase *counter memory* to describe this recovery of lost history. According to curator Douglas Fogle, the term describes "a new kind of historiography where the marginal and the everyday take precedence over world historical figures."²⁴ Judy Baca's mural project *The Great Wall of Los Angeles* (1976–83), was a monumental effort in this inclusive vein. More than thirteen feet high and almost a half-mile long, the mural depicts a multiethnic history of the Los Angeles area from prehistory until after World War II. Her subjects include women's suffrage,

the Japanese internment camps, and the Zoot Suit Riots. To complete the mural, Baca and her collaborators interviewed hundreds of residents and academics about the history of Los Angeles, and four hundred fifty inner-city youth and forty community artists executed the designs. Baca says, "Murals embody certain qualities of visual storytelling. First, there is the difference between public voice and private voice. Murals are pulpits: what you say in the pulpit is different from what you say to an intimate. Next, you must consider their scale. Scale is about amplifying the voice, about making it the voice of people who were excluded from history."²⁵

Besides recovering lost histories, many artists are interested in deconstructing the principles and methodologies used to record and shape historical events. For example, Brazilian artist Adriana Varejão makes constant references in her work to the iconography of the seventeenth-century Baroque, which was the leading artistic style in the European countries that conquered South America (Portugal, in the case of Brazil). Her motives include the (postcolonial) desire to challenge a history of Brazil that suggests European culture subsumed and replaced indigenous culture, exemplified by the prevalence in Brazilian art and material culture of Baroque-inflected designs and motifs. Varejão believes that Brazilians were able to absorb and transform the colonizers' culture without completely losing their own history and identity. The process was not without struggle and wounds; hence the violent, visceral imagery in much of her work. One series of relief paintings depicts writhing masses of bloody, fleshlike forms erupting from beneath floors tiled in azulejo, the terracotta tile used widely in Portuguese national art and in Portugal's former colonies, including Brazil. Like a range of other Brazilian theorists and artists, Varejão uses cannibalism as a metaphor and sometimes includes images of humans consuming one another in her paintings. According to Rina Carvajal, the artist's use of cannibalism as a cultural allegory "suggests the swallowing, the critical absorption of foreign influences; of the discourse of 'the other,' and its re-making in Brazilian terms."26

Historical memory is dependent on the forms in which historical material is conveyed: history books, historical novels, painting, sculpture, photography, and, increasingly, film and video. These various media structure the content and perception of history. Various artists have deconstructed how the popular understanding of history is shaped by fictional treatments of the past. For example, Piotr Uklanski, who was born in Poland, created The Nazis (1998), an installation of 166 publicity photographs showing famous movie actors in costume as Nazi officers, from Ronald Reagan to Ralph Fiennes. Uklanski, in presenting images of Nazis from popular culture, demonstrates that stars with alluring faces have repeatedly been selected to play these roles, thus fetishizing the perception of Nazis. American Kara Walker is concerned with how the history of the pre-Civil War South is romanticized and sugarcoated in popular portravals such as the novel Gone with the Wind. Initially trained as a painter, Walker makes cutout black-paper silhouettes, a craft technique previously associated with genteel portraits and sentimental genre scenes. Walker's large wall-mounted works such as Camptown Ladies (1998) [2-9] are parodies of historical romances that undermine any nostalgic expectations the silhouette technique might imply. In her dreamlike vignettes, blacks and whites alike enact sadomasochistic behaviors, as figures morph into one another. Her strategy is to inflate and reverse stereotypes so that they unravel into kitsch parodies of racist imagery. Walker's works are controversial among viewers of all races and have provoked debate about how to represent the history of slavery in the United States.

2-9 Kara Walker Detail of Camptown Ladies, 1998 Cut paper and adhesive on wall, 9 x 67 feet

Collection of the Rubell family Courtesy of Brent Sikkema, New York

Reshuffling the Past

Why, in recent decades, has there been a revival of period styles and a rush to appropriate elements from the past? With the rise of postmodernism in the 1980s, an increased interest in using art historical styles and images has dovetailed with the trend of increasingly rapid style changes in popular culture, where, for example, styles of cars and clothing change every year. Of course, a rapid change of styles results in a heterogeneous mixture, since the examples of past styles are not eliminated entirely but continue to exist in a mix with more-recent versions. The utilization of a pastiche of past images (or forms) became a recognized hallmark of postmodern art. Following the belief that "there is nothing new under the sun," numerous artists, from David Salle in the 1980s to Christian Schumann more recently, have forged their own individual styles by the characteristic manner in which they recycle the past. These artists work in ways that tend to destabilize the present; for them, the present is conceived as a reshuffling of mementos from the past.

A knowledgeable viewer's understanding of a work of art is related to the viewer's memory of other works of art and past visual culture and his or her sense of how that particular work fits into the history of art and visual culture. If an artist "quotes" earlier imagery, the viewer who recognizes the quotation interprets the new work of art, in part, as an exploration of the theme of memory or history. For example, British brothers Jake and Dinos Chapman borrowed the gory tableau of mangled bodies in their sculpture *Great Deeds against the Dead* (1994) from an early-nineteenth-century etching in Francisco Goya's *Disasters of War* series. Knowledgeable viewers find themselves weighing the bad taste of the Chapmans' macabre scene against the genuine despair of Goya's firsthand witnessing of the real horrors of the Napoleonic wars. American comic-book artist Alex Ross, who has a cult following among devotees of the genre, appropriated famous characters (Superman, Captain America) and imagined them in middle age in one of his comic books. The conceptual subtlety of Ross's work depends on his audience's knowledge of the past exploits and foibles of his superheroes in their younger incarnations.

Reframing the Present

Underlying the work of Kara Walker [2-9] and many contemporary artists who revisit history is a determination to change how we understand the present. When we revisit history, time collapses; what was once present and is now past becomes vividly present once again. The present appears in a new context, and it becomes possible to see the present more critically through the past. Walker, for example, wants viewers to consider how representations of history affect race relations today. Atul Dodiya, a contemporary painter in India, made a recent series of paintings on the corrugated metal exteriors of roll-up doors that detached from actual shops. The exterior paintings celebrate India's history by depicting historical figures such as Gandhi and the Nobel laureate Rabindranath Tagore. The doors raise to reveal more surreal painted versions of events underneath. Critic John Brunetti remarked, "These hidden images are stark portrayals of an India very different from that presented by Gandhi's non-violent resistance." Dodiya shows how celebratory versions of history prevent India from taking a hard look at present problems and anxieties.

In many cases the history that artists review is the recent past—a history that is still alive in the memories of firsthand witnesses. American printmaker Warrington Colescott pokes wicked fun at the escapades of American politicians and other members of the ruling elite by providing a behind-the-scenes look at what the artist imagined "really" occurred. An example is the satirical print *Meanwhile . . . Underneath the Oval Office* (1987), which provides an alternative view of events occurring in an imaginary subterranean level of the White House. Colescott often turns his attention to bona fide historic events, using his rendition of the past as a thinly veiled critique of what is occurring now. Willie Doherty is concerned with current political events in Northern Ireland. Well aware of the power of television in controlling what and how the public perceives events in Ireland, Doherty purposely uses the tools of the news media: video and language. Douglas Fogle has commented, "Calling into question our reliance upon the truth value of the news broadcast or newspaper report to make sense of the world, Doherty at the same time stresses the power of mediated language in constituting our own collective memory."²⁸

Artists revisiting history have also turned their attention to their own personal and family histories. For example, English artist Tracey Emin's installation *Everyone I Have Ever Slept with* 1963–1995 (1995) is a tent embroidered with the names of all the people

2-10 Roger Shimomura (Minidoka), 1997

American Diary: October 16, 1942

Acrylic, 11 x 14 inches
Courtesy of Bernice Steinbaum Gallery

Emin had shared a bed with over the prior three decades. In the 1980s American painter Eric Fischl painted many exaggerated fantasy scenes evocative of his suburban childhood. Roger Shimomura, an American of Japanese descent, was inspired by his grandmother's diaries as well as his own childhood memories to create prints and paintings depicting life in the Minidoka internment camp in Idaho during World War II [2-10].

Autobiography and social history are not distinct realms and cannot be wholly separated. Many works about personal history, such as Shimomura's, also highlight the profound impact of culture. What is significant in an artist's own life is tied to larger public events as well as historically based social concepts that are often charged with emotion.

Commemorating the Past

Since 1980 there has been a resurgent interest in creating *memorials*, which pay tribute to the dead, and *monuments*, which pay tribute to the past. This interest stems from a number of factors: the need to reassess the past (seen, for example, in monuments dedicated to the civil rights movement in the United States and the Holocaust in Europe), a desire to mark tragic events in the present (exemplified by the Vietnam Veterans Memorial), and a desire to legitimate the right of a government and social structure to continue into the future (in reverse fashion, the world watched the toppling of statues of dictators in the former Soviet Union and Iraq as a dramatic way of signaling the demise of a government).

While people in previous eras also felt the need to remember past events and people in some tangible and permanent form, we may feel a unique pressure to do so today because of the impact that the information age, and information overload in particular, has had on the process of remembering. Andreas Huyssen, a historian of contemporary culture, observed that "the more memory is stored on data banks and image tracks, the less our culture is willing and able to remember." Increasingly we abdicate our power to remember as individuals and as communities in favor of the artificial, and mediated, memory banks supplied by technology. Every snippet of coded knowledge about the past, present, and future is available almost instantaneously to anyone with a computer and high-speed Internet access. The result? What Huyssen terms a "synchronicity of the archive" that dissolves time and confuses memory. In analyzing Huyssen's contributions to our understanding of the "tenuous place of history and memory in our time," curators Neal Benezra and Olga Viso explained, "[Huyssen] sees society's current assertion of memory as a struggle for history and a form of 'temporal anchoring' against high-tech amnesia."29 Artists creating memorials and monuments offer forms that slow down the looking of viewers, providing time for contemplation and counteracting our collective forgetfulness.

Of course, our relationship to the past is never free of emotional baggage, politics, and value-laden ideologies. In designing memorials and monuments, contemporary artists find they are (willingly or not) tiptoeing through minefields of public opinion. The Vietnam Veterans Memorial, dedicated in 1982 on the Mall in Washington, D.C., provoked widespread debate when its design was first announced. Maya Lin, then a senior at Yale University, won the design competition with a plan that proposed a pair of elegant black granite walls, dug into the earth and gaining height as the viewer descends to the place where the two walls meet at an open angle of about 125 degrees. Lin proposed carving into the wall surface the names of the more than fifty-five thousand Americans who lost their lives during the conflict or remained missing in action at the war's close. Looking at a section of the wall, viewers would see a dim, ghostlike reflection of themselves, appearing behind the wall. Opponents felt the design should be more conventionally heroic, featuring figures in uniform, as is typical of most war memorials.

The Vietnam Veterans Memorial is now the most visited monument in Washington, D.C. Its focus on time occurs on several distinct levels. The entire sculpture commemorates U.S. involvement in the war as a chapter in national history. Indeed, the shape of the sculpture seems to echo the shape of a book opening, thereby hinting at additional chapters yet to be written. The individual names of the dead and missing in action are arranged in chronological order. Time is marked on the wall by the names. 30 Time is also central to the experience of viewers. As Lin explained, "I think of all my works not as static objects, but strictly in terms of a personal journey or experience of it. A crucial element to this work is my reliance on time."³¹ Older visitors bring their own sense of time to the experience as they reflect on what they were doing in the 1960s when all those listed were making the "ultimate sacrifice." Seeing the dates, we inevitably think of how much time has passed since these deaths occurred. Analyzing the form and meaning of the memorial, philosopher Charles Griswold called the work "fundamentally interrogative": Americans as a whole must ask themselves, were these deaths worth it?³² Griswold noted that the Vietnam Veterans Memorial, like any war memorial, "seeks to instruct posterity about the past . . . [the memorial is the result of] a decision about what is worth recovering."33

In contrast to memorials created from a material that will endure permanently, artists' projects may commemorate events in ephemeral or temporary forms. For example, Krzysztof Wodiczko's *Hiroshima Project* (1999) lasted for only two nights. The work consisted of a sequence of large-scale photographic images of Japanese survivors' hands projected along the waterfront in Hiroshima while the survivors' recorded testimonies were amplified. The hand gestures represented anguish and grief. The short-lived and dematerialized nature of the event transformed the survivors into ethereal presences, as if ghosts from the atomic blast had returned to recount their experiences.

One trend in public art today is the production of *antimonuments*, works that deconstruct traditional forms of public monuments or commemorate unexpected events and memories. For example, American sculptor Chris Burden pursued a challenging alternative vision in creating the *Other Vietnam Memorial* (1991), which symbolically names the three million dead Vietnamese in the war. German Thomas Schütte questions traditional forms of commemoration by making groupings of figures whose scales are mismatched in relation to one another. Neal Benezra and Olga Viso remarked, "Addressing the significance of public monuments in a post—Cold War world, Schütte questions the ability of traditional forms of commemoration to serve as effective carriers of memory and meaning in our time." In the 2002 Whitney Biennial in New York, American Keith Edmier exhibited in Central Park two three-quarters-lifesize bronze sculptures of men in uniform; the two were not the usual "great men" of commemorative statuary but represented Edmier's two grandfathers, who played modest roles in World War II.

In creating a memorial or monument, an artist faces a range of complicated issues. Because the work will be seen in a public setting, the varying emotional and political attitudes of a multitude of viewers must be addressed (or ignored at considerable risk). Additionally, people who live in the future will eventually view the public monuments we erect today; for them, the same symbols may not carry the same meanings. One of the poignant debates in the aftermath of the terrorist attacks on the World Trade Center focused on what kind of monument should be erected on the site to commemorate the magnitude of events that occurred on September 11, 2001.

Over time, works of art may gain unintended elegiac and memorial resonance for viewers. For example, Joel Meyerowitz, starting in 1981, created a series of photographs showing the southern view of Manhattan out his studio window [color plates 3 and 4]. Echoing Monet's series of paintings of haystacks and the Rouen Cathedral at different times of day and in different weather conditions, Meyerowitz's work shows the changing pattern of color and light in the sky and the expanse of buildings. A key focal point in each photograph is the double towers of the World Trade Center, looming deep in the background. The sense of time, and of tragedy, is invoked in these images now in ways that the artist could not have contemplated as he was creating them.

Finally, although we have been discussing memorials and monuments in terms of the theme of time, we note that the topic can also tie into the theme of place, the topic of our next chapter, notably when a memorial or monument commemorates an event associated with its site. Wodiczko's *Hiroshima Project* is a case in point. Various themes can intersect.

The past keeps surfacing into the present—this is a leitmotif in much of Brian Tolle's art. We can see this perspective embodied in *The Philadelphia* (1995), a sculptural installation featuring the artist's version of an eighteenth-century gunship's rotting hull, still half submerged, rising from the depths (the water's surface represented by the colored floor of the gallery). Tolle's artwork recreates an actual event: the *Philadelphia*, a Revolutionary War gunship that sank fighting the British, was raised in 1935. To accomplish the salvage operation, the ship's cannonballs were brought up first. Tolle references this process by filling the gallery floor with cannonballs carved out of Styrofoam. In the actual event, freed of the dead weight, the ship floated up to the surface; in Tolle's re-imagining, the process of remembering history is never complete; our collective recall is partial.

While in Tolle's artistic vision, the sense of history is fragmentary, it is also the case that partial echoes of the past keep surfacing, in surprising ways, inserting themselves into the present but with their original shapes and meanings distorted by time. For example, in Declaration of Independence Desk: Thomas Jefferson (1994), Tolle replicated not one but a whole series of versions of Thomas Jefferson's portable writing desk. Jefferson's original desk, left to an heir, had taken on the status of a national relic, famous as the surface on which the founding document was written. Over the decades, knockoffs of the original desk were carefully crafted in order to satisfy the demand of luminaries (Henry Ford and LBJ, for instance) who wished to own a distinctive reference to American history. Tolle takes the process a step further, fabricating a simulation of the original desk by Jefferson as well as simulations of the earlier knockoffs, each with its own idiosyncratic details that identify the owner. Tolle's simulations of other people's simulations of Jefferson's desk place us in a peculiar position, two steps removed from Jefferson's original version. The viewer may feel a sense of vertigo, as the process of creating new simulations seems capable of expanding endlessly. Tolle's project, in terms of the infinite reduplication of culture (as if culture has taken on the condition of fecund nature), epitomizes what Jean Baudrillard termed hyperrealism: "the meticulous reduplication of the real, preferably through another, reproductive medium . . . [reduplication] becomes reality for its own sake, the fetishism of the lost object."35

Tolle's most widely known project is the *Irish Hunger Memorial* (2002) [color plate 5], located in Battery Park City, New York. This artwork focuses on the Great Hunger of 1845–52, when the population of Ireland decreased from eight million to five million. Approximately one million people died as a result of a widespread blight of Ireland's potato crop over a period of several years, a condition that, many historians feel, was worsened by mismanagement of the crisis. Another one and a half million Irish emigrated, fleeing the famine. Many of these entered America through Ellis Island in New York's harbor, a site that is visible from the upper portions of Tolle's memorial.

To symbolize the suffering and loss and the flight by many to America, Tolle replicated on a half-acre site a chunk of harsh Irish countryside. The site is nestled among the tall buildings of lower Manhattan. The plants and shrubs incorporated into the artwork are native to County Mayo. There's even a stone cottage like those inhabited by Irish farming families during the early 1800s. The cottage is roofless, a vivid reminder of a tragic fact: in order to "prove" their poverty, and therefore be eligible for government aid, many farmers tore the roofs off their dwellings. The half acre duplicates the maximum size plot farmers were allowed to own to qualify for famine relief.

The artwork is elevated (twenty-five feet above ground level at its highest point) and cantilevers out from a base of stone and glass. These structural features emphasize that *Irish Hunger Memorial* is a sculptural object, not a nature retreat or theme park. Climbing over the path that leads past the abandoned cottage and fallow potato field, viewers are catapulted backward in time, while also responding to the present conceptual and tactile qualities of Tolle's work. Indeed, Tolle places primary emphasis on contemporary visitors' experience of the artwork itself, rather than asserting that we focus on the Irish back in time: "I'm not interested in situations where there's an empathetic other. When you're dealing with history, it's too easy to say, 'This is about them, then.' It's about the experience that you're having right now. It's about you." Along the base below the sod [color plate 6], printed lines of text recount memories by the Irish victims, while other passages, interspersed with those recounting the Great Hunger, reference recurring instances of famine worldwide.

The cottage is a memorial within the memorial, and it is also the real thing—an actual farmhouse. Relatives still living in Ireland of Brian Clyne, Tolle's partner, donated the cottage for the project. The farmhouse was shipped over and rebuilt, rock by rock. According to Tolle, the use of the dwelling in the artwork is appropriate: "to be able to have an actual place that has a history and not feel anxious about taking something from where it belonged, because the house was in fact a gift between families and between nations and had a history and a history as part of my extended family."³⁷

Tolle's art transforms our view of history and historic architecture, calling into question the reliability of any view of the world we thought we knew. With *Eureka* (2000), Tolle transformed the front facade of a seventeenth-century home facing a canal in Ghent, Belgium. For this project, the artist collaborated with computer specialists who helped digitally map the appearance of wave patterns, complete with the wakes of passing boats, on top of the building's actual exterior. The model was output using a computer-operated milling machine. The result—a false front of carved and painted Styrofoam that recreates the building's reflection in the canal—was installed on the front of the original facade of the building. The structure itself appears to reflect the reflection in the canal; Tolle refers to the result as "liquid architecture."

For an exhibit titled *Alice and Job* at Shoshana Wayne gallery in New York in 2000, Tolle installed two enormous stone hearths, representative of what little remains today of Llano del Rio, a socialist community founded in the early 1900s in Southern California. Each hearth bears an initial, "A" and "J": "A" signifies Alice Austin, architect for Llano del Rio's city plan, and "J" is for Job Harriman, visionary leader of the community. The two hearths are stand-ins for Alice and Job.

As symbols for minor historical figures, people who pursued a dream of creating a utopian society, the hearths operate on multiple levels. Individually, the hearths can be seen as memorials for the two individuals whose initials they bear (like large gravestone markers). Together, the hearths and the pristine room they are in constitute an exhibition that serves as a monument to a failed utopia. At first, viewers may see the hearths as authentic artifacts of a bygone lifestyle. On closer examination, it becomes apparent that the artist fabricated the fireplaces; they are meant to look like clever fakes. Furthermore, the mystery of the large. faux-stone sculptures deepens as viewers realize that they are moving slowly around the room. At a rate approximately a foot per minute, the hearths' motions seem robotic or alive, but functioning much slower than humans today. In writing about Tolle's exhibit, critic Josh Blackwell observed, "Modernism and the twentieth century heralded the arrival of speed and efficiency. . . . Time became a precious commodity, something to be saved and not wasted. . . . Consequently, slowness became a demonized notion, and wonder and reverie were transformed into anxiety and distraction."38

Viewers with a sophisticated knowledge of the theoretical apparatus surrounding the reception of contemporary art may understand Tolle's art as employing a strategy by which the past becomes a text we interpret within the context of our own present perspective. Theoretically inclined viewers may "read" his sculptural forms—the Styrofoam cannonballs of the Philadelphia, the simulations of Thomas Jefferson's desk, and the stone hearths Alice and Job meandering endlessly—as indications of how the past is retraced by the present in allegorical terms. In an influential essay first published in 1980, the late critic and theorist Craig Owens outlined how a vital quality of allegory is its "capacity to rescue from historical oblivion that which threatens to disappear."³⁹ It would be a fascinating project in critical interpretation to analyze Tolle's art in terms of Owens's essay, which outlines the impulse to "supplant" an original meaning, in danger of being "foreclosed" in the distance of time, by a fresh, fabricated overlay. Indeed, many of the key qualities Owens identifies as facets and strategies of the contemporary impulse for allegory in the visual arts—including appropriation, hybridization, pastiche, site specificity, the referencing of the past in fragmentary terms, as well as the representation of the past in ruins—are arguably central to Tolle's work.

Looking at examples of Tolle's body of work, our perspective on history, time, and perception keep shifting. In fact, many qualities in his art conspire to disorient the visitor: if the present is the culmination of the past but the past keeps

shifting, then where are we now, how can we take our bearings? In the face of temporal disorientation, Tolle's work requires that we pay attention and refuse to take the present for granted.

Brian Tolle was born in 1964, the son of a mechanical engineer and a real estate agent. He was raised on Long Island and studied at the Parsons School of Design and Yale University School of Art. He now lives in New York, working in a studio in Williamsburg, Brooklyn.

Notes

- 1. Amy Cappellazzo, "Fischli/Weiss," in *Making Time: Considering Time as a Material in Contemporary Video and Film* (Lake Worth, Fla.: Palm Beach Institute of Contemporary Art, 2000), p. 41. An exhibition catalog.
- 2. Nancy Princenthal, "Heide Fasnacht: Exploded View," Art in America, February 2001, p. 125.
- 3. Irene Netta, "Time in the Work of Jan Vermeer and Bill Viola," in Helmut Friedel, ed., *Moments in Time: On Narration and Slowness* (Stuttgart, Germany: Hatje Cantz; New York: Distributed Art Publishers, 1999), p. 157.
- 4. Contemporary artists working with illusionistic space and the drama of a moment suspended in time include the painters Gregory Gillespie, Paula Rego, Odd Nerdrum, and Vincent Desiderio and the photographers Jeff Wall, Tina Barney, and Philip-Lorca DiCorcia.
- 5. Dominique Nahas, "Enkindled Memories: The Art of Whitfield Lovell," in *Whitfield Lovell: Embers* (New York: DC Moore Gallery, 2002), unpaginated. An exhibition catalog.
 - 6. Netta, "Time," pp. 160-61.
- 7. Vicki Goldberg, "The Artist Becomes a Storyteller Again," *New York Times,* November 9, 1997, p. 25.
- 8. See Lucy R. Lippard, *Six Years: The Dematerialization of the Art Object* (New York: New York University Press, 1979).
- 9. Lateral Thinking: Art of the 1990s (La Jolla: Museum of Contemporary Art San Diego, 2002), p. 70. An exhibition catalog.
- 10. Rosalind Krauss, "Notes on the Index, Part 1," reprinted in Charles Harrison and Paul Wood, eds., *Art in Theory: 1900–2000: An Anthology of Changing Ideas*, second ed. (Malden, Mass.: Blackwell Publishing, 2003), p. 996.
- 11. Lincoln Barnett, *The Universe and Dr. Einstein*, rev. ed. (New York: Bantam Books, 1957), p. 53.
 - 12. Ibid.
 - 13. Victor Burgin, "Situational Aesthetics," reprinted in Art in Theory, p. 896.
- 14. Douglas Fogle, "Volatile Memories," in *No Place (Like Home)* (Minneapolis: Walker Art Center, 1997), p. 116. An exhibition catalog.
- 15. Paulo Herkenhoff Roxana Marcoci, and Miriam Basilio, *Tempo* (New York: Museum of Modern Art, 2002), p. 7. An exhibition catalog.
- 16. Lynne Cooke, Bice Curiger and Greg Hilty, "Notes on the Artists and Biographies," in *Doubletake: Collective Memory and Current Art* (London: South Bank Centre and Parkett Publishers, 1992), p. 221. An exhibition catalog.
- 17. Amy Cappellazzo, "Making Time: Considering Time as a Material in Contemporary Video and Film," in *Making Time*, p. 16.
 - 18. David Hockney, Cameraworks (New York: Alfred A. Knopf, 1984), p. 33.
- 19. Kundera's and Benjamin's observations are both described in Helmut Friedel, "why has pleasure in slowness disappeared," in *Moments in Time*, p. 11.

- 20. Seth McCormick, "Artists' Biographies," in Making Time, p. 90.
- 21. Michael Rush, New Media in Late Twentieth-Century Art (New York: Thames & Hudson, 1999), p. 165.
- 22. Irving Sandler, Art of the Postmodern Era: From the Late 1960s to the Early 1990s (New York: HarperCollins Publishers, 1996), p. 223.
 - 23. Cited in ibid., p. 229.
 - 24. Fogle, "Volatile Memories," p. 117.
- 25. Quoted in Barbara Tannenbaum, "Where Miles of Murals Preach a People's Gospel," New York Times, May 26, 2002, p. 29.
- 26. Rina Carvajal, "Travel Chronicles: The Work of Adriana Varejao," in Lia Gangitano and Steven Nelson, eds., *New Histories* (Boston: Institute of Contemporary Art, 1996), p. 171. An exhibition catalog.
 - 27. John Brunetti, "E.T. and Others," in Dialogue, January/February 2003, p. 44.
 - 28. Fogle, "Volatile Memories," p. 117.
- 29. Neal Benezra and Olga M. Viso, *Distemper: Dissonant Themes in the Art of the 1990s* (Washington, D.C.: Hirshhorn Museum and Sculpture Garden, Smithsonian Institution, 1996), p. 12. An exhibition catalog.
- 30. The name of the first American casualty (in 1959) is listed in the center where the two walls meet, from where the list extends outward on the right wall. The list continues from the far left of the other wall and ends back in the center, with the name of the last casualty (in 1975).
- 31. Maya Lin, Maya Lin: Between Art and Architecture (New York: Cooper Union, 2000), p. 15. Transcript of a slide lecture.
- 32. Charles L. Griswold, "The Vietnam Veterans Memorial and the Washington Mall: Philosophical Thoughts on Political Iconography," in Harriet F. Senie and Sally Webster, eds., Critical Issues in Public Art: Content, Context, and Controversy (New York: HarperCollins Publishers, 1992), p. 91.
 - 33. Ibid., pp. 71-73.
 - 34. Benezra and Vigo, Distemper, p. 12.
- 35. Jean Baudrillard, "The Hyper-realism of Simulation," a selection reprinted in *Art in Theory*, p. 1018.
 - 36. William Kaizen, "Brain Tolle," Bomb 77 (Summer 2001): p. 60.
- 37. As quoted in Lynda Richardson, "Like Potato Fields, His Memorial Lies Follow," New York Times, May 14, 2003, p. B2.
- 38. Josh Blackwell, "Brian Tolle at Shoshana Wayne," Art Issues no. 63 (Summer 2000): p. 49.
- 39. See Craig Owens, "The Allegorical Impulse: Towards a Theory of Postmodernism," extracts reprinted in *Art in Theory*, p. 1026.

Detail of 3-8

Place

Where you hail from and where you now reside are two of the most significant facts about anyone. Certainly an artist's geographic history affects the appearance and meaning of his or her art. The place or places where one has lived, with their attendant physical, historical, and cultural attributes, condition what one knows and how one sees. But beyond this, a conscious awareness of place informs the work of a wide range of contemporary artists. In this chapter, we examine how and why place is an enduring theme in art, with continuing, powerful relevance for artists today.

Many contemporary artists who make art that fits the theme of place are responding to specific scenes in front of them or are trying to capture the appearance or feeling of places they remember. More abstractly, some artists are grappling with ideas of place in a conceptual way. For example, they might symbolize or represent what it means to come from a certain geographic location (such as Nigeria or China or a large city or a rural hamlet); or they might try to convey the cultural and emotional qualities of a certain kind of place, such as a wilderness, a city square, a mental institution, or a bedroom.

Other artists of place are responding to broader trends and developments that are changing where and how people live. The map of the world has been redrawn many times in the last thirty years, and we likely will see new maps in the years ahead, affecting how people define identities in geographic terms. Moreover, the development of an internationalized economy and the worldwide flow of information through cyberspace are connecting once-distant places. At the level of everyday experience, the increasing encroachment of humans on the natural environment and artificiality of the places in which we live and work mean that many of us have to make a conscious effort to experience wild places firsthand. No wonder artists are making works that express changing ideas about place.

Places Have Meanings

What is a place beyond a point on a map? Time and space coalesce in a place. Places contain metaphoric or symbolic meanings that go deeper than the surface appearance of

a particular landscape or architectural style. Cultures transform places, imbuing them with memories, histories, and symbolic significance; they also change them physically. Seen through the lens of culture, a place is a setting for human behavior, an environment infused with a particular spirit. Places come to signify and mirror the viewpoints of inhabitants as well as others. A forest traversed by an indigenous tribe is psychically a much different forest than the one a band of tourists floats through on boats. Places may have particular meanings that are widely known, or they may have hidden meanings known only to intimates of the place.

The theme of place intersects with the theme of time, especially the subthemes of memory and history. A place is an event as well as a collection of tangible materials, for places inevitably undergo change, however slowly this may occur (only the conception of an idealized place, or utopia, remains fixed and static). As events unfold in a specific place, they invest the location with historical significance. The meaning of a place may be charged by events that transpired there (think of the beach at Normandy, where the D-Day invasion took place). A place may be overlaid with multiple histories (think of Jerusalem). Places that are steeped in historical significance may become part of a nation's identity and collective memory (think of the Nazi concentration camps). One artist who has dealt with this last aspect of place is German painter Anselm Kiefer. Beginning in the 1980s, Kiefer created a widely exhibited series of paintings showing charred fields and cavernous rooms with flaming ovens, to call attention to Germany's troubled past.

In this chapter, we consider contemporary artists who are investigating the political, social, cultural, philosophical, poetic, and psychological implications of place. Many disciplines are engaged in studying the physical features and cognitive meanings of place, including history, geography, cartography, geology, anthropology, literature, architecture, and theater. Visual artists have drawn on insights, information, and theories from all these disciplines and more as they navigate the theme of place.

But before we look at place in contemporary art, it is useful to consider how we use the word *place* in ordinary discourse. A place is a location. A place can be as large as Africa or as small as a closet. A place can be real or imagined. A place is a site of possibility, hypothesis, and fantasy—a somewhere where something might occur. Today, a place can even be a nonplace, perhaps in cyberspace. People interpret places just as they interpret other cultural images, objects, or texts. Place is a function of both perception and cognition.

People in all societies pose similar questions about place: What features define this place? Where are we? Who belongs here? Whose place is this? These questions address description, orientation, identity, and ownership. The ability to navigate places is of vital importance to human survival; nomadic tribes must be concerned with recognizing locations as much as civilizations with long histories anchored in specific locales.

Catchphrases and figures of speech hint at how our worldview is saturated with concepts of place. It is common, for instance, to observe that an event "took place." Saying this, we lay bare a bedrock assumption: something doesn't happen unless it happens somewhere. Similarly, when we speak of things being "in place" or "out of place," we imply that having an expected context is valuable and normal. Some cultures have rules for the ideal placements of objects, such as *feng shui* in the Chinese tradition, or the layout of architectural spaces. The post-Enlightenment notion that something cannot be in two places at once remains a powerful idea about the nature of the physical

universe (although this assumption is now challenged for the location of light quanta in the world of quantum mechanics).

Places Have Value

Places have literal value; they may contain natural resources such as timber, oil, or abundant water or they may contain a large investment in infrastructure, including roads, bridges, and public buildings. Places also have symbolic value. For example, terrorists targeted the World Trade Center in New York City in 2001 not only because the twin towers represented valuable property and contained thousands of human beings but also because those particular buildings symbolized the enormous prestige and global power of the United States and international capitalism. The World Trade Center and many other places, such as Jerusalem and Belfast, have different symbolic value to different people.

The symbolic value of a place reflects an accumulation of psychic meanings. Some theorists of culture have adopted the term *space* to refer to the social and psychological attributes of a place.¹ The psychic dimensions of a place are changeable and subject to redefinition as new inhabitants occupy a place. Multiple psychic spaces may exist in the same place at the same time. Just as places can be physically transformed, as older buildings are demolished and new ones are erected on the same site, for instance, they can also be transformed culturally, as new psychic spaces open up to replace or coexist with older ones. For example, suppose a women's college became coeducational. The buildings and campus grounds would basically remain the same, but a new psychic space for the voices and viewpoints of male students would open up.

Some kinds of places can trigger intense physical or emotional responses, such as vertigo, claustrophobia, or disorientation. Some adults experience fear of heights on tall buildings or bridges or fear of public places (agoraphobia), and many children are fearful of the place under the bed.

Because places have material and symbolic value, disputes over the ownership, use, development, and naming of places are common. The history of the world is a complicated lineage of shifting borders and changing place names. The maps that we studied as children are not the ones we use today, nor are today's maps likely to remain accurate in the future. Just since 1980 the world has witnessed the breakup of the former Soviet Union into numerous smaller states; the fracturing of Yugoslavia into the countries of Serbia, Croatia, and Bosnia; the unification of East and West Germany; and the incorporation of Hong Kong into the People's Republic of China. Throughout history, changes in dominion have often been accompanied by horrendous bloodshed and destruction. Today we still witness confrontations over territory, such as those between Israelis and Palestinians in the Middle East, between India and Pakistan over Kashmir, and between Catholics and Protestants in Northern Ireland.

Contemporary artists have explored how changes in a geographic location may impact how people value the social landscape. For example, artists in South Africa in the 1990s created works in a range of media that explore memories of an integrated community (District Six) that once stood in the heart of Cape Town. District Six was bulldozed from 1966 to 1981 to clear the way for the more structured and regimented space, divided along racial lines, ordered by the apartheid government then in power. A once vibrant community became a barren landscape. The contrast is made clear in

Shop/Site/Shrine (1997), an artwork by South African artist Nadja Daehnke. Composed of a map of the former thriving locale imprinted on a sheet of glass, Shop/Site/Shrine functions as a kind of time machine: by looking through the glass in front of the current landscape, the viewer becomes a witness to a symbolic representation of all that is now missing.

Exhibits about Place

Contemporary artists are maintaining, extending, revitalizing, and critiquing the long tradition of making art about place. A number of important group exhibitions from the past fifteen years attest to the importance of place as a theme in art. Artificial Nature (Deste Foundation for Contemporary Art, Athens, Greece, 1990) looked at how artists are responding to the increasing artificiality of our environments. La Frontera/The Border: Art about the Mexico/United States Border Experience (Museum of Contemporary Art and Centro Cultural de la Raza, San Diego, 1993) focused on cultural mixing and conflicts along the border. About Place: Recent Art of the Americas (Art Institute of Chicago, 1995) included work about place by sixteen artists in the Western hemisphere. Claustrophobia (Ikon Gallery, Birmingham, England, 1998) considered contemporary artistic explorations of "home" and domestic themes, including tensions provoked by feelings about places, real and imagined. Small Worlds: Dioramas in Contemporary Art (Museum of Contemporary Art, San Diego, 2000) displayed artists' use of dioramalike formats to examine the hyperreality of contemporary culture. Enclosed and Enchanted (Museum of Modern Art, Oxford, England, 2000) examined the relationship of gardens and landscape architecture to contemporary art. And Out of Site: Fictional Architectural Spaces (New Museum, New York, and Henry Art Gallery, Seattle, 2002) examined artistic reactions to the increasing permeability between real and virtual spaces.

History's Influence

Fifty years ago, if you opened a chapter in a book about how artists treat the theme of place, you would read about paintings and photographs of landscapes and cityscapes, perhaps read about how a certain sculpture was sited in its natural or architectural setting, and—if the scope of the book was wide—you might read about the designs of gardens, parks, and city plazas. Today artistic treatments of place go beyond paintings, photographs, and sculptures in traditional media. Contemporary art about place is made using a wide array of materials and styles for an equally diverse range of artistic goals.

In spite of changes in our conceptions of place and the strategies of artists who explore this topic, much contemporary art about place remains anchored in (or at least related to) traditions and ideas that would be recognizable to earlier generations. For starters, the tradition of landscape painting remains vital. Every adult who has grown up in a Western culture knows what a landscape painting looks like. Vast numbers of these paintings were produced over the past several centuries, and many professional and amateur artists today favor landscapes.

The Western tradition of landscape painting can be traced back over two thousand years to wall paintings in Roman villas that included natural scenery. The motif fell out of favor in Europe, however, until it was revived in the sixteenth century, and landscape became an independent genre. In contrast, landscape painting in China, where the tradition of monumental landscape painting is referred to as *shanshui* ("mountain and water"), has

maintained great vigor since the tenth century. In nineteenth-century Europe, the Realists and Impressionists elevated landscapes and cityscapes as they rejected academic history painting. Indeed, many of the great achievements at the beginning of modernism happened in landscape painting. In the United States, landscape painting likewise thrived in the nineteenth century, led by artists of the Hudson River School and artists who represented explorations of the American West. Landscape as a motif continued throughout the twentieth century in Europe and America, serving in avant-garde art as a means to explore formal issues and express personal emotions and visions.²

While much has been written about the theme of place in art history,³ here we will limit ourselves to examining some of the concepts and strategies developed and utilized by earlier artists that recur in contemporary art, with new twists.

(Most) Places Exist in Space

An actual place exists in space, the three-dimensional field of everyday experience. A working artist, however, has a range of options for representing or incorporating space. Even for artists using three-dimensional media (sculpture, installation art), no single approach to the representation or manipulation of space dominates: space can be naturalistic (as in the tableaux using found objects and furniture by Ed and Nancy Kienholz), space can be flattened (as in bas-reliefs), scale can be shifted in an accordion-like arrangement of flat planes (as in the constructions of Red Grooms), and mass can become void and void, mass (as in sculptural treatments that build on Cubism). The space of a place may be interpenetrated by video, slide, and light projections, and sounds and smells can permeate and fill space.

Artists working in two-dimensional media represent the space of places on a spectrum ranging from illusionistic treatments (including photorealism, magic realism, and naturalistic realism) to diagrammatic treatments (such as the case of an artist utilizing architectural blueprints) to the flattened or collapsed spatial treatments frequently found in abstraction.

Each culture invents and manipulates its own archetypal ways of representing space artistically. In the West, for some five hundred years, from the fifteenth century until the late nineteenth century, visual artists working on flat surfaces (in paintings, drawings, and prints) depicted physical space by employing the conventions of linear and atmospheric perspective. The resulting illusionary images show how a scene would appear to a stationary observer from one specific viewpoint. The systems of linear and atmospheric perspective continue to underpin many artistic representations of place. For example, most photographic and video equipment utilizes a lens system that is based on the principles of linear perspective. Contemporary artists who mine a surrealistic aesthetic, creating images of heightened sexuality, sci-fi imagery, or computer gaming, often rely on the contrast between the successful illusion of three-dimensionality and the incredibility of the subject to heighten the work's aesthetic impact.

Over the course of the twentieth century, alternative spatial systems attracted many visual artists working in two-dimensional media. Two such strategies remain particularly relevant for contemporary artists. The first is the use of a disjunctive representation of physical space within one artwork. In contrast to portraying a single cohesive space (like that represented in an ordinary photograph or painting with linear perspective), a disjunctive representation shows multiple spaces coexisting or multiple views of a space. For example, Kerry James Marshall made a series of paintings of

3-1 Kerry James Marshall | Better Homes Better Gardens, 1994

Acrylic and collage on canvas, 100 x 144 inches Courtesy of the artist and Jack Shainman Gallery, New York

Chicago housing projects [3-1] whose compositions fuse naturalistic images, flat forms, decorative patterning, and collage elements. Ethiopian-born artist Julie Mehretu overlays depicted fragments of built environments drawn from varied sources, such as airport plans, weather maps, stadium seating charts, and architectural diagrams of new and ancient buildings. Working with multiple layers of ink and colored pencil on architect's vellum or mylar, Mehretu constructs (and deconstructs) the visually dense, heterogeneous character of urban space.

In the 1980s British artist David Hockney advanced a strategy of taking multiple snapshots (sometimes hundreds) of a scene, which he then arranged together to create an expansive panorama of space, seen from the shifting viewpoints of a moving observer. In related fashion, a series of quick jump cuts in a film or video serve to fracture or multiply spatial and temporal settings. Hockney compared his own strategy with the multiple viewpoints found in Cubist paintings as well as the changing viewpoints found in Chinese scroll paintings. (With the latter, a viewer scans the landscape as if actually traversing the scene.)

A second strategy widely used by artists to represent space is to adopt or adapt techniques, concepts, and images from cartography. Mapping allows for the layering of information and for documenting a place without committing to a single unchanging vantage point. All locations exist simultaneously; the viewer hovers theoretically at an equal distance above all points on the map. In addition to mapping, artists have employed various forms of diagramming as a way to visualize a subject without resorting to Cartesian perspective. Some artists even utilize sophisticated new technologies, such as global positioning systems (GPS), which make it possible to track locations and movements on the earth by satellite. Artists may also combine mapping and diagramming with other systems of spatial representation in the same work, as Mehretu does.⁵

Some of the more intriguing map-based artworks explore the political and emotional aspects of place. Palestinian artist Mona Hatoum created an installation in a gallery in Jerusalem, *Present Tense* (1996), in which she used soap blocks and red beads to reproduce maps pertaining to the division and control of lands on the West Bank, which were accompanied by photographs of local shopping and cooking activities. The maps abstract the Arab-Israeli struggle over territory, while the everyday images and evocative scent of the soap ground the conflict in local habitats and customs. Kathy Prendergast, an artist from Ireland, alters maps to tantalize viewers with alternative readings of geographical identities. According to curator Mel Watkin, for a digital print entitled *Lost* (1999), Prendergast took a "straightforward map of the United States. . . . The map is dotted with hundreds of towns all of which bear the same name: Lost. These are all real towns (Lost River, Lost Gulch, etc.) Every other city in the country, however, has been systematically deleted from the map. What does this imply? Are we lost? Are they lost? Or is she?"⁶

Artists working in three-dimensional media (sculptors, installation artists, and so on) can explore the spatial treatment of place with an even wider spectrum of options. American sculptor Richard Serra, for instance, invites the viewer to walk around and through his huge twisted forms. The viewer is immersed in a warp of space, as the sculptor orchestrates how space flows around enormous, curving iron plates. No single vantage point is privileged, in contrast to the frontal viewpoint that is constantly dominant when viewing a painting or a relief sculpture.

The Work of Art Exists in a Place

Art exists in a place. This fact has been an integral part of the aesthetic impact of countless projects through history. Moreover, because in the past much art was permanently located in one place, the connection between art and its context seemed conceptually (sometimes literally) indissoluble. Paleolithic wall paintings positioned deep in caves at Altamira, Spain, carved sculptures attached to Chartres Cathedral in France, and Michelangelo's frescoes adorning the ceiling in the Sistine Chapel in Rome are three unforgettable examples. In fact, in the West, from ancient Greece to seventeenth-century Europe, a large proportion of the most significant examples of art were attached directly to a work of architecture.

It didn't change overnight, but ultimately the strong link between art and its original location weakened. Eventually, a total separation occurred. One aspect of this separation was physical. While there had always been small-scale art objects that could be moved from place to place, such as decorative vases, the arts of painting and sculpture were primarily place-bound. But when easel painting was popularized as a practice in Europe some five hundred years ago, the number of painted images that were portable increased exponentially. Even though projects linked to specific architectural sites were still widely undertaken, including murals and sculptures designed for specific

buildings and stained glass windows executed for particular churches, it became commonplace to plan and execute a work of art independent of its setting. This change in the physical nature of art influenced (and was in turn affected by) shifts in aesthetic theory and art production alike. Equally importantly, the invention of photography (in the nineteenth century) and the ability of photography to mechanically reproduce artworks with detailed accuracy had a profound impact on changing our notion of art's attachment to place. People now had ready access to reproductions of works of art without seeing their original settings.

The separation of art from its location also involved a mental or cognitive shift. This, too, occurred gradually but took a striking turn during the modern period. Modernists who were formalists believed that the meaning of an artwork should remain consistent regardless of where the artwork is displayed. Archetypal examples of modern art, such as the color-field paintings of the mid-1950s to late 1960s in the United States, which emphasized formal aspects and were designed to be portable, were expected to make the same visual impression on viewers in any exhibition site. Underscoring the de-emphasis on site, modernist artists and curators at the time favored pared-down gallery spaces—white walls, even lighting, no windows—that appeared neutral and did not call attention to themselves.

The formalist faith in self-contained artwork with a consistent meaning did not endure. Beginning in the mid-1960s, the importance of the place where an artwork is displayed was recognized once again. Works sited outdoors obviously interact with the surrounding landscape or architecture, but every gallery, even the modernist "white cube," has its own particular architecture that becomes part of the visual experience of any artwork it contains. By the 1980s postmodernists, feminists, and multiculturalists all agreed that no art is seen or understood independently of its exhibition context, nor is it entirely free of the cultural connotations of the place in which the art originated.

Acknowledging that the viewing context has an influence on meaning, a wide range of contemporary artists have made deliberately *site-specific* artworks, in which the work takes part of its meaning and form from the particular location where it is installed. For example, for the 2002 Whitney Biennial, Roxy Paine made a life-size sculpture of a tree out of shining sheets of aluminum. The artist designed his tree to be placed in Central Park rather than inside the museum's building on Madison Avenue. Viewed in situ, Paine's simulacrum transformed the surrounding park from what it had been, an island of designed nature within the sea of architecture that is Manhattan, to a zone of skepticism: What is natural? What is constructed? Who or what controls which is which? De Oliveira, Oxley, and Petry offer an expanded definition of site-specificity:

Site-specificity implies neither simply that a work is to be found in a particular place, nor, quite, that it is that place. It means, rather, that what the work looks like and what it means is dependent in large part on the configuration of the space in which it is realized. . . . What is important about a space can be any one of a number of things: its dimensions . . . , its general character, the materials from which it is constructed, the use to which it has previously been put . . . , the part it played in an event of historical or political significance, and so on. ⁹

Earth art or land art is one form of site-specific art that emerged in the mid-1960s and continues to be practiced today by artists such as Nancy Holt, Michael Singer, Alan Sonfist, Gabriel Orozco, David Nash, and Meg Webster. Earth artists move into nature

and use aspects of the landscape as part of their artistic materials. The artwork may be built directly out of the organic materials in the surrounding landscape. British artist Andy Goldsworthy, for example, lays stones, flowers, or leaves in a particular pattern at the outdoor place where he finds the materials. In other instances, manufactured materials are formed and placed in a specific setting, as in the case of *Surrounded Islands* by Christo and Jeanne-Claude. In this project, from 1983, a series of islands in Biscayne Bay, Florida, were wrapped temporarily in six and a half million square feet of bright pink, woven polypropylene fabric.

Installation art is a form that is often site-specific. As an ensemble of elements intended to be experienced as a single artwork, an installation is site-specific when created especially for a particular location. The viewer is not expected to see a site-specific installation as a self-contained tableau, independent of the place where it is displayed. In the case of a site-specific installation in a gallery or museum, the art melds with the surrounding architecture; the building's walls and spaces become part of the art. American video artist Diana Thater, for instance, projects her large-scale video installations onto columns, windows, ceilings, walls, and floors, thereby accentuating the architectural structure that is the context of our viewing [color plate 7]. (Paradoxically, by casting video projections onto the structure Thater partly dematerializes the structure's physical presence.)

Contemporary artists who have made installations that specifically address themes of place include Thater, Ann Hamilton, Robert Irwin, Fred Wilson, Sarah Sze, Ilya Kabakov, Daniel Buren, and Tadashi Kawamata. Of course, many installations focus on other themes than place; nevertheless, an installation exists as a constructed environment that situates and involves viewers. An installation provides an intensified version of our encounters with actual places in the world. It transforms an entire setting into a work of art. An installation offers a physical experience that can be emotionally and intellectually involving as well, as if viewers had walked into a stage set (with certain props, scenery, lighting, and sound effects) and found they were called upon to imagine unknown performances.

The concept of site-specificity has remained significant throughout the contemporary period, even as its definition and practice continue to evolve. 10 One recent direction that relates to site-specific installation, as well as to architecture and landscape architecture, is the construction of functional structures by visual artists. Contemporary artists, including Vito Acconci, Dennis Adams, Athena Tacha, and Mary Miss, to name a few, have taken on projects or worked in a team with architects to design structures for specific sites that are used by the people who live or work there. Acconci, who became widely known as an iconoclastic artist in the 1970s with his performances and installations, founded Acconci Studio in 1988, combining his talents and vision with a team of architects, engineers, and other artists. Courtyard in the Wind, 1997-2000, for example, was constructed for the Buildings Department Administration Building, Munich, Germany. The courtyard consists of a ring-shaped portion of landscape that revolves on a large turntable hidden below the ground. The circle of landscape moves as the wind powers a turbine located on a nearby tower. According to the artist's poetic description, "As the wind blows, the ground moves slowly under your feet making it impossible to walk in a straight line. The revolving ring displaces the landscape; grass separates from grass and walkway from walkway . . . two trees become dislodged from a grove."11

Looking at Places

Within the theme of place, many contemporary artists have created works that embody the physical and emotional particularities of specific locales, such as the Grand Canyon, Tokyo, the local diner, or the artist's studio. In such works, the tactile and the psychological qualities of places rub off on each other.

The artistic treatment of a physical setting owes as much to the viewers' mental outlook as to the texture of materials found there. (By "viewers" we mean the occupants of the locale, the artist who creates the art, and the observers of the finished work.) In comparison to their nineteenth-century precursors, today's artists are more likely to be conscious that their looking at places is filtered through social concepts. As critic Liz Wells explains, "Land is a natural phenomenon. . . . 'Landscape' is a cultural construct." Places exist out there, external and independent of our thinking about them, but the concepts we use to organize and interpret places are inventions and interventions of human thought.

Since 1980 painters and photographers such as Neil Welliver, Robert Berlind, Jane Freilicher, Mark Innerst, Joel Meyerowitz, and William Eggleston have continued the tradition of working from their own direct observations of specific places. Some forge images of natural places as gateways to inner peace or the contemplation of metaphysical concerns; for these artists, aspects such as weather and lighting conditions often serve as symbols for human feelings projected onto the landscape. Some artists, including British painter Peter Doig and Americans David Bates and Joan Snyder, create images of remembered places, underscoring the power of places to evoke personal memories and buried feelings. Still others, notably Gerhard Richter in Germany and Vija Celmins in the United States, explore how we relate to particular places whose appearance has been altered by the medium of photography or other technology. In Richter's and Celmins's paintings, a specific locale, such as a star-studded night sky (Richter) or a wave-encrusted ocean (Celmins), is twice removed from the viewer. Although their works are based on photographs of specific scenes, their true subject is less the actual place than the visual information (and style of representation) evident in the photograph. They never consult the real world directly.

The practice of rendering local landscapes remains popular in the United States in certain scenic locations, notably Santa Fe and Taos, New Mexico; Provincetown, Massachusetts; and the coast of Maine. These regions support a thriving commercial gallery system that attracts many collectors seeking images of scenic grace, grandeur, or at least charm. A similar emphasis on landscape motifs can be found in other parts of the world. Along the Li River in southern China, for instance, painters continue to depict the steep, rounded mountains that distinguish the region.

Of course, two-dimensional media are not the only ones that contemporary artists have used to represent a specific locale. In fact, serious critical attention has been devoted recently to artists who represent places using other approaches to working with materials. For example, U.S. artist Roxy Paine's *Crop* (1997–98) [I-2] is a life-size and lifelike sculptural representation of a patch of earth with poppies. Robert Lobe pounds sheets of aluminum around large boulders and tree trunks; the result is displayed as a direct cast from nature. British artist Rachel Whiteread has become well known for her casts of negative spaces, such as the empty space under a bed or a desk, the interior of a room, a stairwell, which preserve, in reverse, specific details such as the location and design of windows, moldings, and wall plugs.

Within contemporary art, representations of built places are more prevalent than representations of natural places. This fact mirrors a general shift in living patterns worldwide as people inhabit increasingly populated places and become distanced, and sometimes estranged, from nature. The range of built places explored by artists is diverse. Artists are interested not only in how urban environments look but how they feel, sound, smell, and impact residents and visitors. They are interested in how cities work and what they mean. In exploring cities and other segments of the built environment, artists address many of the same issues that can provoke strong opinions among city dwellers in general—crowdedness, vulnerability, the economic disparity between rich and poor—as well as those qualities that make cities exciting places to live, such as the dazzling sensory impressions one encounters both night and day. Wayne Thiebaud's paintings from the early 1980s are highly recognizable for the way in which they exaggerate San Francisco's earthquake-prone topography: depicting buildings and streets perched on steep hills, the images conflate the physical precariousness and emotional pizzazz of the city by the bay.

For some artists, a place is defined by the patterns of behavior revealed there. In the early 1980s, Denis Wood created a series of maps that locate idiosyncratic details of his neighborhood. Wood's art charts patterns such as sidewalk graffiti, traffic and road signage [3-2], and the location of pumpkins in the neighborhood on Halloween night. By

3-2 Denis Wood and Carter Crawford Adrawing from Denis Wood's Dancing and Singing: A Narrative Atlas of Boylan Heights: Street Signs, 1982

Map by Carter Crawford and Denis Wood Courtesy of the artist

graphically documenting a category of details located in a specific place, each of these maps reveals a holistic pattern of social meaning.

Today, the city serves as the primary stage for human action. In large-scale panoramic photographs, Andreas Gursky provides breathtaking bird's-eye views of people crowded together in huge places: "International stock-exchange trading floors, vast factories, office buildings, parliaments, libraries, Olympic events, and other subjects produce the same jaw-dropping awe to which Romantic landscape painting once aspired." Gursky's images present visual evidence that places are defined by the people who congregate in them, just as people mirror the places they inhabit [color-8]. Gursky's photos appeal to our fascination with watching the spectacle of other people. They also capture the huge quantity of visual details that city dwellers must process.

Somewhat surprisingly, the organizers of visual art exhibitions increasingly are including work by artists who explore the aural dimensions of places. Video, performance, and installation artists have helped us to listen to as well as look at the places we inhabit. Additionally, contemporary visual art exhibitions often include work by composers and sound artists, such as Maryanne Amacher, who construct forms of aural architecture that immerse the audience in an experience of place that melds sights, sounds, and feelings. In Amacher's works, extremely loud sounds and extremely subtle ones create unique echoes within the body. As we sit within one of these sound artworks, our experience of place shifts from one that emphasizes the static and the visual to one that emphasizes the temporal flow of sounds. Sounds engulf us, rising and falling in pitch and volume, changing in tonality.

Looking Out for Places

Why are some places so valuable that artists would devote their art-making efforts to calling for their protection? A number of factors are at work. In the case of attempts to protect natural places, some artists subscribe to a pantheistic view of nature, a belief in wilderness as a source of spiritual energy. For them, a desert is not merely a place of little rainfall, and a mountain is not simply a place of extreme elevation. Rather, a desert may be a site for inducing mystic awareness, and a mountain may be cherished as a place of spiritual birth or rebirth. The idea of nature as a site of sacred significance is exemplified by Native American Truman Lowe's *Red Banks* (1992) [3-3], a twenty-foot-long sculpture created out of wood, purchased from a building supply store, that is adorned with natural branches. The work portrays the riverbank that tribal beliefs mark as the site where the ancestors of the Ho Chunk people first stepped into being. Various artists in other cultures, including in Germany, Japan, Australia, and China, have likewise connected natural sites with the origin of their culture or society. In creation stories around the globe, the explanation of humankind's origin often begins with the place of the gods (or God), from whence flow forces that create the place of earthly life.

The wilderness myth that underlies America's image of itself, "the image of America as a pristine land divinely favored," has long exerted a pull on artists in the United States, although contemporary artists usually view the myth with nostalgia or irony. For example, in 1994–95 Frank Moore made three large paintings of Niagara Falls that showed the awesome splendor of the falls but also the industrialization that is destroying their scenic beauty. (For example, because water is diverted to supply hydroelectric power, the flow is often reduced to 40 percent of its former force.) Critic Faye Hirsch writes that "all three paintings are framed by copper pipes with faucets at

3-3 Truman Lowe Red Banks, 1992
Wood, 36 x 144 x 96 inches

Courtesy of the artist

the top, and floating through the mists are delicately rendered, screenprinted symbols of the toxic chemicals found in the waters. . . . The thundering torrent, once the paradigm of sublime nature, has here become the emblem of its demise."¹⁵

Throughout the last three decades, artists have expressed the alarm felt by many people over the increasingly imperiled ecology of the earth. Rather than offering artistic laments about the environment in general, numerous artists have focused on conditions that are specific to one site or region, or reveal the interconnections between places. For example, Richard Misrach's photos of deserts in the American West examine the disturbing discrepancy between natural splendor and traces of human incursion [I-1], such as evidence of nuclear bomb tests. Helen and Newton Harrison solidified their reputations as artists who are social activists by identifying ecological problems in various places around the world, researching scientifically feasible solutions, and engaging a community in a dialogue about restoring certain environmental areas to a natural condition. In a project in the former Yugoslavia (1988-91), the Harrisons proposed a reclamation project for the Sava River. Another project (initiated in the late 1970s) involved creating a series of maps that offers potential ways to answer the question, Who owns the sea? The Harrisons view the process of collaborating with community residents as an integral part of their creative process. According to Eleanor Heartney, "they see themselves as catalysts whose outsider status allows them to offer insight or reformulations (to improve an ecological problem area) that might be impossible for those who are more technically trained or more closely tied to local politics. Solutions, the Harrisons believe, will evolve from conversations among all concerned."16

3-4 Betsy Damon | The Living Water Garden, 1998 Chengdu, China

Chengdu, China
Aerial image of the constructed wetlands
Courtesy of the artist and Keepers of the Waters

The Harrisons are not alone in their willingness to tackle real-world problems. In 1982 Patricia Johanson completed a project in Dallas that restored the ecosystem of a lagoon and created paths, bridges, and benches that buttress the shoreline and also allow visitors to enjoy the place. Mel Chin has turned polluted fields into art, reviving them by using plants that leach toxins out of the soil. Betsy Damon designed *The Living Water Garden* (1998), an organic system for water purification that now serves the city of Chengdu in mainland China [3-4]. Damon's project is notable because she is a Western artist venturing into a communist country to propose art as a viable response to serious environmental problems. Other artists with deeply felt concerns about ecology have opted for less pragmatic, more metaphoric approaches. For example, German-born Justen Ladda's sculpture *Romeo and Juliet* (1988) shows a structure shaped like an automobile engine and constructed from plastic models of buildings that dominates an idyllic landscape. The title, according to one interpretation, refers in part to "our troubled romance with nature: we simultaneously idealize it even as we develop and destroy it." ¹⁷

It is not only wild places with imperiled ecosystems that have captured artists' attention; inhabited places have also gained advocates. Beginning in 1989, Alfredo Jaar, an artist born in Chile who resides in New York City, created a series of artworks under the general title Geography = War. These artworks take complex forms, layering information so that the ideas presented are elusive to a viewer who gives a cursory look. Upon careful examination, Jaar's overriding concern becomes apparent: he calls into

3-5 Alfredo Jaar | Geography = War, 1990

Double-sided light box with color transparencies, framed mirror broken in five pieces, 50 x 40 x 28 inches
Courtesy of the artist

question the moral equation in which developed industrial nations gain power and profit as they manipulate processes that involve economically disadvantaged nations.

In his art, Jaar expands the definition of place. Instead of defining a place solely in terms of its geographic location and physical appearance, Jaar shows how a place is more fully defined in terms of its economic, political, and cultural relationships to other places. For a 1990 installation of *Geography = War*, Jaar embodied his concepts in three primary materials: large maps installed in light boxes, metal barrels, and photographic images of residents [3-5]. Together, these materials reveal the links between a place in Italy where barrels of petroleum from Nigeria are shipped and Koko, a village in Nigeria where toxic waste from Italy is returned in the same barrels and dumped. The economic efficiency is obvious: tankers carry a full cargo in both directions. The maps graphically represent the geographical distance separating Nigeria and Italy. The photographic images show the human faces of the residents in Koko who retrieve the toxic barrels and reuse them for storage. For better and for worse, an African and a European country are interconnected.

Other approaches to protecting inhabited places examine the appearance and meaning of streets, buildings, parks, and other structures that make up the fabric of

cities. In 1988 Japanese sculptor Tadashi Kawamata made Favela in Battery Park City: Inside/Outside, a temporary installation in which he attached a crude structure derived from South American slum dwellings (favelas) to the World Trade Center in New York City, contrasting urban poverty and corporate wealth as embodied in buildings. Although Kawamata was using the World Trade Center as a symbol of economic stability and power, the destruction of the twin towers thirteen years later shows the provisional nature of all human structures, even the most apparently substantial.

Constructing (and Deconstructing) Artificial Places

Some artworks that address the theme of place represent and interpret artificial, fictional, and fantastic places. These places include synthetic environments that actually exist (Disney World, Las Vegas, Hollywood sets, zoos, habitat displays in natural history museums) and fantasy environments concocted by artists from their own imagination, which may blend the fictional and the real. For example, British artist Paul Noble has created a compelling series of large-scale drawings showing fictional cityscapes and imaginary architecture [3-6]. In this section, we will consider how artists are charting and challenging the false dichotomies that separate real from fictive places and nature from culture or exploring the intermingling of these realms.

Art about artificial places may examine the artificiality of real places that exist (or could exist) in the world. For example, Gursky's photographs of crowded built environments (discussed above) comment on the synthetic environments that we work and play in [color plate 8]. Moreover, Gursky often digitally manipulates the final images, deleting unwanted forms, repeating details for effect, and so on. Gursky's digitally modified scenes exemplify the practice of introducing fictive elements into something real.

Another artist who combines the real and the artificial is American Liza Lou, who has created full-scale archetypal middle-class environments, including a kitchen, a suburban backyard, and the interior of a 1949 Spartan Mobile Mansion trailer, using papier-mâché forms, crystal, and beads. The environments evoke real places through their accurate details, including, in *Kitchen* (1991–95) [color plate 9], elements such as boxes of food and cleaning products bearing familiar brand names, but the encrustations of brilliantly colored beads transform the places into fantasies. The glittery surfaces of the products can also be read as a comment on the seductive advertising that promotes the excesses of consumerism.

According to curators Jeffrey Deitch and Dan Friedman, all artistic representations of places, even natural landscapes, inevitably have conceptual overtones that are based on social constructs. "Even the generations of artists who strove to depict absolute truth in their renderings of nature tended to spiritualize it, romanticize, or intellectualize it." Artists today are even more prone to see places through the lens of culture because (like the rest of us) the places they experience most of the time are far removed from wilderness. "The Post-Modern artist now confronts a Post-Natural nature," Deitch and Friedman write. 18

At the start of the twenty-first century, humans are increasingly removed from the natural world. Natural sites are bulldozed to make way for development; we visit the outdoors in the designed environments of parks and playgrounds; we learn about wilderness through the filter of television and film; geneticists are turning animals and vegetables into constructs of human desires; we obtain our food already processed

з-6 Paul Noble

Nobspital, 1997–98

Pencil on paper, 8 feet, 2 1/2 inches x 59 inches (250 x 150 cm)

Courtesy of Gorney Bravin + Lee, New York, and Maureen Paley / Interim Art, London

and packaged; and there is wide acceptance of experiments in altering human chemistry and appearance through mood-altering drugs, robotic implants, plastic surgery, prosthetic devices, and injections of Botox, collagen, and other substances. Artists are responding to the artificial environments made by designers, corporate developers, genetic engineers, computer programmers, museum curators, and others for a variety of social and economic purposes.

One type of synthetic environment that has inspired a subset of artists is dioramas. These include both models, such as architectural models, model train displays, and dollhouses, and full-scale dioramas in museums that are intended to simulate scenes from the past. Dioramas may appear empty like a stage set, or they may be peopled with wax or plastic figures. The roots of contemporary artists' dioramas go back to the creation of alternative worlds in the surrealist tradition (for example, the intimate shadow boxes of American artist Joseph Cornell).

Curator Toby Kamps notes that most dioramas "present idealized, concentrated views" and that the simulations "engage our sense of depth perception and, with it, a bodily awareness of space, which encourages us to make the imaginative leap into their constructs." In their uncanny amount of detail dioramas are precursors of today's virtual reality environments, but according to Ralph Rugoff, a diorama's "antiquated virtual technology has long since ceased to dazzle us," and thus viewers understand that a diorama is a metaphor. An artist can use the obvious artificiality of a dioramalike format to make a distilled statement about some aspect of existence. For instance, California artist Liz Craft presents a comic interpretation of how artificial our home environments have become in her large-scale, dioramalike installation *Living Edge* (1997–98). In concocting this fantasy version of a suburban Los Angeles backyard, Kraft was more influenced by Walt Disney Studios and Home Depot than by nature itself. Using Astroturf, vinyl, and foam, Kraft created a synthetic miniature environment complete with artificial flowers and lawn statues of deer.

Hiroshi Sugimoto, Mark Dion, and Alexis Rockman are three artists who have responded to the typical habitat display used in natural history museums, a type of diorama that emerged in the nineteenth century. Sugimoto, a Japanese photographer, has made a series of images of actual museum habitat displays that simulate early environments, such as a prehistoric landscape during the Permian era [3-7]. The perfect linear perspective view produced by the camera's lens heightens the weird hyperreality of the museum simulation. Rockman and Dion, both Americans, create dioramalike constructions that ironically subvert the sanitized, idealized view of nature offered in museum displays. For example, an installation by Dion shows animals scavenging through a trash dump, and Rockman has made assemblages depicting ecological horror stories.

One way that artists engage with the constructed nature of place is to invent settings of their own. There is a long line of artists who depict their own invented dream scenarios and fantasy places (often concocted from observed elements as well as imagination), encompassing artists such as Hieronymous Bosch, Caspar David Friedrich, J. M. W. Turner, and Yves Tanguy. Contemporary artists continue to invent fictional places, working in both two- and three-dimensional media; some have even incorporated the so-called fourth dimension of time. Frank Moore, whose paintings of Niagara Falls were discussed above, also painted vast imaginary landscapes that emphasize disaster and decay. In the 1980s Piero Gilardi, an Italian, started creating what he refers to as *tappeti-natura* (nature carpets). These soft-textured bas-reliefs simulate in painstaking detail a single section of the earth's surface, about the size of a small rug. Featuring a tree made from polyurethane

3-7 Hiroshi Sugimoto Permian-Land," 1992

Black and white photograph, 16 x 20 inches Courtesy of Sonnabend Gallery

foam, *Inverosimile* (1990) is kinetic: branches dance and the sounds of bird calls are heard when viewers squeeze the leaves. The movements are controlled by hidden electronics. Including a number of artworks that bear affinities to Gilardi's work, Biokinetic, a 1989 exhibition organized by Illinois State University, was devoted to sculptures that "refer to, or are wholly dependent upon, the functions of nature. . . . [They] transform themselves within the same sphere of action as their 'real' counterparts in nature. . . . Plants began to grow from the soil housed in Michael Paha's *Nature's Detail*." ²¹

Contemporary artists have combined two- and three-dimensional approaches by building a tableau that they then paint or photograph (perhaps further manipulating the image on a computer). They ultimately destroy the model and display the photograph. American Sandy Skoglund and German Thomas Demand are two among the many who fabricate and then photograph constructed tableaux that are particularly evocative of a sense of place.

In creating a simulated place, an artist is engaged in an unusual quest: to create an alternative world (or a detail of one) that evokes the real one and yet retains its identity as a world apart. Rather than representing or symbolizing an actual place, a simulation offers an intense substitute. Typically the viewer remains keenly conscious that the simulation is an artifice. Nevertheless, the skilled craftsmanship and involved conception that went into producing the simulation yield an uncanny effect: as viewers we feel

ourselves transported into another realm brought magically to life within the borders of art. The Swiss team of Peter Fischli and David Weiss provoke our curiosity with *Room at the Hardturmstrasse* (1990–92), in which all the furniture, tools, and other objects in a workroom were crafted anew in trompe l'oeil fashion from polyurethane and paint. When the conceit is recognized, the ordinary becomes extraordinary, leaving the viewer to wonder why and how was such an exacting clone of a place accomplished.

Ever since the invention of photographic negatives, darkroom procedures have provided photographers with the ability to alter the final appearance of photos. (Photographs were altered far more than the general public recognized during the first century and a half of photography's history.) Recent advances in digital imagery (both still and video) have allowed artists to blend the factual and the fictive even more, to warp space, fold time, and find openings to new dimensions. The computer's ability to create convincing illusions has given artists a powerful new tool for simulating places, real and imagined. Yoshio Itagaki, for example, in "Tourists on the Moon #2" [1-2] wittly inserted portraits of people into a startling moonscape. His art, although dependent on digital-editing software, still references the history of photography; the images he creates echo nineteenth-century hand-colored prints, and in "Tourists" he picks up on the popular custom of taking snapshots to document a trip.

Unlike the virtual-reality environments favored in video games, the fictional architectures and topographies created by visual artists do not necessarily aspire to hyperrealism. For example, Paris-based Thomas Hirschhorn used cardboard, packing tape, aluminum foil, and other throwaway materials to produce his installation *Cavemanman* in a gallery in New York in 2002. No viewer was likely to mistake the flimsy, obviously artificial environment for a real place. (*Cavemanman*, supposedly the labyrinthine dwelling of a fictional hermit, also included books, mannequins, and video footage of the cave paintings at Lascaux, France, and seemed to represent the interior of the hermit's mind as well as his physical habitation.)

Shirley Tse, originally from Hong Kong, is another artist who emphasizes the artificiality of her constructed places. Tse, who is fascinated by the proliferation of plastic packaging in the world economy, carved shapes into the surfaces of sections of sheets of polystyrene to make *Polymathicstyrene* (2000), a landscape on shelving that follows the walls of a gallery. Visitors look down on a morphing array of sky-blue "stairs, mazes, buildings, arenas, reservoirs, rivers, pyramids, hills, rock formations. Each section is inspired by different elements of our culture—some are aligned with technology and include forms resembling computer monitors, data chips, and control panels; others are otherworldly, like the surface of another planet or a spaceship launching pad."²²

The exploration of invented environments can include those that exist only in the shared imaginations of the audience. While the set for a television show, for example, truly exists at a specific location (on a lot in Hollywood, perhaps), the environment it represents is somewhere else, a somewhere that may not be anywhere, really. American artist Mark Bennet creates detailed floor plans of the living spaces of fictional television families and groups—the home of the Ricardos from *I Love Lucy*, the island of *Gilligan's Island*, and so forth. In looking at one of Bennet's drawings, we see the architectural context in which the television shows of the fifties, sixties, and seventies were staged. We are touched by the fact that life, even fictional life, can take place in such narrow confines. Bennet's work probes how these domiciles in television-land mirror our own homes, then and now. What does it say about us that a make-believe space (Ralph and Alice's apartment in *The Honeymooners*, for example) can seem more real to us,

because we know it in more intimate detail, than our neighbor's house, a place we may never have been invited into?

Placeless Spaces

Visual artists are increasingly responding to transformations brought on by rapidly evolving technologies such as the Internet, cell phones, E-mail, electronic banking, and surveillance cameras. The heightened flow of information through vast media networks has accelerated the creation of a world in which multiple media spaces can exist in any physical place and the same media space can exist in multiple physical places. The real and the virtual interpenetrate to such a degree that we have witnessed "a profound cultural shift, permanently altering the way we experience and represent space . . . marked by speed of mobility through space, the viewing of multiple perspectives simultaneously, . . . the breakdown of physical boundaries and temporalities." More and more we traverse a network of placeless spaces, or spaces that have no fixed geographical location. David Toop poses the change like a riddle, "Where . . . does the music exist if it can be accessed only through the Internet? Or in which space is it created if no physical space (other than a computer screen) or conventional sound-generating tools are used in its construction?"

Responding to and representing the digitizing of information, contemporary artists may investigate places that are not tangible but exist only as virtual spaces. Craig Kalpakjian's *Corridor* (1997) [3-8], for example, is a digital video representation of the view we would have moving through an environment that was created "entirely on the computer. Every detail of *Corridor*, from the texture of the paint to the slight reflections on each surface, is the result of programming, not the hammering of nails."²⁵

Cyberspace and other new realms of virtual reality have spawned new conceptions of structure, such as *liquid architecture*, a term that refers to structures that mutate or expand into multiple, seemingly non-Euclidean dimensions. Another important arena of experimentation, for artists and scientific researchers alike, is immersion environments created by three-dimensional imaging technology. While some of these environments attempt to mimic the actual world, others present fantastic realms that are strictly computer generated. A participant may enter these worlds, like Alice going down the rabbit hole, by donning goggles (for viewing) and a wired glove or chest device (for navigating).

Artists who are exploring the new terrain of fictional immersion environments include Canadian Char Davies. Utilizing different technology, Scandinavian Sven Pahlsson creates 3-D computer animations on a computer monitor that allows the viewer to swoop and careen above the landscape, then zoom in for periodic close-up views. Japanese artist Mariko Mori has created nirvanalike dreamscapes, some of which exist only as computer simulations viewed through 3-D glasses and an advanced 3-D video system, which is projected into a specially designed structure.

Virtual-reality simulations and cyberspace offer one avenue for creating seemingly physical places that do not exist in the real world, but digital technology has enabled photographers and video artists to do the same thing. For example, to create *AUTO-SCOPE* (1996–97), Heike Baranowsky made four copies of a video documenting a car trip around Paris. Two of these were then flipped, to make a mirror reversal of the original image. These were projected flush with the original video. The final four-channel video projection, shown on the gallery wall, takes the viewer on a ride around the City of Lights, but the unusual perspective created by the mirror-images

3-8 Craig Kalpakjian Corridor," 1997 Cibachrome mounted on aluminum, 29 1/2 x 39 1/2 inches Courtesy of Andrea Rosen Gallery, New York, © Craig Kalpakijan

funneling together at the center creates a space that does not exist anywhere else on earth. Surely the creative exploration of such placeless spaces will continue at an increased pace as the new century unfolds.

What's Public? What's Private?

Just as the zone between the real and the artificial is eroding, the borders between public and private have blurred. Anyone who follows the news knows that differences of opinion concerning the social, legal, psychological, and moral boundaries between the public and the private have crystallized into positions that are hotly debated in political arenas, schools, churches, and households. To name just a few issues: Does the state have the authority to make laws concerning private sexual acts performed between consenting adults in a bedroom? Are the images that you see alone in a room, looking at a computer

screen, private or public? Should governments regulate cyberspace? To maintain a competitive edge, is it acceptable for businesses to engage in corporate espionage and attempt to steal one another's secrets? Does an employer have the right to screen employees' E-mail messages and Internet use? Should military and civil authorities watch people on hidden cameras in case some of them are engaged in criminal behavior? Public and private no longer function as absolute terms (if they ever did). The bedroom is more public than a grocery store if it can be viewed on the Internet 24/7; a person talking on a cell phone loudly enough for all to hear in a grocery store mixes a private and a public space.

Communications media have penetrated so many aspects of life that almost no place is free of the possibility of public display or contact with others. Artists responding to this trend have explored the feeling of losing a sense of control over one's living space, the practice of voyeurism, and the fear of a political power watching over one's actions (e.g., Big Brother). Bruce Nauman, for example, conceived an artwork in which he spied on his own place, which turned into a series of four seven-channel video recordings made in 2000 and 2001 of his New Mexico studio at night. Entitled *Mapping the Studio (Fat Chance John Cage)*, the series "is a portrait of the private life of the artist, made, for the most part, in his absence" that gives audiences "the opportunity to enter the studio of an artist as famously reclusive as Andy Warhol was sociable." ²⁶

Issues of privacy and who is watching whom in various spheres are not unique to the present age. Architectural historian Witold Rybczynksi explains that in Europe the concept of privacy in the home began in seventeenth-century Dutch society (from where the concept spread) as the home became separated from the place of work. In consequence, the home became more intimate, less public.²⁷ Taking a broader view, historian Philippe Aries also identifies the growing importance of the public/private divide from the seventeenth century onward. Aries notes that with the rise of large cities, a distinction arose between the private sphere (of one's home and place of work) and the larger public world in which everyone was anonymous. Prior to this period, most people mainly saw other people they knew, as they lived out their lives in smaller, rural communities. The cities of nineteenth-century Europe gave rise to the concept of the *flaneur*, a person who freely watches the crowd because he is unknown to them.

Life in contemporary society has created even greater anonymity as well as more opportunities for voyeurism, as there are many more people now and people are more mobile (both in their careers and places of habitation). Yet as cities grow more crowded, the upper and middle classes are retreating to the fortress environments of gated residential communities. Meanwhile, new technologies, such as electronic surveillance equipment, tracking devices, and remote sensors, and changing views about what should be private and public are impacting the places we occupy and how we behave.

Artists exploring the dimensions of public and private space wrestle with a range of serious questions: Who holds the power to control activity within a place? Who is watching whom? Who determines the conventions of behavior in private domestic settings (bedroom, bathroom, kitchen, living room) and in public settings? These questions have also engaged philosophers, such as Michel Foucault, who wrote about the socialization of space, as well as sociologists, such as Erving Goffman, who studied the layered behaviors that allow public and private actions to coexist.

Foucault wrote about mechanisms of social control in institutions such as prisons, hospitals, schools, factories, and asylums, arguing that those who can be watched can be controlled. Foucault used the model of the *panopticon*, a place where all occupants

(prisoners, patients, workers) can be observed from a central point and thus controlled without numerous guards, supervisors, or other personnel. In order to succeed, this power of surveillance has to be constant, omnipresent, and invisible to those being watched. Building on Foucault's theories, scholars such as John Tagg have analyzed the use and meaning of photographic technologies of surveillance in institutions and other settings. From early in its history, photography has been used for surveillance. Since 1980, with the development of video cameras, satellites, and other sophisticated surveillance technologies, we have reached a point where the entire world is "becoming encapsulated by whole networks of orbital devices whose eyes, ears, and silicon brains gather information in endless streams."²⁸

Not coincidentally, many of the artists who are preoccupied with issues of surveil-lance in both institutional and public places are working with camera-based technologies. New York artist Julia Scher has been making work since the mid-1980s about the intrusion of security cameras and other devices that monitor peoples' movements in public places. In *Security by Julia II*, an installation presented in different places and configurations over the past fifteen years, visitors can watch images of themselves and others on a bank of monitors linked to standard security-industry cameras placed throughout the building housing the exhibition [3-9]. The installation reveals and exaggerates the feeling of being watched by mechanical eyes.

3-9 Julia Scher | Security by Julia II, 1989

Mixed media, dimensions variable Installation view at Artists Space, New York, Dark Rooms, March 2–April 1, 1989 Courtesy of Andrea Rosen Gallery, New York, © Julia Scher While a contemporary city contains multiple worlds, an institution is a place unto itself. Some artists making art about institutional places are concerned with the dynamics of how the private world inside an institution contrasts with the public world outside. British-born artist Sue Coe, for example, has made biting drawings of factory slaughterhouses that make public what meat-industry insiders and much of the public would prefer to keep private. She peels back innocuous exteriors to reveal hellish interiors in dark shadows punctured by gleaming lights, where terrified animals are subjected to mechanical cruelties and the human workers perform robotically.

The home might seem like the paradigmatic private place. But this privacy has both positive and negative connotations. A home can provide security and safety, but it can also be a place of confinement, of being bounded by rules and shut off from opportunities and possibilities outside. For example, children in American culture are sometimes punished by being grounded, or made to stay indoors, separate from other places and people.

Throughout the 1950s and 1960s in the West, especially in the mass media, the home was portrayed as a special province separate from the "real world" of politics and commerce. From today's perspective, many family shows from the golden age of television seem quaint; now the home is subject to a constant influx of information from electronic communications devices. Nevertheless, the value of preserving the privacy of the home is not clear-cut. Feminists and others have called for breaching the privacy of homes to expose domestic violence and sexual abuse. Ida Applebroog is an artist who has undercut illusions of the safety and comfort of being at home by making art that reveals hidden domestic violence.

Jim Campbell's *Untitled (for Heisenberg)* (1994–95) provides an example of art focusing on the privacy of that seemingly most private of places in the home, the bedroom. Entering the gallery where Campbell's interactive video installation is displayed, a viewer sees what appears to be a double bed with a projected image of naked figures coupling. As the viewer approaches the bed to get a closer look, the video becomes more unfocused and grainier. The viewer's voyeurism is thwarted as hidden electronics control the artwork's focus relative to the viewer's position. The work is one big tease.²⁹

Guillermo Kuitca, from Argentina, also alludes to the bed, that private, intimate place for the body, in his well-known series of maps painted onto mattresses. In *San Juan de la Cruz* (1991), Kuitca repeats the Argentinian city's name on a painted map of a region of Poland, and the mattress buttons mark the city's multiple locations. The rivers and roads painted in blue and red evoke the circulatory patterns of veins and arteries. The private place of the human body implied by the mattress serves as the foundation for the artist's mysterious linking of two geographic locations—Argentina and Poland—that are distant from one another.

In-between Places

The flip side of place, locale, home, habitation is placelessness, dislocation, homelessness, journeying. Many people in the world do not live in the place they were born. Many of us move several times in our lives. In America, people change where they live frequently, whether they are moving to a nearby neighborhood or clear across the country. Indeed, the idea of displacement is stitched into the fabric of the national consciousness; America is a land of immigrants and their descendants, and the vision of moving to a new place to seek a better life still drives many Americans.

Some people positively embrace a condition of rootlessness; they yearn to travel and escape from familiar places. During the heyday of European modernism in the first half of the twentieth century, the expatriate artist (for example, Pablo Picasso or Marcel Duchamp) was a romantic, even heroic figure who voluntarily chose to leave behind his place of origin for the adventure of living and working in a foreign land. The displaced artists of today are more ambiguous figures: many see themselves as exiles, refugees, or nomads. An emotionally shaded reaction to leaving home is expressed in the work of Cuban artist Kcho (Alexis Leyva Machado), who creates boat forms out of found materials. Although his vessels are readily interpreted as evocations of refugees' struggles to escape Cuba and reach the United States, Kcho says his work more generally addresses the experience of living on an island and wanting to overcome the barrier of the ocean [3-10]. According to Deepali Dewan, Kcho's forms "reflect the tension between rootedness and travel, the attachment to home and the desire for the next horizon." ³⁰

At any given moment, many people on the globe are in transit. Many of these are international business travelers and tourists. Such travelers spend inordinate amounts of time in bland nonplaces such as airport lounges, hotel rooms, train stations, and highways. According to German photographer Uta Barth, these places of transit echo each other and are "out of place" with the architecture of their various locales: "Anonymous and self-sufficient, these and similar 'non-places' appear across different countries bringing with them an uncanny sense of familiarity while hardly showing a trace of local specificity or exoticism." ³¹

3-10 Kcho (Alexis Leyva Machado) | El Camino de la Nostalgia (Road of Nostalgia), 1994–95

Mixed-media installation, length of dock approximately 16 1/2 meters Courtesy of the artist and Barbara Gladstone

More profound than the temporary dislocations of tourists and business travelers are the experiences of those whose understanding of place is fragmented as a result of moving far away from their homeland. Changing geographical locations, once or repeatedly, may involve radical changes in political, cultural, and social milieus. While some of these relocations are voluntary, others are involuntary displacements due to war, disease, poverty, or persecution, often involving large numbers of people. Pulled up by their roots, displaced peoples must often cross national borders and even oceans. A forced dislocation is an intense experience with both political and psychological effects.

Displacement is one of the central facts of contemporary culture. Writer and curator Ella Shohat describes "today's morphing, crisscrossing movements across regional and national borders" of "people, capital, digital information, and ecological flow."³² Powerful art is being made today by artists who want to bear witness to displacement. Some of these artists are immigrants themselves who have moved to a new country, often with a new language, and practice their art in a radically altered context. Others identify with a culture that earlier in history was uprooted, forcing large numbers of people to look for a new place to live. The word *diaspora* refers to the "movement, involuntary or otherwise, of large bodies of people, their thoughts and ideas."³³ The world today is dotted with uprooted peoples who have no state or homeland where they can settle, among them Palestinians and Kurds. British artist Hew Locke, of Guyanese descent, evokes the idea of diaspora in his *Ark* (1992–94), a colorful, lavishly embellished model boat that symbolizes the richness of the ideas and practices that slaves brought with them from Africa to the Americas, and more generally represents the migration of culture that inevitably occurs with all diasporas and emigrations.

Art about displacement may focus on the journey itself, the condition of being in transit between places with different languages, customs, material culture, and ideas—a condition theorist Homi Bhabha calls "in-betweenness." Artists might explore the meaning and location of borders, boundaries, and zones of transition. They might consider the place left behind ("there") or the adopted place ("here"), or their interactions. The displaced artist retains an emotional connection with the place left behind; indeed, the resonance of the original place is often enhanced and intensified by distance. At the same time, the artist is forging a new hybrid identity that draws on the physical surroundings and cultural climate of the new place.

Contemporary artists who have explored travel, tourism, migration, nomadism, homelessness, and dislocation include (in addition to those already mentioned) Cubanborn Felix Gonzalez-Torres, Chinese-born Hung Liu [color plate 10], Chilean Eugenio Dittborn, Cherokee Jimmie Durham, Mexican Guillermo Gómez-Peña [4-7], Willie Doherty of Northern Ireland, Palestinian Mona Hatoum, and Thai Rirkrit Tiravanija. Imagery in works related to the theme of in-betweenness is often *syncretic*, that is, it mixes or juxtaposes multiple cultural references and ideas. (The term *syncretism* will reoccur throughout this book, as this practice is widely employed by artists in the exploration of many themes.) Maps and mapping concepts may enter into this work as well as iconic objects suggesting travel and boundaries, such as boats, luggage, footwear, identity documents, and barricades. The provisional quality of place is brilliantly captured in Japanese artist Yukinori Yanagi's *World Ant Farm* (1990). In this work, 170 plastic boxes connected by tubes each contain the design of a different national flag formed in colored sand. As the ants travel through the tubes from one box to another, they mix the sand and erode the symbols of nationality.

Janet Cardiff, working alone or in collaboration with her husband George Bures Miller, is a pioneer in multimedia art. Her distinctive works immerse viewers within fictive environments where she controls key aspects of what gets perceived, visually and aurally. Her art has been represented in such high-profile exhibitions as the São Paolo Biennial (1998), the Carnegie International (1999) in Pittsburgh, and the Venice Biennial (2001).

Among Cardiff's most memorable creations are what she identifies as audio and video "Walks." To experience a "Walk," each participant dons a CD Walkman or looks into the monitor of a camcorder. Once linked to the surrounding environment (via the Walkman or camcorder), the viewer then proceeds to navigate along a route, following directions carefully scripted by the artist. The experience can be both unsettling and familiar, like having a stranger talk intimately in your ear, indicating what to look for and which way to go. A Cardiff "Walk" is a witty and intellectually rich parallel to the guided audio tours visitors take through many museum collections and special exhibitions. Instead of standing within the museum or gallery and looking at discrete works of art, taking a walk with Cardiff means the viewer follows a path inside a place where everything has been transformed into one extended work of art.

During the Walk, a viewer discovers she is inside a setting; some of the objects and architectural details are identified (on the soundtrack) so that they function as props in a dramatic narrative. The narrative, however, is never made explicit. Visual and aural clues (such as the sound of gunshots and rushing footsteps) only hint at a plot. Cardiff develops her art on the philosophy that the best stories leave much for the viewer or reader to imagine. Moving within the Walk, each participant fills in, in her own imaginative way, chunks of information that Cardiff leaves out of the unfolding tale.

In a different vein, Cardiff's *Forty-Part Motet* (2001) consists of forty microphones placed in an otherwise empty gallery. Each microphone takes the place of a member of a chorus. Seen from a distance, the microphones resemble an arrangement of tall, vertical sculptures, like abstractions of the human form. Hidden inside the microphones are audio speakers that allow each microphone to project the specific sounds made by one particular singer. Coming into a deserted gallery, visitors are surprised and delighted to find themselves surrounded by the sounds of a choral group preparing for a concert. Singers cough. Throats are cleared. Score sheets rustle. Then the singers (one voice per microphone) launch into a full-fledged performance of the polyphonic *Spem in Alium*, by the sixteenth-century English composer Thomas Tallis.

The circle of microphones transforms a nearly empty gallery into a live performance. With stereophonic accuracy, the recreation of the performance gives gallery visitors an uncanny illusion of being onstage, among the singers. The aural

illusion is so complete that *Forty-Part Motet* even seems to transform the physical dimensions of an exhibition gallery into the larger volume of the architectural space where the chorus' actual performance was recorded.

Cardiff's art is not unique in its incorporation of sound and sound effects. In fact, with increasing frequency, viewers of contemporary art find exhibit sites full of sounds as well as sights. For example, the 2002 Whitney Biennial featured a cadre of artists such as Meredith Monk and Stephen Vitiello, who, like Cardiff, are architects of aural experiences. Some artists create works of pure sound that are designed to be experienced in a darkened space. To achieve her stereophonic illusions, Cardiff employs a recording technology called *binaural sound*. This sophisticated process allows the listener to discern the specific direction sounds come from with startling fidelity. As one reviewer of Cardiff's work explains, the result of binaural recording is a "completely spatialized sound environment. . . . [Cardiff allows you] to climb inside" recorded sound. In fact, Cardiff intensifies our experience of sound; our natural tendency to filter out extraneous sound (and to concentrate only on sounds we expect to be meaningful) is bypassed when we hear Cardiff's soundtrack through headphones.

Other recent artworks by Cardiff offer the viewer access to totally fictive places. To experience Cardiff's (and Miller's) *The Paradise Institute* (2001), viewers enter through the door of what appears, from the outside, to be a nondescript plywood sculpture, approximately a dozen feet in length and width and about seven feet tall [3-11]. A maximum of sixteen visitors can enter the artwork at one time. Inside, each viewer takes a seat in the simulated balcony of a movie theater (circa 1940s). Donning headphones, each visitor hears ambient noises (on a prerecorded tape). Because the noises are so faithful to what one would expect to hear at the cinema (shuffling feet, the sounds of people taking their seats), disbelief is willingly suspended. The visitor/viewer of *The Paradise Institute* quickly forgets all about wearing headphones and is convincingly transported into the imaginary realm. As the lights go down and the film starts, suddenly, in your right ear, you hear a voice whisper, "I'm worried, I'm afraid I left the stove on . . ."

A film, reminiscent of the film noir genre, appears to be projected onto the screen inside the movie house [3-12]. The soundtrack of the film competes with more ambient sounds from the audience (a cell phone, for example, starts to ring, the sound seeming to come from the left side of the mezzanine). As a member of the audience, each viewer becomes a member of the "cast" in the imaginary story that takes place in the balcony. Cardiff and Miller embed each visitor in their artwork so cleverly that the borders between the film and the film's audience, and between the artwork and real life, dissolve. *The Paradise Institute* reproduces the multileveled experience of being in a specific place (a movie theater), watching a movie (with its own twisting plot), and sensing a restive audience all around (halfway through the movie you hear a person whisper in your ear that she is leaving the theater to "check on the stove").

3-11 Janet Cardiff and George Bures Miller | The Paradise Institute, 2001 (exterior)

Wood, theater seats, video projection, headphones, and mixed media, 118 x 698 x 210 inches Installation view: Hamburger Banhof, Berlin Courtesy of the artists and Luhring Augustine. New York

As viewers/visitors/listeners to Cardiff's artwork, we find ourselves inside a sculptural simulacrum of the cinema. We shift back and forth mentally in how we make sense of the experience. While the overall size of *The Paradise Institute* is much smaller than an actual theater, the illusion is choreographed (both visually and aurally) so that all the details and dimensions appear accurate and to scale. Inside the artwork, we are immersed in a convincing representation of a fictive environment.

Janet Cardiff's clever, mesmerizing works explore how lived experiences are anchored in a sense of place. Whether an event is quotidian or mysterious and dramatic, the place where the event occurs colors and shapes our understanding of our experience. What did the room look like? From what direction did the sound come from? Our experience of place, its physical and emotional specificity, is a leitmotif of Cardiff's art.

The artist was born in Ontario, Canada, in 1957. She currently lives and works with her husband, George Bures Miller, in Alberta, Canada.

3-12 Janet Cardiff and George Bures Miller | The Paradise Institute, 2001 (interior)
Wood, theater seats, video projection, headphones, and mixed media, 118 x 698 x 210 inches
Courtesy of the artists and Luhring Augustine. New York

Notes

- 1. The concept of a "psychically constituted space" is elaborated in the writings of Irit Rogoff and Henri Lefebvre, among others. See, for example, Irit Rogoff, *Terra Infirma: Geography's Visual Culture* (London and New York: Routledge, 2000), especially pp. 20–24.
- 2. Notable modernist artists who maintained an interest in rendering places include the Europeans Henri Matisse, Georges Braque, Paul Klee, Fernand Leger, Joan Miro, and Yves Tanguy; the Americans Marsden Hartley, John Marin, and Georgia O'Keeffe; and the Canadian Group of Seven.
- 3. The classic, and still valuable, study of Western landscape art is Kenneth Clark's *Landscape into Art* (Boston: Beacon Press, 1961). For a look at the landscape motif in Chinese art, consult the section "Constructing Landscapes" in *Chinese Art and Culture*, by Robert L. Thorp and Richard Ellis Vinograd (New York: Harry N. Abrams, 2001). William V. Dunning, *Changing Images of Pictorial Space: A History of Spatial Illusion in Painting* (Syracuse, N.Y.: Syracuse University Press, 1991), provides an excellent analysis of variations in the representation of physical space within pictorial space. A classic volume that analyzes the psychic dimensions of place from the perspective of phenomenology, with applications to literature and art, is Gaston Bachelard, *The Poetics of Space* (Boston: Beacon Press, 1969).

- 4. The history of the representation of space and its changing conceptualization, especially in architecture, is traced in Anthony Vidler, "Interpreting the Void: Architecture and Spatial Anxiety," in Mark Cheetham, Michael Ann Holly, and Keith Moxey, eds., *The Subjects of Art History: Historical Objects in Contemporary Perspective* (Cambridge: Cambridge University Press, 1998), pp. 288–307.
- 5. The use of maps by contemporary visual artists relates to earlier examples of imcorporating maps in art, from the paintings of Johannes Vermeer in the seventeenth century to Robert Smithson's plans for earth art projects in the 1960s.
- 6. Mel Watkin, Terra Incognita: Contemporary Artists' Maps and Other Visual Organizing Systems (Saint Louis: Contemporary Art Museum, 2002), unpaginated. An exhibition brochure.
- 7. For an analysis of the modernist gallery space, see Brian O'Doherty, *Inside the White Cube: The Ideology of the Gallery Space* (San Francisco: Lapis Press, 1986).
- 8. Sometimes work made for a specific place is capable of surviving a move to another location. Some artists use the phrase *site-sensitive* rather than *site-specific* to refer to such work.
- 9. Nicolas de Oliveira, Nicola Oxley, and Michael Petry, *Installation Art* (London: Thames and Hudson, 1994), p. 35.
- 10. For a theoretical analysis of visual artists' work dealing with site-specificity and related issues, see Rosalind Krauss, "Sculpture in the Expanded Field," reprinted in Hal Foster, ed., *The Anti-aesthetic: Essays on Postmodern Culture* (Seattle: Bay Press, 1983), pp. 31–42.
- 11. As quoted in Michael Corris, "Para-Cities and Paradigms," Art Monthly, March 2001, p. 11.
 - 12. Liz Wells, Photography: A Critical Introduction (London: Routledge, 1997), p. 236.
- 13. Casey Ruble, "Andreas Gursky," in Katy Siegel, ed., Everybody Now: The Crowd in Contemporary Art (New York: Hunter College, 2001), p. 16. An exhibition catalog.
- 14. Ken Johnson, "West to Eden," Art in America, December 1991, p. 88. Johnson's article concerns an exhibition of the work of nineteenth-century American landscape painter Albert Bierstadt.
 - 15. Faye Hirsch, "Frank Moore's Ecology of Loss," Art in America, May 2003, p. 129.
 - 16. Eleanor Heartney, exhibition review, Art in America, December 1991, p. 121.
- 17. Richard Martin, ed., *The New Urban Landscape* (New York: Olympia and York Companies, 1989), p. 116.
- 18. Jeffrey Deitch and Dan Friedman, eds., Artificial Nature (Athens, Greece: Deste Foundation for Contemporary Art, 1990), unpaginated. An exhibition catalog.
- 19. Toby Kamps, "Small World: Dioramas in Contemporary Art," in *Small World: Dioramas in Contemporary Art* (San Diego: Museum of Contemporary Art, 2000), p. 7. An exhibition catalog.
 - 20. Ralph Rugoff, "Bubble Worlds," in Small World, p. 16.
 - 21. Ibid.
- 22. Anne Ellegood, "Out of Site: Fictional Architectural Spaces," in *Out of Site: Fictional Architectural Spaces* (New York: New Museum of Contemporary Art, 2002), p. 30. An exhibition catalog.
 - 23. Ibid., p. 7 and 11.
- 24. David Toop, "A Least Event," in 010101: Art in Technological Times (San Francisco: San Francisco Museum of Modern Art, 2001), p. 108. An exhibition catalog.
 - 25. Ibid., p. 94.
- 26. Jonathan P. Binstock, *The 47th Corcoran Biennial: Fantasy Underfoot* (Washington, D.C.: Corcoran Gallery of Art, 2002), p. 74. An exhibition catalog.
- 27. See Witold Rybczynski, *Home: A Short History of an Idea* (New York: Penguin Books, 1987).
- 28. Quoted in Martin Lister, "Photography in the Age of Electronic Imaging," in *Photography: A Critical Introduction*, p. 275.

29. For further discussion of this and other interactive works by Campbell, see Marita Sturken, "The Space of Electronic Time: The Memory Machines of Jim Campbell," in Erika Suderburg, ed., *Space Site Intervention: Situating Installation Art* (Minneapolis: University of Minnesota Press, 2000), pp. 287–96.

30. Deepali Dewan, "Place of Movement," in No Place (Like Home) (Minneapolis: Walker

Art Center, 1997), p. 122. An exhibition catalog.

31. Uta Barth, "The Space of Non-place," in Claire Doherty, ed., *Claustrophobia*, (Birmingham, United Kingdom, Ikon Gallery, 1998), pp. 28–29. An exhibition catalog.

32. Ella Shohat, introduction to Ella Shohat, ed., Talking Visions (Cambridge: MIT Press,

1998), p. 46.

33. Rohini Malik and Gavin Jantjes, A Fruitful Incoherence: Dialogues with Artists on Internationalism (London: Institute of International Visual Arts, 1998), S.V. "diaspora" (in glossary).

34. Aruna D'Souza, "A World of Sound," Art in America, April 2002, p. 110.

Detail of 4-6

Identity

Beginning art students often fervently believe they want to find out who they are as a unique individual and convey this in their art. In our own teaching, we find that many students admire the stance (if not always the art) of the "heroic" generation of Abstract Expressionist painters active after World War II, who strove to express their personal feelings and their sense of their own radical individuality. The postwar generation asked questions philosophers have been asking since ancient times: What is the true nature of the self? What does it mean to be human? For some of these artists, including Jackson Pollock and Mark Rothko, the true self was a self-directed, free individual. Influenced by Jungian psychology and existentialist philosophy, they held up the ideal of an integrated, stable, unique self who acts independently, with meaningful intentions and a coherent inner psychology. According to Claire Pajaczkowska, the belief in a true inner self is "liberal humanism," where "answers to the question of what it is to be human [are] phrased in terms of philosophical concepts such as 'self-knowledge', 'consciousness', and 'thought', which emphasize the significance of self rather than the significance of division."¹

In contrast, recent art on the theme of identity has expressed a communal rather than an individual sense of self. Carrie Mae Weems's *Kitchen Table Series*, a series of untitled photographs, one of which is illustrated [4-1], provides an example. The same woman protagonist (Weems using herself as the model) appears in all the photographs, sometimes alone and sometimes with various other people, and she is always at the same kitchen table but with different props around her. Any of the photographs viewed singly might be mistaken for a simple portrait. But viewing the entire series, we realize that the woman's identity is shaped by many social variables, including her gender, her status as a working-class black American, her relationships with other people, and her cultural history. This last variable is represented by the photograph of the civil rights leader Malcolm X on the back wall in 4-1.

Identity defined through culture and relationships is a preeminent theme in Western art and art discourse in the late twentieth century and today. Furthermore, whether or not a particular artist makes art about identity, describing artists in terms of cultural

4-1 Carrie Mae Weems Untitled, from the Kitchen Table Series, 1990 Gelatin silver print, 28 1/4 x 28 1/4 inches
Courtesy of the artist and P.P.O.W Gallery, New York

affiliation has been and continues to be a common practice in the contemporary art world. In her influential 1990 book, *Mixed Blessings: New Art in a Multicultural America*, critic Lucy Lippard argues that "an individual 'identity' forged without relation to anyone or anything else hardly deserves the name." Lippard maintains that identity is relational and defined by our similarities and differences with others. Moreover, Lippard advocates embracing a collective self, expressed through naming oneself as part of a group and representing oneself verbally and visually in terms of a shared identity.

Interest in identity in the mainstream art world reached a peak during and just after two high-profile exhibitions in the early 1990s: The Decade Show: Frameworks of Identity in the 1980s, which was held simultaneously in New York in 1990 at the Studio Museum in Harlem, the New Museum of Contemporary Art, and the Museum of

Contemporary Hispanic Art; and the 1993 Whitney Biennial (sometimes nicknamed "the Identity Biennial"). These exhibitions turned a spotlight on artists who were engaged in work revolving around cultural identity and set off a firestorm of critical debate on the value of "identity art." Subsequent influential (and controversial) shows in New York included Asia/America: Identities in Contemporary Asian American Art at the Asia Society Galleries (1994); Black Male: Representations of Masculinity in Contemporary American Art at the Whitney Museum (1994); Bad Girls at the New Museum of Contemporary Art (1994); and Too Jewish? Challenging Traditional Identities at the Jewish Museum (1996).

The artists whose works could be discussed under the heading of identity are numerous and ethnically diverse. Every kind of art medium is involved, every scale, every type of forum and venue, and many purposes and ideas. The artworks we show in this chapter are varied but only hint at the range of what artists have produced on this theme. Many of the images show the human figure (and thus relate to the theme of chapter 5, the body). Certainly the body carries many signs of identity (hair, skin color, gestures, posture, clothing, and so on), but identity is expressed by other means as well, including by words, symbols, objects, and settings. These may be used alone or in conjunction with figurative imagery. For example, Pepón Osorio's *La Bicicleta* [4-2] is a found bicycle that the artist embellished with plastic streamers and knickknacks. Osorio's sculpture is both a tribute to the vernacular culture of his native Puerto Rico,

4-2 Pepón Osorio | La Bicicleta, 1985 Mixed media, approximately 42 x 60 x 24 inches

Courtesy of Ronald Feldman Fine Arts, New York

where ordinary objects are often exuberantly decorated (although rarely to the degree of Osorio's bicycle), and an exploration of his heightened awareness of cultural identity after he moved to New York City as an adult.

Most of the art we illustrate in this chapter is embedded in concepts of gender, race, ethnicity, and class, reflecting the prominence of these concerns in the art of the 1980s and 1990s. In chapter 5 we continue a discussion of sexuality and gender within our exploration of the theme of the body, and in chapter 7 we discuss religious identities.

Identity in Art History

Within the Western tradition, two genres with enduring histories, the portrait and the self-portrait, are directly linked to the artistic exploration of the theme of identity in art today. Rembrandt, Pablo Picasso, and Frida Kahlo are among those who invested significant energy in recording their own likenesses. Indeed, popular myths that romanticize artists as a special category of people are fed by such representations; think of the dramatic self-portraits of Vincent van Gogh. Closer in time to ourselves, postwar artists of note, including the British painter Francis Bacon and the American Pop Artist Andy Warhol, produced influential bodies of work that featured a range of portraits and self-portraits. Each artist of talent who took up these genres did so in a way that revitalized the traditions. Bacon, for instance, revealed a startling capacity for retaining an identifiable likeness of a specific person while forcing the painted representation to undergo expressive contortions. Warhol, through a pristine, almost mechanical application of color, created mass-media icons of recognizably famous persons.

In the contemporary period, a number of artists have continued to create images and objects that are anchored in the familiar traditions of portraiture and self-portraiture. Americans Chuck Close, Alex Katz, and Susanna Coffey, British artist Lucian Freud, Italian Francesco Clemente, and Chinese artist Zhang Xiaogang, for instance, have each demonstrated how representations of human likeness are manifested through the prism of artistic style.

A deep, implicit connection between art and human identity has existed throughout art history. How the world views you, how you view yourself, how you view others—these fundamental dimensions of human identity have influenced artists' ideas, emotions, and creative expressions in classical Greece, in eighteenth-century sub-Saharan Africa, and during the Tang Dynasty in China alike. An artwork's subject matter, its formal properties, and the very materials it is created from reflect the identity characteristics, on the individual and broader cultural level, of both the artist and the intended audience.

While a connection between art and identity has existed throughout history, the ways in which humans understand themselves or conceive of their identity are constantly changing. In some periods and in some societies (such as the dynastic period of Egypt's Old Kingdom), these changes seem almost glacial in their slowness and subtlety. In other periods, changes have occurred at a cataclysmic pace. For example, the Enlightenment in Europe and North America was marked by profound social, political, and scientific changes that changed how humans understood themselves. Starting with the American Revolution in 1776, a series of conflicts over the right of self-determination produced a new democratic order, in which the individual came to be seen as the agent of his own free will rather than part of a rigid social structure.

In our own contemporary period many interweaving forces and events have reshaped concepts of identity on a worldwide basis. Among these are rapid technological change, the dismantling of the Soviet Union, the globalizing of economic systems, incremental victories for feminist and civil rights causes, the rising world influence of societies beyond Europe and the United States, the ever-increasing speed of information transfer, and the influence of postmodern theory on a range of intellectual and cultural arenas. Such changes have not taken place everywhere or equally, of course, but they have occurred in a wide range of societies over the past two and a half decades. Think of the emerging economies of the Pacific Rim, the unification of much of Europe within one monetary system, and the dismantling of apartheid in South Africa. Such changes in the fabric of whole societies, even when transformation has been followed by a period of retrenchment or reversal, inevitably influence artists. A new international awareness, a new vision of possibility, produces new understandings of what it means to be human; these, in turn, are embodied in artistic portrayals of human identity that look unlike the art of the past.

While recent and ongoing changes in concepts of identity mirror the dramatic and decisive changes in other periods (e.g., the deep influence of colonial Spain on the art and identity of the native peoples of Mexico during the sixteenth century), contemporary artists offer a new spin on the question, What does it mean to be human?

Identity Is Communal or Relational

Identity was a key theme in artistic production in the United States and Europe right after World War II. For the immediate postwar generation of artists, identity meant individual identity. Later in the twentieth century, this belief in a consistent, unique inner self and the individual's ability to act independently of society was severely questioned. The challenges came from philosophers, social activists, artists, psychologists, and others who doubted all claims to ultimate truth. Roland Barthes's formulation of the "death of the author" is a famous example of the challenge to individual self-determination and self-expression. For many reasons, critical thinkers grew skeptical of the emphasis on uniqueness and instead focused on how people are powerfully influenced by forces outside themselves (in addition to whatever unconscious motivations propel behavior).

In contrast to the existential focus on independent individual identity, today when Western artists and writers on art use the term "identity," they are usually referring to social and cultural identity. A contemporary artist interested in the theme of identity is asking not only, Who am I as an individual? but also, Who are we as members of groups? Today we recognize ourselves as inhabiting a world in which membership in any particular group implies identification with a set of characteristics that differ from the characteristics that define other groups. The identity of any group is constructed in the context of other groups' existence. Theorists use the term *alterity* for this state of being different from others. It conveys the idea that identity is communal and relational.

Social and Cultural Identities

Although group identities conceivably could be based on many traits, in art discussions in the West since the late 1960s the traits often most emphasized fall into the categories of gender, race, ethnicity, and (more so since 1980) sexual orientation. Artists involved

in the feminist and civil rights movements readily named themselves as members of identity-based groups ("women artists," "black artists," "Chicano artists"). They created artworks that represented their communal identities and at the same time advanced their social agendas. Indeed, from this era of social activism onward, women artists and artists of color continually surface as voices that matter in the art world. Some, such as African American artist Adrian Piper and Native Americans Hachivi Edgar Heap of Birds and Jimmie Durham, have explored how identity is a result, in part, of intergroup conflict. Their art is the kind critic Lucy Lippard has described as functioning to expose "the vulnerable point where an inner vision of self collides with stereotypes and other socially constructed representations."⁴

James Luna, a member of the Luiseño/Diegueño tribe, makes art that exposes prejudices and stereotypes about Native Americans. In his performance *The Artifact Piece* (1987) [4-3], Luna turned himself into an artifact by laying clad only in a breechcloth on a display case in the Museum of Man, San Diego, in a section devoted to the Kumeyaay Indians, who once inhabited San Diego County. Labels beside his body explained his physical scars (caused by drunkenness and fights) and hidden emotional scars (caused by life experiences). According to writer Linda Weintraub, "The gallery was otherwise given over to relics and dioramas honoring the revered aspects of Native American life. No part of its permanent display addressed the real problems that beset the living representatives of these people. Rather, the museum placed Indian life in the same category as dinosaur skeletons and plant fossils. Luna shattered the impression that Indians are extinct by presenting himself as a breathing artifact." 5

Other categories of group identity include class, religion, and age. These have played a lesser role in contemporary artworks made in the United States. In Europe, however, where class-consciousness is more pronounced, artworks that reflect class values or class identity are more apparent. In 1993 a young British sculptor, Rachel Whiteread, gained great attention by casting as one monolithic sculpture the negative space of a building scheduled for demolition in London's East End. Made by filling the entire interior space of a row house with concrete, Whiteread's artwork signified the working-class identity of the inhabitants of this typically constricted space.

Identity Politics

When artists began to name themselves as part of a group, they at first used general terms such as "women," "African Americans," and "Native Americans." This made political sense. In the art world as in the rest of the world, people have often been stereotyped and discriminated against on the basis of their perceived gender or ethnic identity or class. Discrimination includes unequal access to opportunities for making money in the arts and little or no representation in art exhibitions, gallery shows and sales, art history texts and teaching, art criticism, or any other kind of art discussion and analysis. Economic and institutional discrimination used to be rampant and still occurs. It is one reason why feminists, among others, got so angry about the "white male patriarchy." People observed that a high percentage of the artists who were succeeding in the Western art world in terms of shows and sales were white and male. They started to question why, since they could see for themselves that there are many excellent women artists and artists of color.

Artists have responded to the exclusionary politics of the art world in many ways, including picketing, demonstrating, speaking out in public forums, and working

4-3 James Luna | The Artifact Piece, 1987
Mixed media installation and performance, dimensions variable
Courtesy of San Diego Museum of Man

for equal opportunities for all artists to participate in art institutions and the public interpretation of art. Some have also made art with a political agenda, sometimes called *activist art*. The Guerrilla Girls, for instance, are a feminist group working anonymously (since 1985), primarily in New York City, on behalf of women and other

underrepresented artists. None of the Guerrilla Girls is ever named as an individual, but without doubt each is also doing feminist work in other arenas. When any member of the collective appears in public as a Guerrilla Girl, she wears a gorilla mask and costume that conceals part of the torso. One of the group's favorite strategies is to use advertising forms such as bumper stickers, posters, and ads in magazines to communicate socially activist visual messages. An example is their 1989 poster with a text that bluntly asks, "Does a woman have to be naked to get into the Metropolitan Museum of Art?" The implication, of course, is that women artists are underrepresented, while women as models in male artists' work are ubiquitous.

Identity politics is a term used to refer to the beliefs and activities of those who target racism, sexism, and other forms of prejudice and work for social rights and economic parity. Identity politics in the art world is a fierce arena. Activist art on the theme of identity has some powerful contemporary practitioners and defenders, for example, Adrian Piper, Barbara Kruger, and David Hammons. At the same time, other people, both from the art world and the world at large, remain steadfastly critical of art made with an overt political agenda. As in earlier periods, the sanctioned purposes of art are hotly contested in our current age.

The focus on topics of social and cultural identity in art mirrors the importance of these topics in society at large. Such concerns are not limited to the West, of course. In a statement for a 1998 exhibition of her work at ShanghART, one of the premier private galleries displaying experimental contemporary art in the People's Republic of China, artist Jin Weihong expressed her view of her situation as a young woman in contemporary China with these words: "I am always confronted by such kind of questions: 'As a woman, how will you deal with this?' . . . But we never hear that some male individuals can be asked this kind of questions." Jin Weihong hypothesizes a world in which all humans would share all possible gender characteristics, or, in her terms, we would be "human beings of obscure sex." Her delicate ink brush paintings, while reflecting Chinese tradition in the choice of medium, explore the poetic possibilities of such a fanciful future world.

Identity Is Constructed

A second concept that distinguishes art about identity in the contemporary period is the notion that identity is constructed. The initial formulation of this concept and its eventual widespread acceptance in the contemporary art world can be traced back to the writings of intellectuals and academicians active in the 1960s and 1970s. Among the most influential was a group of French philosophers, semioticians, and structural anthropologists, including Jacques Derrida and Michel Foucault. Their writings provided key parts of the intellectual scaffolding upon which postmodern theory was built.

These thinkers posited the idea that identity results from a network of interdependent forces that define roles, reward status, govern behavior, and order power relationships for all members of a community. While those in science, religion, and other fields still believed (and argued) that key aspects of identity are biological or spiritual in origin, these points of view were not considered pertinent to the "reading" of most critically championed contemporary art. For those embracing the concept that identity is constructed, no one is born with a unified, inevitable identity; rather, a person's identity is a product of, and in concert with, human culture, the colored water in the fishbowl in which each of us swims.

Essentialism

From the 1970s to the early 1980s, artists who identified with a group tended to play down distinctions among group members in the interest of building a large, cohesive coalition. Artists who identify themselves as belonging to a group have sometimes made art that zeroes in on traits or experiences that members of the group share. Thus some feminist artists, including Judy Chicago, Carolee Schneemann, and Monica Sjoo, have made art about pregnancy, birth, and menstruation and about domestic tasks that are largely carried out by women, such as housecleaning. Rachel Rosenthal, Mary Beth Edelson, and others have looked back to history for real or mythical heroines they could identify with and have made art about them. African American artists such as Raymond Saunders and Jacob Lawrence likewise have found heroes and role models by searching history and current events in the United States as well as gazing over the ocean at Africa. Some have made art that emphasizes a shared history of slavery and consciousness of present-day racism.

Kerry James Marshall, a painter now residing in Chicago, has made the present-day culture and activities of African Americans his primary subject matter. He creates complicated narrative and symbolic paintings [3-1] in which virtually all the figures have very dark, inky skin. Through the repetition of this one intense tone, Marshall seems to be making a general claim that blackness (as a color and as a concept) is fundamental to what it means to be African American.

Although such general statements can be powerful and unifying, in awkward hands generalized interpretations of group identity can be challenged easily. Two issues for an artist claiming a communal identity are How large a group do you identify with? And who is making visual and verbal claims on behalf of your group? By the late 1980s people resisted claims that sounded too sweeping. Attributing certain qualities or points of view to "women" or "blacks" seemed simplistic. The term *essentialism* began to be applied to statements and images that conveyed overly generalized or stereotyped notions of identity. In particular, an accusation of essentialism is often made when claims about a group's identity are based on the notion that the shared qualities are natural or based on biology. If the order of things is "natural," then you have an insurmountable obstacle to overcome if you are on a lower rung of the existing order. The term *essentialist* is usually used negatively, often to resist a claim made about you by someone claiming to speak on your behalf. For example, most feminists today would resist as essentialist any claim that women are "naturally" suited to nurturing roles, and thus should bear the major responsibility for child rearing or tending the sick in society.

Difference

By the 1990s writers such as bell hooks, Edward Said, Homi Bhabha, and Gayatri Chakravorty Spivak were discussing identity in increasingly complex terms. They were theorizing that identities are not formed around and dominated by one central variable such as race. Instead, identity is formed within a complex matrix of many variables, including gender, sexuality, ethnicity, class, religion, community, and nation. Moreover, the members of a group are not alike in every way; they have diversity within their own commonality. In discussing contemporary art, the word difference is often used to refer to the recognition of a great diversity of identities. Awareness of difference contrasts strongly with essentialism. Instead of looking for sameness, one looks for

differences. Groups still exist, but they are smaller, and an individual may identify with different groups in different situations. As Walter Truett Anderson says, "The postmodern person is a *multi-community* person, and his or her life as a social being is based on adjusting to shifting contexts and being true to divergent—and occasionally conflicting—commitments."

The current interest in difference is a rediscovery and reinterpretation of its relevance. Through trade and colonization, Europeans in the nineteenth and early twentieth centuries, for example, were well aware that cultural "others" existed elsewhere in the world. Among the new conceptions today is that those interested in diversity are more likely to recognize difference within the context of their own society. As critic Lucy Lippard puts it, "Every ethnic group insists, usually to deaf ears, on the diversity within their own ethnicity." Moreover, more people are inclined to view diversity as a positive condition rather than as something to be feared and repressed.

The emphasis on and recognition of differences is also called *multiculturalism*. Multiculturalists believe that different identities are formed mainly through social interactions and shared histories; that is, they are learned within certain cultural and political settings, rather than being set at birth. Multiculturalism usually implies an acceptance of difference and diversity as desirable and good. For example, a multiculturalist may admire the European cultural tradition but does not elevate that tradition above all others.

The cultural theorist bell hooks embraces the concept of difference as liberating and politically desirable for people who have been stereotyped by essentialist thinking. Speaking of African Americans, she says, "Such a critique [of essentialism] allows us to affirm multiple black identities, varied black experience. It also challenges colonial imperialist paradigms of black identity which represent blackness one-dimensionally in ways that reinforce and sustain white supremacy." Although hooks values differences and is against simplistic generalizing, she argues that it still makes sense to talk about a communal black identity that is cultural and formed by sharing a major stream of history with other African Americans. She advocates that people should pay attention to "the specific history and experience of African-Americans and the unique sensibilities and culture that arise from that experience."

Numerous artists have expressed the concept of difference in their works. For example, Lyle Ashton Harris is an American artist who, over the past fifteen years, has used self-portrait photography to investigate notions of identity complicated by issues of race, sexual orientation, and gender. Harris, who is black, gay, and male, uses costume, makeup, gesture, and pose to deconstruct and mock simple binary codes: male versus female; gay versus heterosexual; black versus white. In some self-portrait photos, he has taken on feminine identities, including ballerina and supermodel, while contradicting the femininity of the poses by revealing his anatomically male torso. Harris's "Memoirs of Hadrian #26" (2003) [4-4] is one of a series of twelve unique twenty-by-twentyfour-inch Polaroids. The title is borrowed from a 1951 novel by Marguerite Yourcenar, whose text takes the form of a letter written by the aging Roman emperor Marcus Aurelius to his successor Hadrian following the drowning of his lover, Antinous. In eight of the photos Harris poses as a bare-chested prizefighter wearing Everlast boxing gloves and a Duke jockstrap. Harris's evocative self-images of an isolated, bloodied, bruised, tormented fighter seem to suggest both Harris's private emotional self and his need to defend his public identity. The series may also reference the historical role of boxing in the construction of African American identity. Although an individual sport,

1 and 2 Bill Viola | The Quintet of the Silent (Still 1 and Still 2), 2001

DVD, Panasonic plasma screen, line doubler, surge suppressor, DVD player Courtesy of Indianapolis Museum of Art, Dan and Lori Efroymson Fund, acquired through Art for Today 2002, an exhibition organized by the Contemporary Art Society, © 2001 Bill Viola

4 Joel Meyerowitz | "The Blue Hour, New York City, 1982," 1982

From the series *Looking South: New York City Landscapes, 1981–2001* C-print, 20 x 24 inches

5 Brian Tolle | Irish Hunger Memorial, installed Battery Park, New York, 2002

Stone, landscaping, glass, illumination, audio, and concrete, 96 x 170 feet
Photo by Stan Ries
Courtesy of the artist

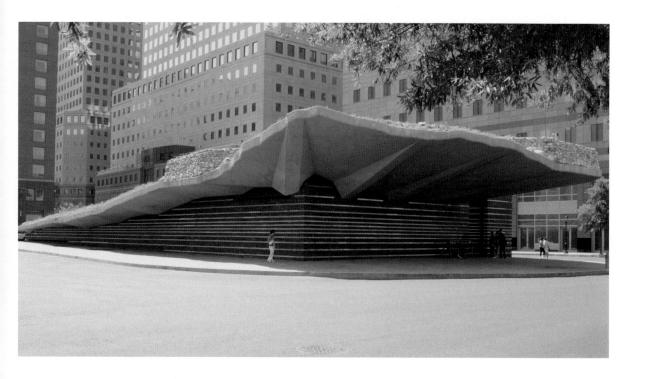

6 Brian Tolle | Irish Hunger Memorial, installed Battery Park, New York, 2002 Stone, landscaping, glass, illumination, audio, and concrete, 96 x 170 feet

Photo by Stan Ries Courtesy of the artist

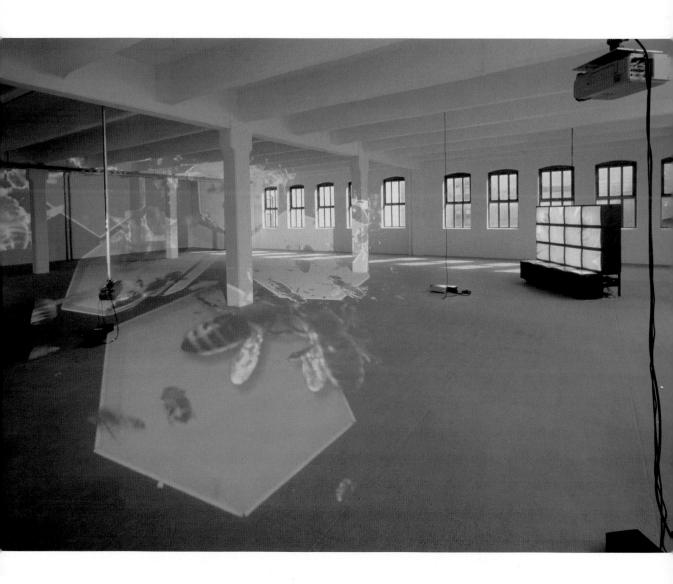

7 Diana Thater | Knots + Surfaces, Version #1, 2001

Installation for 5 LCD video projectors, 16 video monitors, 6 DVD players, 1 VVR-1000, synchronizer, 6 DVDs unique, + 1 AP

Courtesy of David Zwirner, New York

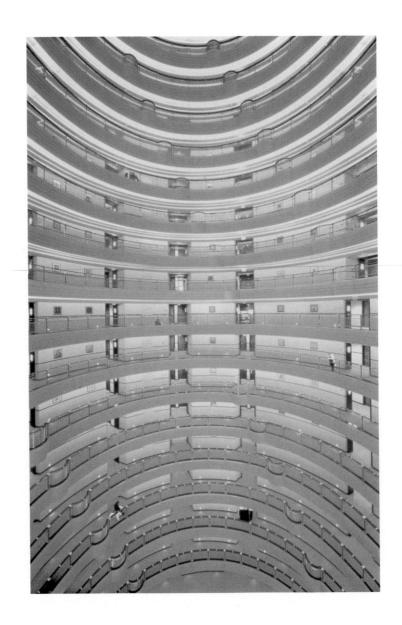

8 Andreas Gursky | "Shanghai," 2000

C-print mounted on Plexiglas in artist's frame, 119 1/2 x 81 1/2 inches Edition 2/6, signed, titled, numbered, and dated in graphite (verso); A. Gursky Courtesy of the artist and Matthew Marks Gallery, New York, © 2004 Andreas Gursky / Artists Rights Society (ARS), New York / VG Bild-Kunst, Bonn

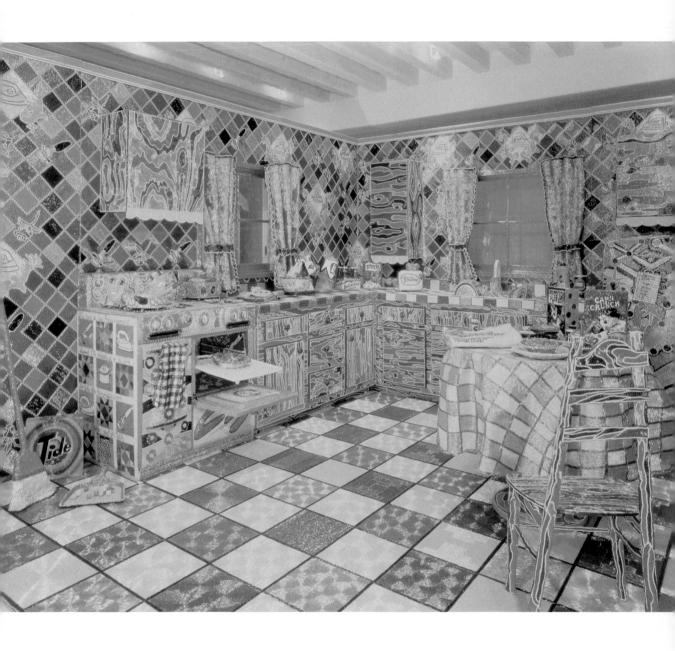

12 Janine Antoni | To Draw a Line, 2003

Performance, tightrope stretched between one-ton spools
September 5th, 2003, Luhring Augustine Gallery, New York
4000 lbs. of raw hemp fiber, 120 feet of handmade hemp rope spliced into 1200 feet of machine-made hemp rope
Photo by Paula Court
Courtesy of the artist and Luhring Augustine, New York

13 Matthew Barney | Cremaster 3, 2002

Production still Photo by Chris Winget
Courtesy of Barbara Gladstone, © 2002 Matthew Barney

14 Lisa Yuskavage | XLP, 1999 Oil on linen, 40 x 75 inches

Courtesy of Marianne Boesky Gallery

16 Xu Bing | Reading Landscape, 2001
Installation at North Carolina Museum of Art, April 2001
Courtesy of the artist

17 Ken Aptekar | Dad is showing me how to develop, 1997

Oil on wood, sandblasted glass, bolts, 60 inches square

Based on Willem van de Velde the Younger's *Before the Storm*, ca. 1700, with text overlay about Aptekar's father teaching him photography

Collection of Ivy and Mark Powell, Aspen, Colo.

Photo by D. James Dee

Courtesy of Bernice Steinbaum Gallery, Miami

18 Fred Tomaselli Untitled (Expulsion), 2000

Leaves, pills, insects, acrylic, photo-collage, resin on wood panel, 84 x 120 inches Photo by Erma Estwick Courtesy of James Cohan Gallery

19 Shahzia Sikander | Uprooted Order I, 1996-97

Vegetable color, dry pigment, watercolor, tea on hand-prepared Wasli paper, 17 $1/2 \times 12$ inches Courtesy of Brent Sikkema, New York

4-4 Lyle Ashton Harris Unique Polaroid, 20 x 24 inches Courtesy of the artist and CRG Gallery

"Memoirs of Hadrian #26," 2003

boxing provides a culturally constructed image of African American manhood, a display of athletic prowess to the point of injury for a voyeuristic crowd.

Another artist who works with ideas of difference is Hung Liu, who immigrated to the United States from China in 1984, at the age of thirty-six. She built the composition of her painting Judgment of Paris [color plate 10] around her own painted copies of historical images of Chinese and European women. The two Chinese figures, standing in pink at either side, are painted from vintage "photographs of young Chinese prostitutes posed in elaborate Western settings typical of the Victorian era." These constructed images, from around 1900, "had been made by Chinese photographers to promote the services of such women among their countrymen."10 The two Chinese women flank a central panel with Hung Liu's painting of a late Qing-era porcelain vase. The vase is decorated with a painting of a European-style mythological scene that includes two goddesses with breasts exposed, one of them in a classic reclining nude pose. Such vases were made in eighteenth-century China to appeal to Western male tastes and were exported to Europe for sale. Hung Liu includes references to eighteenth-, nineteenth-, and twentieth-century cultural clashes in a work that expresses a feminist point of view. The artist is expressing something about differences between cultures and differences within Hung Liu, the person, as well. Hung Liu is bicultural at a minimum, fusing the worldviews of East and West. Artists interested in identity issues in the 1990s often identified with more narrowly focused groups, such as "Korean Americans" rather than "Asian Americans" or "lesbian feminists" rather than "women." This enabled many distinctive voices to emerge, adding to the rich diversity we enjoy in the current scene. It also led to fragmentation and odd specializations in the art world. The increasing diversity makes it harder to build coalitions around shared interests and needs.

Identity Is Not Fixed

Related closely to the concept that identity is constructed is the concept that identity is not fixed or consistent. Individuals are continually engaged in a process of exchange and adaptation as groups intermingle. The forces that influence the construction of identity are not stable, and thus identity itself is always in flux. Because identity is largely determined by outside influences, it is fluid and transformable as the context changes.

The notion of a fluid identity can be hard to grasp. But think about how you behave differently in different situations: in a classroom, at home with your family, on a date, at a job interview, or in a situation where you are outnumbered by people of a different age or race or nationality or religion. Are you the same person in all those situations, or do you present a somewhat different public image of yourself in each context? A postmodernist would say that you are "performing" constructed versions of your identity that work in different contexts; none of these versions is a true self because each identity is transformed or abandoned in other situations.

Motifs of mutating and shifting identity run through the work of numerous artists in the current era. While this chapter focuses on the work of artists who examine aspects of the theme of identity explicitly, many other artists touch on the theme more obliquely. Endless transformations—male into female, people into animals, animals into organic matter—animate the mixed media paintings of American Phyllis Bramson. A related theme of flux surfaces in the playful series of sculptures created by English artist Bill Woodrow in the 1980s, in which the identities of found objects seem to shift.

The metal in a refrigerator, for instance, is partially unraveled, then rewound and transformed into a guitar. In the images and objects created by Bramson and Woodrow, the idea that identity is not fixed is magnified into an entire worldview. Seen through their eyes, the world is composed of shifting states of being, not static, insular things.

Photography, performance art, and video are especially popular practices among artists interested in constructed, unfixed identities. Masks, disguises, and theatrical settings frequently appear in their artworks. For example, Cindy Sherman, who became well known, starting in the 1980s, for using herself as a model in staged photographs exploring female identity, has made many series that deconstruct stereotyped images presented in the fashion world, advertising, movies, pornography, and other massmedia sources. Sherman is never herself in her photographs; she assumes a different identity in each one, reinforcing the idea that identity is artificially constructed and transformable. In her series *Historical Portraits* (1989), Sherman posed in female and male costumes and used makeup and fake body parts to parody the figures in historical paintings. The series demonstrates how paintings, like other images, offer compelling role models for building identity, but models that do not apply in all times and places. Identity is not essential and universal.

Japanese photographer and video artist Yasumasa Morimura, like Sherman, appears in all his works of art. He is himself, and simultaneously, he becomes a range of famous historical art-world personalities. We see Morimura in a still from a video sequence [4-5] in which the artist accompanies himself on an electronic keyboard

4-5 Yasumasa Morimura

Still from Dialogue with Myself (Encounter), 1995

instrument while he appears, then disappears, then appears, over and over, dressed as the Mexican artist Frida Kahlo as she appears in her own painted self-portraits, which

capture her multiple identities.

The belief that we do not have a fixed self can be exhilarating or frightening. Some people welcome the idea that identity is fluid because this condition holds the possibility of change. Indeed, the ability to start over, to remake yourself, is part of the mythology of being an American and an attraction to youth in many cultures, who are increasingly exposed to the American mass media. For others, letting go of the idea of a fixed self is unnerving. Perhaps as a defense, irony sometimes characterizes art about postmodern, constructed identity. For example, Paul McCarthy's video performance *Santa Claus* can be interpreted as an ironic riff on the theme of identity. In the performance, McCarthy enacts a demented parody of Santa Claus, a beloved icon of Western culture, turning the benevolent old man who makes toys for Christmas into a caricature of anger and degradation. Among the other themes that McCarthy's performance connects with (popular culture, religion, and fairy tales, among them), *Santa Claus* also seems to reflect on being white, specifically being a white male. McCarthy's alternately abject and violent figure is a parody of a white male authority figure, who appears on the verge of madness at the loss of his former confidence about his position, role in life, and identity.

Sexual Identity Is Diverse

In mainstream Western culture, binary oppositions are the central way of structuring sexual difference: "male" and "female" are understood as clear opposites, and heterosexuality is viewed as normal. ¹¹ But in people's actual lives, as well as in the realms of art and theory, sexual identity is more complicated, more open to change and debate. Philosopher Judith Butler's influential 1990 book *Gender Trouble*, ¹² along with the emergence of "queer theory" in the early 1990s, helped make people aware of the heterosexual bias of previous art theory and practice and brought new visibility to the work of lesbian and gay artists. Since then artists have increasingly represented the great diversity of sexual identities in our midst—heterosexual, lesbian, gay, bisexual, and transgendered—registering desires that cross the old boundaries of age, race, class, disability, nationality, and ethnicity. Among the many contemporary artists representing diverse sexual orientations are Lyle Ashton Harris [4-4], Holly Hughes, Nan Goldin, Robert Gober, and Nicole Eisenman.

For some artists focusing on issues of sexual identity, gender instability is an area of particular interest. Sexual differences are encoded visually; we learn to read a person's gender and sexual orientation by noting stereotyped visual clues such as hairstyle, clothing, pose, and gesture. Artists who wish to subvert the social stereotypes of masculinity and femininity employ props, masks, makeup, and costumes to represent bodies of uncertain gender that resist classification by viewers. Artists who have made work depicting transvestism and other behaviors that blur gender boundaries include Cindy Sherman, Collier Schorr [5-3], Nancy Burson, Yasumasa Morimura [4-5], and Catherine Opie. Opie's photograph "Chicken" (1991) [4-6], from her portraits of women in drag in the series *Being and Having* (1990–91), might disconcert viewers who are not certain if they are looking at a male or a female. On a fundamental level, such transgressions do more than challenge gender stereotypes; they undermine the whole notion of a stable, consistent gender identity.

4-6 Catherine Opie Chicken" (from Being and Having), 1991 Chromogenic print, 17 x 22 inches

Courtesy of Gorney Bravin + Lee, New York, and Regen Projects, Los Angeles, © 1991 Catherine Opie

While the history of art prior to 1960 is relatively devoid of female artists exploring their own sexual identity, there has been a rich tradition of male artists representing aspects of their male sexual identity. Such a practice has taken new turns as contemporary male artists, such as Matthew Barney and Robert Mapplethorpe, have explored gender identity as a much more flexible continuum of negotiable possibilities. In a memorable scene in his film Cremaster 3, Barney, a former star high school quarterback, scales the walls of the spiraling ramp inside New York's Guggenheim Museum. Such a taxing physical feat may be a metaphor for facing the challenges of defining maleness within contemporary culture. Interpretations of Barney's work are as varied as the range of images in the films. Some see Barney's gymnastics as a symbolic search for a new balance—a third sex, so to speak. In Roger Hodge's view, however, "the theoretical paradigm that . . . provides Barney with his marvelously fecund source of inspiration is that of the Men's Movement. . . . It is so very hard to become a man, Barney repeatedly, almost obsessively insists. Everything threatens to beat us down, to strip us of our biological birthright. . . . And it is this, man's fundamental ontology . . . that concerns the adherents of the Men's Movement, which has so little to do with actual male dominance in the material world."13

In addition to sexual orientation and gender codes, artists have examined ways in which sexual identity is stereotyped by race or national origin. Their critique has gone beyond revealing the voyeurism of the male gaze to countering a Eurocentric point of view. According to this critique, the norms of Eurocentric aesthetics pervade Western representations of sexuality; for example, white women are held up as socially acceptable

objects of desire, while women of color are portrayed as racially and sexually "other." Although treated as sexually taboo (for the presumed white male viewer), women of color are frequently stereotyped as sexually promiscuous and erotically exotic. Thus women of color are not only objectified, as white women are, but they endure the added pain and shame of finding themselves the objects of extreme fetishization and pornographic voyeurism. Postcolonial theorists such as Rasheed Araeen, bell hooks, Trin T. Minh-ha, M. A. Jaimes Guerrero, Ella Habiba Shohat, and Kobena Mercer trace these attitudes back to the power dynamics of colonialism, when European conquerors justified slavery, rape, and other forms of oppression and violence by stereotyping their captives as wild, overly physical beings, without any subjectivity of their own, who had to be controlled by extreme measures. Voyeuristic and patriarchal attitudes also permeated Western medicine, anthropology, and ethnography. In the nineteenth century, colonized people were regarded as specimens to be studied and were measured, photographed, and put on actual display in public spectacles to feed the fantasies of Western audiences.

Visual artists who have made works about the legacy of colonialism and scientific voyeurism with respect to women's sexuality include Adrian Piper, Coco Fusco, Sonia Boyce, Mona Hatoum, Kara Walker, Adriana Varejão, and Renée Cox. Cox photographs black female nudes (often herself) in poses that sometimes mimic historical Western renditions of women, shaking up assumptions about whiteness as an ideal, and also embody the proud subjectivity of the model, who gazes back assertively at the camera. Nevertheless, B. E. Meyers has argued that despite the power of Cox's images and her political intentions, Cox like other female artists of color has a daunting task to try to overcome the blind conditioning of viewers who automatically assign black women to a certain category of sexual identity. Meyers argues that "part of what makes Black women's audiences unable to recognize them as fully human is the fact that their dark bodies are over-determined. The bodies themselves signify too greatly because they are heavy with history, and audiences come to understand these historical memories through at least two voices: through a scientifically-laden analytical lexicon; as well as through the wordless and very neurotic push of desire." 14

Even well-intentioned Western feminists often direct a Eurocentric gaze at sexual practices and politics elsewhere in the world. Ella Shohat writes about "Western feminists' imperial fantasies of rescuing clitoridectomized and veiled women," suggesting that the tendency to see white Western values as universal is not limited to men. For instance, the films and photographs of Shirin Neshat [5-9 and 5-10], which show Iranian women garbed in the head-to-toe black garments known as *chador*, are typically assumed by Western viewers to be unambiguous critiques of the practice of veiling in a Muslim country. Neshat's own view acknowledges the importance of context; the artist recognizes, for instance, that veiling may even serve as a protest against Western hegemonic influence. In contemporary Western culture it is deemed important to have nothing veiled, including female sexuality, but is that an unequivocally positive social value?

Hybridity

Although identity is always an implicit factor in the creation and interpretation of art, the use of identity as a highly theorized and often politically charged theme in art is a recent development. Contemporary artists are self-conscious about identity to a degree that was rare in previous periods. The theoretical exploration of identity has given rise

to a diverse range of artworks of the late twentieth century and today. Moreover, artists (and those who write and think about art) operate under the assumption of an art world in which every artistic act is identity-laden. The extreme sensitivity to identity issues (of artists, curators, critics, and collectors) creates a sort of feedback loop that is fueling ever more intense explorations of identity as a key theme in art production.

The theories, ideas, terms, and definitions surrounding the large topic of identity are numerous and have been morphing constantly in the period this book covers. They have also generated many contentious discussions. One theory that has gained currency since the mid 1990s is *hybridity*, which is related to the notions of difference and multiculturalism. (The term *syncretism* is used more or less synonymously with hybridity.)¹⁶

A working definition provided by Rohini Malik and Gavin Jantjes defines *hybridity* as "a state of being, arrived at through the innovative mixing and borrowing of ideas, languages and modes of practice." The study of hybridity focuses on the blending and synthesis of different cultures that come into contact with one another. This cultural blending, or syncretism, can be voluntary and seamless or can be the outcome of a painful culture clash, such as the forced imposition of one culture on another as happens in colonization, when inhabitants from one country move into and dominate another people's territory. Forced colonization happened in the Americas, Africa, Australia, and other parts of the world when Europeans displaced or conquered native peoples.

In addition to colonization, a great deal of hybridity all over the world is the result of immigration. Indeed, nearly all the people living in the United States have ancestors who were voluntary or involuntary immigrants or are immigrants themselves. Over the centuries, people have moved to the United States from virtually every other place in the world. Hybridity, a blending or fusion of cultural influences, is endemic to being an American.

Hybridity is found in all cultures worldwide; no culture has ever been immune to the ongoing exchanges and adaptations that result from migration, displacement, and contact with other cultures. Even ancient and isolated peoples, such as the Anasazi living in cave dwellings in remote areas of what is now New Mexico, did not live in total isolation. The phenomenon of hybridity has been intensified today, however, because of the rapid spread of visual and other ideas through international media and commercial forces. The notion of hybridity, or syncretism, qualifies the concept of difference, suggesting that there is not now nor has there ever been an absolute difference between self and others. As South African artist Gavin Jantjes says, "There are no uncontaminated peripheries full of authentic others."

Jaune Quick-to-See Smith (see profile) and Guillermo Gómez-Peña are examples of artists who exhibit syncretism in their art. In different ways, each mixes ethnic motifs, techniques, and interests with ideas and formal strategies learned from Western modern and postmodern art.

Hybridity can be especially dramatic in the art of recently arrived immigrants or those who live along borders or in places where strong ethnic enclaves exist side by side. Gómez-Peña uses the term "border art" to describe his own and other artists' works that blend ideas from cultures in close proximity. Gómez-Peña was born in Mexico in 1955; since the 1980s he has divided his time between Mexico City and the United States, often working in San Diego, California. In his installations and

4-7 Guillermo Gómez-Peña

Border Brujo, 1989

Performance art still Courtesy of the Video Data Bank, www.vdb.org, July 20, 2004

performances [4-7], the artist asserts a proud hybrid identity even as he portrays the uprootings and disjunctures that are products of colonialism. Gómez-Peña's confrontational art reflects a root optimism—a faith that clashes of cultures and ideologies can fuel a creative synthesis that is ultimately beneficial to many.

Reinventing Identities

What theories, political ideas, technological developments, and historical events will impact how identity is defined and represented in art over the next decade or so? Many developments are possible. There is a growing interest in creating virtual identities, a direction supported by new digital technologies. In everyday interactions on the computer, many people are now creating artificial identities they use to interact in cyberspace. In the fine arts, artists use digital media to create sophisticated manipulated images of people. An early experimenter in this realm is Nancy Burson, who since the early 1980s has created many images that are composites of several photographic portraits scanned into a computer and combined into one face [4-8].

Another factor that will continue to impact identity as an artistic theme is the continuing internationalizing of culture. Even artists who remain rooted in one place are shaped by interchanges with people, ideas, images, and products from elsewhere. For artists who operate regularly on an international stage, the collapsing boundaries of local and national communities make the establishment of identity more difficult. Identity is a particularly acute issue for artists raised in one culture who now live and work somewhere else.

4-8 Nancy Burson | Evolution II
(Chimpanzee and Man), 1984
Computer composite, 11 x 14 inches
Courtesy of the artist

Finally, there is evidence that interest in identity as an explicit theme in art is waning in the mainstream art world. The political need for art that self-consciously promotes identity is less pressing where some real advances have been made. Moreover, art-world fashions change; already the terms "identity" and "multiculturalism" have begun to sound dated.¹⁹ A younger generation wants to move beyond identity labels and make art about a wide variety of themes. Many express no interest in exploring ethnic or gender identity through art. With playful seriousness, curator Thelma Golden uses the evocative term post-black to describe art and ideas characteristic of certain artists who emerged at the end of the 1990s "who were adamant about not being labeled as 'black' artists, though their work was steeped, in fact, deeply interested, in redefining complex notions of blackness." Golden explains that post-black artists "emerged empowered" by the multicultural debates and identity politics of the previous decade: as a result, they had the confidence to develop in individual directions. But theirs is not the self-contained individualism of a premulticultural generation. They are embracing multiple histories and influences and are reinventing identities for the twenty-first century.²⁰

In 1992 the United States recognized the five hundredth anniversary of Columbus's first voyage to the Americas. While most public events designed to mark the anniversary were planned as proud celebrations, Native Americans offered their reactions from a more somber vantage point. For them, Columbus's arrival in the Western hemisphere is remembered as the initial encounter of European and Indian civilizations, an encounter that resulted in violent contact and tragic results. Over a span of some four hundred years (from 1492 until the closing of the American frontier at the end of the nineteenth century), Native Americans lost their rights to land, Indian cultures were uprooted, and indigenous peoples suffered subjugation (especially in South America). Horrific numbers became victims to diseases the Europeans brought with them. The colonial era of European discovery and settlement meant increased warfare and displacement for the indigenous peoples who were already in the Americas.

In response to the Columbian quincentennary, Jaune Quick-to-See Smith, a prominent contemporary artist and enrolled member of the Flathead Salish, created a monumental oil painting. Measuring over thirteen feet wide, *Trade (Gifts for Trading Land with White People)* [color plate 11] is a multi-layered artwork. The representation of a canoe dominates the image. The canoe's abstract simplicity is reminiscent of a pictographic image—a flat, abstracted style of representation that was used in many Indian cultures prior to the twentieth century. In the context of Quick-to-See Smith's art, the canoe shape serves as an icon symbolizing Native American people—their culture, history, and ongoing existence. Constructed on three separate canvases, *Trade* is a triptych, a tripartite format often reserved for sacred imagery (such as scenes from the Bible) in European art in the late fifteenth century, the time of Columbus's voyage. Smith employs the image of an Indian war canoe as a sacred object, worthy of veneration and meditation.

Around and within the image of the canoe, Smith affixed a plethora of collage material, including photographic images of news events, illustrations of animals, and snippets of text from current newspapers and magazines. She also incorporated imagery culled from other artists' work. For example, in the upper right of Smith's painting we find a copy of a drawing by George Catlin (an artist who accompanied expeditions into Indian territories in the early nineteenth century); the image in the drawing juxtaposes an Indian in headdress with the same Indian wearing European-style clothing. The various newspaper clippings incorporated into *Trade* provide tidbits of information about late-twentieth-century daily life, such as a culture fair on an Indian reservation and an event at a university. Taken as a whole, the painting expresses Smith's understanding of the dynamic process of history: while earlier ways of life are lost, other patterns of living take shape. The canoe endures. The artwork's entire composition is

embedded in a field of gestural brushstrokes. The overriding color scheme of bold greens and reds calls to mind the world of nature as well as the bloody conflicts of earlier Indian wars.

A row of trinkets (including a toy tomahawk and Atlanta Braves baseball cap) is festooned above the three canvases. Smith's tongue-in-cheek approach holds up evidence of the commercial exploitation of Native Americans by the dominant capitalist culture. Stereotyped portrayals of Indians, such as the Atlanta Braves baseball team's mascot with his huge grin and bright red skin, hang alongside consumer goods featuring a racialist use of nicknames, such as a pouch of Red Man tobacco. In her painting, Smith seems to offer to trade these cheap items *back* to white America; doing so, Smith offers an ironic commentary on the history of European colonialism, which perpetrated a long litany of "peace treaties" and "trades" with Indians—such as the purported purchase of Manhattan Island for the equivalent of twenty-four dollars' worth of cheap trade goods.

Some critics, collectors, and viewers of Native American art prize the work of artists who continue to utilize styles and subjects that identify closely with the work of their ancestors. Exemplifying this approach are current artists and artisans who create pottery and jewelry that look almost identical to objects made over a century ago. Other artists foster an approach to making art that signals the vitality of change and emphasizes the reality of the present. For example, Quick-to-See Smith's hybrid approach to the use of disparate materials and modes of image making is consistent with her identity as a contemporary artist educated in both mainstream and Indian cultures. For these artists, to insist on preserving an unchanging vision of what it means to be Indian would be to foster a romantic, essentialist view of the past. In fact, history shows that tribal cultures were never static; all cultures underwent a process of change, including the incorporation of new ideas, tools, and resources. The Plains Indians, for instance, adopted (and adapted to) horseback riding only after Spanish conquistadors first shipped horses from Europe in the sixteenth century.

Quick-to-See Smith explains, "Dying cultures do not make art. Cultures that do not change with the times will die." The pastichelike quality of Smith's approach to painting—combining found objects with oil paint—matches the hybrid character of her expression of Indian identity. Today's Native Americans live complex lives, embedded in a rich mixture of cultural influences. Like most, Quick-to-See Smith's life has involved interactions with the world of mainstream culture and commerce; like other Americans, she has watched television, experienced her own direct encounters with the natural world, and heard stories passed down from her ancestors.

Trade exemplifies an activist approach to art-making. Activist art is an art of conscience, of creating for a cause. Donald Kuspit describes the preferred stance of activist artists as a willingness to "confront rather than console." In this painting, the artist critiques mainstream American culture's tendency to pigeonhole

4-9 Jaune Quick-to-See Smith | Paper Dolls for a Post Columbian World with Ensembles Contributed by the U.S. Government, 1991

Watercolor, pencil, and Xerox on paper, 13 pieces, 17 x 11 inches each Courtesy of the artist and the Eiteljorg Museum of American Indians and Western Art, Indianapolis

Native American identity. In *Paper Dolls for a Post Columbian World with Ensembles Contributed by the U.S. Government* (1991) [4-9], the artist refers to the shameful act of giving Native Americans blankets and clothing purposely infested with smallpox germs. In other artworks, Quick-to-See Smith incorporates an image of Coyote, a trickster figure in Native American culture who can alter his appearance by shape-shifting. Coyote is a primary figure in some tribal creation stories: "It is said that the Human Beings were created when Coyote turned on the light." Coyote's ability to survive is an apt symbol for Smith's recognition that Indian cultures must be capable of transformation and renewal if they too are to continue in the twenty-first century. Never sentimental, Smith's use of the Coyote image is an example of a Native American artist reasserting control over the meaning of a Native American symbol.

Smith is one of only a small number of contemporary Native American artists who have received widespread attention. Her work has been collected by important museums, and she has been featured in solo exhibitions in prominent galleries in New York City, Chicago, and other cities throughout the nation. As a way of supporting others. Smith has initiated activities that foster recognition of a wider group of Native American artists. She has broadened her career by accepting roles outside of her practice as an artist. Serving as a curator of exhibitions featuring other artists' work, she helped validate a more experimental range of artistic expressions for contemporary Native Americans. For example, at the time of the quincentennary, Smith organized Submuloc Show: Columbus Wohs. This exhibit traveled the country in 1992 and presented artworks by a large group of significant Indian artists. The exhibit's title—spelling the explorer's name in reverse—underscores the importance of seeing the world from another's perspective. While organizing group Native American shows is an important step, Smith recognizes that Native artists also need recognition and inclusion in exhibitions alongside artists of other backgrounds if they are to gain widespread critical attention.

As an artist, Smith could be described as a postmodernist: she appropriates and combines styles of imagery from other cultures and periods of history. Smith's approach to painting references the mark-making bravura of the Abstract Expressionists of the 1950s and 1960s, the irony of 1960s Pop Art, the energy of 1980s Neo-Expressionism, and the collage strategy of many modern and postmodern artists. Smith's work emphasizes deeply felt ideas about topical social issues, and her output also seems to be made in a spontaneous burst of emotion and creativity. What separates Smith's approach from many postmodernists' is that in undertaking her work she refuses to employ the products of culture as if objects and images were only arbitrary signs without any underlying significance. Smith insists that actions have real consequences. She examines some of the consequences of Native Americans' and newer arrivals' shared historical legacy and calls on all of us to reexamine the past and face the future without blinders.

Born 1940, on the Indian Mission Reservation in Saint Ignatius, Montana, Quick-to-See Smith received a masters in art from the University of New Mexico, Albuquerque. She now lives and works in Corrales. New Mexico.

Notes

- 1. Claire Pajaczkowska, "Issues in Feminist Visual Culture," in Fiona Carson and Claire Pajaczkowska, eds., Feminist Visual Culture (New York: Routledge, 2000), p. 8.
- 2. Lucy R. Lippard, Mixed Blessings: New Art in a Multicultural America (New York: Pantheon Books, 1990), p. 21.
- 3. See Roland Barthes, "The Death of the Author," in *Image, Music, Text*, trans. and ed. Stephen Heath (New York: Noonday Press, 1977), pp. 142–48.
 - 4. Lippard, Mixed Blessings, p. 22.
- 5. Linda Weintraub, Art on the Edge and Over: Searching for Art's Meaning in Contemporary Society, 1970s–1990s (Litchfield, Conn.: Art Insights, 1996), p. 99.
- 6. Jin Weihong, "A Theme of Me—Woman," in *Jin Weihong* (Shanghai: ShanghART, 1998), p. 3. An exhibition catalog.
- 7. Walter Truett Anderson, ed., *The Truth about the Truth: De-confusing and Re-constructing the Postmodern World* (New York: Putnam, 1995), p. 128.
 - 8. Lippard, Mixed Blessings, p. 20.
 - 9. bell hooks, "Postmodern Blackness," in *The Truth about the Truth*, p. 122.
- 10. Margo Machida, "Out of Asia: Negotiating Asian Identities in America," in *Asia/America: Identities in Contemporary Asian American Art* (New York: Asia Society Galleries and New Press, 1994), p. 107. An exhibition catalog.
- 11. Portions of this section, "Sexual Identity Is Diverse," appeared previously in Jean Robertson, "Artistic Behavior in the Human Female," in Betsy Stirratt and Catherine Johnson, eds., Feminine Persuasion (Bloomington: Indiana University Press, 2003), pp. 23–38. The material has been revised and shortened for this book.
- 12. Judith Butler, Gender Trouble: Feminism and the Subversion of Identity (London and New York: Routledge, 1993).
- 13. Roger D. Hodge, "Onan the Magnificent," Harper's Magazine 300, no. 1798 (March 2000): p. 77.
- 14. B. E. Myers, "What Is My Legacy? Transient Consciousness and the 'Fixed' Subject in the Photography of Renée Cox," in Salah M. Hassan, ed., *Gendered Visions: The Art of Contemporary Africana Women Artists* (Trenton, N.J., and Asmara, Eritrea: Africa World Press, 1997), p. 32.
- 15. Ella Shohat, introduction to *Talking Visions: Multicultural Feminism in a Transnational Age*, ed. Shohat (New York: New Museum of Contemporary Art; Cambridge: MIT Press, 1998), p. 12.
- 16. Homi K. Bhabha, Edward Said, Olu Oguibe, Trin T. Minh-ha, and Sarat Maharaj are among the many writers who have contributed to these discussions.
- 17. Rohini Malik and Gavin Jantjes, A Fruitful Incoherence: Dialogues with Artists on Internationalism (London: Institute of International Visual Arts, 1998), S.V. "hybridity" (in glossary).
 - 18. Gavin Jantjes, introduction to A Fruitful Incoherence, p. 16.
- 19. Gavin Jantjes told artist Marlene Dumas that he prefers the term "new internationalism" to "multiculturalism." He explained, "I have been using the term internationalism as an open ended term. I have not used multi-culturalism because I think that certain associations, both historical and cultural, make it a discourse of the past. I speak of internationalism because it allows me to understand what is happening in the world on the back of those

historical notions of multi-culturalism." Gavin Jantjes, "Marlene Dumas," in *A Fruitful Incoherence*, p. 55.

- 20. Thelma Golden, introduction to *Freestyle* (New York: Studio Museum in Harlem, 2001), p. 15. An exhibition catalog.
- 21. Jaune Quick-to-See Smith, quoted in Lucy Lippard, Mixed Blessings: New Art in a Multicultural America (New York: Pantheon Books, 1990), p. 28.
- 22. Donald Kuspit, quoted in Allan M. Gordon, "George Longfish and Jaune Quick-to-See Smith at UC Davis," *Artweek*, April 1997, p. 21.
- 23. Jaune Quick-to-See Smith, quoted in Erin Valentino, "Coyote's Ransom: Jaune Quick-to-See Smith and the Language of Appropriation," *Third Text* 38 (Spring 1997): p. 25.

Detail of 5-2

The Body

The bodies we inhabit distinguish humans from all other species on the planet. According to the view of science, after a million years or more of evolution, our shared human physiology of flesh and bone and blood and muscle (including our unique hands with opposable thumbs), the structure of our sensory apparatus, and the complex network of synapses in our brain shape our physical beings and our sense of our own humanity. Our body functions like a prism through which we perceive the world.

According to many religions (and the worldviews of societies permeated by those religions), the body is also the earthly home for the soul. This idea has had a paramount influence on past Western art. As art historian and critic Thomas McEvilley notes, "Traditional Western sculpture of the figure, from Pheidias to Michelangelo to Rodin, attempted to portray the soul in the body—or rather, the body ensouled. . . . The soul was the essential truth of human nature and the sculptor was engaged in the portrayal—ultimately the embodiment—of that essence." ¹

In the postmodern outlook, in contrast, there is no soul but only the body. We are bodies alone. Postmodern art of the figure deals with this condition, according to McEvilley, by portraying the body as an empty vessel. The figurative works of Kiki Smith, Juan Muñoz, Mike Kelley, Jeff Koons, and James Croak [5-1], among others, are examples McEvilley believes show "the human figure as empty in itself or emptied out, gutted, by experience." Croak, for instance, has made skinlike suits of cast latex that appear hollow, as if emptied of any essence or soul.

As explored by artists of the 1980s, 1990s, and today, the theme of the body overlaps with the theme of identity. The body carries many of the visual signs that mark our own and others' identity as to age, gender, race, and so on. Thus artists who wish to make visible the enormous diversity of identities in our midst and to renegotiate how we value different identites often turn to body imagery. On the other hand, Western culture has inflated the importance of sight, as if identity were simply a matter of surface appearance. As we will see, there are artists who undermine the role of sight in defining identity by showing bodies that give ambiguous visual clues.

5-1 James Croak Decentered Skin, 1995
Mixed media
Courtesy of the artist

Is the body a biological organism or a cultural artifact? Bodily experiences are complex. Certainly many characteristics of the body are intrinsically physical. Men and women have different reproductive organs, people age, and physical disabilities and diseases are real conditions, no matter what their causes and consequences. Other aspects of the body are socially constructed, such as whether a person in a wheelchair

has difficulty entering a building or whether someone with gray hair or AIDS is welcomed in a workplace. Contemporary artists show the human form as a material entity, a tissue of flesh and bodily fluids; they also explore the many ways in which the body, like identity, is a cultural artifact, reflecting a society's views of proper behavior, social and economic roles, and power relationships.

This chapter considers contemporary art that is focused directly on the body and what the body means. As we look at this art, keep in mind that theme and subject in an artwork are not synonymous, even though they do, of course, bear a relationship to each other. The two often but not always overlap; while the majority of artworks with the body as a theme include figurative imagery, the reverse is not necessarily the case. Many artworks showing a human form (or parts thereof) are primarily concerned with other themes, such as time, spirituality, and place. Moreover, an artwork can be about the body without depicting the human form directly. For instance, an artist might use an article of clothing or a piece of domestic furniture such as a bed as a metaphorical substitute for the body. Maureen Connor's *Thinner Than You* [5-2] uses a tightly stretched dress form as a metaphor for the pressure American women are under today to strive for extreme thinness. Connor's empty dress also could be interpreted as an instance of the postmodern "empty vessel," a body drained of the illusion of a soul.

Past Figurative Art

The human figure is one of the oldest and most significant motifs in the art of most cultures, other than a few cultures that have prohibited figurative imagery in art used for religious worship. (Both Islam and Judaism are notable as religions that limit figurative imagery in religious art.) In the West, the vast majority of sculptures were figurative forms until artists began experimenting with nonobjective art in the twentieth century. In the European academic tradition, paintings showing the human figure were considered a greater accomplishment than paintings showing a landscape, still life, or other nonfigurative motif, and painters who aspired to fame devoted years to learning how to render figures. From its invention in 1839, photography took the human body as a major subject. Even in twentieth-century modernism, after figurative art had lost its dominance, significant artists continued to take up the challenge of the figure. Among these were renowned artists such as Pablo Picasso, Henri Matisse, Käthe Kollwitz, Henry Moore, Alberto Giacometti, Salvador Dali, Diego Rivera, Frida Kahlo, and Romare Bearden.

Through history, the body has provided artists with both form and content. Human figures are challenging, versatile forms that can strike many poses and provide a multitude of contrasting, complex shapes and visual relationships. As content, human figures have served to express deeply cherished cultural values, including beliefs about religion, sexuality, politics, and personal and social identity.

Figurative art has had a tumultuous history in the West since World War II. The most critically acclaimed art in the 1950s was nonobjective (although some of the Abstract Expressionists also made figurative works, such as the *Women* paintings of Willem de Kooning). At the same time, much attention was given to artists' gestures and creative process; think of the well-known photographs of Jackson Pollock making his drip paintings. Artists' self-consciousness about their own physical actions and creative process helped open the way to live-art forms such as Body Art, where the artist's

5-2 Maureen Connor | Thinner Than You, 1990 Stainless steel and cloth, 60 x 15 x 7 1/2 inches Courtesy of the artist

body literally served as the medium, as well as the Fluxus and feminist performance art events that flourished in the 1960s and 1970s. Meanwhile the Pop Art that emerged by the early 1960s reintroduced the human figure into avant-garde painting. Pop representations were clearly artificial, secondhand images appropriated from popular entertainment and mass-media advertising. Also in the 1960s, abstract, nonfigurative art continued and evolved in the form of Minimalism.

Beginning in the late 1960s, art by women focusing on bodily themes surfaced overtly and dramatically.³ Building on the consciousness-raising and activism of the political movement for women's rights, pioneering feminist artists claimed women's experiences, emotions, dreams, and goals as legitimate subject matter for art. Female sexual desire was a major topic they addressed from the outset, along with many others such as women's history, women's spirituality, and activist issues of equal access to education, jobs, and income. Early feminist artists explored a liberated sexuality through a range of media, from painting and sculpture to photography, video, installation, and performance.

Because women's sexual side had been repressed and unacknowledged for so long, artists at the outset used a sort of shock therapy to claim female sexuality as a theme. Women artists often breached the boundaries of the hitherto private realm of the female libido with sensational public displays. In some cases women artists of the 1960s and 1970s, including Carolee Schneemann and Hannah Wilke, flaunted their own hypersexualized bodies in erotic performances that celebrated their new-found sexual power. These works have been characterized as narcissistic and exhibitionist by some critics, but the approach was effective in asserting women's active libido and subjectivity.

A famous, widely publicized achievement of the early 1970s was the exhibition Womanhouse, organized by Judy Chicago and Miriam Schapiro and created by them and their students in the pioneering Feminist Art Program at the California Institute of the Arts.⁴ Working in a house in Los Angeles, the women created installations that exuberantly displayed tampons, underwear, and other items that referred directly to women's biological functions, including menstruation and childbirth. Various sections of the exhibition and accompanying performances raised issues of sexual violence, the psychic confinement of traditional women's roles, and restrictive social standards of feminine beauty.

Judy Chicago's collaborative installation *The Dinner Party* (1974–79) was another landmark. Besides recovering women of distinction from the dustbins of history, the iconography of *The Dinner Party*, particularly the use of vulva designs on the plates, was a clarion call to rescue the female body from Western male stereotypes. Indeed, the use of "cunt imagery" (to use Chicago's terminology) from the 1970s on has been a recurring strategy for resisting male voyeurism and asserting a female sexuality centered on female perception.

A New Spin on the Body

Starting in the 1970s in Europe and booming in the United States in the 1980s, Neo-Expressionism moved figurative art to center stage. Buoyed by a frenzy of interest from well-heeled collectors, prominent German, Italian, and American Neo-Expressionist artists, such as Jorg Immendorff, Georg Baselitz, Sandro Chia, Mimmo Paladino, and Julian Schnabel, turned art's brightest lights back on the human body and, not

coincidentally, back on painting. Neo-Expressionism, with its emphasis on the physicality of the creative process and the tactility of the materials used, proved a perfect vehicle for representing the corporeal body, as well as the body of myths and dreams. Neo-Expressionist art, however, was often about history, personal psychology, or mythology and literature rather than about issues of the body per se.

Also in the 1980s, other artists, particularly feminists and artists of color, were engaged with politicized issues pertaining directly to the body. Cindy Sherman, Barbara Kruger, Mary Kelly, Helen Chadwick, Adrian Piper, and Lorna Simpson, to name a few, deconstructed the ideological meanings of objectified and stereotyped representations of the body from the past and present. Ideas from the theoretical discourses of post-Freudian psychology, Marxism, poststructuralism, and postmodernism, articulated by writers and theorists such as Hélène Cixous, Julia Kristeva, Luce Irigary, Griselda Pollock, Craig Owens, Lisa Tickner, and Kate Linker, exerted a strong influence on artists engaged with the politics of the body.

The dramatic increase in the 1980s in artistic representations of female sexuality from a female point of view can be traced back, in part, to the recognition that body images and sexual identities are, to a large extent, culturally and psychologically constructed. This change started to take shape in the 1950s, following the publication of two groundbreaking books: Alfred C. Kinsey's Sexual Behavior in the Human Female and Simone de Beauvoir's The Second Sex. De Beauvoir famously wrote, "One is not born a woman, but, rather, becomes one," claiming that sexual identity depends primarily on cultural conditioning, not biology. According to de Beauvoir (and many others who have worked from similar hypotheses), how people see themselves and others as sexual beings, how we define our sexual identity, and even our erotic responses to stimuli are reshaped by social experiences and political events. Sexual behaviors, preferences, and attributes reflect social values. At the same time, as researchers in a wide range of fields from genetics to physical anthropology have proposed, some facets of sexuality are biological and instinctual. Women artists have debated, through both verbal and visual means, how much of sexuality is simply physical and how much is intellectual.

In the 1990s and early 2000s artists reinvigorated and reinvented figurative art, emphasizing the physical and the tactile. To a greater degree than ever before, such art has not only shown the figure but has been about the body. Artists have given visual form to previously tabooed aspects of sexuality; they have explored the impact on the body of developments in medical science and computer technology; and they have vigorously expressed what it feels like and what it means to inhabit a mortal, physically changing, and vulnerable body, in all its aspects.

In exploring the theme of the body, contemporary artists have utilized a range of strategies and motifs. Artists have dealt with the body in unusual ways—by multiplying it, by fragmenting it, by isolating body parts, by using hair or bodily fluids such as blood as stand-ins, and by showing organs and other elements of the body's interior. Moreover, a great deal of art evokes the body without presenting any human image or including an actual person. Clothing has served as a metaphor for the body, as have household furnishings such as beds, which are in intimate contact with the body. Negative spaces in sculptures record imprints made by the body. Installations resemble empty stage sets, waiting for a human presence. At the same time, contemporary artists have continued to use the body as an artistic medium in both live events and recorded performances.⁶

The Body Is a Battleground

"Your body is a battleground," proclaims a text in a 1989 artwork by Barbara Kruger. Kruger was referring specifically to the pro-choice movement and women's struggle for reproductive rights, but the slogan more generally encapsulates the notion that the body, including its expression in sexuality, "is one of the great political arenas of our times," as Thomas Laqueur puts it. Cultural battles over bodies are waged in the mass media, in the streets, in halls of government, and in sleeping quarters the world over. Controversies address the following issues and more: conventions regarding the most socially preferred size, shape, age, and color of bodies; taboos against specific forms of sexual expression; attitudes about what constitutes mental and physical well-being; moral and legal ramifications of medical decisions affecting the dying; and rules governing the treatment of prisoners, patients, and other institutionalized people. Battles over bodies generally boil down to the question: who should be in control? Who is in charge of how we see a body, when we see it, why we see it, and what it means to us when we see it?

Artistic explorations of the body in contemporary art reflect attitudes about the body in the culture at large, but attitudes about the body are seldom clear-cut and totally one-sided. Fundamentalist churches exercise a considerable degree of power in the United States, for instance, by spending money to buy radio air time to communicate a message about the moral need to abstain from premarital sex; at the same time, this message competes with the forceful message that runs through much of pop culture, that sexual desire, and its fulfillment, is highly pleasurable and a natural and healthy expression of youth. This is a battle over the control of aspects of sexual expression. Similar contests for the attitudes citizens hold regarding the appearance and display of the body are being waged in societies all over the world. Think, for instance, of the mid-1990s Taliban law in Afghanistan decreeing that each woman's body and face must be hidden by a burka. The "culture wars" in the United States over the past two decades have turned frequently over issues of control of bodies, particularly as artistic representations challenge mainstream commercial representations. Much of the most widely debated art of the period—such as Robert Mapplethorpe's photographs of homosexual subcultures and Karen Finley's performance pieces in which sometimes she smears food on herself (chocolate, eggs, kidney beans) to present herself metaphorically as an abused woman-confronts the viewer with the often shrouded but everyday occurrence of bodily processes and physical desires. The culture wars were concerned with protests against sexually explicit art as well as politically activist protest art and art that some deemed religiously offensive. The distinction in types of content can be blurred. For instance, sexually explicit art, especially if it is homoerotic, came under attack because religious fundamentalists often viewed such depictions as immoral on religious grounds. As artists have transgressed taboos, controversies have erupted and attempts at censorship have reached courtrooms and the halls of the U.S. Congress, primarily through attempts to pressure politicians to cut off public funding for art exhibitions.

The Body Is a Sign

The body has value, and it is often measured relative to the value of other bodies. In contemporary society, for example, thinness is a highly valued characteristic of female bodies. Size and strength are highly valued characteristics of male bodies. These values are communicated by the preponderance of messages in the mass media linking thin female

bodies and strong male bodies with other qualities that are valued. For example, a study conducted by researchers at Michigan State University showed that thin female characters in television shows are far more likely to be involved in romantic relationships than their heavier counterparts. This linkage of values involves viewers in the interpretation of the body as a sign; when a thin female body is seen, we are trained to read into it sexual potential. The body is a sign in a language of social meaning. Connor's sculpture *Thinner Than You* [5-2] exaggerates the quality of thinness to such a degree that its positive value is called into question. The thinness is so excessive that it no longer functions as a sign of sexual appeal but, according to Alison Ferris, refers "directly to the extreme consequences of the current fitness and slimming mania—anorexia and bulimia."

Identification of a person by gender is a key area where we rely on bodily signs to name someone as "male" and "female." In chapter 4, we discussed the fluidity of identity as understood by postmodernists and multiculturalists. In terms of gender, this perspective suggests that gender identities, such as masculinity and femininity, are roles influenced by culture. Hence, gender roles are open to challenge, negotiation, and redefinition. The fluidity of gender and sexual identity is one theme of Collier Schorr's posed photographs taken in Germany of young models. In her photo "In the Garden (Karin in Grass)" (1996) [5-3], the body of the model is displayed as an erotic object, while the model's gender is ambiguous. The model lies in a reclining pose that is part of Western male artists' conventions for depicting the female. The model wears makeup and a gauzy bra bound tightly across the chest, yet displays signs of "maleness" such as a short haircut, hairy legs, and underwear bunched at the crotch in a phallic shape.

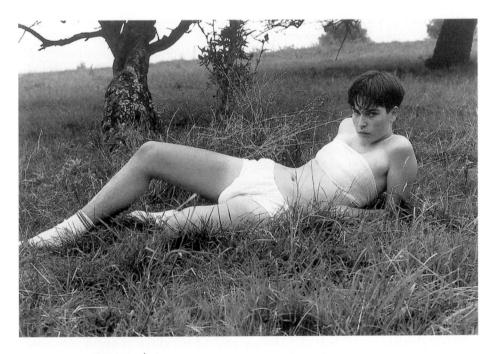

5-3 Collier Schorr

"In the Garden (Karin in Grass)," 1996

C-print, 9 x 13 1/4 inches Courtesy of 303 Gallery, New York Reactions to Schorr's photographs also reveal national differences; for instance, German viewers do not automatically see unshaven legs as male.

The practice of using the body symbolically in visual art is long-standing. For example, in ancient Egyptian sculptures and paintings, the pharaoh is often shown much larger than ordinary mortals, to emphasize his higher status; moreover he stands in an erect, stiff posture that signifies his unyielding majesty and authority. Artists utilize a range of symbol-making strategies. For instance, art dealing with the body may employ a *metonym*, a part that symbolizes the whole. The dress shape in *Thinner Than You* [5-2] is an article of clothing that stands for the whole, a clothed female body.

People Are Bodies

We experience the world through our body. Our body's sensory apparatus allows us to gain knowledge about the world and to seek pleasure and feel pain. People are tactile, physical, visceral beings. Artists have focused on this fact with great intensity, using actual bodies as tools or body materials as art media. For example, Anne Wilson created a series of fiber artworks by embroidering human hair into remnants of antique table linens, and Adrian Piper, in her work-in-progress *What Will Become of Me?* presents in honey jars the artist's own hair, nails, and skin saved since 1985.

Janine Antoni, an artist who grew up in the Bahamas and now lives in New York, has become well known for works she creates by using her body as a tool. Antoni is interested in how the body and its physical processes can manipulate and mark objects, and what meanings different viewers infer when they perceive the residue of bodily actions. For example, in Gnaw (1992) Antoni created a pair of sculptures by biting enormous cubes of lard and chocolate, leaving the imprint of her teeth on the blocks. The bites were spit out and turned into other objects. The lard was mixed with bright red pigment and beeswax to make 135 lipsticks, and the chocolate was cast into 27 heartshaped packages for chocolate candies. To make Eureka (1993) she had herself lowered into a bathtub filled with lard then exhibited the tub with the imprint of her now-absent body. The artist used the lard that she displaced, mixed with lye and water, to make a large block of soap. She then washed herself with the cube of soap, slowly sculpting it through her repeated action. In Slumber (1994) [5-4] the artist's brain became a creative tool while engaged in the unconscious process of dreaming. Slumber was shown in museums around the world. In each installation, Antoni incorporated herself as part of the artwork, sleeping in a bed in the gallery while an electroencephalograph (EEG) machine recorded her eye movements while dreaming. During the day Antoni used fabric from her nightgown to weave the pattern of her EEG record into an ever-lengthening blanket woven on a large wooden loom. The body's state of dream-consciousness was integrated with the artist's conscious daytime awareness to produce the overall work.

In 2003 at the Luhring Augustine Gallery in New York, Antoni performed *To Draw a Line* [color plate 12], a work for which she spent equal time over an extended preparatory period disciplining her body to learn to tightrope walk and to fall safely. During the performance the artist walked to the center of a tightrope and balanced there for as long as she could. Inevitably, she fell, gracefully descending into a mound of soft, raw hemp fiber. Antoni, inspired by her experience of learning to balance and fall, created an object that mirrored the action she performed. On opposing inclined planes, the artist balanced two large steel industrial reels, bearing more than six thousand pounds of lead ingots; the construction held a handcrafted hemp rope in tension. The sculpture,

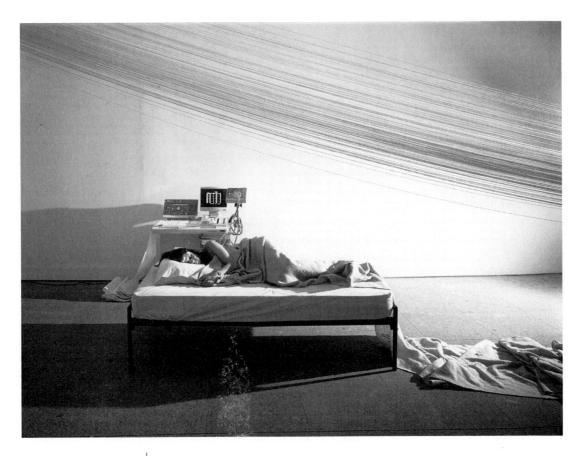

5-4 Janine Antoni | Slumber, 1994
Loom, yarn, bed, nightgown, EEG machine, and artist's REM readings (detail of performance)
Photo by Javier Campano
Courtesy of the artist and Luhring Augustine, New York

bearing the imprint of her body from the fall, remained on view for several weeks. Antoni's tightrope walk, where she must constantly adjust her body position to maintain balance, seemed to suggest that moments of balance (in life and in art) occur but are fleeting; no possibility of permanent stasis exists. The fall itself was a wonderful unique event in the arc of the performance, wherein the artist relinquished conscious control over her body in the confidence that her kinesthetic memory achieved through months of rehearsal would bring her to a safe landing.

Why have many contemporary artists focused on the body? In some cases, this focus is a result of an activist stance towards art making, in which the personal becomes political. In an essay analyzing the formation of the feminist art movement in the United States, artist Suzanne Lacy provides a list of key ideas that helped propel the work that feminist artists were making in the 1970s and into the 1980s. Among these, she notes that the body became a primary site for works of art. Lacy explains: "Not only was the body a site, it was an important source of information. Much of women's social status was seen as based in the body, so issues like violence, birthing, sexuality and

beauty were frequent subjects."¹⁰ In other cases, artists using the body have made an aggressive decision to blur the boundaries between art and life. Linda Montano, discussing a work of performance art in which she was tied by rope to the artist Tehching Hsieh for one continuous year (1983–84), explained the consequences of viewing all their bodily actions as forms of art: "because I believe that everything we do is art—fighting, eating, sleeping—then even the negativities are raised to the dignity of art."¹¹

The Body Beautiful

Although the human body is a perennial theme in art, not all body images are equally valued; in any culture, some images have high status while others are despised and even censored. Western concepts and images of the human body owe much to the ancient Greeks, who believed the gods took human form and that the most physically perfect humans reflected the ideal beauty of the gods. Greek figurative art typically showed an intact, young, healthy body with proportions that the culture considered most desirable—a model of the perfection they believed humans should aspire to. From the Renaissance onward, classical Greek ideals of physical beauty pervaded European art. Even today, some artists, including sculptor Robert Graham, photographer Jock Sturges, and painters Mel Ramos and Carlo Maria Mariani, continue to produce variations on the classic image of the young, beautiful body.

While the specific Greek ideal of a young, classically proportioned body has been influential, alternate ideals of physical beauty can be found in many cultures. For example, although contemporary Americans make a fetish of the slim female body and well-toned male body, in sixteenth- and seventeenth-century Europe an ample body was most admired as evidence of a person's wealth and power. Cultural ideals dominate the representation of bodies in art even though few real bodies resemble the images. Whatever the culture's dominant body ideals, people see so many images of the preferred body types that they may think those types are innately superior and that other kinds of bodies are lesser and defective. But a look at history destroys the illusion of the natural superiority of any one culture's ideals of what is beautiful.

Different Bodies

Every culture constructs images of attractiveness. Certain body types are presented as the ideal objects of desire and they dominate advertising, movies, and other areas of visual culture, while other body types are denigrated and characterized as undesirable. In Western culture today, for example, the sexual ideal for women is defined within incredibly narrow parameters—they must be young, thin, and fit—and there is enormous pressure on women to strive for this ideal, however unrealistic. As Ynestra King writes, discussing disabled women in particular, "It is no longer enough to be thin; one must have ubiquitous muscle definition, nothing loose, flabby, or ill defined, no fuzzy boundaries. And of course, there's the importance of control. Control over aging, bodily processes, weight, fertility, muscle tone, skin quality, and movement. Disabled women, regardless of how thin, are without full bodily control."

Over and over we find artists making works that critique the narrow standards of beauty and sexual attractiveness, which stunt people's perceptions of their sexual potential. Some artists, among them Hannah Wilke, Joanna Frueh, Laura Aguilar, Jenny Saville, and Jo Spence, challenge the assumption that the "perfect" body found in media

images is the only attractive one by representing people who are aging, physically large, disabled, or scarred who are also erotic. Such bodies provide a spectacular contrast to the sanitized, frozen-in-time images found in the world of fashion and advertising. Other artists, including Martha Wilson and Maureen Connor, explore the psychic stresses that accompany eating disorders, excessive plastic surgeries, restrictive clothing, and other self-punishing attempts at conforming to the social ideal. Some artists, including Lorna Simpson and Barbara Kruger, strive to "lay bare the ideological underpinnings (including sexism, ageism, and racism) of ideals of beauty."¹³

One strategy popular today is the use of humor, parody, or excessiveness to subvert stereotypes of the ideal body. Drawing on the work and terminology of the Russian literary critic Mikhail Bahktin, writers and artists use notions of *carnival* and *the grotesque body* to discuss works that borrow "tropes from the traditions of the carnivalesque, the tradition of licensed subversion in which hierarchical rank and prohibitions are suspended via vulgar humour, profanities, and costumes and masks." For example, Nancy Davidson takes inflated giant weather balloons and molds them with fetishistic props such as fishnets, corsets, and G-strings into camp versions of voluptuous female buttocks and breasts. Davidson says, "I am interested in humor, excess and the gigantic woman. It comes from being a longtime feminist and being aware as a woman, feeling powerful. When you feel in control, you can take a risk. You can play the part of the clown or the fool." Is

In contemporary consumer culture—in advertising and popular media such as television and films (especially in so-called action films)—narrowly defined ideals of physical beauty continue to dominate. In art in contrast, the human body appears in great variety. Not only do artists represent bodies of all types, some expose the narrowness and artificiality of having an ideal of physical beauty in the first place. For her 1998 performance *Show* at the Guggenheim Museum in New York, Italian-born Vanessa Beecroft posed fashion models (a few in the nude, most wearing black bikini underwear) in triangular formations. Her tableau presented living, breathing women, yet the models were so similar in their tall, thin proportions that en masse they appeared bizarrely dehumanized, lacking in the individuality we expect to see in crowds. *Show* can be read as a deconstruction of the artificial ideal of the female body promoted by consumer culture.

Along with representations of bodies that are diverse in size and shape, we find a range of bodies expressing diverse cultural identities in contemporary art. This trend began in the 1980s and 1990s as issues of multiculturalism, fueled by the civil rights and feminist movements of the previous twenty years, received attention in the mainstream art world. Representations of ethnically and racially diverse bodies by artists such as Faith Ringgold, Hung Liu [color plate 10], Guillermo Gómez-Peña [4-7], James Luna [4-3], and Shirin Neshat [5-9 and 5-10] became visible in prominent art museums and art publications. These representations of difference also served to undermine the notion of a universal standard of beauty for human figures.

Body Parts

An important motif in contemporary art that is decidedly anticlassical is the use of a partial body or body parts. While relating to such historic masterworks as the Venus de Milo (a well-known classical Greek statue with missing arms), contemporary fragmented figures are deliberate, not the result of accidental breakage. ¹⁶ For example,

British artist Marc Quinn created life-size figurative sculptures carved in marble, whose pristine white surfaces at first glance evoke classical statues that have lost limbs or exist only as fragments. A closer look reveals that the sculptures are portraits of actual people who are missing one or more limbs. Quinn's sculptures "challenge and displace the classical ideal of 'beauty' and the category of the heroic and perfected nude," an effect that was accentuated in a 2001 installation of his sculptures in a hall of Neoclassical statues at the Victoria and Albert Museum in London.¹⁷

Sculptures by artists such as Bruce Nauman, Kiki Smith, Dinos and Jake Chapman, and Robert Gober have featured dismembered body parts (such as heads rotating on a carousel-like contraption by Nauman and a single leg protruding from a gallery wall by Gober). Matthew Barney's film *Cremaster 3* features an actress, Aimee Mullins, who has a prosthetic leg [color plate 13]. (The film cycle itself is titled after a muscle in the male body, the cremaster, which raises and lowers the testicles.) According to Helaine Posner, who curated Corporal Politics, an important exhibition of art showing fragmented bodies held in 1992 at the MIT List Visual Arts Center, "The dismemberment of the body in late-twentieth-century art is no accident. It is the result of living in a world in which violence, oppression, social injustice, and physical and psychological stress predominate. We may long for the secure ideals of beauty and wholeness embraced by past generations, but experience tells us that this worldview is obsolete." 18

Mortal Bodies

Numerous contemporary artists believe that in order to fully understand the human condition we need to perceive the body in its raw physicality and in all its changing shapes and states. In particular, conditions that remind us of mortality—aging, disability, pain, illness, and death—must not be hidden. Especially since the advent of AIDS in the 1980s, art has increasingly presented the human body as fragile, diseased, wounded, or dying. David Wojnarowicz and Felix Gonzales-Torres were well-known artists dealing with AIDS as a theme in the 1980s and 1990s, respectively. (Both artists died as a result of contracting the virus.)

In addition to representing mortality, contemporary artists question what terms such as "wholeness," "beauty," and "health" mean and who has the power to define them. John Coplans revealed his own aging body in a series of large-scale photographic self-portraits (first exhibited in 1986 and continued until the artist's death in 2003) that provide close-ups of wrinkles and sagging flesh. These artists seem to be asking: Why can't age, like youth, be considered beautiful or erotic? Who decided that a disability or a scar or a missing breast or limb are abnormal and must be masked? Of course a wound to the body or a disability causes unavoidable hardships, but societal assumptions and value judgments add unnecessary pain.

In recent art, body images and forms in which the figure has lost control over bodily processes, muscle tone, weight, and mobility are prevalent. Bodies sag, bleed, ooze, and drip; they sprout hair in odd places; limbs are wrenched off; surfaces are broken open. These nonconformist and anarchic bodies are another form of the "grotesque"; they defy the classical image of unchanging perfection. According to critic Sally Banes, who writes about dance and performance: "the classical body is smooth, finished, closed, and complete, in contrast to the grotesque body, which is rough, uneven, unfinished, open, and full of apertures." ¹⁹

The grotesque body is marked by time and life events. Although disagreeable, embarrassing, and even offensive to some, grotesque bodies assert the corporeal existence of the body and its mortality. Moreover, by transgressing acceptable boundaries of appearance and behavior, grotesque bodies subvert and resist social practices that tend to suppress individual differences or constrain freedom of expression. Furthermore, grotesque bodies can reveal suffering, violence, and abuse experienced by real people.

Many artists have produced works that include images of mortal bodies. Joel-Peter Witkin constructs and photographs surreal tableaux using dismembered corpses or living models who have missing limbs or ambiguous sexual organs. Kiki Smith has made sculptures of figures losing control of bodily processes, oozing blood or trailing feces behind them. And Rona Pondick has made sculptures in which anthropomorphic pieces of furniture or articles of clothing serve as substitutes for the body and as sexual fetishes. Pondick's *Baby Fat* [5-5] shows just the lower half of an anatomically grotesque body wearing little-girl shoes (a sign of gender and age). The "baby fat" sags around the girl's ankles, implying her lack of control over her body. Pondick's figure conveys the powerlessness and psychic stresses of childhood. It also can be interpreted as a metaphor for child abuse; in this way, Pondick's art is an effort to make public a type of bodily and psychological harm that is usually hidden.

Numerous artists have made art about illnesses, including Hannah Wilke, Nancy Fried, and Hollis Sigler about breast cancer, Bob Flanagan about cystic fibrosis, and Ron Athey about AIDS. When she was dying of lymphoma in 1993, Wilke made a series of life-size color photographs of her nude body swollen from cancer treatments. Fried, who made a series of sculptures about her own mastectomy, said, "I wonder if this society will ever break the tradition of the idealized female figure and create a new norm that looks at every woman's beauty with pride and acceptance no matter what shape her body is in? Will we ever get over the assumption that only flawless bodies are deserving of public display, approval and sexual expression?"²⁰

Some artists are building on developments in the medical sciences to emphasize the physicality and mortality of bodies. Belgian artist Wim Delvoye's Cloaca (2000), created with the help of doctors and biotech engineers, is a room-size installation that replicates the human digestive system. Mona Hatoum, a Palestinian artist from Lebanon who now lives in London, has represented her own body from the inside out. She employed specialist medical echographic technology to record the sounds of her body and endoscopic and colonoscopic technology to create a visual scan of her body's exterior and interior surfaces. The close-up imagery is presented as one sweeping continuous video image projected on the floor inside a white enclosure [5-6] in her installation Corps étranger (meaning "foreign body"). In watching the video, accompanied by recorded sounds of Hatoum's heartbeat and breathing, viewers follow as the camera pans the body, eventually penetrating the interior of the stomach, intestines, and vagina through various orifices. The meanings and politics of Corps étranger are ambiguous. On one level, Hatoum appears to be examining the increasing power and voyeurism of the clinical medical gaze, which now can invade the internal spaces of the female body; at the same time, the artist resists and destabilizes the customary male gaze by presenting strange or "grotesque" views. As Amelia Jones writes: "Here the naked female body is all vagina dentata, all hole, with nothing phallic/fetishistic left to palliate the male gaze."21

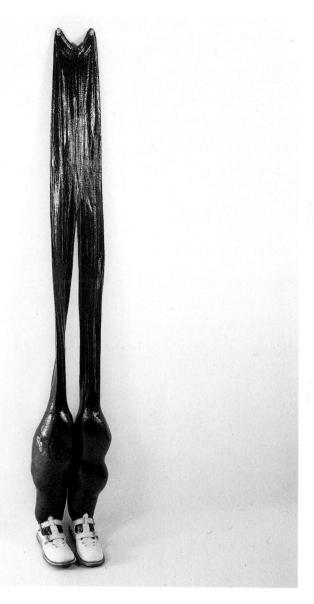

5-5 Rona Pondick | Baby Fat, 1991 Tights, polyester stuffing, shoes, and acrylic resin Courtesy of Sonnabend Gallery

Sexual Bodies

Sexuality has been expressed in artistic renditions of the body from very early times, although it has been denied or repressed in some times and places. For example, early Hindu figurative art was often sensual to the point of being erotic, while early Christian art hid the sensuality of the body under stiff, stylized garments. When figures were depicted in sexualized poses in Christian art before the Renaissance, their purpose was

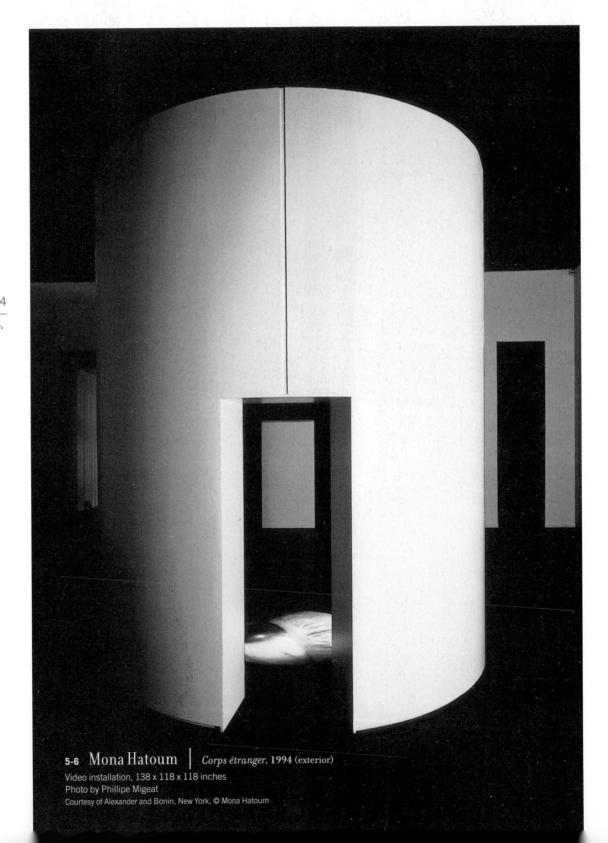

to portray sinful behavior that could lead to damnation. (Later Christian art, especially in the Baroque period, became more openly sensual and accepting of sexuality.)

The contemporary period in the West includes many examples of figurative art in which bodies are explicitly sexualized. Sometimes the art simply celebrates the pleasures of the flesh; at other times sexualized bodies serve as a means for investigating concerns about sexism, racism, gender roles, sexual identity, homophobia, reproductive rights, sexual violence, and the boundary between pornography and erotica. For example, gay and lesbian artists in the late twentieth century and today have fought for the visibility of their sexual identities by openly representing homosexual desire and same-sex relationships in artworks. Similar artistic challenges to normative views of sexuality and physicality are seen in works that display body types of all sizes and shapes brimming with erotic energy. For instance, in large-scale self-portraits, British painter Jenny Saville reveals her nude body in gargantuan proportions. That her flesh is marked, in some paintings, with incised words exposes the ever-shifting zone that links cultural representations of sex with violence.

The Gaze

A useful concept for thinking about sexual bodies in art is *the gaze*, a term that reflects the intertwining of visual control and power structures in society. In the West we tend to privilege the sense of sight as we interpret the world. This reliance on visual perception means that how we look and how we are looked at influence who we are as social beings. Those who hold the most power in society exercise some control over others by dominating the visual representations of people who lack power. This process of controlling vision (who gets looked at and how they get looked at) is what is meant by *the gaze*. The powerful want to gaze at images that give them pleasure and that reinforce their worldview. Those with less power often feel they must conform to prevalent images or risk being marginalized or ignored.

According to theories of the gaze advanced by John Berger, Michel Foucault, and others, looking is never neutral. Visual representations are not addressed to a neutral, universal audience but instead assume viewers are of a certain gender, class, and race. The concept of the gaze was given a feminist elaboration by film theorist Laura Mulvey, who argued that the gaze is gendered and who helped promote the argument that in the West the gaze addressed by most imagery historically has been male, heterosexual, white, and economically well-to-do, reflecting a patriarchal power structure built on gender, race, and class. According to Mulvey, Western visual representations of females typically assume a male spectator gazing at the female as a passive object. Further, the gaze is voyeuristic when the female is seen as a pleasurable sexual object.

Writings and artworks that analyze the gaze have considered many types of viewers and images. For example, various artists, including video artist Julia Scher, have examined the gaze of surveillance cameras that watch us in stores and other public places [3-9]. In terms of sexuality, up to now the most frequently considered topic pertaining to the gaze has been the voyeuristic gaze of men looking at representations of women as erotic objects. In European and Euro-American visual culture, most representations of sexual bodies are female stereotypes, depicted completely or partially naked, that appeal to the male heterosexual imagination. Women appear as passive and sexually desirable according to a narrowly defined ideal, which is often hypereroticized.

Artists who have made explicit the voyeuristic male gaze abound in recent decades. In their sculptural tableau *The Rhinestone Beaver Peep Show* (1980), Ed and Nancy Reddin Kienholz present an intense scenario pairing power and lust, in which someone with sufficient money can pay to spy on a female stranger's naked flesh. More recently, John Currin has combined meticulous craftsmanship with dry wit in painted scenes that include sexualized caricatures, such as large-breasted young women in tight sweaters. Lisa Yuskavage plays with the notion of the male gaze in many of her paintings by endowing her female figures with strangely shaped breasts and buttocks, simultaneously riveting and repelling the gaze on parts of women's bodies that are often fetishized [color plate 14]. (It is debatable whether Currin and Yuskavage subvert or pander to the male gaze.)

The concept of the gaze has provided a key area of analysis for women artists who are feminists. Feminist artists have resisted the male gaze by asserting the presence of a female consciousness and answering with a gaze of their own. Moreover, since the 1980s a great deal of effort has gone into revealing masculinist values embedded in the process of looking, as artists have deconstructed stereotyped images in art history and

visual culture generally.

In an openly feminist deconstruction of the hidden sexism in historical images addressed to the male gaze, Zoe Leonard juxtaposed her own unambiguous photographs of women's crotches with seventeenth-century portraits of women, all painted by men, in an installation (*Untitled*) at the Neue Galerie in Kassel, Germany, in 1992. Helen McDonald describes one juxtaposition: "a hand masturbates a vulva, while in the adjacent painting a seventeenth-century lady fondles her hair and veil in such a way as to reveal her naked breast and shoulder. Thus the frankness of the photograph shows up techniques of erotic titillation in the history of painting."²³

Multiculturalists and postcolonial writers have employed the idea of the gaze to analyze how Europeans and Euro-Americans dominated and objectified those they subjugated or enslaved. In the past, when Western artists, such as the French painter Paul Gauguin, represented people of color, they often portrayed their subjects as primitive, exotic, and sexually promiscuous.²⁴ Lorna Simpson [5-7], Michele Wallace, and other contemporary artists of color have struggled to make visible issues of racial difference that affect the politics of the gaze and to claim control over their bodies, including how and by whom they are depicted.

The gaze, as a construct of Western thinking, has generally turned on the idea of binary opposites. In terms of sexuality, binary thinking assumes that bodies can be unambiguously classified as male or female, as heterosexual or not heterosexual, and as white or not white. In contrast, artistically rendered bodies in some recent art, such as those by Catherine Opie [4-6], Lyle Ashton Harris [4-4], Collier Schorr [5-3], and Matthew Barney, are more ambiguous. These artists use body images to blur gender boundaries and counter the dominance of the male Eurocentric gaze by depicting lesbians, gay men, and androgynous individuals, as well as persons of mixed race and

ethnicity.

Finally, contemporary Western culture has begun to objectify the male body. The trim, sculpted "hard body" of the male found in mass media images has become an object of intense longing and desire; in American teen parlance in the early 2000s, a man, as well as a woman, can merit being called a "hottie." It will be interesting to see how this development influences future revisions of the theory of the gaze.

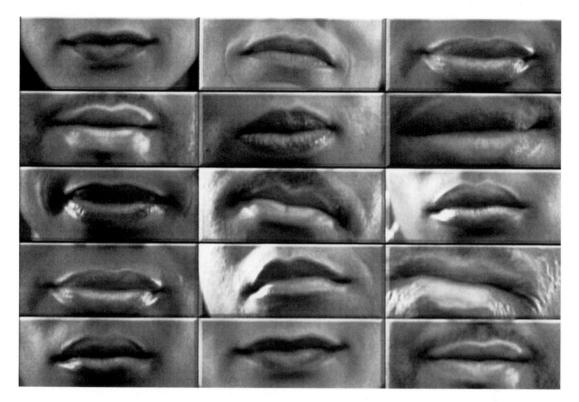

5-7 Lorna Simpson | Easy to Remember, 2001
16 mm film transferred to DVD, sound, 2 1/2 minutes
Courtesy of Sean Kelly Gallery, New York

Sexual Pleasure and Desire

Sexualized bodies represented in the art of the 1980s, 1990s, and early 2000s are often excessive in the desire or eroticism they convey. Robert Colescott, a painter who emerged in the mid-1970s, has depicted many such figures. His painting *Knowledge of the Past Is the Key to the Future (Love Makes the World Go Round)* (1985) is on one level an over-the-top image of voracious sexual attraction; it depicts mutual lust between a man and a woman. But the painting also presents a black male and white female. As Colescott knows, race is an area where sexuality has been highly charged throughout American history. Lucy Lippard writes that in this painting the naked figures "are shackled together, slaves to passion, as well as to historical precedent and taboo." Colescott uses broad exaggeration to force viewers to acknowledge the violent history of racial mixing in America and our present conflicted attitudes about eroticism and race.

Representations of female sexuality have occurred throughout the history of Western art, but until very recently they were almost invariably produced by male artists. The female nude was a long-standing artistic subject but not one permitted to women artists. Typical depictions by male artists of sexualized females were objectified, the women rendered in a state of total passivity as objects to be exploited for male

sexual gratification (and as sources of energy to be absorbed by the turned-on male). Female sexual desire, when it was shown at all by male artists, tended to be debased, as in the figure of the fallen woman, a temptress associated with carnal sin who led men astray, such as Eve or Salome.

One of the startling developments in contemporary visual art is the unparalleled rise in artistic representations of sexual pleasure and desire by women artists. Instead of appearing as passive, eroticized objects, women represented in art by women frankly register sexual needs and desires of their own. As with other sexual themes, the representation of eroticism has evolved over time. At first, emancipated women artists expressed conventional forms of heterosexual eroticism; their breakthrough was in asserting a female libido and in reversing the gaze to show their desire for men. Gradually women gained the confidence to enter the forbidden territory of same-gender or cross-racial desire.

In the 1980s artists and critics increasingly focused on how sexuality is socially and psychologically manifested, rather than on its biological expression. There was a move away from personal, vernacular work based on autobiography toward more conceptual pieces. Some women artists rejected any display of the fleshy, needy, organic female body, preferring to examine the social, political, and psychic systems that shape or constrict female sexuality. As Fiona Carson explains, "The physicality of the female body began to disappear under the weight of its own history in the early 1980s, becoming almost a taboo subject for image-makers because one would add to the overwhelming pile of objectified and stereotyped representations in the dominant culture. As its physical representation became increasingly problematic, the female body dissolved into a flux of shifting signifiers and tangential references. . . . What mattered was to deconstruct its ideological meanings, the interrogation of signs across its surface." 26

The 1990s and today have seen a renewed emphasis on physical displays of female potency in art. Younger women artists are highly transgressive, giving visual form to multiple, complex aspects of sexual pleasure and lust, in works that may refer to voyeurism, fetishism, and erotomania. For example, Annie Sprinkle, a former worker in the sex industry, achieved notoriety in the 1990s for performances in which she invited audience members to examine her cervix through a speculum. In a series begun in the mid 1990s, Ghada Amer took images from sex magazines of women masturbating and remade them in embroidery thread adhered to painted canvases, her signature technique. Marlene Dumas likewise has used pornographic images as source material. The now-routine depictions of explicit sexual acts in films and other forms of popular visual culture may be forcing women artists to up the shock value of their works as they try to get viewers to recognize female perspectives on sexual issues.

Artists and writers about art have also examined the ways in which erotic responses, like other aspects of sexuality, are culturally constructed. For example, Laura Letinsky photographs staged intimate encounters between real heterosexual couples that highlight, in their everyday details and awkward poses, the discrepancy between actual sexual encounters and our romantic expectations for them based on Hollywood images.

Not surprisingly, the expression of female eroticism in visual art is highly controversial. Some feminists, including the artist and writer Mary Kelly, are wary of pleasurable representations of female sexuality, particularly displays of an erogenous female body. Their reasoning is that because mass-media versions of the female body, which reinforce the view of women as sexual objects, are so pervasive, they compromise and even predetermine how viewers see images of female eroticism in a fine-art context. For

example, Renée Cox has made erotic photographs of herself in fishnet stockings or a leather corset posed in a sexually alluring way. Do viewers see these photos as a liberated expression of Cox's erotic fantasies or do they gaze pornographically? At issue is whether viewers perceive such images in a voyeuristic way that continues and reinforces old power structures, no matter how empowered the artist may feel in making the work.

Many contemporary feminists recognize that if an artist wants to articulate truthfully what it means to inhabit a female body, she should not repress her own sexual desires. As Amer says about her attraction to pornography, "At first I lied to myself because I was worried about my family's reaction. I thought I was using sewing because it is a submissive act, and the women showing their bodies in the magazine is a submissive act, so the work was about double submission. Instead, in my work there is an indication of women's pleasure. I think women like to show their bodies and men like to look at them. There is an allusion to masturbation for women, to pleasure."²⁷

Women artists striving to reclaim subjectivity in sexual expression and representation seek two often competing goals: how to advance freedom of sexual expression and how to repel the voyeuristic, controlling scrutiny of male viewers. One strategy is to embrace ambiguity. For instance, Patty Chang makes videos that convey mixed messages about sexual pleasure and erotic response. In one video, Chang sits dressed in schoolgirl attire, contorting her face and body as something writhes under her white blouse leaving wet spots; as Chang squirms, we glimpse her panties beneath a short black skirt. In fact, unseen by us, large live eels are moving around inside the artist's blouse. The scene is creepy and erotically charged; the expressions on Chang's face do not tell us clearly if she is experiencing erotic arousal or disgust.

Women artists who represent female eroticism in ways that are simultaneously attractive and alienating, arousing and anxiety-producing, may be deliberately reflecting the confusion about sexuality in contemporary culture. These artists, working within a society in which women's sexuality is a Pandora's box, may feel they are damned if they open it and damned if they don't.

Sex and Violence

The growing political consciousness of the past few decades has been accompanied by a growing awareness and analysis of sexual violence, including rape, incest, and domestic abuse. An examination of art history reveals that eroticized images of women are often presented within a context of male violence. Poussin's painting *Rape of the Sabine Women* (c. 1636–37) and Peter Paul Rubens's *Rape of the Daughters of Leucippus* (c. 1616–17) are famous examples from the Baroque period in European art. This tendency is found in visual art up to present day. The widely popular use of titillating imagery in violent narratives in virtually all forms of mass media, including movies, television programs, music videos, and video games, has impacted cultures across the globe with increasing force over the past quarter century.

In contrast to this torrent of eroticized images, many women artists have represented violent sexual experiences as painful. They have created works revealing and examining the relationship between sexuality and violence, depicting the physical and psychological trauma women experience from rape, battery, murder, and sexual harassment, and in some instances critiquing social practices and attitudes that ignore or hide sexual abuse. The history of such artworks by women can be traced back at least as far as Artemisia Gentileschi, who was active as a painter in seventeenth-century Italy, but such historic examples are rare indeed. Feminist activism in the 1960s brought a

dramatic surge in art about violence toward women. In the early 1960s, for example, Yoko Ono performed her *Cut Piece*, inviting audience members to come up on stage and cut off pieces of her clothing. The performance revealed viewers' willingness to watch and even participate in a ritualistic violation of a woman's body.

Exploration of (and outrage over) the pairing of female sexuality and the cult of violence continues in contemporary art. Sue Coe's painting *New Bedford Rape* (1983), based on an actual rape in Massachusetts, shows a woman pinned on a pool table while men line up to take their turn. Barbara Kruger has made many works since the early 1980s that spotlight ways in which language reinforces stereotypes that facilitate violence against women as well as gays, blacks, and other minorities. Sue Williams's painting *A Funny Thing Happened* (1992) expresses rage about sexual violence using a cartoonish technique. In a startling reversal of the power dynamics of most sex crimes, Nicole Eisenman made several paintings in the 1990s depicting women castrating men.

For feminists, violence against women and girls has everything to do with the social and political structures that normalize, and even naturalize, male assumptions about women. In patriarchal society, females have conventionally been viewed as helpers, followers, and servants of men, and this inequality opened the door to exploitation, mistreatment, and abuse. Women's art about sexual violence often functions as a kind of visual consciousness-raising, demonstrating the prevalence of abuse and suggesting causes and solutions. Still, women artists face an uphill climb in their efforts to represent the grim reality of sexual violence because of the weird (and wildly profitable) fusing of violence and glamour in the mass media. Western popular culture is obsessed with violence and with depicting female victims of violence as young, glamorous, and sensual. In contrast, the victims of violence in artworks by women are neither glamorous nor erotic; they are vulnerable and diverse, in pain and angry.

Posthuman Bodies

At the dawn of the twenty-first century we have been witness to extraordinary developments connected with the human body: routine plastic surgery for cosmetic purposes, artificial organs and prosthetic limbs, the wide acceptance of behavior-altering drugs such as Prozac and Ritalin, the successful cloning of mammals, and the mapping of the human genome. Sophisticated tools such as mechanical arms replicate and even surpass human functions. New electronic and digital technologies have made memory a feature of machines. Computers with the superhuman capacity to perform complex calculations and other mental functions are used daily, even by toddlers.

A number of artists have responded to these developments by blending artificial and human elements in their works. French artist Orlan is gradually transforming her appearance through plastic surgeries that she describes as art performances, and Australian artist Stelarc has performed with synthetic organs such as a "third hand" created for him by robotic engineers and attached to his body. In some works, machines even take the place of the artist. Rebecca Horn's *Painting Machine* (1988) and Roxy Paine's *SCUMAK* (1998), a computer-driven machine programmed by the artist to produce one abstract sculpture each day, are two examples.

The term *posthuman* has been used by Jeffrey Deitch, among others, to suggest that humans are entering a new phase of evolution in which biotechnology and computer science will give us the power to reconstruct and extend human bodies in artificial ways

that take us far beyond biological evolution.²⁸ The future is near: in 2002 worldwide news media reported that, in a scientific experiment, a British professor was implanted with technology "enabling his nervous system to be linked to a computer . . . effectively [making] him the world's first cyborg—part human, part machine." A posthuman world inevitably will produce new social behaviors and structures. Some people find the prospects of such a world enormously seductive, while others are repelled. Many people are ambivalent about the interface of human bodies with technology. We may feel alienated by technology or fear our dependence on it, yet we also are fascinated by it and always hungry for the latest developments.

Biotechnology and computer science have begun to intersect with art about the human body. Not only are artists using computers and other new media to make art that visualizes the body, they are exploring the ethical and social implications of having bodies that contain nonhuman parts. Artists are concerned not just with how genetically, surgically, and mechanically altered bodies might look but with what they mean. In photographs, Margi Geerlinks plays with the visual oddities and conceptual perplexity that can result from the quest for eternal youth by depicting elderly women whose wrinkles have been digitally erased. Her images anticipate the miscalculations about age that may emerge as plastic surgeries and Botox injections become increasingly commonplace.

The concept of bodies that combine human and nonhuman elements is not new. Hybrids of humans and other organisms appear throughout the history of art and literature. Centaurs, half-human and half-horse, are one ancient example. More recent images include robots and automata, machines that perform human functions, which appeared with increasing frequency in Western art after the industrial revolution made machinery and machine-made objects common in everyday life. The Futurists in early-twentieth-century Europe imagined and represented human bodies as a fusion of the human and the mechanical.

Such fusions are found in contemporary art as well. Alan Rath, who has a degree in electrical engineering from the Massachusetts Institute of Technology, makes mechanical sculptures that embed human features in machine bodies. In *Infoglut* [5-8], a moving mouth and signaling hands convey messages on video screens that rest on a "neck" and "arms" made of industrial components, suggesting that human communication is dependent on technology.

Today the fascination with links between the body and technology has extended into the digital realm. On the Web we can interface in virtual reality with people we cannot see in person. We can invent new identities for ourselves; we can even inhabit new physical bodies in the form of "avatars," beings who visibly move through cyberspace as substitutes for the person sitting in front of the screen. The cyborg, a hybrid creature that is part organism, part machine, is big business in the popular media of movies and DVDs. What does all this imply for how we think about and value humans as organisms? Has digital technology enabled us to transcend the limitations of our own bodies? Might we someday prefer the company of cyborgs to flesh-and-blood humans?

Moriko Mori, a Japanese artist working in Tokyo and New York, creates digitally manipulated photographic and video tableaux which she populates in various futuristic personas that "draw on a fusion of traditional Far Eastern spiritual iconography, Japanese popular culture such as Japanimation, video games and Western cinematic cyborgs." Replicating herself three times in "Miko no Inori (Last Departure)," Mori

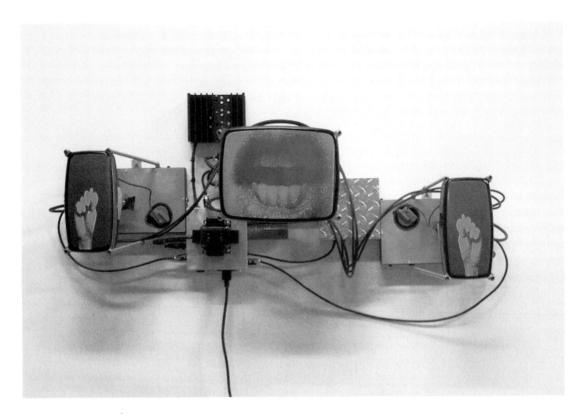

5-8 Alan Rath | Infoglut, 1996
Aluminum, electronics, cathode ray tubes, 22 x 46 x 15 inches
Courtesy of the artist. © Alan Rath

appears in a fantasy costume holding a crystal ball in the shiny high-tech environment of Osaka's Kansai International Airport.

The human organism is not entirely organic anymore. Where can and should we draw any line between human, animal, and machine? As Sarah Chaplin writes, "we no longer need reminding of the extent to which we are all increasingly augmented by technology, that we are all in some senses already cyborgs, and are haunted . . . by our relationship to technology." Deciphering and influencing the patterns of a posthuman world is one of the greatest challenges contemporary artists face.

With increasing acceleration, our species appears headed for a voyage in which scientific and technological advancements release us from our genetically imprinted, biological bodies. In cyberspace, our virtual egos are already inserted into a new construct of postbody-ness. We are creating realities in which material bodies do not exist. In following this path, we seem to be discovering pathways that mystics glimpsed in earlier eras: we acquire the capacity to extend, alter, and magnify our bodies to a degree that appears almost supernatural and that allows us to inhabit astral-like projections. This state of postbody human-ness may turn the relationship of art to life inside out; in the future, life may be a subset of art, not the other way around.

Shirin Neshat, who is known for her large-scale film installations, makes multi-leveled work that we could examine through the lens of virtually all the themes of this book: time, place, identity, the body, language, and spirituality. Here we approach Neshat's work primarily in terms of the body as a theme, looking at her use of images of the veil as a shield, symbol, and surrogate for the female body. Neshat's representations of veiled Islamic women stand in intriguing contrast to so-called body art in Western cultural contexts. Contemporary Western artists often reveal what is hidden (such as an exploration by feminist artists of taboo subjects such as menstruation). In contrast, Neshat focuses attention on female bodies that are in public but hidden under ubiquitous veils.

Born in Iran in 1957, Neshat moved to the United States in 1973 to attend college at the University of California, Berkeley. When she was growing up, her homeland was under the leadership of the shah, who supported a liberalization of social behavior and economic changes modeled after the West. In 1979, however, while Neshat was still in America, Iran underwent a cataclysmic transformation: an Islamic revolution overthrew the shah, and in its aftermath the new regime of the Ayatollah Khomeini re-asserted fundamentalist control over public and private behavior. Even minute details of secular life, including dress codes, became governed by sacred strictures. (A similar return to fundamentalism occurred in many Islamic nations in the Middle East and northern Africa in the latter part of the twentieth century.)

Returning for a visit to Iran in 1990 after a twelve-year absence, Neshat was stunned by the magnitude of change. Women everywhere now wore the head-to-toe black *chador*, the version of veiling characteristic of Iran, which had been abolished in 1936. While many in the West expressed dismay and disdain for Iran's return to fundamentalism (charging, for instance, that fundamentalism casts women into total subjugation), Neshat's artistic response has been far more nuanced and full of ambiguities.

From the era of colonialism, Westerners have been fascinated by images of women wearing veils. Such images evoke a paradox of sexual attraction—how desire may even increase in an inverse proportion to the exposure of bare flesh. The historic Western stereotype of the exotic and erotic veiled and cloistered Muslim woman also embraced the notion of a repressed woman who is too passive and fatalistic to attempt to resist her oppression and needs to be rescued by the West; this view of the veil as a symbol of an inferior society helped justify colonialism. Over the last twenty-five years, however, the context has altered for interpreting the symbolism of the veil. Another, more threatening image has surfaced. Post 9/11, Westerners are increasingly suspicious that the veil may conceal a would-be terrorist, perhaps a suicide bomber preparing to strike. "The veiled woman as an object of fantasy, excitement and desire is now replaced by

the xenophobic \dots gaze through which the veil \dots is seen as a highly visible sign of a despised difference."

Women in chadors have become an iconic presence in Neshat's photographs. films, and video installations. Old and new stereotypes about the "Orient," the Islamic world, gender roles, religious fanaticism, and violence meet and mix in Neshat's work, without any resolution. In interviews, the artist acknowledges her awareness of the debates and contradictions inherent in her use of "loaded" imagery. In her provocative Women of Allah series of photographs, begun in 1994, including "Rebellious Silence" [5–9], Neshat layers Farsi (modern Persian) calligraphy, the image of the gun, and the black veil. Neshat thereby challenges "the western stereotype of the eastern Muslim woman as weak and subordinate."33 The failure of cross-cultural communication is embodied in Neshat's use of writing that is illegible to most Western readers. Westerners recognize the beauty of the calligraphy but don't realize that the shapes spell Iranian feminist poetry, considered radical in Iran because individual poems offer different views on the value of wearing the chador. The writing adorns those specific female body parts that remain visible in a fundamentalist Islamic land: the eyes, face, and hands.

Neshat's rise to international prominence stems primarily from the acclaim that greeted a trilogy of films—*Turbulent* (1998), *Rapture* (1999), and *Fervor* (2000). Shot dramatically in black-and-white, these films examine a mythic existence in an imaginary version of Iran, an Iran stripped down to its poetic essentials. The Iranians (played in her first films by Moroccan actors), like people everywhere, struggle for individual freedoms while simultaneously seeking the meaningfulness that stems from shared values and traditions. An exploration of how historic forces that seem to tug in opposite directions seek balance turns Neshat's staged tableaux into tragic sagas.

In *Turbulent* a male singer performs a traditional song of lost love; he sings facing out to the camera, with his back to a small audience of men dressed in matching dark pants and white shirts. Following his performance, a woman—perhaps the subject of the man's lost love—begins her song. The contrast is stunning: the female singer projects an entirely personal, intuitive, emotional, musical scream. While the male's performance remains locked within tradition—a tradition that, however beautiful, inhibits his expression—the woman's performance appears without precedent and without boundaries. Her performance rivets us, as well as the male singer who watches and listens from the other wall. What makes the film especially poignant is the knowledge that in present-day Iran it is forbidden for a woman to sing in public, so tightly restricted is female behavior.

Neshat's signature style of filmmaking—initiated in *Turbulent*—is a simultaneous projection of paired narratives. Typically the artist creates an installation of two facing screens that separate men and women into separate spheres. This format allows Neshat to present dichotomies—male and female, culture and nature, light and darkness, tradition and change, control and freedom, sound and silence.

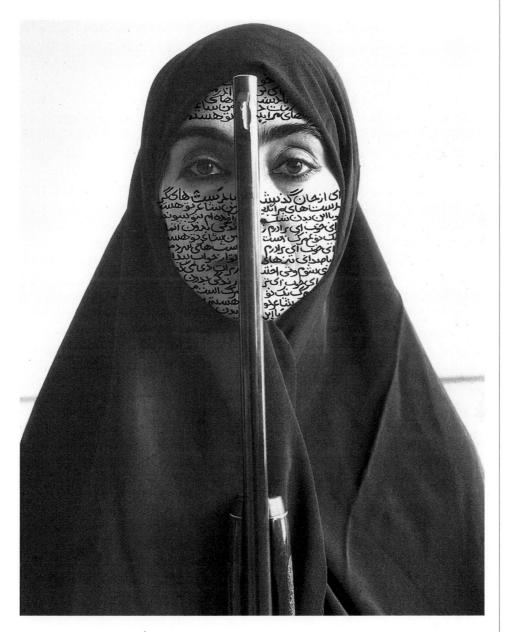

5-9 Shirin Neshat | "Rebellious Silence," 1994
B & W RC print and ink, 11 x 14 inches
Photo by Cynthia Preston
Courtesy of Barbara Gladstone, © 1994 Shirin Neshat

As the audience, we occupy the void, the no-man's-land between the twin flows of moving imagery. From our vantage point, we never see the entire artwork at once; we must choose one screen at a time. This simple device of separation echoes the limitations of Neshat's primarily Western audiences: someone possessing a

Western viewpoint cannot gain full understanding of the Middle Eastern existence Neshat depicts. That her audience is unable to see clearly is a leitmotif of Neshat's artistic vision. The layered meaning of her extraordinary art remains a veiled mystery viewers glimpse but never fully fathom.

In the second work in the trilogy, *Rapture*, a pair of twelve-and-a-half-minute videos are projected simultaneously. In one, a throng of more than a hundred Arab men, again clad in uniform dark pants and white shirts, march through a town, eventually making their way to an ancient fortress. There, the men undertake ritualistic activities—they climb ladders, practice drills, wash their hands, unroll carpets, wrestle, and so on. They seem to be "working" at the business of controlling the fortress, perhaps preparing for attack. Ironically, the men seem to be as much prisoners of the worn fortress, which appears to symbolize their man-made, tradition-bound society, as they are in control of it.

On the facing screen, a similar-size group of women appear on a barren desert. Each woman wears the chador. They look across to the other filmed image, observe the men, and begin in unison sounding a kell, a traditional wailing sound that serves in the Middle East as either a warning or a congratulatory acknowledgment. The movement of the women is breathtakingly beautiful. Like wind-blown members of an enormous Greek chorus, they gather at a shoreline where a half-dozen women, assisted by the others, shove off to sea in a small, fragile-looking wooden boat. On the facing wall, the projection shows the men saluting from their fortress toward the women.

Looking at images of veiled women in Islamic societies, the current-day Western viewer faces a quandary. Should one interpret these images as the representation of the systematic oppression of women in Islamic societies? In contrast to this view, Neshat observes: "In the West where you can talk specifically about the body and sexuality, things are so extroverted that in the end there is no mystery, there is no boundary." 34

While her videos have the direct look of documentary realism, in fact they are carefully staged. Neshat simulates the behavior of veiled women, then makes us aware of the constructed and fluid meanings of veiling, showing us different meanings in different contexts. Within her work, the chador serves multiple purposes: it shrouds its subject (the female body) in mystery, and it protects the body. Above all, being veiled in Neshat's world does not equate with being blinded or silenced. The veil empowers women, as Neshat shows repeatedly in her works in which women appear actively navigating landscapes, gazing and giving voice to their feelings in song and cries. The women are powerful agents. At the same time, Neshat probes the challenges and costs for both men and women of the separation of feminine and masculine spaces. In the final film in her trilogy, *Fervor*, which centers on a tale of sexual desire, the separation is stark and monumental, sometimes shown within one image [5–10].

Shirin Neshat is not alone in her artistic engagement with the discourse that swirls around the veil. Like a number of other artists and writers, Neshat's work is

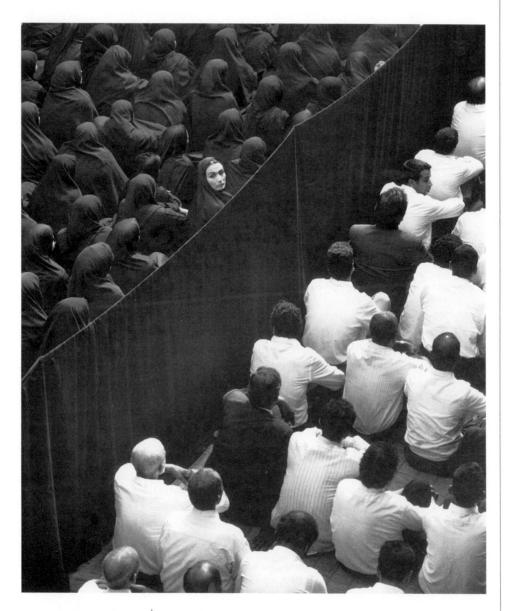

5-10 Shirin Neshat | Fervor, 2000

Production still
Photo by Larry Barns
Courtesy of Barbara Gladstone, © 2000 Shirin Neshat

prying open this overdetermined motif to new, more complex readings, positing Muslim women, veiled or unveiled, as active subjects in the contemporary world. Shirin Neshet was born in 1057 in Oarring Iron. The artist record to the

Shirin Neshat was born in 1957 in Qazvin, Iran. The artist moved to the United States in 1973. She currently lives in New York City.

Notes

- 1. Thomas McEvilley, *Sculpture in the Age of Doubt* (New York: Allworth Press, 1999), p. 384. 2. Ibid., p. 386.
- 3. Several sections in this chapter, beginning here, appeared in a previous form in Jean Robertson, "Artistic Behavior in the Human Female," in Bettsy Stirratt and Catherine Johnson, eds., in *Feminine Persuasion: Art and Essays on Sexuality* (Bloomington: Indiana University Press, 2003), pp. 23–38. Passages of that earlier essay have been revised and inserted at appropriate points in the remainder of this chapter, with the permission of Indiana University Press.
- 4. For a history of the Feminist Art Program written by one of the key participants, see Faith Wilding, "The Feminist Art Programs at Fresno and CalArts, 1970–75," in Norma Broude and Mary D. Garrard, eds., *The Power of Feminist Art: The American Movement of the 1970s, History and Impact* (New York: Harry N. Abrams, 1994), pp. 32–47. For a discussion of Womanhouse in particular, see Arlene Raven, "Womanhouse," in the same volume.
- 5. Simone de Beauvoir, *The Second Sex*, trans. H. M. Parshley (New York: Vintage Books, 1989), p. 249. The book was published in France in 1949.
- 6. Performance artists working with issues pertaining to the body in the last few decades include Bob Flanagan, Marina Abramovic, Linda Montano, Karin Finley, and Tim Miller, among numerous others. In addition to live events, performances about body issues recorded by still and video cameras became increasingly prevalent after 1980, as seen in works by Hannah Wilke, Paul McCarthy, Matthew Barney, and Orlan.
- 7. Thomas Laqueur, "Clio Looks at Corporal Politics," in Donald Hall, Corporal Politics (Cambridge: MIT List Visual Arts Center; Boston: Beacon Press, 1992), p. 14. An exhibition catalog.
- 8. The Michigan State University study was reported by Nanci Hellmich, in "Obese Characters Are Stereotyped," writing for *USA Today*, reprinted in *Indianapolis Star*, *TV Week*, Sunday, January 6, 2002, p. 11.
- 9. Alison Ferris, "Discursive Dress," in *Discursive Dress* (Sheboyan, Wis.: John Michael Kohler Arts Center, 1994), p. 11. An exhibition catalog.
- 10. Suzanne Lacy, "The Name of the Game," Art Journal 50, no. 2 (Summer 1991), reprinted in Kristine Stiles and Peter Selz, eds., Theories and Documents of Contemporary Art: A Sourcebook of Artists' Writings (Berkeley and Los Angeles: University of California Press, 1996), p. 784.
- 11. Linda Montano and Tehching Hsieh, "One Year Art/Life Performance: Alex and Allyson Grey Ask Questions about the Year of the Rope," *High Performance* 27 (1984), reprinted in *Theories and Documents of Contemporary Art*, p. 780.
- 12. Ynestra King, "The Other Body: Reflections on Difference, Disability, and Identity Politics," Ms., March/April 1993, p. 74.
- 13. Amelia Jones, ed., Sexual Politics: Judy Chicago's "Dinner Party" in Feminist Art History (Los Angeles: UCLA/Armand Hammer Museum of Art and Cultural Center, in association with University of California Press, 1996), p. 257. An exhibition catalog.
- 14. Jessica Evans, "Photography," in Fiona Carson and Claire Pajaczkowska, eds., Feminist Visual Culture (New York: Routledge, 2001), p. 114.
 - 15. Quoted in Lauren Parker, "Inflated Desire," Smock 2, no. 1 (Winter 2002): p. 75.
- 16. The Venus de Milo, with its arms missing, was discovered on a beach in Greece in 1821. Interpretations of its meaning and explanations of its appeal to viewers have not been homogeneous. In an essay first published in 1980, Peter Fuller argues that among the reasons for the appeal of the Venus de Milo to modern viewers is, in fact, its fragmented form. A concise analysis of Fuller's argument is offered in Jonathan Harris, *The New Art History: A Critical Introduction* (London: Routledge, 2001), pp. 140–42.
- 17. Give and Take (London: Serpentine Gallery and Victoria and Albert Museum, 2001), p. 33. The actual carving of the figures was done by stonemasons in Italy. An exhibition catalog.
 - 18. Helaine Posner, "Separation Anxiety," in Corporal Politics, p. 30.

- 19. Sally Banes, "'A New Kind of Beauty': From Classicism to Karole Armitage's Early Ballets," in *Beauty Matters*, ed. Peg Zeglin Brand (Bloomington: Indiana University Press, 2000), p. 271.
- 20. Cited in Matuschka, "Got to Get This off My Chest," On the Issues 25 (Winter 1992): p. 33.
- 21. Amelia Jones, "Survey," in Tracey Warr, ed., The Artist's Body (London: Phaidon Press, 2000), p. 43.
- 22. Laura Mulvey's seminal essay presenting her argument that the gaze is gendered and is distinctly male is "Visual Pleasure and Narrative Cinema," *Screen* 16, no. 3 (Autumn 1975): pp. 6–18, and reprinted in Mulvey, *Visual and Other Pleasures* (Basingstroke, United Kingdom: Macmillan, 1989).
- 23. Helen McDonald, Erotic Ambiguities: The Female Nude in Art (London and New York: Routledge, 2001), p. 94.
- 24. A groundbreaking analysis of Gauguin's stereotyped view of native bodies is the essay by Abigail Solomon-Godeau, "Going Native: Paul Gauguin and the Invention of Primitivist Modernism," *Art in America* 77 (July 1989): 118–29, and reprinted in Norma Broude and Mary D. Garrard, eds., *The Expanding Discourse: Feminism and Art History* (New York: HarperCollins, 1992), pp. 313–29.
- 25. Lucy R. Lippard, Mixed Blessings: New Art in a Multicultural America (New York: Pantheon Books, 1990), plate 38 sidebar.
 - 26. Fiona Carson, "Sculpture and Installation," in Feminist Visual Culture, p. 62.
- 27. Ghada Amer, "Interview with Ghada Amer," by Marilu Knode, New Art Examiner 27, no. 4 (December/January 1999/2000); p. 38.
- 28. Deitch curated a groundbreaking exhibition on this theme. See the exhibition catalog, Jeffrey Deitch, *Post Human* (Pully and Lausanne: FAE Musée d'Art Contemporain; New York: Distributed Art Publishers, 1992). An exhibition catalog.
- 29. The story, from CNN.com, was carried on the World Wide Web, http://cnn.netscape.cnn.com/news/ March 22, 2002.
 - 30. Warr, The Artist's Body, p. 160.
 - 31. Sarah Chaplin, "Cyberfeminism," in Feminist Visual Culture, p. 268.
- 32. Alison Donnell, "Visibility, Violence and Voice? Attitudes to Veiling Post–11 September," in David A. Bailey and Gilane Tawadros, ed., Veil: Veiling, Representation and Contemporary Art (Cambridge: MIT Press, 2003), p. 123.
- 33. Tina Sherwell, "Bodies in Representation: Contemporary Arab Women Artists," in Fran Lloyd, ed., *Contemporary Arab Women's Art* (London: Women's Art Library, 1999), p. 65.
- 34. As quoted in Marine Van Hoof, "Shirin Neshat: Veils in the Wind," Art Press 279 (May 2002): p. 38.
- 35. Other artists focusing on the practice of veiling include the video artist Ghazel, born in Iran and now living in Paris, and Jananne Al-Anni, born in Iraq and now living in London. The latter is particularly interested in historic Western photographic studio portraits that constructed tableaux of veiled women.

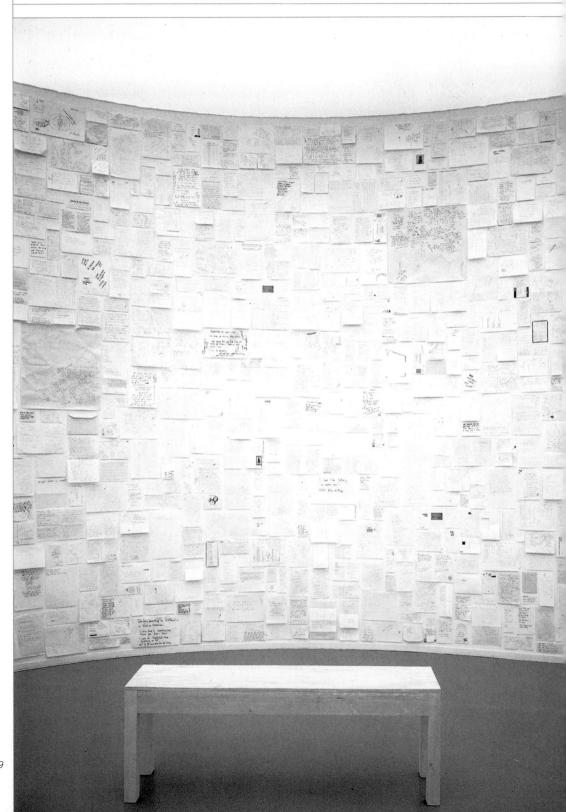

Detail of 6-9

Language

In 1996 the Museum of Modern Art in New York City mounted a large exhibition titled Thinking Print: Books to Billboards, 1980–95. Walking through the galleries, visitors saw an array of two-dimensional prints and other printed artworks that had been created in an edition of multiples. Among the artworks, there were T-shirts with printed maxims (by Jenny Holzer), shopping bags and compact disk covers printed with slogans (by Barbara Kruger), a text prophesying the prejudice a young boy will face when society discovers his homosexuality (by David Wojnarowicz) [6-1], a lithograph incorporating various styles of writing, entitled *The History of Her Life Written across Her Face* (by Margo Humphrey), a poster in which the artist inserted text describing himself under an image of a runaway slave (by Glenn Ligon), and a swatch of wallpaper repeating a design of the word "AIDS" in bold colors (by General Idea). Among the various works in Thinking Print, a large number combined a print technique (e.g., lithography, serigraphy) with print (printed text).

Visiting the exhibition, a viewer could conclude that the incorporation of language in visual art is a common strategy among contemporary artists working in various printed formats. Furthermore, a broader survey of art since 1980 would reveal that language has been incorporated frequently in artworks in almost every conceivable medium. In this chapter we will look at this phenomenon, examining how, when, and why *visual* artists turn so often to the use of *verbal* language, both written and spoken.

While this chapter's focus is on language *in* art rather than language *about* art, the two topics cannot be neatly cleaved. Although they often refer to diagrams and illustrations, art historians and critics depend most heavily on words to discuss and interpret works of visual art.² Gavin Jantjes claimed, "Ever since art has been recognized as an autonomous discipline, its central dilemma has been the dominance of the discursive over the visual." The critical reception of all the arts is weighted toward their analysis in words.

The current popularity of language as a theme in visual works (and as a means for exploring other themes) stems, in part, from the impact of theories that emphasize how cultural meaning is negotiated within language and other symbolic systems. In the

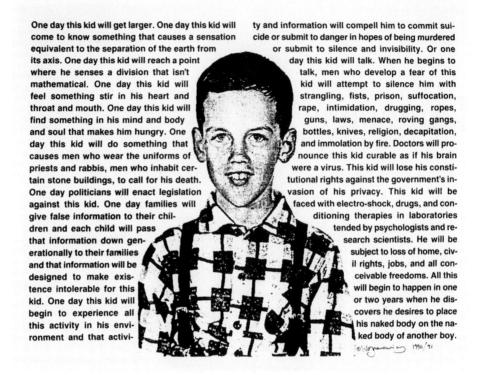

6-1 David Wojnarowicz Untitled (One day this kid . . .), 1990-91

Photostat, 30 3/4 x 41 inches
Courtesy of the estate of David Wojnarowicz and P.P.O.W Gallery, New York

latter half of the twentieth century, works of visual art came to be viewed as "texts" to be examined for internal contradictions, hidden meanings, and implicit ideologies. In the 1980s visual artists themselves often appeared to be responding to philosophical and linguistic theories about how language works. Artistic strategies of the 1990s and today have moved away somewhat from direct engagement with theory, although language continues to be a popular, powerful medium and vital theme. We begin our exploration of the theme of language by a look at the paired history of art and words.

Words with Art: A History

Language appears in two primary modes: spoken and written. Written language bears a more obvious relationship to visual art because both have traditionally depended primarily on the sense of sight in order to be perceived. Scholars cannot pinpoint where and when writing originated, but we do know that writing as we know it today was preceded in human development by numerous systems of symbolic communication utilizing tangible devices (such as knots in ropes). We also know that our prehistoric ancestors made pictures and *pictographs*, simplified representations with conventional meanings. (A contemporary example of a pictograph is the silhouette of a figure in a skirt that stands for the door to a women's rest room.) Later societies, such as ancient

Egypt, developed hieroglyphic writing, in which pictographs are aligned in a sequence to connect together to form a much-larger range of ideas. True written alphabets, which are based on a system of symbols that relate, by convention, to the sounds of speech, seem to have appeared only in the past four thousand years.

In contrast to alphabetic writing in contemporary Western societies, the traditional written languages of Asian societies continue to combine visual and verbal representations in an integrated system. Unlike the alphabetic system of English, in which a mere twenty-six letters are used in various arrangements to spell the sounds of words, the Chinese system, for instance, which has been in use thirty-five hundred years, features an enormous number of characters, each of which conveys a concept. (Most characters are compounds of abstracted shapes with different meanings that are built upon a basic, root element of meaning.) Even speakers of different dialects can understand the same Chinese characters, because the characters do not symbolize the sounds of language but the meaning.

Various methods and styles of writing the characters using ink and brushes, called *calligraphy*, developed at different times in China. Calligraphy has been vitally important as a force for cultural unification. In contemporary China, calligraphy remains revered as a form of visual art and an opportunity to display one's poetic sensibility, which is demonstrated by nuanced brushstrokes as well as in the thought transmitted. In tracing the importance of calligraphy, curator Chang Tsong-zung wrote, "By virtue of the art of calligraphy, words acquired a physical body and demanded attention as material incarnation rather than just conceptual ideas or abstract signs."⁴

As in China and other Asian societies, calligraphy is highly esteemed as a form of visual art in Islamic cultures. Calligraphy carries the message of the Qur'an, the sacred book of Islam, which records the divine revelations received by the prophet Muhammad. Islamic tradition generally opposes artistic representations of human figures and animals in religious settings and contexts, a circumstance that contributed to the elevation of the art of calligraphy. Even in secular manuscripts, which permitted narrative illustrations, painting was secondary to script.

Skill at handwriting was a hallmark among the educated in Europe at least as far back as the Middle Ages, paralleling, to some degree, the recognition of calligraphy as an esteemed art form in China and the Muslim world. Even among German immigrants to America in the late eighteenth and early nineteenth centuries, some were trained in making handwritten documents, such as wedding certificates, that included decorative calligraphic flourishes (known today as *fraktur*).

Writing in English-speaking countries, at the start of our current period, primarily emphasized the semantic meaning of the words and, in the case of poetry, the pattern of the sound of those words. But in the history of world literature, there are numerous instances in which written words have evoked visual qualities (for example, when a poem "paints" a mental picture in words) or have manifested enhanced qualities of visual form. Another strategy is exemplified by composing poems with a distinctive pattern or shape on the page, including shapes that represent objects or figures. Such shaped poetry was a popular pursuit among creative writers in widely different times and places, including ancient Greece, ancient Persia, the Italian Renaissance, and sixteenth-century England.

The tradition of shaped poetry, in which traditional lines of verse are arranged on the page, comes down to us in poems by Guillaume Apollinaire (an early-twentieth-century

French experimental writer) and in such recent examples as a book of shaped poems by the American writer John Hollander.⁵ By the middle of the twentieth century, however, a distinct shift occurred, overshadowing shaped poetry and resulting in a movement known as concrete poetry. Concrete poetry broke free of writing strictly in horizontal lines of traditional verse. Starting with the influential work of Eugen Gomringer, a Bolivian-born Swiss, concrete poetry emphasized such aspects of writing as the repetition of letters in nongrammatical patterns, while the choice of typeface and the scale and color of the letters became viewed as strategies to expand the range of language's meaning. The same letter, word, or short phrase might be repeated again and again across the page, creating an abstract shape. Concrete poetry gained wide popularity among experimental writers in the 1950s and 1960s in Europe, the United States, and South America.

Since 1980 visual poetry has continued to attract devoted practitioners, including Richard Kostelanetz (in the United States), Bern Porter (in Ireland), Pierre Garnier (in France), and Alberto Vitacchio and Carla Bertola (in Italy). Contemporary visual artists, such as Americans Kay Rosen [6-5] and Kenneth Goldsmith, have produced paintings and prints that bear strong affinities to the practice of concrete poetry, in experimenting with how words can be freed from the traditional linearity of lines of text.⁶

Art with Words: A History

Just as writers have experimented with the visual qualities of language and have developed works that overlap with the concerns of visual artists, visual artists in turn have experimented with the incorporation of language into their work. The practice of creating visual imagery that makes reference to literature, for example, provides the viewer with an expanded basis for appreciating and understanding what he sees. Illuminated manuscripts of the European Middle Ages, Renaissance fresco cycles based on stories from the Bible, and the emergence, in late-eighteenth-century England and the lowlands of northern Europe, of a genre known as the "conversation piece" are just a few examples of the verbal and visual commingling. In the latter type of painting, the composition unfolds around a scene of people talking, gesturing, listening, and reacting. Examples linking the visual and verbal abound from around the world, including a long-standing tradition of Chinese ink paintings that incorporate poetic texts in the background area.

In American art in the nineteenth century, the incorporation of words in paintings served multiple purposes. One function was to test artistic skill by attempting painstaking depictions of handwritten notes and lettered signs in *trompe-l'oeil* (fool-the-eye) paintings, as in the popular paintings of William Harnett. An idiosyncratic use of highly stylized writing can be seen in a wide range of work by nineteenth-century, twentieth-century, and contemporary American folk artists, such as the Reverend Howard Finster.

A range of visual artists in the twentieth century incorporated language into their work. For example, in the early twentieth century, European Cubists, who pioneered the technique of collage, discovered that affixing clippings from newspapers, printed labels, and similar text-based materials to the surface of a painting or drawing was a way of breaking down the distinction between art and life, which became an important leitmotif in many artists' work over the past hundred years.

Influenced by the Cubists' example, vanguard graphic designers in Europe and the United States in the 1920s and 1930s began to combine typography, photographs, and graphic elements within a single design, often based on the spatial formation of the grid. In late-twentieth-century America, graphic designers, such as April Greiman, began to explore emerging digital technologies as a means of combining photo-based images, computer art, and printed text, often in dense layered compositions that resist a quick reading. Inspired by European precedents, some American modernists, including painters Stuart Davis and Gerald Murphy, created artworks that incorporated words or portions of words. Critics compared the compositional freedom in Davis's renowned abstractions to jazz improvisation. Later abstract artists, such as Cy Twombly and Morris Graves, developed signature styles of painting that echoed the flow of written script.

American Pop Artists, who gained prominence in the 1960s and 1970s, including Roy Lichtenstein and Andy Warhol, expanded the playing field by appropriating the combination of verbal and visual imagery in everyday life, particularly in commercial product designs and the products of popular culture. Lichtenstein, for example, incorporated into his own paintings imagery and dialogue he culled from period comic books, especially those dealing with romance and war stories. Robert Indiana, a still-active Pop Artist, used words to weigh in on political issues (he was an ardent champion of civil rights) and also called attention to the potential to see words in fresh ways, as in his world-famous rearrangement of the word "LOVE" into a stacked pairing of LO above VE. The 1970s saw a burgeoning of photo-realist paintings, prints, and drawings using urban and suburban landscapes as subject matter. Several noted photo-realists, including Richard Estes and Robert Cottingham, included portions of storefront signage, theater marquees, and billboards in their images.

Conceptual artists in the 1960s and 1970s redefined the relationship of visual art to language, building on the breakthrough efforts of Marcel Duchamp (1887–1968), a French Dadaist who moved to the United States during World War I. According to Kristine Stiles, "In 1917, Marcel Duchamp . . . had already defined an artist as someone able to rethink the world and remake meaning through language, rather than someone who produces handcrafted visual objects for 'retinal' pleasure."8 Five decades later, Conceptual Artists carried forward the banner Duchamp had unfurled; they utilized words as a way of making ideas the central component in their art. In extreme instances, the words themselves became the artwork. Some artists, including Lawrence Weiner, even claimed that anyone who read the words that defined a work of art, and could therefore imagine it, had experienced the art just as fully as someone who saw an actual sculpture or painting. Sol Lewitt, whose geometric wall drawings and sculptures are rooted in both Minimalism and Conceptualism, emphasized the importance of the written instructions that defined how his artworks were to be created. Rather than draw or paint his art himself, Lewitt often relied on others to follow his written directions to complete a project.

Since the 1960s a number of artists have employed words along with photographs and other graphic representations as a way of documenting a work of art. This *documentation* may take the form of a historical record of the artwork's creation, such as the recording of a live performance event; at other times, the documentation commemorates a static artwork in its completion. Documentation is especially useful for artists who make works that are so large in scale, remote in location, or long in duration that only a limited number of viewers ever experience the actual work. Documentation is a

strategy for enlarging the audience and ensuring that the artwork survives, at least in its documented format. Site-specific earthworks and temporary installations are available to us now as charts, captioned photographs, blueprint drawings, and planning documents. In many instances, artists have declared that each image or object of documentation constitutes a work of art in its own right; sales of the documentation can be a strategy for recouping the outlay of funds that made the initial project possible.

Recent Theories of Language

The exploration of language by visual artists gained renewed prominence after 1980 due, in part, to the expanding application of concepts from semiotics and linguistics in the analysis of visual culture. *Semiotics*, the branch of philosophy that deals with the study of symbolic signs, and *linguistics*, the study of languages, provide systematic approaches to decoding human communication. Visual art, as a form of communication using representational signs as well as abstract symbols, became a topic caught up in the web of theoretical debates concerning language and the use of signs. Many contemporary artists, in fact, have chosen to make artworks that explicitly refer to or extend the academic discourse about language.

In thinking through the ramifications of a prickly question—Where does the meaning of language reside?—various scholars, philosophers, linguists, and, more recently, artists, art historians, and art critics began to look at language (and other sign systems) as a structure. Their conclusion was that meaning resides in (or results from) the condition of language as a system. With respect to language, this approach posits that there is no preexisting meaning that is imported into linguistic form. The meanings made by a given language are generated within and by the operation of that language's system of conventions, including rules of grammar and units of significance that function in relationship to other units. Writings of the philosopher Ludwig Wittgenstein (1889–1951), an Austrian who served as a professor at Cambridge University in England, were profoundly influential in their emphasis on language as a "game," which a person learns to play by learning the appropriate rules. Knowing the names for words—just like knowing the names for pieces in a game—is not enough in order to know how to "speak." Another way of saying this is that language performs meaning. In the wake of Wittgenstein, scholars and critics applied variations of linguistic analysis to a wide variety of fields of intellectual and creative endeavor, including the production of art within a culture.

To reiterate: a fundamental belief was called into question—language was no longer seen as the pure conveyer of ideas (ideas whose truthfulness could purportedly be measured against a reality external to language itself). Instead, there was a paradigmatic shift that emphasized language as a structured network of meaningfulness, a network of abstract symbols (including letters, words, and punctuation marks) and the rules for using those symbols. Language came to be seen as the all-important context within which thinking was embodied.

The structure of language (phonetic sounds combining into words, the rules of grammar and syntax that govern how words combine into larger units of meaning, and so on) seems so ingrained into the fabric of human beings that some scholars (such as the linguist Noam Chomsky) have argued that the deepest structure of language is hardwired into us. A simplified version of this concept would state: We humans are born to learn to use language as inherently as a bird is born to fly. This can occur because all

languages share underlying traits, and our human brains seem to have adapted (through evolution) a natural propensity for fluency in the language we learn as children.

While the structures of all language bear some similarity, there are and have been myriad languages throughout history and in use today, and within any language there are multiple dialects and individual speakers who each has a different style of speaking (even among speakers of English, pronunciation and vocabulary choices differ). How language functions, how it is structured, how it identifies us as a species, how it distinguishes one group from another—in all these ways language is central to what it means to be human and how we humans make meaning. Because of language's centrality in the process of human thought, contemporary visual artists have found language to be a rich focus for art—as they have aimed to broaden their thematic palette.

The shift in ideas about language, within the field of linguistics, occurred alongside changes in seeing culture in general (including language, laws, institutions, codes of behavior, customs, and so on). Together these changes evolved, by the 1960s in France, into an intellectual movement called *structuralism*. Structuralism was based on a strategy for analyzing cultural conditions in terms of an underlying, structural framework. The structural approach employed in the 1960s was heavily influenced by the pioneering work of a Swiss linguist, Ferdinand de Saussure (1857–1913). Saussure's focus on the systemic condition of language was applied to culture as a network of systems of meaning. Furthermore, Saussure understood how language can change over time while always remaining cohesive. Fredric Jameson explained, "Saussure's originality was to have insisted on the fact that language as a total system is complete at every moment, no matter what happens to have altered in it a moment before."

Structuralists were content to assume a neutral stance as they analyzed how language and other symbolic systems work. Then, the structuralist approach was supplanted to a wide degree (starting in France in the 1970s and becoming enormously influential in the United States in the 1980s) with the advent of the more politically engaged concepts of *poststructuralism*. Poststructural thinkers analyzed language and other sign systems as part of the broader power structures of society. Poststructuralists claimed to uncover the ways in which humans are at the mercy of the systems that create and disseminate the texts and images that surround us regularly in our everyday lives. According to poststructuralist theory (a position that was widely influential with the development of postmodernism in the 1970s), our individual subjectivity is a myth: our thought patterns mirror the fractured "maze of competing signs" we are enmeshed in.¹⁰

Poststructuralists questioned the ingrained habit of "reading" texts, discourses, and visual representations as if they were authoritative sources with fixed, single meanings. Instead, poststructuralists opened various communicative signs to the process of deconstructing (also called decoding); deconstructing might involve the critical analysis of a message or image from alternative cultural or theoretical perspectives. Poststructuralists posited that no one can control all interpretations or readings of an image or text, and, just as important, no interpretation or reading is solely the work of one author. Even an artist's style, for example, is the result of both the artist and those critics who articulate observations that the original artist could not have intended (for example, by comparing qualities in an artist's style to qualities in the work of artists who worked later in time).

Poststructuralist ideas have resonated strongly with various artists involved with feminist and postcolonial issues. Text is often an important component of these artists' work. For example, American Elaine Reichek used needlework samplers to re-present

texts by male artists and authors and reformulate their meanings. American Lorna Simpson made works that pair bodies or body fragments with short, enigmatic texts as a way of provoking commentary about how our view of ourselves and others is influenced by ideas of race, gender, and sexuality, infused in the vocabulary we share [5-7].

The basic idea that meaning can change depending on the context and the viewer's knowledge of conventions has been used effectively to analyze a range of languagelike systems, including body language and the coded display and packaging of consumer objects. Seen in this light, even everyday objects communicate identity, prestige, sexuality, and other hidden meanings. As Howard Singerman wrote, "Always part of a serial chain of identical copies, clothes, cars, computers, and so on are necessarily enfolded in a rationalized and differential system of exchanges that is, according to Baudrillard, not a mirror or a replica of the exchanges of language but the same as it. 'What is consumed is the object not in its materiality, but in its difference—i.e., the object as sign.'"¹¹ Our consumption of a certain article of clothing communicates meaning within the fashion code of our particular social system. A range of contemporary artists have been inspired by the semiotics of body gestures, flags, diagrams, maps, direction signs, and corporate logos of consumer culture, among them Ilona Granet, Ashley Bickerton, Matt Mullican, and Haim Steinbach.¹²

Reasons for Using Language

The surge of activity and interest in the use of language in contemporary art has many causes. While the specific reasons for using language are as varied as the artists themselves, some basic trends and influences are in evidence.

As noted, the development of Conceptual Art, which gained critical mass in the late 1960s and 1970s, resulted in a rapid proliferation in the number of artworks incorporating language as a medium and in the purposeful dematerialization of the artwork. Conceptual Art at that time included plans or descriptions of works of art that might never be realized. While artists in recent decades have moved away from such "pure" forms of conceptualism, artists still turn to language (in its diverse formats) because words can articulate complex ideas and embody abstractions. Taiwanese Conceptual Artist Wu Mali created *The Library*, an installation for the Venice Biennale in 1995, in which she put volumes of literature (by earlier authors) through a shredder and displayed the paper fragments in acrylic boxes with the book titles embossed in gold lettering. Wu Mali's action created, in the viewer's mind, the concept of books that no longer exist and, simultaneously, called into question the enduring value of those books, symbolic of a lost literary canon.

Another reason language is employed is to document events or artworks that otherwise would exist only as temporary actions or ephemeral forms. English artists Richard Long and Hamish Fulton, for example, have each made a practice of taking extended solitary walks through nature. In some cases Long has subsequently arranged stones and other natural material gathered on the walk in an art gallery as a way of alluding to these walks. Both Long and Fulton have also created prints and artist's books, often incorporating a text that is created in response to the walk. A page in Long's *Planes of Vision* (1983), for example, lists in a vertical column fourteen words that represent elements in his surroundings: "crow cloud trees hedge grass boots long grasses." The word "boots" also functions as a witty metonym for the artist walking on his journey.

A third reason for the surge of interest in using language in artworks is that words supply cognitive content. Some artists use words to augment their visual responses to sociopolitical issues. Language empowers those who wield it. Language can be subversive. By exposing the ways in which language expresses and bolsters social ideologies, adversarial groups can clear a path for the emergence of new meanings. Feminists in the West, for example, insist that language is gender based and that the culturally dominant European languages historically have reinforced patriarchal systems of authority. Other artists use words for their content in ways that are devoid of political inflection. American photographer Duane Michals, who often employs captions to suggest meanings that go beyond what is shown explicitly in the image [6-2], explains his own reasons for adding words to images, "Traditional photographers are unaware that they live in a world of make believe and assume the hard reality of appearances to be the only possible subjects for photographic documentation. . . . Language can complement the picture as a form of suggestion into what cannot be seen within its two-dimensional space." ¹³

Language is a central element in new genres of art such as performance, video, computer-based art, and sound art. These art forms acknowledge that the verbal is as central to life as the visual. Performance art is especially difficult to imagine without the

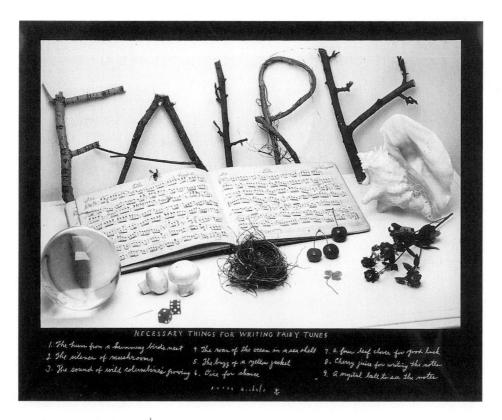

6-2 Duane Michals | "Necessary Things for Writing Fairy Tunes," 1989

regular use of speech. Many performance artists have perfected an idiosyncratic approach that combines different tones of voice, styles of speaking, dialects, and related gestures (all standard fare in theatrical acting) with a script that makes no or little attempt to develop a plot. A performance artist may focus intensely on the pure flow of words, spinning an ever-shifting intricate net of associations. Variations on this approach are found in the autobiographical monologues recorded by Spalding Gray in the 1980s, such as his *Swimming to Cambodia*, and Miranda July in the 2000s, in various performances that focus on her interpretations of the lives of contemporary women. In *The Swan Tool* (2001) [6-3], July tells the story of a woman working in an insurance company, using a performance, live music, and digital video effects projected onto screens in front of and behind her.

Another compelling reason for incorporating language in art is that hearing and reading words take time. Since language is sequential (to read a text completely you read every word), appending language to art slows down the viewing experience; the viewer becomes involved, often with an increased level of self-consciousness, as a collaborator in the production of meaning. In a world in which the average museum visitor spends only a few seconds looking at a painting or sculpture and will swear that he has seen the whole of it, works that incorporate any sizable text present a challenge. To read even the equivalent of one page of text requires that the viewer pay attention to a work of art far longer than he or she is accustomed to.

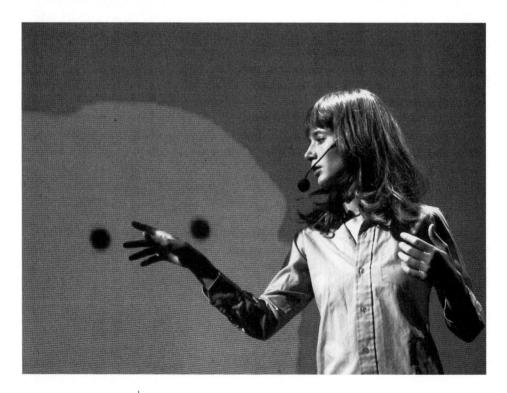

6-3 Miranda July | The Swan Tool, 2001
Performance

Photo by Harrell Fletcher Courtesy of the artist While this list of reasons for using language could be extended, we can say in summary that words have become widely used by visual artists because of their special capabilities to communicate abstractions, document events, argue politics, tell stories, and slow down the aesthetic experience.

Exhibitions and Publications Concerning Language in Art

A number of exhibitions since 1980 have been organized around the theme of language: Verbally Charged Images (a traveling exhibition by Independent Curators Incorporated, New York, 1984–85), Perverted by Language (Hillwood Art Gallery, Long Island University / C. W. Post Campus, 1987); Committed to Print: Social and Political Themes in Recent American Printed Art (Museum of Modern Art, New York, 1988); The Words and the Images (Utrecht: Centraal Museum, 1991); Is Poetry a Visual Art? (Turman Art Gallery, Indiana State University, 1993); and photo text text photo (Museum für Moderne Kunst, Bozen, 1996, and the Frankfurter Kunstverein, 1997). Many other thematic exhibitions since 1980 addressed issues and displayed material closely related to this chapter's topic, including Pictures and Promises (curated by Barbara Kruger at The Kitchen, New York, 1981); Artists of the Book: 1988 (Boston Athenæum, 1988); A Forest of Signs: Art in the Crisis of Representation (Museum of Contemporary Art, Los Angeles, 1989); Knowledge: Aspects of Conceptual Art (a traveling exhibition organized by the University Art Museum, Santa Barbara, 1992); Thinking Print: Books to Billboards, 1980–95 (Museum of Modern Art, New York, 1996); and Artist/Author: Contemporary Artists' Books (a traveling exhibition organized by the American Federation of Arts in 1998).

In addition to exhibitions of art in museums and gallery spaces, journals that include artists' writings or regularly focus on the topic of the verbal/visual interface have proliferated during the last few decades. These include: Semiotext(e) (inaugurated in 1974 in New York); Parkett (Zurich); Art and Text (Victoria, Australia); Texte zur Kunst (Cologne); and WhiteWalls (Chicago). Other publications have devoted sections or entire issues to the theme of language art, offering space in their pages for artists' projects. For example, Art Journal, published by the College Art Association, New York, devoted its summer 1982 issue to the works of visual artists who work with words.

Language Makes Meaning

While contemporary artists have made works that engage directly with theories of symbolic communication and strategies of analysis (such as semiotics, poststructuralism, and deconstruction), many visual artists who incorporate verbal language are not particularly interested in theories and academic discourse. (In a series of paintings completed in the late 1980s and early 1990s, American Mark Tansey, responding wryly to the complex writings of French intellectuals then in vogue, depicted entire landscapes of densely textured, unreadable text.) Many artists use text simply for its ability to communicate meanings that are difficult to express in images alone, to convey ideas, descriptions, arguments, stories, flights of fancy, and so on.

The use of words to express meaning in art can be categorized in at least eight primary ways: words can serve as signs, words can function as metaphors (constructing associations or relationships of meaning), words can tell or hint at narratives, words can decode the structure of language itself, words can function as titles or captions, words can be employed for their formal qualities, ¹⁴ words can provide sociopolitical commentary,

and words can function as an integral part of interactive artworks involving dialogue or text. Of course these categories can overlap, and an artist may employ words for multiple purposes in any single artwork. In this section and the two that follow, we look in turn at each of these primary ways in which artists use language to express and embody cognitive and formal content.

Words function primarily as signs when the emphasis is on the denotative meaning of language. Language can refer to subjects, both real and imaginary. A printmaker, for example, could incorporate the words "a snarling dog" within the composition of a lithograph, intending for viewers to imagine the animal. Stephanie Brody Lederman incorporated the phrase "You will have many friends when you need them" (printed on the slip of paper from a Chinese fortune cookie) into a small, painted folding screen entitled *Setting the Table for Romance* (1992). The words appear to refer to the future in a very specific, optimistic way. Language can refer to actual or fictive people, places, objects, and events, as well as to abstract concepts.

While some words function strictly as signs, referring directly to a denoted subject of language, words may also function to construct meanings that are more than, or different than, the explicit definitions of the words themselves. In some cases, the use of multiple words or words paired with imagery may create in a viewer's mind an association of meaning. A common example would be words used metaphorically, as in the phrase "he was a mountain of a man." An artist can create a similar link by combining words with an image. An artist can create an unexpected association, one that triggers a search for a fresh interpretation of meaning.

As an example of words used to construct associations of meaning, we first cite the multipart *City Projects—Prague* (1996) by Lawrence Weiner, who has been active in Conceptual Art since the 1960s. Weiner's project consisted of phrases that were painted in letters approximately two feet tall, using stencils, on the sides of walls and buildings. For example, one work was called *THINGS PUSHED DOWN TO THE BOTTOM AND BROUGHT UP AGAIN* (1996). Weiner's use of words created mental associations in the minds of viewers who have some knowledge of Prague's history. "Things pushed down" refers to an abstract category of objects (those pushed down); these objects in turn serve as a metaphor for downtrodden people. Weiner's art refers to Prague as a place where to write free verse or messages on the sides of buildings would be seen as a subversive political act within the successive totalitarian governments that governed the Czech people (first the Nazis, then the Soviets) in the latter twentieth century. In Eastern Europe following the dismantling of the Soviet Union, Weiner's words bear special historical significance.

Another example of the associations of meanings artists can construct using language is provided by large-scale paintings completed in the early 1980s by American David Salle, who inscribed a single word or name (e.g., "King Kong," "Tennyson," "ugly") that appears to float on a plane in front of the depiction of the subject matter. The words make references (to the gorillalike creature featured in the movie, to a dead poet, and to a description of unattractive appearance, respectively). To theoretically minded viewers in the early 1980s, Salle's strategy of juxtaposing words and multiple images in one composition seemed to refer to the postmodern condition of clashing frames of reference and the slipperiness of meaning. Salle's paintings seem to exemplify Roland Barthes's observation that there is no such thing as a single, all-powerful "author," in the sense of a creator who predetermines all interpretations of his text. By combining existing imagery and words in novel ways, Salle authors new meanings for

someone else's creations. Additionally, in interpreting a meaning for a text or image, each and every reader or viewer becomes his own "author."

Due to its form, in which units of meaning are presented in succession, language is well suited to conveying narratives, because stories involve sequential events that unfold over time. The renewed emphasis on content in contemporary art has resulted in an increased use of language to help communicate a wide range of stories, including autobiographical stories, histories, and invented fictions. The recent surge of interest in telling stories in visual artworks contrasts with the preceding era in American and European art, in which formalism, Minimalism, and then Conceptual Art shunned storytelling. Through storytelling—recounting who we are, how we got to be this way, and so forth—artists have reinvigorated the practice of tying visual image-making to oral and literary traditions that were central to the maintenance of many societies throughout history.

Artists' stories in the 1980s and 1990s have often been paired with photographic images (for example, in the work of Carrie Mae Weems, Duane Michals, and Jeff Wolin). The text deepens or even challenges our reading of the images, adding its own different expressive meanings. Ken Aptekar uses text to reframe our "reading" of paintings (see profile). In the decades prior to the 1980s words were also used for storytelling purposes, but the stories told by contemporary artists are often combined with intellectual irony (a hallmark of postmodernism), social consciousness, and fragmentation, qualities that are rarer in earlier examples.

An undercurrent of irony and self-consciousness can be seen in the narrative art produced as Ektacolor photographs by Larry Johnson during the 1990s. Just a selected snippet of flavorful language from Johnson's "Untitled (5 Buck Word)" (1989) gives us a taste of his approach in concocting eccentric autobiographical tales: "The waiter brought two more margarooties and I must say I was intrigued . . . this pinstriper had yet to provide me with any (here's a word I snatched from a crossword puzzle) . . . emollients."

Artists employ words to decode the structure of language itself. One of the intriguing qualities of language, both in speech and writing, is that the meaning of words can change dramatically with just a slight shift in pronunciation or spelling or a different placement of a word within a sentence or a different intonation in how a word or phrase is spoken. Puns, homonyms, and anagrams are examples of such shifts. Such peculiarities of language have inspired everything from enchanted whimsy to poetic beauty to the contemplation of serious philosophical paradoxes.

The ongoing series of "photoglyphs" produced since the late 1980s by Russian-born Rimma Gerlovina and Valeriy Gerlovin reflects one such exploration of language. Before immigrating to America in 1980, the Gerlovins were active participants in the samizdat tradition of self-published artist-made books, which provided avant-garde artists in the Soviet Union with a cheap strategy for bypassing the restrictive official exhibition system. After relocating in the United States, the Gerlovins began to work collaboratively, typically photographing one of their faces decorated with a word, phrase, diagram, or numbers. "Be-Lie-Ve" (1990), a color photograph measuring four feet by four feet, for example, reveals how language can create paradoxical meaning. In this case, Rimma's face is decorated with the letters "B E L I E V E" written in dark paint across her pale forehead. Rimma's hands pull strands of her wavy hair into an X shape that trisects the word to highlight the word "lie" at its center. According to the artists, their photoglyphs offer paradoxical riddles for each viewer to ponder: "Language conceals more than it reveals until we reduce words to their hidden meanings." ¹⁵

In responding to a work of art, viewers may attempt to translate what they see into language. They may do this in an attempt to answer in their own minds the question, But what does it mean? A common strategy used by artists to coax meaning in a certain direction is to provide a title or caption for the work of art. The act of titling can influence the interpretation by providing a small bit of language as a starting point. While the text or title affixed to a visual work can provide a straightforward explanation, some intriguing contemporary works feature titles and captions intended to alter our interpretation of the visual imagery in surprising fashion. For example, John Baldessari created six artworks for presentation at the exhibition Documenta 7 in Kassel, Germany (1982). In each work in the series, twelve photographic images taken at random from film stills from different movies were combined in a grid. A text panel above the grid served as a title, pointing the viewer to a specific fairy tale by the Brothers Grimm (who lived in Kassel). The grid of twelve photos—each from an unrelated movie—does not convey an actual plot, but the title provoked an interpretation that the arrangement of images must in fact be related to the fairy tale, although how they are related was never made explicit.

Language Takes Form

Amazingly, language does not need to take on a form that is perceptible to any of the five senses in order to exist. As human beings, we constantly engage in thinking silently in language that exists only within the conscious mind. In an amusing riff on the fact that thoughts imperceptible to others are always passing through people's heads, Gillian Wearing (United Kingdom), in 1992–93, asked strangers on the streets of London to write the thought passing through their head on a sign and then photographed them holding up their sign [6-4].

Once you opt to communicate your language-thoughts to others or record them so you can perceive them later, then the language you use must take on form. For most artists, this generally means speaking or writing, although some artists have produced works that incorporate other language-like systems. German painter Rune Mields, for example, has utilized symbols of mathematics and such signs as the horizontal figure 8, symbolizing infinity. Speaking and writing exist in many variations as well as in alternative forms, including sign language for the deaf and Morse code. Writing itself can be handwritten, stenciled, printed by letterpress, and so forth. Handwritten words can be printed in block letters or written in longhand. Words written in longhand can express different styles of penmanship. Words can be written on paper, and different types of media, such as ink and pencil, can be used for writing on paper. Writing can be carved or shaped using three-dimensional materials, such as wood or plastic; it can be formed into braille letters to be touched. Written language can also be encoded in digital form and transmitted electronically, and manipulated using features such as scrolling and dissolves.

Language that is heard is likewise varied. The medium (unmediated human voice, telephone, radio, bullhorn, and so on), the sound (nasal, melodic, guttural, soft), the language itself and its dialect (Cockney English, Mandarin Chinese) all affect the form of aural language. Alphabetic systems dominate communication by writing in contemporary Western society, and it is the incorporation of language conveyed by an alphabet into works of visual art that links most of the activities that we examine in this chapter. A growing field of interest, however, for visual artists is the incorporation of

6-4 Gillian Wearing "WORK TOWARDS WORLD PEACE." 1992–93

From the series Signs that say what you want them to say and not Signs that say what someone else wants you to say C-type print, mounted onto aluminum approximately 16 1/2 x 12 inches Courtesy of Gorney Bravin + Lee, New York, and Maureen Paley / Interim Art, London

spoken language, as the visual arts increasingly become more hybrid, exploring areas of performance, digital, and sound art.

Transparency and Translucency

Whether language is written or spoken, under many ordinary circumstances words seem transparent; that is, we read or hear *through* the words to grasp whatever things or ideas the words signify. It doesn't make any difference, in terms of spelling or semantics, whether the words are handwritten in pencil or ink or printed in ten-point Garamond or twenty-point Geneva. Similarly, when we hear words, we can listen through the words to understand the information and ideas that the language denotes, and it may seem incidental regarding who is speaking them. It probably would not matter, in terms of our understanding of what was being said, if we heard a weather report read from a script by different broadcasters.

Of course, we seldom focus only on the words semantically in the case of the spoken word. As we listen to the words, we also scrutinize tone of voice and hand and facial gestures for emotional meanings. The fact that we see the body reduced to just the lips is a disorienting feature of Lorna Simpson's film installation *Easy to Remember* (2001) [5-7], which presents fifteen pairs of disembodied lips arranged in a grid of

fifteen screens separately humming the Richard Rodgers's love song of the title. Without accompanying facial expressions, hand gestures, and body postures, we learn little about the individual hummers and how they might be responding to the song's lyrics and melody. Our full understanding seems thwarted by the cropped view.

When words are included in a work of art, we often find that their format takes on special significance. When painted in strident colors onto the surface of an artwork or photographed using high-contrast film or sculpted out of stone, words and individual letters take on a concrete, visual presence. In these instances, the physical qualities become additional carriers of meaning, enriching or altering what the words signify grammatically. In some cases, words incorporated into works of art may lose their transparency and become an element that is never actually read but only seen, like a different type of texture within the mix of other forms that make up the particular artwork. Most frequently, however, written words in an artwork are both read and consciously seen. Such words that function both visually and verbally can be thought of as having a quality of translucency, our term for a balance or fluctuation between verbal and visual emphasis. An equivalent analysis can be performed on spoken words. Translucency applies to spoken words that are heard as words and also as nonlinguistic qualities of sound. The performances of Laurie Anderson in which her voice is distorted through a special synthesizer but remains intelligible are a case in point.

We discover such a translucent use of language in paintings by American artist Kay Rosen (who earned a graduate degree in linguistics). For example, in *Sp-spit It Out* [6-5], duplicating letters wittily mimic the nervous speech pattern of an actual stutter. Similarly, on first impression, looking at the 1987 painting *John Wilkes Booth*, the viewer sees a short, peculiar list of duplicated words:

ass ass in in the the ater

Here, as in all of her art, Rosen's strategy produces a time-release effect. The particular arrangement of letters, which subverts a too-quick decoding of the entire phrase, increases our appreciation of the visual qualities of the composition (the choice of colors and the shape of the typeface making the individual letters). We see that sets of letters repeat, and we see that the letters make short words. Connecting the title of the painting, *John Wilkes Booth*, to the letters, we arrive at a new level of interpretation. Now the letters spell a historically loaded phrase: *assassin in the theater*. As we study Rosen's clever painting, we switch back and forth between reading and seeing and discover that Rosen's painted clump of letters refers to the tragic ending of Abraham Lincoln's presidency.

Christopher Wool, another American painter, developed his own signature style of chopping up words arbitrarily at the ends of lines and closing the spaces between words. A short phrase of ordinary words appears surprisingly unfamiliar:

RUND OGRU NDOG RUN

M-murder erer! St-Stuttered ed Ed

6-5 Kay Rosen | Sp-spit It
Out, no. 3 out of 5 paintings comprising The Ed Paintings, 1988
Enamel sign paint on canvas, 32 x 20 inches
Courtesy of the artist. © 1988 Kay Rosen

Artists sometimes design the visual qualities of the text they incorporate in a manner that enriches the semantic meaning of the words. For example, painter Ouattara often combines occult symbols (comprising a kind of vocabulary of signs from a secret language) from his native Ivory Coast with collaged images from popular culture, such as record-album covers for jazz, reggae, rap, and ethnic music, to communicate his multilingual identity within a diverse world of culture and commerce.

In other cases, artists intend their selected text to operate primarily on a visual level, as something to be looked at for its shape, texture, and color, like any other visual element. (We might coin the term *opacity* to refer to those cases in which we never see through the words to the denoted level of meaning. An ordinary instance of this occurs when a traveler abroad sees a newspaper in a foreign language, and to her the text appears as a meaningless pattern of shapes.) In his work before 1996, Laotian artist Vong Phaophanit was more interested in language as a physical material than as a carrier of semantic meaning. Using materials such as neon [color plate 15], bamboo, rice, and silk, he created works that included Laotian characters that had mutated into almost abstract sculptural forms. Writer Claire Oboussier remarked, "The use of fragmented Laotian script places the viewer on the 'outside' of meaning, suspending the semantic function of the words used and foregrounding their neglected sensuous side." ¹⁶

Spatiality and Physicality

In exploring language, artists often work in tension with Western culture's common practice of reading letters and words in sequential order. To understand a text correctly, a reader follows a single flow of letters in which words become sentences that become paragraphs and then pages. Any deviation from this path—of reading words from left to right, lines from top to bottom, and pages from front to back—is prohibited by the rules of grammar and by the publishing tradition. Reading the text in a different sequence would change the meaning intended by the author or disrupt the meaning altogether.

Within the last century, many visual artists, graphic designers, and experimental poets have used words in ways that are not sequential; their words, instead, have a quality of *spatiality*. The eye can dart across a spatial composition in a multitude of directions. The strict linearity of language is overthrown. Artworks that are high on the scale of spatiality offer us words we first look at as an element of the entire composition and second read for content. (Examples of concrete poetry and modernist graphic design also exhibit language composed spatially.)

Contemporary visual artists have explored how words take on different connotations depending on the medium the artist uses to produce the words, the shapes the words are given, and even the size of the words. In his *Notes on Language*, Conceptual Artist Vito Acconci contrasts two different scales in which language is used: "Language on a page is small language; language on a billboard is large language. Small language is convoluted and over-structured, in order to draw a reader inside it." According to Acconci, language made large results in our view of it as a physical form, a thing. Acconci theorizes a relationship between the concept of transparency and physical size. "Large language is not so much language as it is a picture composed of the elements of language. Large language becomes a thing, but not necessarily the thing it began talking about. Thingness makes language solid but, in so doing, destroys language—which, in order to work 'normally,' has to remain transparent so that it leaves the world as it is. When language becomes solid, it prevents normal flow, from person to language to world."17 Acconci's definition of "large language" is exemplified humorously by his own sculpture Name Calling Chair (1984), a four-foot-tall wooden chair that spells the word "Ass," with the letter A forming the chair's back and two small letter s's forming the sides. Sitting on the chair-sculpture, the viewer embodies its verbal-visual meaning.

Egyptian-born artist Ghada Amer's *Love Grave* (2003) [6-6] was carved directly into the grounds of the Indianapolis Museum of Art. By burying her text in the earth, Amer's use of language seems to embody literally and poignantly the death of love. In an inventive twist on placing primary emphasis on the physical qualities of language, some artists (such as Kay Rosen) have hidden letters or words behind an opaque rectangle, so that the viewer of the artwork must puzzle out what the text says. Ed Ruscha's painting *Better Get Your Ass Some Protection* (1997) shows six black oblong shapes on a maroon background. The variation in lengths clues the viewer that the oblongs have obscured or censored the text (spelled out in full in the title).

Other artists have explored how simulating the ability to talk can seem to bring an inanimate object to life. American sculptor Tony Oursler, for example, has made a series of hand-stitched ovoid forms upon which a digital projector casts a video recording of a face. A recorded stream of incessant chatter, synchronized to the moving lips, instills a mesmerizing presence to the head and its limp body. The stream of talk emanating from

6-6 Ghada Amer Love

Grave. 2003

Installation at the Indianapolis Museum of Art

Courtesy of the artist and the Indianapolis Museum of Art, © 2003 Ghada Amer and Deitch Projects

one of Oursler's video effigies typically shifts back and forth from the abject to the hyperaggressive. For example, the doll in *Don't Look at Me* (1994) cries out statements such as, "Don't look at me!" and "You're making me sick."

Books Made by Artists

One of the classic forms that language takes is the book. Building on explorations by artists in earlier periods, contemporary artists who create their own books have pushed forward along three primary fronts: the tradition of *livre d'artiste*, bookworks in multiple editions, and mass-produced comic books. These fields of activity can blend together.

Both a *livre d'artiste* and a bookwork are often referred to by the more general term *artist's book*, meaning a work by a visual artist in book form. A *livre d'artiste* is a handmade, booklike artwork of which only one or a few copies are ever made. Numerous contemporary artists have created one-of-a-kind artist's books, building on a practice that had been explored off and on for centuries. (The English Romantic artist and writer William Blake and the German modernist Max Ernst were important precursors.) Since the 1980s German artist Anselm Kiefer has made handmade books a specialty of his artistic practice. Often monumental in size, Kiefer's unique books incorporate unexpected materials such as lead and hay. Many artists' books include an extensive and

creative use of text. In some intriguing examples, artists take an existing book and mark out or cut away some of the original words and phrases to reveal a wholly new text or story, as the viewer connects words that were not in sequence originally. This approach echoes strategies that have been used at times by experimental writers.

A bookwork refers to an artist's book that is created in multiple copies. This practice received a dramatic boost in the United States from the widely praised bookworks produced by California artist Ed Ruscha in the 1960s. In his earliest bookwork, Ruscha presented twenty-six gas stations along a particular route in a sequence of pages. In addition to exploring language, artists' books frequently employ offbeat humor or have autobiographical elements. One reason for the popularity of bookworks is their democratic quality: books can be produced in copies that are affordable to people with limited financial resources. Each copy of a bookwork is an original work of art, since each is created in the form the artist originally intended. Experiencing a work of book art is similar in some ways to experiencing a normal book, but it usually provides an enhanced opportunity for viewers to interact with the art. The process of turning the pages to reveal new portions of the artwork might be done in a number of ways, thus increasing the spatiality of the book, while perusing the book at the viewer's own pace exaggerates the sensation that a book is a time-based and intimate art form. To limit cost, artists creating book multiples in the 1980s made use of available technologies such as the mimeograph machine; since the late 1990s many book artists have taken advantage of desktop publishing software and computer technology.

Other bookworks during the contemporary period have been produced by art institutions and cooperatives using equipment often unavailable to the individual artist, such as letterpress equipment or today's commercial printing equipment, including laser scanners and multiple-color presses. One example of a commercially printed volume is *Raymond Pettibon: A Reader* (1998), in which short passages from various writers such as Mickey Spillane, Henry James, and Charles Manson are interspersed with drawings by Raymond Pettibon (United States). We illustrate an example of a page showing a drawing from 1985 [6-7]. The visuals, in a 1980s punk style, appear with terse texts (e.g., "You didn't have to stab the man 577 times to get \$45 from him."). The reader/viewer is invited to peruse the volume in any sequence, to explore within the pages selections that touch on a range of themes (youthful angst, anomie, and suspicion) that reflected the waning of 1960s counterculture idealism as the twentieth century drew to a close. ¹⁸

Comic books and fanzines make up a third category of artist's books. These books have a visual style and subject matter that is closely tied to youth-oriented popular culture. Pettibon's series of fanzines *Tripping Corpse*, produced throughout the 1980s, is one example. More recently, American Chris Ware in 1993 began a comic series called the *ACME Novelty Library* that featured stories about Jimmy Corrigan, the "Smartest Kid on Earth." Combining text and images in dizzyingly complex framed sequences of action, Ware's work explores the language of cartoon dialogue as well as the visual "language" of cartooning. Art in comic-book form is found in much of the world today and is especially popular in Japan.

Art Made with Books

Stacked up or placed in a row on shelves, books can be powerful symbolic objects. As containers of information, books hold a central place within the history of cultures.

6-7 Raymond Pettibon Untitled ("What's better science than creating me? And I have the skills to do it.") 1985

Black ink on paper, 12 1/4 x 8 15/16 inches Collection of Gaby and Wilhelm Schurmann Courtesy of Regen Projects, Los Angeles, and Renaissance Society, University of Chicago

Indeed, books have served as the primary vehicle within which the general history and knowledge of the world over the past two millennia have been recorded. As works of literature, as scientific treatises, as political tracts, and so on, books encode the civilizations that produced them; books can also symbolize the individual who chooses to own, collect, and read them. A book is a physical object; a book also represents the subject matter that the language on the pages refers to. Books are loaded symbols. For these reasons, contemporary artists have used found books (i.e., books written by others) as raw material for creating new artworks. Found books have been manipulated and refashioned in the creation of artists' books; books have been taken apart and the pages used as collage material; books have been represented as objects within two-dimensional artworks (such as paintings and photographs); and books have functioned as props and raw materials in an array of performance art events, sculptures, and site-specific installations.

We cite three examples to hint at the range of activities. American Buzz Spector created piles of books with the overall title *Toward a Theory of Universal Causality* (1984) [6-8] that functioned as metaphorical monuments. The piled books obviously contained intellectual content, and yet viewers had no access to the actual texts. Spector's piles of found books purposefully echo the compositional strategies of modernist sculpture, especially as seen in the simplified geometries of 1970s Minimalism.

 $\hbox{6-8} \quad Buzz\,Spector \quad | \quad \textit{Toward a Theory of Universal Causality.} \ 1984 \\ \hbox{Installation of hardcover books, dimensions variable} \\ \hbox{Courtesy of the artist}$

The collaborative team of Michael Clegg (born in Ireland) and Martin Guttmann (born in Israel) conducted a project called *Open Library* in several cities since 1991. In selected public places within each locale, the artists placed cupboards and shelves filled with books that people could borrow or exchange at will. *Open Library* produced a representation of the inhabitants of a particular urban area based on how the

recorded pattern of what was taken from the library revealed their collective reading habits.

Tim Rollins + K.O.S. (Kids of Survival) are a collaborative team of artists who work with famous works of literature. The "Kids" are a changing group of youth from the South Bronx—a poorer section of New York City—and many of the themes they gravitate toward, such as awareness of violence and the history of race relations, relate to urban situations. In making an artwork, the team dismantles the text of a well-known work of literature and pastes the individual pages together in a large grid on a canvas. Painting directly across the pages, Tim Rollins + K.O.S. enter into a pictorial dialogue with the subject matter of the book. Curator Thelma Golden analyzed the creation of By Any Means Necessary—Nightmare (1986): "Using their characteristic method of painting on the pages of a book that the group has read and discussed, this work takes its title from one of the pivotal chapters in Malcolm's autobiography. K.O.S. intervenes over the prophetic and spiritually engaged text with a freeform X, the iconic signifier of the man, one side of which becomes part of the letter M."¹⁹ To appreciate this visually bold artwork, it isn't necessary for the viewer to read much of the background text, although a basic familiarity with the role of Malcolm X in the civil rights movement in the United States deepens a viewer's encounter with the artwork.

Wielding the Power of Language

Artists who incorporate words in a work of art often have a purpose beyond provoking an aesthetic reaction. In these cases, art is not for art's sake alone. Numerous artists of the 1980s, 1990s, and early 2000s have turned their attention to addressing social and political issues. In making art about environmental pollution, violence, nuclear arms proliferation, sexism, racism, and other concerns, today's artists find that language helps them to make a strong impact on viewers.

Artists have used many strategies to take their messages to the streets. Collaborative artist groups, such as ACT UP, Guerrilla Girls, Group Material, and Gran Fury, as well as individual artists such as Jenny Holzer, utilized street posters, mass-produced pamphlets, and ads and inserts in mass-circulation newspapers and magazines to develop and distribute their messages. Sometimes coupling printed words with bold visual graphics, these artists challenged the status quo on specific issues and also offered more generalized critiques of society and human foibles. For example, the phrase "Silence=Death," seen on posters made in the late 1980s by ACT UP, tersely advised that unless citizens voiced their concerns, the government would fail to provide adequate funding for AIDS research.

While the proliferation of artists' texts inserted fresh ideas into the social land-scape, the low-cost formats and production as multiples challenged the prevailing art gallery distribution system. For example, instead of producing precious objects and images that only the economically privileged could afford to own, Jenny Holzer pasted her early word works (e.g., "Abuse of power comes as no surprise") in poster form on the sides of buildings, and graphic artist Art Spiegelman created *Maus* (published in 1986), sold commercially as a softcover book available in bookstores nationwide. *Maus* is a comic book that recounts the history of a Jewish family in Europe during the Nazi era and in America after WWII (with mice standing in for Jews and cats for Nazis). Consistent with their function in most comic books, the words in *Maus* comprise the dialogue spoken by the various characters in the story.

The 1980s also witnessed an increasing number of graffiti artists who "tagged" public spaces. The graffiti artist's approach—writing furtively on a public site, often on the sides of government or corporate-owned property or over existing commercial or public signage—can be interpreted as a guerrilla tactic. Frequently hard to read and consisting only of a word or two (often the artist's nickname), the underlying message of graffiti art is complex, and its value and status as art are open to debate. Is graffiti art even art at all? For those who think so, then the strategy of taking their art to the streets empowers graffiti artists to bypass art-world institutions and the commercial gallery system. Graffiti art can also be seen as an effort by private individuals (many of them impoverished) to communicate outside of the system of mass consumerism and its brand-name approach to commercial representation. Gallery-based artists such as Keith Haring, Jean Michel Basquiat, and Barry McGee borrowed heavily from graffiti art to develop idiosyncratic and highly recognizable approaches that combine stylized writing and a cartoonlike approach to image making. In addition to posters and graffiti art, other artists have incorporated their use of language in such public formats as billboards, bus signs, and loudspeakers.

Politically motivated artists often use text rhetorically, in an attempt to influence the thoughts and actions of their audience. This kind of language art tends to be declarative, stating its messages bluntly and unambiguously. The Guerrilla Girls, a collective established in New York in 1985, use street posters printed with statistics and short texts to draw attention to discrimination against women artists, as well as issues such as racism and censorship. Sue Coe (born in England) has used the tradition of political caricature to highlight apartheid in South Africa, animal rights, rape, and other issues. Numerous artists have created language works that address the AIDS crisis, which has become a global catastrophe. One of the first was the Canadian group General Idea, who in 1987 created a logo of the word "AIDS" based on Robert Indiana's "LOVE" design of the 1960s. Deborah Wye commented, "At the time, it was painful and shocking to associate the playful free love of the hippie period with the suffering and finality of AIDS. General Idea subsequently made this logo the basis of a visual campaign that duplicated the strategies of advertising in its placement of the image in worldwide venues. Over time, the logo began to represent the epidemic's very pervasiveness. It was seen on the streets, in the subways, on a stamp, a lottery ticket, the covers of medical and dental journals, and also in wallpaper available by the roll."20

In other cases, political messages are more indirect. Combining old family snapshots with text that parodies the style of writing in the children's book *Reading Dick and Jane with Me*, American Clarissa Sligh alludes to child abuse in her print suite *Reframing the Past* (1988). In the 1990s American Glenn Ligon made paintings, such as *I Am Not Tragically Colored* (1990), in which he stenciled phrases from black literature and culture repeatedly on panels. Read from top to bottom, a given phrase gradually becomes smeared and illegible, implying that experiences of racism erode a person's self-confidence, even destroying his identity over time.

While liberal-leaning tendencies gird the majority of artworks addressing sociopolitical issues that have received critical attention in the past two and a half decades, works that use language to offer a reactionary viewpoint have also been made. The most successful of these employ humor or irony. For example, Richard Prince (born in the Panama Canal Zone and now living in New York) has developed joke paintings, often featuring clichéd scenarios, which lampoon political correctness. Prince often

captions his cartoon paintings with a text that seems to belong to another cartoon, bearing no logical connection to the scene in the image. The caption printed on the painting *What a Kid I Was* (1988–89), for example, reads: "I remember practicing the violin in front of a roaring fire. My old man walked in. He was furious. We didn't have a fireplace." The cartoon itself shows a man in a suit walking in to see a young woman—his wife?—on the lap of an older gentleman.

In addition to using text to make statements about real-world issues, artists have explored how language in culture functions as a tool of authority and power. As post-modern and poststructuralist theorists (notably Michel Foucault) pointed out, controlling language—controlling what is put into words and who has the authority to speak publicly—is an important means of gaining and wielding power.

Building on the theoretical critique of the language of authority, artists such as Jenny Holzer set up situations in which supposedly neutral or authoritative information is revealed as contradictory and untrustworthy. Holzer's series of aphorisms, including Truisms (1977–79) and Inflammatory Essays (1979–82), have been shown in numerous formats and locations over the past two decades, such as electronic advertising boards in public places, engraved metal plates, carved stone benches, T-shirts, posters, and stickers. The truth of one aphorism may undermine another. For example, in the *Truisms* series, the statement, "Everyone's work is equally important," precedes the contradictory statement, "Exceptional people deserve special concessions." Moreover, in Holzer's work the physical material used influences the viewer's perception of the significance of a particular message. An aphorism carved into the granite seat of a public bench is interpreted differently than that same aphorism flickering across an electronic signboard above Times Square. In a reversal of the strategy used by Holzer in creating her Times Square signboards (in which a profound thought may flicker momentarily), Belgian Wim Delvoye in 1996 created laser ink-jet paintings in which trivial messages ("Susan, Out for a Pizza, Back in Five Minutes, George") appear to have been carved into the rock walls of mountains. These works humorously raise the question of what messages are significant enough to merit permanent inscription in stone.

Artists have employed text with the aim of undermining the truth or authority of public language. Barbara Kruger uses commercial advertising techniques appropriated from graphic designers to expose the ideologies underlying advertising and the mass media. Louise Lawler has investigated how labels, invitations, advertisements, and other texts used by auction houses and museums to present and describe artworks lend those works authority and status as high-priced commodities and collectibles. Lawler reveals how the practice of collecting fine art upholds the mystique of the wealthy and powerful in a capitalist economic system. Fred Wilson, in his acclaimed reinstallation of the collection of the Maryland Historical Society, titled Mining the Museum (1992-93), placed a museum's prized possessions such as silver goblets alongside humble items such as iron slave shackles, which would not normally be featured in an exhibit of collectibles, and ironically labeled the whole group of objects "Metalwork, 1723–1880." Wilson's installation, including the objects and educational labels, demonstrated, by counterexample, how exhibits of material culture relating to Eurocentric colonialist history have been organized frequently in ways that fail to represent the history, achievements, and treatment of African Americans.

In tackling perceived problems in the here and now, artists engage in a process that serves to demystify the grand narratives by which society anchors itself to the past.

History, religion, patriarchy, scientific reasoning, and rationalism—artists have taken them all to task, unmasking them as invented networks of meaning, however enduring. In 1987, for example, Group Material began a project called *Democracy*, in which they looked at the subject in the context of late capitalism. Kristine Stiles wrote, "Their art took the form of public lectures, exhibitions, town meetings . . . and a book. . . . Group Material's examination of democracy is consistent with the aims and values of those who developed conceptual art as an alternative means to generate greater theoretical involvement on the part of artists in material culture."²¹ A focus of Group Material's project was to reveal how power flows through society.

An extreme way in which people wield power over language is through censorship—the suppression of speech that someone finds distasteful, subversive, or dangerous. Book burnings and the wholesale destruction of visual images are measures that people in authority have taken at earlier times in history to try to stamp out ideas and beliefs contrary to their own. Within our own period, censorship issues have emerged over such actions as the artist Dread Scott's placement of an American flag on the floor of a gallery so that visitors would need to stand on it in order to get close enough to read a text. (Scott's piece created a furor when it was first exhibited in a student art exhibition at the Art Institute of Chicago, where the artist was enrolled.) Contemporary artists have made works designed to reveal the prejudice and intolerance behind acts of censorship, and in some cases they have tested the limits of free speech through their own extreme expressions. Russian artist Svetlana Kopystiansky, who often uses books symbolically, said, "I also worked a lot with the issue of censorship, hiding parts of a text and exposing its fragments which then became absurd."²²

Confronting the Challenge of Translation

The video work *Dialogue* (1999), by Japanese artist Shigeaki Iwai, features four screens; each screen shows four people who seem to be in conversation with one another. The sixteen people are from different countries, and each is speaking in his or her native language. On each screen, subtitles in the four languages spoken by that particular group almost obscure the speakers' faces. *Dialogue* illustrates metaphorically the problem of misunderstanding that can occur when people from different cultures meet. Iwai also gently mocks a utopian belief that everyone can or should be heard equally in a free exchange. Iwai's *Dialogue* implies that within the context of a multilingual glut of information, no voice separates easily from the din. Curator Eriko Osaka remarked, "From this hubbub, you could hardly pick out even your native tongue."²³

Iwai is one of a range of contemporary artists exploring the inevitable miscommunications that accompany multicultural exchanges. Osaka has commented, "Even in the same language, we do not understand each other well all the time. While acknowledging the absolute usefulness of language as a tool of communication, we have to perceive differences in cultural background which appear in language, to know untranslatable facts, and to become aware of the weaknesses and dangers of solely verbal communication."

Translation is the process of transposing a text, statement, or idea from one language into another while retaining the original meaning. A translation is never perfect even under the best of circumstances. There is no one-to-one correspondence of denotative and connotative meanings, for instance, between an essay in Standard English and its translation into Mandarin Chinese. A slippage of meaning inevitably results. Some meanings mutate and some get left out.

Art that addresses the challenges of translation has emerged, not surprisingly, in multilingual societies and in the work of artists who, having moved from one country to another, find themselves immersed in a new language, Translation is a significant issue in the contemporary period because of the internationalization of commerce and worldwide exchange of information; furthermore, translation is relevant for artists who are on the move and for an art world that has expanded its global reach. Tension can result whenever a language, code of behavior, or style of visual representation initiated in one culture is inserted into another. For example, most African societies had oral traditions; writing entered these societies as European languages were taken up by native populations, leading to what Valentin Y. Mudimbe characterized as "an epistemological break represented in the passage from orality to writing."²⁵ African artists have necessarily struggled with issues of translation and the decision of what voice to speak in. Chéri Samba successfully translates a strategy from his locale (the combination of text and image found on advertising signage in his native Zaire) to a fine art practice (paintings that focus on social and political issues in present-day Africa) that has received favorable attention in the international art world.

Xu Bing [color plate 16] is among a group of contemporary Chinese artists who are exploring how China's written language inevitably takes on new meanings and values within the context of a fast-paced, evolving world. Xu's installation A Book from the Sky (1987–91) features printed elements that appear to be traditional Chinese characters but are actually fictitious, incomprehensible characters that the artist invented by rearranging elements from real characters. The work embodies the idea that, although impressive, the complex and cumbersome Chinese system of writing translates inefficiently into the present, an age in which a streamlined exchange of information would seem more appropriate. The installation also analyzes written language as an invented system of communication; new advances in human knowledge inevitably require concomitant additions to our shared vocabulary. After immigrating to the United States in 1990, Xu Bing began to explore the difficulty of translating between languages, particularly Chinese and English. Cultural Negotiation, an installation in 1993 at the Wexner Center on the campus of the Ohio State University, included a large table, surrounded by reading chairs, that was covered with several hundred (handmade) volumes of unintelligible text in Xu's made-up Chinese characters and English nonsense syllables. Other artists exploring China's written language include Wenda Gu and Song Dong.

Artists who are members of historically marginalized groups (women, people of color, gays, the colonized, the displaced) are attuned to the power that the dominant speakers of a culture have and the corresponding struggle to be heard of those who speak differently. Works about issues of translation by those whose language is dying out or has been supplanted can be especially poignant. When you must assume a new language, you learn a different culture and a different way of thinking, which can exert a corrosive influence if the new culture visually or verbally represents your original culture in a negative light.

Naming is a way of gaining power. Various groups, attempting to gain control over how social issues are examined, seek to manipulate perception by determining the public terms used to name, describe, and classify what we encounter in the world. (For example, the terms "pro-life" and "pro-choice" emphasize what their supporters feel are positive aspects of the opposing positions in the debate over abortion in the United States.) A group who succeeds in gaining control of the names by which we call things

may reduce the power of those outside the center by excluding not only their terms but their concepts. 26

Many artists have addressed issues of naming. In his series of paintings *Notes to Basquiat* (1998), Australian Gordon Bennett wrote lists of racist slang names and brand names associated with Australian colonialism and African American history and slavery beside images of bodies, some displaying ribs and skeletons in X-ray fashion. Anthropologist Nicholas Thomas explained, "As always, [Bennett] insists upon the connotations, for instance between commercial 'brands' and the branding of slaves." Yet even as people are "trapped within a language that is structured through simple, but racially invidious and violent ascriptions," Bennett's images of opened-up bodies "display the sameness of humans beneath colour and beyond the operations of naming and misnaming."²⁷

German artist Lothar Baumgarten has investigated how European colonizers used language as a tool of cultural domination in North and South America by replacing native names with European ones (e.g., "Indians," "America," and "Venezuela," which means "little Venice," are European in origin). Baumgarten inscribes the native names for plants, minerals, animals, populations, and places on building facades, walls, and floors; the renamed features of architecture are combined in installations with other objects, as well as being illustrated in photographs and in artist's books. For a project in Paris in 1986, Baumgarten temporarily replaced the Napoleonic-era names of metro stations with the names of the native populations of France's colonial empire. In using native names, Baumgarten attempts to restore voices that were forcibly rendered mute and to challenge the hegemonic practices of colonialism and ethnography.

Hachivi Edgar Heap of Birds, a Native American artist of Cheyenne and Arapaho ancestry, developed a practice of inserting words and names from Native American languages on billboards and in other public places to remind viewers who retains the original claim of ownership to a specific geographic site. Heap of Birds has also employed a strategy of writing English words in reverse, to alert how language can misrepresent and estrange. The artist has noted that the English-given name "Cheyenne" is, in fact, a mistaken form of a Lakota word meaning "unintelligible speech."

In addition to considering the challenge of translating from one language to another, artists have explored how meaning changes when we shift from one mode of language into another (such as speaking to writing or from language to a nonverbal mode of representation). Artists who currently explore these issues follow in the footsteps of earlier artists, such as René Magritte, a twentieth-century Belgian Surrealist whose paintings often examined the disparities in how language and visual imagery function as separate systems of representation, and how representation differs from reality. For example, contemporary artist Christian Marclay, an American raised in Switzerland, has extensively explored the mode of music and how "if you try to translate it into language it fails." In Mixed Reviews (1999), Marclay made a collage from excerpts of published reviews of music performances. The new text, consisting of many authors' words taken out of context, is translated into the local language of the country or site where the piece is exhibited. The translated text is painted in a line on a wall. The futility of translation, from music to words and from one language to another, becomes tangible.

In his installation *Reading Landscape* (2001) [color plate 16], at the North Carolina Museum of Art, Xu Bing translated the view out a museum window into a representation that fused verbal and visual modes. According to critic Jonathan Goodman, by

employing "seal script, an ancient Chinese writing whose forms tend to simulate the object they denote, [Xu Bing] created a world in which what is read may be easily linked to what is seen—the characters for bird, hung from the ceiling, look like birds flying. . . . The pond is rendered with the characters for water, cut in transparent plastic so that they simulate the translucency of water." 30

An intriguing artistic exploration of translation is found in the work of American Joseph Grigely. Deaf since childhood, Grigely developed a habit of "conversing" with people by having them write their thoughts down on whatever slips of paper were at hand. Accumulated over years, Grigely's inventory of these slips of paper contain many hundreds of thoughts from the prosaic to the poetic, in as many styles of writing. To create a work of art, Grigely installs a large selection of conversational snippets together on a wall [6-9] or across the surfaces of an entire room. The reader/viewer encounters the individual verbal expressions (e.g., "She's a great party WOMAN—not a girl.") in random order, without a clue as to how the phrases fit into a conversation someone once had with Grigely. Quite unexpectedly, by displaying a tapestry of scrawled messages, the artist reveals how rich with nuances conversations are and how these written phrases inevitably display "the unmistakable oddness of ordinariness." Sound effects have been eliminated, but the feeling of a verbal flow and human intimacy remain in these written translations of the spoken word.

Using Text in the Information Age

Western society's transmittal of information has been dominated by the written word since Johannes Gutenberg invented movable type more than five centuries ago, making possible the efficient printing of books. The standardized appearance of typeset words placed a heightened emphasis on reading words transparently and tended to deemphasize the visual qualities of words. (Type designers, of course, paid enormous attention to the look of language, but readers of text in such formats as newspapers and novels tended to overlook such aspects as typeface while giving their primary focus to the semantic meaning of a message.) In the latter half of the twentieth century, however, with the dramatic growth in mass advertising and the development of more-flexible print technologies, the visual qualities of print became, once again, increasingly salient. Words are designed visually in ways that heighten an ad's emotional message.³²

The rapid changes brought by the information age have prompted contemporary artists to examine how language has become a necessary component in both the means and the meaning of art. Information overload and the proliferation of text/image combinations in digital environments specifically cannot be addressed fully by an artist limited only to visual representations. The complex information-processing systems available today utilize photographic imagery, handmade imagery, sounds, music, spoken words, and text. Artists seeking to explore this mediated world may incorporate all these forms of representation and information exchange. In some cases, an artist utilizes an interactive strategy. For example, Australian Jeffrey Shaw created three different versions of his interactive installation *The Legible City* (1988–91), based on the downtown areas and history of Karlsruhe, Amsterdam, and New York. A viewer sits on a stationary bicycle and uses controls to decide his route and speed for riding through a projected simulation of the city. "The city's 'buildings' are computer-generated letters, which form words and sentences lining the city's streets. . . . In the Manhattan

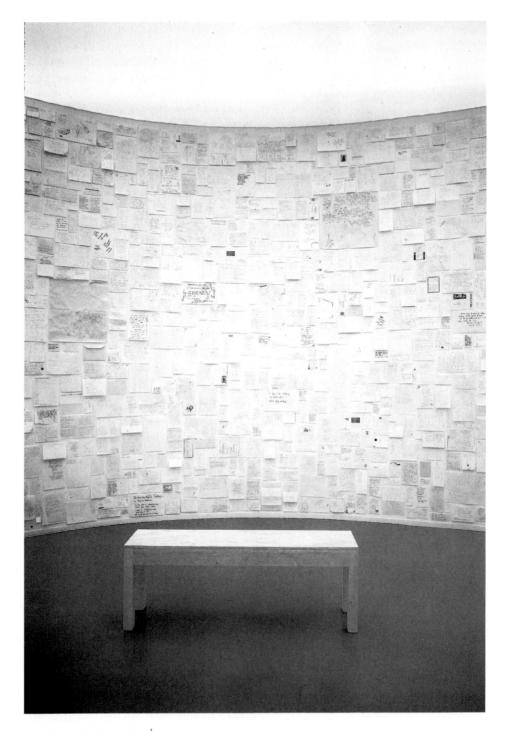

6-9 $Joseph Grigely \mid \textit{White Noise}, 2001$ Installation

Courtesy of Cohan and Leslie, New York

version . . . the viewer can follow eight independent narratives, fictional monologues by Ed Koch, Frank Lloyd Wright, Donald Trump, Noah Webster, a tourist, a con man, an ambassador, and a cab driver, all written by Shaw's collaborator Dirk Groeneveld. Each text appears in a different color, so the cyclist can easily choose a certain story line and follow it through the streets."³³

Since the 1990s artists have been taking advantage of the interactivity and interconnectivity of digital environments. In an interactive digital environment, the viewer is empowered, always having the option to click and move on. Utilizing the networks of information linked together digitally via the Internet, the contemporary world has witnessed an enormous growth in the potential for interconnecting communication between large groups of people located in diverse geographic locations, involving such formats as chat groups, list-serves, bulletin boards, multiuser domains (MUDS), and various other real-time formats. Regarding interconnectivity, Charles Bernstein explains, "Interconnectivity allows for works of collaboration, linking, and exchange, as well as the possibility of simultaneous-event or immediate-response structures. Interconnectivity turns the screen into a small stage and in this way combines features of theater with writing and graphic art." The Internet offers new platforms to make, manipulate, and distribute images and texts.

Artists are also critically examining the impact of information technologies on the individual psyche, on how we think and how we communicate. The volume of images, texts, and sounds that permeate the everyday world is being increased exponentially by our activities within digital environments, and the sheer volume can be overwhelming. American Mark Napier's Internet piece *Digital Landfill* (2001) offers a satirical commentary on the flood of Internet data. John S. Weber explained, "Entering the site, Web surfers are brightly if ludicrously encouraged by Napier to 'Clean up the Web! Dispose of your unwanted e-mail, obsolete data, HTML, SPAM or any other digital debris just by clicking the *Add to Landfill* button. All refuse is automatically layered into the Digital Landfill composting system.' A view of the *Landfill* itself reveals a seemingly endless, chaotic layering of text, images, and still-functioning links."³⁵

Today, the creation of art increasingly involves multimedia mixing. Visual artists are responding to the culture at large, where the diversity of hybrid forms is rapidly expanding. The Internet, movies, television, and commercial advertising consistently conflate the verbal and the visual. With the widespread deployment of computers, video cameras, cell phones with picture-making capabilities, television, and film, today's advanced societies communicate through a blend of words and images. In addition, visual and auditory images are braided together in popular music and other newer genres of emotional expression and information exchange, such as music videos and computer games. With the advent of hypertext and formats that allow the digital combining and overlaying of images, writing, and sounds, and the digital technology that allows for the nonlinear sequencing of links to other data banks and information sources, another arena of exploration has opened up for artists in the twenty-first century. Each person logged on to the computer becomes both reader and viewer, scanning the screen and participating in the control of information that flows before her, along her own path and at her own pace. Purely linear forms of verbal communication and communication formats that deliver only one form of verbal or visual imagery seem destined to become increasingly outmoded in the tangible and digital realities of the future.

Ken Aptekar's paintings are instantly recognizable, even though they share strategies (such as juxtaposing words and visual imagery within one artwork) utilized by many other artists. Aptekar constructs his work in a consistent format. Typically each oil painting starts as a single square wooden panel (thirty inches by thirty inches, or twenty-four inches by twenty-four inches), or multiple square panels combined (such as two thirty inches by thirty inches squares butted together to form a sixty inches by thirty inches artwork). Aptekar paints an image on the panel or panels and bolts a thick pane of glass approximately an inch in front of the image. Typeset words are sandblasted onto the glass. A viewer reads the words hovering in front of the painting and sees the words cast shadows onto the surface of the image.

The artist derives his imagery from other painters' work. Not striving for an exact copy, he translates the source image into a style of painting that combines his own with the original artist's. Colors may change; the most common alteration is a simplification of colors into a monochrome. Scale is manipulated for emotional control. For example, by creating a close-up of a figure's face (done by enlarging and cropping a detail from the original image), Aptekar creates (or exposes) a feeling of intimacy that did not exist (or did not register) in viewing the earlier painting. After creating a digital scan of the source image, Aptekar often employs a computer software program to experiment with alternate layouts for paintings in progress. He can experiment with various combinations of text and details. The computer also facilitates the testing of such options as flipping the image into a mirror reversal of its original format.

Early in his career, Aptekar appropriated details of imagery from famous artists, such as van Gogh, Rembrandt, Watteau, and Raphael. In selecting old master works as his starting point, Aptekar startled and delighted viewers by demonstrating how the meanings of "masterworks" from the history of art can shift dramatically. In *Pink Frick* [6-10], for instance, Aptekar appropriates a well-known self-portrait by Rembrandt, transforming it into a reddish-tinged monochrome (sort of an equivalent to seeing Rembrandt through rose-colored glasses!). Etched onto the panes of glass positioned directly in front of the four-part painting are a series of reincarnations of the words "pink frick." Some of the spellings are nonsense syllables, while others are actual words, such as "fink" and "prick." Aptekar's word play "invites parallel readings about Rembrandt, the current location of the portrait [in] the Frick Museum, and the [Frick's] philanthropic, union-busting benefactor and namesake." Aptekar's painting serves as a complex and witty critique of power. In Aptekar's view, even a sublime work of art (the Rembrandt) inevitably functions within a network of powerful economic and social forces.

More recently, Aptekar has undertaken commissioned installations involving painted details selected from artworks by lesser-known artists. Aptekar's *Dad is showing me how to develop* (1997) [color plate 17], for example, is based on a seascape

6-10 Ken Aptekar | Pink Frick, 1993
Oil on wood, sandblasted glass, bolts 60 x 60 inches (4 panels)
Courtesy of Bernice Steinbaum Gallery. Miami

by Willem Van de Velde the Younger, a little known early-eighteenth-century Dutch artist. Aptekar's composition shows close-ups of ships in glowing red colors (the ships are revised versions of those in Van de Velde's painting). Etched on the sheet of glass that hovers in front of the painted imagery, Aptekar's text concerns his own childhood. The narrative focuses on an episode when his father was teaching him photographic darkroom procedures. Aptekar's strategy of combining an autobiographic story with the reworked imagery results in the latter being seen as a photographic negative. In Aptekar's work, the word "negative" takes on a double meaning: the storyline written on the glass pane hints ominously at the young Aptekar's anxiety over the lack of an appropriate level of parental guidance: "Often I am all alone in the dark / while I'm developing."

Dad is showing me is one of thirty artworks created for a 1997 exhibition at the Corcoran Gallery of Art, Washington, D.C. Aptekar based the entire series of thirty artworks on selections from the Corcoran's permanent collection. Each of Aptekar's artworks incorporates details from an existing work. The texts incised into the glass in front of the paintings are the artist's own writing; many tell stories based on the artist's memories of childhood and adolescence (such as the true tale of an older brother who, tragically, needed to be hospitalized for a nervous breakdown shortly after entering medical school). Other texts quote actual responses to the original paintings that Aptekar elicited from visitors and guards at the Corcoran

Gallery who agreed to participate in focus group discussions about what specific artworks mean to them.

By incorporating the words of viewers into his artwork, Aptekar creates a clever takeoff on Roland Barthes's famous pronouncement in 1967 of the "death of the author." An influential French poststructuralist and semiotician, Barthes theorized that readers and viewers of texts and images necessarily create their own meanings; according to Barthes, no author or artist can dictate fully how others will decode an existing work. Each person unpacks his or her own baggage during the task of constructing an interpretation. Barthes's theory also declares that the artist has no "authentic" voice but creates his work using languages and conventions of writing and image making that are derived from earlier usages. Part of our delight in viewing Aptekar's art is to see how effectively he addresses both sides of a theoretical puzzle: no artist can be totally original, and yet no interpretation can be totally the same as any other.

A study of Aptekar's paintings in the 1990s and today shows his ongoing interest in juxtaposing appropriated visual images with autobiographical texts. He keeps revealing new sides to the question: How is an artwork's meaning altered by the process of interpretation? For an installation of his work in a 2001 exhibition, Give and Take, at the Victoria and Albert Museum, London, Aptekar hung his own paintings alongside the source paintings. Doing so, Aptekar's "spin-off" resonates in a seemingly endless variety of interpretations as the viewer glances back and forth at the Aptekar and the source echoing one another. Aptekar believes, and his art demonstrates, that interpretation is a creative process, too; each viewer completes a new work of art.

From the outset of his career, Aptekar approached other artists' art as an opportunity to remind himself of his *own* life's story. The sandblasted texts attached to paintings include episodes of family strife, the pressures his brother felt growing up in a household where high achievement was expected, and his own childhood anxieties. Aptekar's full range of texts also explores liminal, or border, areas, where his own personality melds with communal identities, including his Jewishness, his male gender, his status as an artist, and his professional career operating within an art world heavily influenced by the politics of museums and the power of critical theorists. Even a Rembrandt self-portrait, as Aptekar revealed in *Pink Frick*, is not evaluated simply on the basis of some neutral scale of artistic value but finds its place shifting within the constantly negotiated and renegotiated arena of art history and institutional practices.

Throughout this book, we approach art in the belief that all artworks are open for interpretation within a context of ideas and issues. Ken Aptekar's work takes this process a step further. Not only do his paintings gain meaning as we consider them *within* a conceptual context, but the artworks themselves embody competing contexts of ideas within their own compositions. What do we mean by this? We mean that taken alone, the visual image in the source painting may imply, to each of us, one set of ideas, whereas Aptekar's copy inserts a different set of ideas and

issues to think about in relationship to the painting. The addition of words adds, literally, another layer of meaning to the entire artwork. Aptekar's paintings address such issues as What artworks are collected by a museum? What do the people who work in and visit a museum think the artworks mean? How are males and females represented in artworks, both masterworks and works that are in the dustbin of art history? How can artworks created by others in earlier times for other purposes retrofit into new compositions that explore the artist's own life story?

The painter Ken Aptekar was born in Detroit in 1950. He received a master of fine arts degree from Pratt Institute in Brooklyn, New York. He now divides his time primarily between New York City and Paris, maintaining residences and studios in both locations.

Notes

1. Deborah Wye, *Thinking Print: Books to Billboards, 1980–95* (New York: Museum of Modern Art, 1996). An exhibition catalog.

2. John Berger is the author of one of the notable exceptions: a work of criticism in which a sequence of visual images without any accompanying text delivers the "message." See Berger, *Ways of Seeing* (London and New York: British Broadcasting Corporation and Penguin Books, 1972), pp. 36–43, 66–81, 114–27.

3. Gavin Jantjes, introduction to *A Fruitful Incoherence: Dialogues with Artists on Internationalism* (London: Institute of International Visual Arts, 1998), p. 16.

4. Chang Tsong-zung, "The Character of the Figure," in *Word and Meaning: Six Contemporary Chinese Artists* (Buffalo: University at Buffalo Art Gallery, 2000), p. 13. An exhibition catalog.

5. John Hollander, *Types of Shape* (New Haven: Yale University Press, 1991).

6. In addition to writers who emphasize the visual qualities of language, a great number of contemporary literary artists have made use of visual art as subject matter. Entire anthologies and critical studies, for instance, have been devoted to poems about paintings. See, for example, Howard Nemerov, "On Poetry and Painting," in J. D. McClatchy, ed., *Poets on Painters* (Berkeley and Los Angeles: University of California Press, 1988).

7. The practice of mixing the visual and the verbal in works of art has a long history, but we note that visual and verbal modes of representation have, at times, been kept strictly separate. For example, in an influential essay "Laocoön, or On the Limits of Painting and Poetry," eighteenth-century German aesthetician Gotthold Lessing argued that the domains of the two arts are so distinct—painting based on simultaneous spatial composition and poetry based on the sequential meaning in words—that even the criticism of each art form must necessarily be based on separate principles. In the era immediately prior to the contemporary, influential modernist critics, especially those favoring formalism, tended to emphasize those qualities intrinsic to each art form. In the case of visual art, this resulted in works that avoided literary sources, narrative, and the incorporation of language.

8. Kristine Stiles, "Language and Concepts," in Kristine Stiles and Peter Selz, eds., *Theories and Documents of Contemporary Art: A Sourcebook of Artists' Writings* (Berkeley and Los Angeles: University of California Press, 1996), p. 804.

9. Quoted in William Innes Homer, *The Language of Contemporary Criticism Clarified* (Madison, Conn.: Sound View Press, 1999), p. 30. We note that our recapitulation of a complex history is quite simplified, leaving out a discussion of others, such as the American philosopher Charles Sanders Peirce and French structural anthropologist Claude Lévi-Strauss, who also developed ideas that bear important relationships to those we are discussing.

- 10. Brian Wallis, "The Artist's Book and Postmodernism," in Cornelia Lauf and Clive Phillpot, eds., *Artist/Author: Contemporary Artists' Books* (New York: American Federation of Arts and Distributed Art Publishers, 1998), p. 95.
- 11. Howard Singerman, "In the Text," in *A Forest of Signs: Art in the Crisis of Representa*tion (Los Angeles: Museum of Contemporary Art; Cambridge: MIT Press, 1989), p. 165.
- 12. For a brief look at why the competing paradigms of semioticians versus "traditional" art historians can engender contention, see Mieke Bal, "Signs in Painting," *The Art Bulletin* 78 (March 1996): pp. 6–9.
- 13. Artist's statement quoted in Andreas Hapkemeyer and Peter Weiermair, eds., photo text text photo: The Synthesis of Photography and Text in Contemporary Art (Bozen, Italy: Museum für Moderne Kunst; Frankfurt am Main: Frankfurter Kunstverein, 1996), p. 139. An exhibition catalog.
- 14. Russell Bowman, a curator and art historian, identified the first six categories we list in the use of words in art. See Russell Bowman, "Words and Images: A Persistent Paradox," *Art Journal* 45 (Winter 1985): p. 336.
- 15. Rimma Gerlovina and Valeriy Gerlovin, "Forward," in *Photoglyphs* (New Orleans: New Orleans Museum of Art, 1993), unpaginated. An exhibition catalog.
- 16. Claire Oboussier, "Vong Phaophanit," in *Beyond the Future: The Third Asia-Pacific Triennial of Contemporary Art* (Brisbane: Queensland Art Gallery, 1999), p. 216. An exhibition catalog.
- 17. Vito Acconci, "Notes on Language," in *Perverted by Language* (Greenvale, N.Y.: Hillwood Art Gallery, Long Island University/C. W. Post Campus, 1987), p. 6. An exhibition catalog.
- 18. See the insightful essay by Hamza Walker, "Don't Throw Out the Shaman with the Bathwater," in Ann Temkin and Hamza Walker, eds., *Raymond Pettibon: A Reader* (Philadelphia: Philadephia Museum of Art, 1998), pp. 217–24.
- 19. Thelma Golden, "My Brother," in Thelma Golden, *Black Male: Representations of Masculinity in Contemporary American Art* (New York: Whitney Museum of American Art, 1994), p. 35. An exhibition catalog.
 - 20. Wye, Thinking Print, p. 87.
 - 21. Stiles, "Language and Concepts," p. 816.
 - 22. Quoted in an interview with the artist in A Fruitful Incoherence, p. 70.
 - 23. Eriko Osaka, "Shigeaki Iwai," in Beyond the Future, p. 72.
 - 24. Ibid.
- 25. Valentin Y. Mudimbe, "The Surreptitious Speech," in Okwui Enwezor, ed., *The Short Century: Independence and Liberation Movements in Africa*, 1945–1994 (Munich: Museum Villa Stuck, 2001), p. 19. An exhibition catalog.
- 26. For a discussion of how naming operates in the formation of social identity, see Lucy Lippard, "Naming," in Lippard, *Mixed Blessings: New Art in a Multicultural America* (New York: Pantheon Books, 1990), pp. 19–55.
- 27. Nicholas Thomas, "The Body's Names: Gordon Bennett's 'Notes to Basquiat," in *Beyond the Future*, p. 174. Bennett produced the works for a show in New York and decided to create a link with the place by aligning the imagery and ideas in the paintings with the work of Jean-Michel Basquiat.
- 28. Magritte's painting *L'usage de la parole I* (The Use of Words I) (1928–29) shows a simply painted pipe below which are painted the words, "*Ceci n'est pas une pipe*" (This is not a pipe). Suzi Gablik commented, "Normally objects are classified under words like 'tree' and 'shoe', and also under pictures that represent them. The more stereotyped these labels and their uses are, the more likely it is that the represented will be confused with the representation." See Suzi Gablik, *Magritte* (Boston: New York Graphic Society, 1976), p. 137.
- 29. Quoted in Jan Estep, "Words and Music: Interview with Christian Marclay," in *New Art Examiner* 29, no. 1 (September–October 2001): p. 79.
 - 30. Jonathan Goodman, "Xu Bing," Sculpture 20, no. 10 (December 2001): pp. 70–71.

31. Joseph Grigely quoted in Michael Kimmelman, "Bit and Pieces From the Intersection Where a Deaf Man Meets the Hearing," New York Times, August 31, 2001, B28.

32. The importance of mass advertising, and the examination of its effect by applying theoretical tools of analysis, has received great attention by various scholars. According to Paul Jobling and David Crowley, Judith Williamson's *Decoding Advertisements* (1978) is "probably the key text in this kind of enquiry, and in it she contextualizes advertising in a Marxist-feminist framework, with resort to semiological analysis." See Paul Jobling and David Crowley, *Graphic Design: Reproduction and Representation* (Manchester: Manchester University Press, 1996), pp. 245–46.

33. Oliver Seifert, "Jeffrey Shaw," in *Mediascape* (New York: Guggenheim Museum, 1996), p. 48. An exhibition catalog.

34. Charles Bernstein, "I Don't Take Voice Mail," in Susan Bee and Mira Schor, eds., M/E/A/N/I/N/G: An Anthology of Artists' Writings, Theory, and Criticism (Durham, N.C.: Duke University Press, 2000), p. 181.

35. John S. Weber, "Beyond the Saturation Point: The Zeitgeist in the Machine," in 010101: Art in Technological Times (San Francisco: San Francisco Museum of Modern Art, 2001), p. 23. An exhibition catalog.

36. Gary Sangster, "Ken Aptekar," in 43rd Biennial Exhibition of Contemporary American Painting (Washington, D.C.: Corcoran Gallery of Art, 1993), p. 34. An exhibition catalog.

37. See Roland Barthes, "The Death of the Author," in Stephen Heath, ed. and trans., *Image*, *Music, Text* (New York: Noonday Press, 1977), pp. 142–48.

Detail of 7-5

Spirituality

Visitors to the Royal Academy of Arts in London in the fall of 2000 found themselves looking at work by thirteen of the foremost contemporary artists in the world. The artists had been selected by the curators, Norman Rosenthal and Max Wigram, who invited each artist to fill one gallery with work on the theme of the Apocalypse. Taking the book of Revelation (a Christian text written almost two thousand years ago and attributed to Saint John the Divine) as its literary godfather, the exhibit, titled Apocalypse, presented visions of beauty and horror.

It was not mere coincidence that the exhibit coincided with the first year in the new millennium. Many of the artists' contributions to Apocalypse explored specific spiritual ideas and issues. Mariko Mori, born in Japan, showed her *Dream Temple* (1999), a complex, multipart artwork combining computer graphics, 3-D surround sound, architecture, and virtual reality. Visitors who entered the octagonal structure of the temple, modeled after a temple completed in Japan in 739 A.D., found themselves engulfed by a luminous video projection that covered all the surrounding surfaces. Mori's imagery, including abstract force fields of light interspersed with mystical scenes in nature (a forest, a waterfall), offered viewers a glimpse of enlightenment, a taste of the eternal present the artist believes is available to us now via cutting-edge technology.

In addition to Mori's optimistic creation, Apocalypse also confronted viewers with clever critiques of contemporary religion and gut-wrenching visions of a world gone awry. Italian-born Maurizio Cattelan's *La Nona Ora (The Ninth Hour)* (1999) consisted of a red-carpeted exhibition gallery, empty except for a life-size and lifelike sculpture of the pope lying on the floor, clutching the cross. The pontiff is pinned beneath a meteorite roughly half his size; by the evidence of shards of glass nearby, the stone from outer space appears to have fallen on him through the skylight overhead. Jake and Dinos Chapman, from England, displayed *Hell*, a work still in progress at the time of the exhibition. Featuring hundreds of tiny victims caught up in a hellish scene of Nazi brutality, the Chapmans' work of art condenses the history of concentration camps into a metaphor for apocalyptic horror and the damnation humans have heaped on each other.

These artworks by the Chapman brothers, Cattelan, and Mori are examples of contemporary art exploring aspects of the theme of spirituality. What do the artworks mean? Cattelan's meteorite appears like a divine message, perhaps sent to awaken us to the fallibility of organized religion. That the possibilities for interpretation of all three works are multileveled and open-ended is a key aspect of the power and mysterious beauty each achieves as a work of art.

The intertwined histories of religion and art contradict the belief that the greatest art is that which serves no other purpose than understanding art itself—"art for art's sake." In all cultures, a vast amount of art has been made in the service of religion. Such art tells the stories that support a particular set of beliefs. Spiritual art also includes objects, images, and sites used during acts of worship and other religious rituals. These works of art helped the believer to achieve spiritual *transcendence*, an awareness of forces beyond the visible world. Indeed, art has probably always overlapped with spirituality in its power to provide an experience of rapture and a sense of purpose. Spiritual art at its most powerful is intended to save souls.

Religious art encompasses a wide range of works stretching back to prehistory. It can include more recent works that have a spiritual tone, such as Mark Rothko's abstract paintings, which have been installed in a nondenominational chapel in Houston, and van Gogh's *Starry Night* as well as earlier works with clearly religious content, such as Rembrandt's etchings of biblical scenes and Michelangelo's Sistine Chapel ceiling. Ancient examples include the gigantic carved Buddhas at Polonnarua in Sri Lanka, Hagia Sophia in Istanbul, the Mayan pyramids at Chichen Itza in Mexico, the Egyptian pyramids at Giza, Stonehenge in England, and the rock art of Africa.

Art concerning religion and spirituality continues to be made today. To begin with a concrete example, *Untitled* (2000) [color plate 18] by Fred Tomaselli, an enormous multimedia work, includes, in the lower right corner, a painted version of the familiar Judeo-Christian motif of Adam and Eve being expelled from the Garden of Eden. Tomaselli borrows the pose of the figures from a fresco by the early Italian Renaissance painter Masaccio. The surface of the artwork is covered with a thick, glossy coating of resin that is reminiscent of the heavily varnished look of old master paintings. The story of Adam and Eve, told repeatedly in the history of Western art, recounts their fall from grace, when they were driven from Paradise to make their way on Earth. In Tomaselli's version of this decisive event, the human pair is expelled in a blinding flash of eternal light, as shown by a complicated starburst pattern that covers a jet-black night sky. According to Gregory Volk, "A concentration of energies on the left made of small paint marks hovering above real leaves (the ensemble is Tomaselli's rendition of God) gives rise to this patterned explosion. . . . Everything occurs everywhere." The emotional impact is a compelling combination of awe, beauty, and horror.

Like their predecessors, contemporary artists use diverse media, forms, and concepts to explore spirituality as a theme. This diversity reflects a range of individual and institutional beliefs, about religion as well as art. In this chapter we analyze some of the fresh perspectives that artists have offered on topics such as the eternal, the visionary, the sacred, the heavenly, and the damned. Rather than supplying answers, however, contemporary artists are likely to ask questions.

Definitions of religion and spirituality vary widely in contemporary culture. We reserve the term *religion* for institutionalized formal practices with a recorded history, established traditions, and shared rituals and doctrines. Long-standing organized religions

include Christianity, Judaism, Buddhism, Hinduism, and Islam. We use the word *spiritual* to refer to the common yearning to belong to something greater than the self, the desire to probe the source of life and the nature of death, and the acknowledgment of ineffable, intangible forces at work in the universe. People who do not participate in a formal religion may nevertheless recognize a powerful spiritual dimension to their life. As curator Susan Sollins puts it, "whether or not we participate in formal religious practice, the human condition seems to demand that we explore the spiritual, question our existence and a possible afterlife; we ponder our connections to the world around us, and examine experiences that seem to be inexplicable."²

As we consider religious and spiritual motifs and content in contemporary art, we will explore a number of related questions: Are any artists still making art in the service of a particular religion? Are artists making art about private spiritual beliefs that may or may not be tied to a defined religion? Are they exploring how spirituality can function in the contemporary world? Are they challenging religious and spiritual ideas, beliefs, or practices? Does art still possess the power to speak to society about fundamental spiritual concepts? We begin by placing the contemporary scene in context with a brief look at the history of spiritual art.

A Short History

If we look back through history, we discover that art and spirituality have had a strong bond throughout human existence, that they have frequently been intertwined and mutually reinforcing. Spiritual art has addressed humanity's most profound needs and life's greatest mysteries; beliefs about death and an afterlife, the nature of the universe and humanity's place in it, and the moral codes that guide private and public behavior have all been explored in art. Art has told the stories of specific religious traditions. given visual form to ideas of divinity, and provided devotional objects and settings (churches, synagogues, mosques, temples) for religious worship and rituals. In the West, Christianity dominated the production of art from the third to the seventeenth century, and the iconography of Christian art (based on stories from the Old and New Testaments, especially the life of Christ and the Crucifixion) is familiar to many viewers of art, whether or not they are Christians. Other great world religions, notably Hinduism and Buddhism, likewise have relied on art to portray gods, holy people, and religious narratives. Judaism and Islam have historically been opposed to images (icons) made for religious purposes. Instead, the religious art of these faiths has focused on abstract symbolism and the embellishment of religious texts through calligraphy and other means.

Different religious belief systems have shaped the art of different civilizations in ways that often contrast dramatically. For instance, some religious traditions and practices are more rational and some are more mystical. The art of the former tended to instruct the faithful in a logical, easily understood way, while the art of the latter provided arcane symbols or ecstatic visions that were meant to overwhelm viewers with a sense of mystery and emotion. Moreover, no religion has remained static; one religion can emphasize different artistic approaches in different historical circumstances. For example, the schism that divided Christianity into Catholic and Protestant churches in the sixteenth century was reflected in the contrasting artistic approaches found in Catholic and Protestant countries of Europe during the Baroque era. Nor is any religion

monolithic. There are many sects within each of the major religions, each of which has its own religious ideas, including ideas about the role of art in religion. Similarly, the members of any one sect may differ in their interpretations of their faith.

In mainstream cultures in the West, from the Enlightenment onward, the worlds of art and of religion grew apart. Many secular institutions that supported and exhibited art arose, and the leadership of churches as patrons of visual art declined. The Constitution of the new United States of America, through the First Amendment (ratified in 1791), mandated the separation of church and state; thus governments in the United States have never promoted religious art. Moreover, beginning with the arrival of the Puritans in New England, North America served as a haven for religious groups fleeing persecution elsewhere; as a result, tolerance for religious differences is built into the social fabric of the country. Historically in the United States, the most openly identified religious artists have tended to come from the margins of society or from the ranks of folk artists.

Philosophical doubts about a divinely created universe and skepticism about the validity or relevance of organized religions were voiced openly in the nineteenth century and culminated in German philosopher Friedrich Nietzsche's famous pronouncement "God is dead" (made in 1882). At the same time in the West, increased exposure to religions from other parts of the world inspired new beliefs. Some alienated individuals became atheists, while others turned to religions that borrowed from many traditions or adopted beliefs that were anchored in nature, which was seen as a vital, pantheistic force.

The philosophical and literary concept of *the sublime*, first popularized in Europe in the eighteenth century by the writings of Edmund Burke, gave a name to the quasi-religious veneration of nature. The term *the sublime* began to be used for any experience that induced awe or terror, overwhelming the mind and senses much as a religious fervor can overwhelm believers. The sublime reaction was induced by extraordinary and grand phenomena. When the concept was attached to nature, the sublime described an awed reaction to viewing mountain vistas, vast oceans, extraordinary thunderstorms, blizzards, magnificent sunsets, and the like.

In nineteenth-century America, belief in the sublime was transposed into *transcendentalism*, whose adherents believed in an ideal spiritual reality that transcended the material world. This philosophy was associated with writers such as Henry David Thoreau and Ralph Waldo Emerson, who viewed nature, especially the American wilderness, as closer to God than more-civilized places. American "earth artists" in the 1960s and 1970s continued this transcendentalist strain of reverence for the natural world. Some of them created site-specific outdoor works that evoked the feeling of prehistoric religious sites such as Stonehenge in England or Serpent Mount in Ohio.

Throughout most of the twentieth century, religion in art largely went silent in Europe and the United States. If you look through art histories and art criticism, you don't find much use of the word *religion* until late in the century. With some exceptions, including Georges Rouault, Max Beckmann, Salvador Dali, and Graham Sutherland, art with recognizable religious iconography no longer commanded the attention of the most innovative or prestigious artists. Frequently, however, notable artists continued to express metaphysical ideas, feelings about spirituality, or a yearning for a utopian future, often using a more coded or private language.³ Scholarly and critical analyses of modern art tended to focus on the designs, colors, and techniques artists were using and

to downplay spiritual content when it was present, unless the artist was regarded as eccentric (as in the case of Marc Chagall, for example).

The most powerful refuge of spiritual art in the twentieth century was nonobjective art. Some artists who were making completely abstract works were on a quest to see if art could inspire a transcendental state akin to the sublime feeling that nature could inspire. They hoped viewers would experience a spiritual revelation or at least a deeply meditative feeling while gazing at abstract surfaces or forms. Wassily Kandinsky and Barnett Newman are older examples of such artists. A more contemporary example is Brice Marden, who nudged his characteristic formalist abstractions in a spiritual direction with a series of paintings titled *Annunciation* (1978–80). The significant current of spirituality running through modern abstract art was finally highlighted and studied in 1986 in a groundbreaking and influential exhibition, The Spiritual in Art: Abstract Painting, 1890–1985, curated by Maurice Tuchman for the Los Angeles County Museum of Art, and its accompanying catalog. 4

In recent decades in the United States, religion and art have often come head to head. The "culture wars" that erupted after 1980, for example, sometimes involved protests against exhibitions that included artworks some people regarded as sacrilegious or demeaning to their religious beliefs or sacred symbols. If government funds were involved, protesters lobbied federal, state, and city governments to prevent the display of the art. In one notorious incident in 1989, protesters challenged the use of National Endowment for the Arts funds for a grant to photographer Andres Serrano, whose photograph *Piss Christ* (1987) depicted a plastic crucifix suspended in urine. A similar controversy occurred ten years later, when then-mayor of New York, Rudolph Giuliani, led the opposition to an exhibition from England at the Brooklyn Museum titled Sensation. Giuliani singled out as blasphemous Chris Ofili's *The Holy Virgin Mary* (1996), a painting of a black Madonna that incorporated balls of dried elephant dung.⁵

Widely publicized controversies such as these give the impression that contemporary art and religion are adversaries. As critic Eleanor Heartney has noted: "Despite Western culture's rich tradition of great religious art, the contemporary world tends to see art and religion as enemies. Whenever the two are mentioned together, it tends to be in the context of some controversy or scandal, in which artists are accused of . . . heaping their contempt on religion. . . . And even within the art world, there seems to be considerable discomfort with the notion that faith and avant-gardism might share any common ground."

Nevertheless, increasingly since the 1990s contemporary art has openly addressed religion and spirituality, and some influential curators and critics are paying attention to this theme. Artists are asking soul-searching questions again about the meaning of life—its mysteries, miracles, and moral lessons—and art's role in the cosmos. Ahead of the curve, in her 1991 book *The Reenchantment of Art*, critic Suzi Gablik called for a spiritual and ethical renewal in American culture and for art that would support that goal. In Gablik's view, "we cannot heal the mess we have made of the world without undergoing some kind of spiritual healing." Eleanor Heartney is another critic with a keen interest in spiritual issues. She has written extensively about contemporary artists who were raised as Catholics, including Serrano and Ofili as well as Kiki Smith, David Wojnarowicz, Joel-Peter Witkin, Robert Gober, and Janine Antoni, and how their work is inflected with religious ideas (whether or not they continue to practice their faith).

A number of significant exhibitions signaled the new climate of acceptance of the theme of spirituality. Magiciens de la Terre (Magicians of the Earth), at the Pompidou Center in Paris in 1989, brought visibility to contemporary artists outside the West who use spiritual symbols and content but was criticized at the time for its romanticizing of spirituality in cultures of the less-developed world. Consecrations: The Spiritual in Art in the Time of AIDS (1994) was a traveling exhibition organized by the newly founded Museum of Contemporary Religious Art in Saint Louis. Negotiating Rapture, a 1996 exhibition organized by the Museum of Contemporary Art, Chicago, examined contemporary art about transcendence and the sublime. Faith: The Impact of Judeo-Christian Religion on Art at the Millennium was organized in 2000 by the Aldrich Museum of Contemporary Art in Ridgefield, Connecticut. And finally, 100 artists see God, organized by Independent Curators International in 2004, featured artists' representations of the divine.

The reasons for the renewed interest in spiritual themes are many. For one thing, the controversy surrounding contemporary artworks that some viewers find offensive has focused attention on religious iconography in recent art. Unexpectedly, it has had the effect of making art about spiritual beliefs seem hip and avant-garde. Real-world upheavals and the migrations of large numbers of people all over the world in the past twenty-five years have also brought spiritual themes to the forefront, as many spiritual traditions have intermingled. Moreover, as the twentieth century drew to a close, a trend toward end-of-the-millennium art surfaced; this art asked questions about the future of the planet and where we are heading as individuals, as societies, and as a species. Some artists framed their questions in a spiritual way or sought spiritual answers. The German Neo-Expressionist Anselm Kiefer, for example, explained, "I think a great deal about religion because science provides no answers."8 Tomaselli's Untitled (Expulsion) [color plate 18] can be viewed as part of this trend. We might have expected the end-of-the-millennium mood to abate once we entered the twenty-first century. but dramatic world events, including wars, terrorism, and ecological disasters, have prolonged this period of spiritual questioning.

A Few Strategies

Visual artists who seek to articulate the theme of religion or spirituality must, like artists dealing with any theme, embody their artistic vision in material forms. These forms promote potential meanings, which take shape in the minds of viewers.

Manipulating Forms, Materials, and Processes

Some forms have spiritual implications because of their repeated use in religious or sacred practices. For example, altars and shrines are traditional forms that a number of contemporary artists, such as Christian Boltanski, Pepón Osorio, and Amalia Mesa-Bains, have used to create a spiritual context. Likewise, the *reliquary*, a container for sacred relics, has been used by artists such as Betye Saar and Paul Thek, who have turned all kinds of objects into fetishes by placing them inside reliquary forms. The *triptych*, a picture made up of three parts, is a shape that recurs throughout the history of Christian art; this form has served as a symbol of the sacred triad Father, Son, and Holy Ghost and of Heaven, Earth, and Hell. In the wake of World War I and World War II, respectively, the German painter Max Beckmann and the British painter Francis Bacon gained

prominence for their extensive use of the triptych format, which effectively referenced the Christian tradition in spite of the secular nature of their subject matter. A 1982 exhibition titled Contemporary Triptychs, organized by David S. Rubin, documented contemporary artists engaged with the three-panel form, both flat and as a folding screen. Pyramids, ziggurats, and labyrinths are additional shapes that often evoke spiritual implications.

As with certain forms, the use of certain physical materials can signal religious or spiritual content. Luxurious materials such as gold or precious jewels or colors with symbolic significance can indicate to the initiated that an image or object holds sacred meaning. The gold background in Chris Ofili's *The Holy Virgin Mary* recalls the traditional gold ground of Christian icon paintings, a representation of the sacred space of Heaven. At the same time, Ofili's incorporation of elephant dung within the artwork sparks mixed messages. To the artist, the dung is an African symbol of fertility; to Mayor Giuliani, the dung is excrement, an insult to the beliefs of practicing Catholics.

Some artists treat natural materials as sublime in and of themselves; they may move out into nature to create site-specific works or bring natural materials such as rocks, honey, beeswax, and flowers into galleries. Artists such as Native American Sara Bates and German Wolfgang Laib choose natural materials because of their belief in the close connection between nature and the sacred. Laib does not profess allegiance to a particular religion but has studied the writings of Jalaluddin Rumi (a thirteenthcentury Sufi poet and theologian), Saint Francis of Assisi (a Christian monastic who venerated animals and nature), and Indian mystical texts from both Buddhism and Jain, all of which inform his approach to art as a kind of ascetic ritual practice deeply attuned with nature. One of Laib's forms is a "pollen square" made by carefully sifting specks of bright yellow pollen onto a square or rectangle of transparent paper covering a designated area of gallery floor (the squares can measure from five to fifteen feet on a side). Laib spends six months each year harvesting pollen from dandelions, buttercups, hazelnut trees, pine trees, and mosses, garnering just four to six jars of pollen each year for his labor. According to writer Clare Farrow, Laib's repetitive labor of pollen-gathering "is not simply about material gain, nor is the repetition a negative aspect of the process, as one might imagine: for the act of doing something again and again brings about a state of equilibrium and intense concentration bordering on meditation."¹⁰

The incorporation of ritual, ceremony, and other forms of highly patterned behavior into the practice of art can bestow on the artist the role of high priest or shaman. German artist Joseph Beuys is a well-documented example of an artist in the 1960s and 1970s who welcomed this role. Beuys orchestrated a range of ritualistic activities, some involving only himself, others involving large numbers of other people. His influence is still widely felt today. Contemporary artists noted for working with ritualistic activities include, to name a few, Laib, Marina Abramovic, Ann Hamilton, Tehching Hsieh, Linda Montano, and Ron Athey, although these artists would not consider themselves shamans.

Artists creating performances, videos, and installations, which involve the temporal dimension, have been especially protean in exploring ritual expression. Performances and installations that have a repetitive, meditative quality or an element of endurance and bodily ordeal are used in a cathartic manner to transport artists and viewers out of the realm of ordinary perception into a state of heightened awareness. For example, in the spellbinding video/sound installation *The Crossing* (1996) by Bill Viola, a man

becomes engulfed over and over in a torrent of water on one side of the work and in fire on the other. Typically, contemporary audiences never fully achieve a state of altered consciousness. At some point, we inevitably turn away from the artwork and back to our everyday lives. But while we stand and let the flow of sounds and images surround us, we may feel we are on the threshold of a spiritual awakening.

The use of transient forms such as installation and performance and unstable materials such as plants and liquids lends itself to spiritual messages about the impermanence of life and fragility of human existence. Felix Gonzalez-Torres's "spills" of piled candies, which diminish and are replenished as viewers take away candies and other candies are added, serve as death-haunted metaphors for life's passage and the value of engaging with the present. According to critic Anne Morgan, the use of transient forms and materials "reflects a spiritual truth common to many spiritual paths about the importance of direct experience, of being fully present, of fully experiencing the 'now'."

The use of ephemeral materials and forms and the performance of ritualistic activities in contemporary art relates to the transitional state that appears to be characteristic of contemporary cultures. Cultural critics have focused on how, when, where, and why whole cultures may be moving away from the acceptance of (or subjugation by) one grand worldview, such as modernism or colonialism. We live in a "post" age: the present state is in transition away from previous worldviews. The future is not yet codified, and boundaries are fuzzy and porous. Theorists use the term liminal to refer to this state of transition, which includes mental shifts as well as physical changes (limen means "threshold" in Latin). The term is borrowed from the writings of the earlytwentieth-century Dutch ethnologist Arnold van Gennep, who described as "liminal" the transitional phase a person moves through when he or she is experiencing a change in status. Historically, a rite of passage, such as a wedding, is associated with a significant change in status; the ritual delivers the initiate safely from one state to another and supports the person during the mentally and physically unstable liminal stage. 12 In related fashion today, ritualistic artworks may help artists and viewers confront the instabilities of our current cultural moment. The pervasive liminality of the present may explain some of the appeal of the paintings of Norwegian Odd Nerdrum, which show archaic characters wandering on private spiritual journeys, for within their borders we may see ourselves. Among contemporary artists focusing specifically on religious and spiritual themes, we discover many who doubt and many who are engaged in a quest; seldom is the artist's outlook one of pious certainty.

Manipulating Meanings and Minds

In the Western world in recent decades, there has been a revival of recognizable religious symbols, icons, and stories in art, particularly ones that borrow from the Christian tradition. In using these elements, artists evoke the mythological, emotive, and psychological power of familiar stories and iconography. In British sculptor Anthony Gormley's *A Case for an Angel II* (1990), for instance, a hollow figure with huge wings attached represents the angel of the title as well as a coffin. Mike and Doug Starn's "Triple Christ" (1985–86), a photographic work, borrows from Phillipe de Champaigne's seventeenth-century painting *The Dead Christ*. The Starns sliced apart

and reassembled photographs of the painting to accentuate the physical pain inflicted on Christ's body during the Crucifixion.

Looking beyond Christianity, African American artists, such as Alison Saar, have created contemporary sculptures that recall African fetishes. Artists such as Shahzia Sikander [color plate 19] (from Pakistan) and Phyllis Bramson (from the United States) have combined representations of religious figures and icons from many religions in postmodern pastiches. Historical religious iconography has also been used ironically, or without any basis in faith, for example in the appropriations of religious kitsch statuary by Jeff Koons.

Other artists, linking the natural world with the spiritual, have made works that recall the veneration of animals in some religions. These artists have used actual animals and animal parts as artistic material or representations of animal forms. British sculptor Damien Hirst encased an entire body of a dead shark in formaldehyde to enact "the physical impossibility of death in the mind of someone living." Native American artists Jaune Quick-to-See Smith and Duane Slick completed suites of paintings and prints devoted to the coyote, an archetype of the shape-shifting trickster in some Native American traditions. A suite of recent bronze sculptures by Kiki Smith shows a transmogrifying human emerging from the side of an animal [7-1].

7-1 Kiki Smith | Born, 2002

Bronze, edition 2/3, overall 39 x 101 x 24 inches (99.06 x 256.54 x 60.96 cm)
Collection of Albright-Knox Art Gallery, Buffalo, New York, Sarah Norton Goodyear Fund, 2002
Courtesy of PaceWildenstein, New York, © 2002 Kiki Smith

In addition to using iconography drawn from the stories of specific religions, artists use more general symbols and metaphors to express spiritual emotions and ideas. Light, both represented and real, continues to serve as a potent symbol of the divine and sacred, and the contrast of light and darkness expresses the ideas of polarity, paradox, and mystery as it has throughout human history. Contemporary expressions involving light range from Bill Viola's use of fire in his video works to Stephen Antonakos's *The Blue Line Room* (1997), a meditation room illuminated by the artist's trademark neon lights (at the Harn Museum in Gainesville, Florida), to James Turrell's *Skyspace* (2000) at Live Oaks Friends Meeting House in Houston, Texas, which uses a retracting roof to open a space in the ceiling that reveals the sky's changing light and color. An ongoing project, Turrell's spectacular choreography of celestial light in his Roden Crater Project in Arizona provides visitors to this remote and monumental earth work inside an extinct volcano an unforgettable transcendent experience.

Contemporary artists continue to make use of abstraction as a vehicle for transcendence, offering nonobjective artworks as a focus for ecstatic or meditative spiritual experiences. Anne Morgan explains, "The potential for artwork to manifest some form of mystical communication that transcends our ordinary reality is great. Abstraction lends itself naturally to this goal, since many of the concepts of spirituality are by nature abstract (such as 'infinity')." In addition to Antonakos, Turrell, and Laib, contemporary artists who have created abstract works that invite spiritual reflection include James Lee Byars, Ann Hamilton, Agnes Martin, Anish Kapoor, Shirazeh Houshiary, Ron Janowich, and Christian Eckart. Not all these artists discuss their art in spiritual terms. For example, Agnes Martin disavows any specific religious connection in her nonobjective paintings and drawings, yet according to Helen Tworkov, she "speaks of drawing 'daily sustenance' from Taoism. . . . [Her] work is an invitation to enter a contemplative space, a space that requires the mind to slow down, dispense with commentary, and take on a posture of receptivity—in other words to assume the attitude of an acolyte." 15

Martin's art is an excellent example of how thematic content is indissolubly linked to form. By composing her work on a grid, Martin draws viewers into a realm of endlessness: a dense pattern of horizontal rectangles appears to repeat infinitely, and this sense of infinite space registers as timelessness. Other contemporary artists have employed intense patterning to induce a rapt mindset in the viewer. American painter Alex Gray, for instance, creates views of the human body of dizzying complexity in which the interior is revealed as an intricate web of veins. Fred Tomaselli and the noted American folk artist Howard Finster likewise utilize dense patterning or symmetry to effect a transformation in the viewer's mind. These patterns have the effect of slowing down looking, overwhelming the senses, and opening the door to a dreamlike consciousness. Their work has an affinity with religious art that uses intensely detailed, symmetrical designs to induce a hallucinatory state in the minds of viewers, as in the intricate Tantric paintings of Buddhism and Hinduism. The use of symmetry itself may draw the viewer into a meditative state, perhaps because the symmetrical form suggests stability and the eternal.

Shirazeh Houshiary, who was born in Iran and lives in London, makes abstract art with a transcendental purpose from a position of faith in a particular religious tradition. Houshiary practices Sufism, a mystical branch of Islam that began in the eighth century.

7-2 Shirazeh Houshiary

Turning around the Centre, 1993 (detail)

Four parts, lead and gold leaf, 100 x 100 x 100 cm each Courtesy of Lisson Gallery

According to architectural historian Kenneth Frampton, Houshiary's Sufism "means that she maintains her Islamic beliefs but has taken on additional ascetic tasks and exercises whose goal is communion with the deity through contemplation and ecstasy." Houshiary studies the teachings of Rumi, "where the significance of 'becoming,' through transcendent exercises, dancing and whirling, leads to divine enlightenment."16 She makes abstract sculptures, sculptural installations, and drawings that are inspired by Sufi philosophy, Rumi's poetry, and geometric symbolism. Her piece Turning around the Centre (1993) [7-2] consists of four cubes encased in lead; embedded in the top of each cube is a square whose indented form is lined with gold leaf. The golden squares represent the dancer (the whirling dervish of Sufism) transcending the material world on Earth (symbolized by the lead) and achieving enlightenment. Houshiary says, "The journey to find out the nature of matter takes you to amazing places, because it is about going deep within your own being and trying to know what you are composed of. I'm not trying to understand who I am in relation to name, culture, and all that. Those things I can describe and understand and finish with, but I cannot understand the magic, the mystery of existence. I can feel it. The nature of being, of existence, is more powerful than anything I know."17

Even when their art contains no explicit religious references, numerous artists approach art making itself as a quasi-mystical experience or a kind of awareness practice. Calling for extreme devotion and a willingness to slip free of the bonds of prosaic, earthly responsibilities, the creative process transports the creator into another realm.

Likewise for some viewers, the process of appreciating the finished artwork can be a transporting experience. Artists and viewers may both look to art for contemplative, emotional, or revelatory experiences that are similar to those provided by religion. Meanwhile, others are skeptical about the ability of art to provide an experience of transcendence or are critical of the reasons why such aesthetic transcendence may be sought. For example, valuing art as a higher calling in and of itself may result in a willingness to avoid tackling problems in the here and now. "Art as religion is the programme of the dispossessed," according to Doreet LeVitte Harten.¹⁸

We now turn to a range of subthemes involving aspects of spirituality and religion. In each category, a host of artworks speak to the human condition and the condition of our universe in terms that are both timely and timeless. Other art dealing with aspects of spirituality might be analyzed from additional perspectives, such as transgression (dealing with taboos and the conflict between the sacred and profane), miracles, and picturing the sublime.

Finding Faith and Harboring Doubt

For our discussion, we define faith as a belief in the tenets of a religion or, more generally, as a belief in a divine universe. Sistah Paradise's Great Walls of Fire Revival Tent (1993) [7-3], a large-scale work of fiber art by American artist Xenobia Bailey, provides a contemporary example of spiritual faith. Bailey hand-crocheted a structure over nine feet tall out of yarn. The form, derived from a Yoruban headdress, symbolizes the Yoruban belief that the head is the sacred center of the body. In this work Bailey grafts together an African religious concept and a personal belief in the power of women as conjurors and spiritual healers; the composite is an expression of faith in a spiritual power beyond the earthly realm. ¹⁹

Of course we would expect art based on faith to be part of art on spiritual themes. Artists who are skeptical of, or don't believe in, the notion of a divinely created universe usually make art about something else. On the other hand, some nonbelievers have expressed their atheism and its implications through artworks. For instance, Bruce Nauman's neon piece *One Hundred Live and Die* (1984), which has one hundred blinking electronic messages that each containing the word "LIVE" or "DIE," is, in Wendy Doniger's view, "a digital, binary, on/off commentary on an existence without any anchors in religious belief." Nauman is saying that death is final and we are alone in "our existential and purposeless journey." ²⁰

The poles of spiritual certainty on the one hand and absence of faith on the other are insufficient for describing much of the contemporary art that has been made about spiritual beliefs. Many contemporary artists are conflicted about the existence, definition, or role of the sacred. Numerous artists who are raising spiritual issues don't know exactly what they believe, and their art suggests ambivalence or a search for answers. According to Harry Philbrick, a key organizer of the exhibition Faith in 2000, some art about religion "is built upon the armatures of doubt implied by a fall from faith." ²¹

Robert Gober, who does not practice the religion of his upbringing (Catholicism), attempted to come to terms with the absence of religion in his life in an untitled installation that was displayed in 1995–97. The work features a life-size statue of the Virgin Mary that is punctured by a culvert pipe through her torso and flanked by two open

7-3 Xenobia Bailey | Sistah Paradise's Great Walls of Fire Revival Tent, 1993 Acrylic and cotton yarn, hand crocheted, 112 x 63 inch diameter Courtesy of Stefan Stux Gallery, New York

7-4 Robert Gober Installation view of Untitled, 1995–97

Geffen Contemporary at the Museum of Contemporary Art, Los Angeles, September 7–December 14, 1997 Photo by Russell Kaye

Courtesy of Robert Gober and Matthew Marks Gallery, New York

suitcases [7-4]. Viewers peer beneath a grate in each suitcase into a grottolike space under the floor where the legs of a man and child appear to be bathing in a tidal pool [7-5], in a reference to the Christian rite of baptism by water. Besides noting the Christian references, curator Dean Sobel offers a psychoanalytic interpretation, noting that "this dual-level installation also explores the dynamic between the conscious world (what is immediately apparent) and the subconscious (those things lurking beneath the surface)."²²

One reason that artists are drawn to the themes of religion and spirituality even when they harbor doubt is that they are interested in morality and ethics. Like everyone else, artists have ideas about ethical behavior, or how people should behave toward each other, toward animals, and toward the planet. Religions provide explanations of good and evil as well as codes of moral conduct and stories that model moral and immoral behavior. Nonbelievers as well as believers have used religious iconography to make moral points or to reference another culture. For instance, American painter Phyllis Bramson, although not a Buddhist, has used the Buddha to represent an admired spiritual figure and model of right behavior. (In Bramson's imagery, the moral message, if there is any, remains ambiguous.) In other cases, artists reference a religion in order to criticize all or some of the moral codes promulgated by its leaders. For

7-5 Robert Gober Installation view of Untitled, 1995–97
Geffen Contemporary at the Museum of Contemporary Art, Los Angeles, September 7–December 14, 1997
Photo by Russell Kaye

Courtesy of Robert Gober and Matthew Marks Gallery, New York

instance, the New York–based artist collective Gran Fury, active from 1988 to 1994, made posters and billboards deploring the Catholic Church's teachings on homosexuality, AIDS, and birth control. Their images were graphic and direct; one billboard-sized work featured images of the pope alongside an erect penis wearing a condom. This work did not challenge the entire Catholic faith, just its official doctrine regarding one important area of behavior, sexuality.

Other contemporary artworks that are intended to encourage ethical behavior have no obvious religious iconography. Much activist art falls into this category. The maker wants to convince viewers to think about an issue and take action, and sometimes even change their daily behavior. Activist artists have strong moral positions, but we don't necessarily know from the artworks what part, if any, spirituality or religious doctrine plays in guiding their beliefs.

Expressing Religious Identities

Violence and armed standoffs all over the world between groups who claim allegiance to different religions demonstrate the continuing importance of religious identity. The role of art in establishing and preserving religious identity is painfully evident whenever one group destroys religious monuments of a rival group in an attempt to

eradicate the beliefs and culture the art represents. In 2001, for instance, the Afghan Taliban, then the theocratic government of Aghanistan, destroyed two great Buddhas and frescoes at Bamiyan following a Taliban decree ordering the destruction of all pre-Islamic statues and sanctuaries in the country.

Despite attempts to build barriers between religions, throughout history, people of different religions have interacted and mingled, voluntarily, by happenstance, and by force. Religious identities do not remain static but are remixed and reformed by historical events and encounters. For example, the Catholic religion of the European colonizers and the indigenous religions of colonized peoples in Mexico, Latin America, and the American Southwest have interacted since the seventeenth century. The art of these regions reflects the dynamism of changing religious identities. From the outset of this forced encounter, the Baroque style of the Counter-Reformation and indigenous forms were melded into artistic hybrids that expressed a syncretism (a cross-cultural interaction) of religious ideas, beliefs, and practices.²³ The work of numerous contemporary Latino artists continues to reflect a religious syncretism. For instance, Mexican Nahum Zenil makes works on paper exploring his combined Catholic and Indian heritage. Zenil's Ex Voto (Self-Portrait with the Virgin of Guadalupe) (1987) pairs a devotional image of the Virgin of Guadalupe, who is the patron saint of Mexico (hence a dual symbol of religious and national identity), with a bleeding heart pierced by a knife, the latter a reference to ancient Aztec beliefs as well as to Catholicism.

Contemporary artistic expressions of religious history and identity, including the history of religious tolerance and intolerance, can be conflicted. Manuel Ocampo, born and raised in the Philippines, was trained to copy Catholic religious paintings. He explores the violent legacy of Spanish colonialism in his homeland in *Heridas de la Lengua* (Wounds of the Tongue) (1991), a painting replete with Catholic references, including a Madonna and child. In the central image, "a knife-wielding figure engages in a bloody act of self-decapitation," as Margo Machida describes it. Ocampo's concept, she explains, is that if "a Filipino/a severs any of the components of his or her complex identity, all that will be accomplished is the painful mutilation of one's psyche."²⁴

On the other hand, encounters between different religions and spiritual practices can have a positive effect, enabling individuals to select and combine beliefs, rituals, and forms in creative and meaningful ways. Many individuals have forged hybrid spiritual practices in this way.²⁵ Betye Saar, an African American who works with mixed media and incorporates many symbols in her assemblages, says, "I am a Christian, but I am interested in Hinduism, Buddhism, paganism, and alternative religions such as Santería and Voodoo. What I really want is a sort of holistic bonding between formal religions so that another essence, another kind of quality comes out."²⁶

When two or more religions are fused into a new one with communal rituals and beliefs that are practiced by many people, the hybrid may become recognized as a separate religion. For example, Santería is a syncretic religion born of the *mestizaje* (crosscultural interaction and mixing) of Yoruba religion and Catholicism. Santería is practiced today in Cuba and other parts of the Caribbean, as well as in many places in the United States and South America, particularly among Latinos of African descent. Well-known past artists who explored Santería aesthetics in their work include the Cubans Wilfredo Lam (1902–82) and Ana Mendieta (1948–86). Another Cuban, José Bedia (the subject of this chapter's profile), who immigrated to the United States in 1993, is a current artist influenced by the Afro-Cuban religions Santería and Palo Monte as well as Native-American religions.

Often art expressing a communal religious identity is as much or more about cultural, ethnic, and national identity and history. For example, Iranian-born Shirin Neshat makes film installations about the impact of a fundamentalist Islamic political theocracy on Iranian culture [5-10]. In addition to exploring religious implications, she considers the role of the fundamentalist revolution in forging an Iranian national identity.

Art that refers to Jewishness provides a good example of how art that references a religious group can be about ethnic identity as well as spiritual beliefs. Too Jewish? Challenging Traditional Identities, a 1996 exhibition organized by the Jewish Museum, New York, raised the question of where Jewish artists fit into Judaism. Additionally, according to independent curator Ori Soltes, the exhibition raised "the myriad cultural, as opposed to religious, questions of a Judaism interfacing with the secular yet Christian American world." The works of Deborah Kass, Ken Aptekar, Archie Rand, Cary Leibowitz, Elaine Reichek, Allan Wexler, and other artists in Too Jewish? consider stereotypes of Jews, anti-Semitism, attitudes about the ethnic Jewish body, Jewish feminism, and issues of consumerism. Some of the works exhibited offer new forms of ritual that support spiritual practices in the contemporary age. ²⁹

Finally, some contemporary art concerning religious identity attempts to deconstruct stereotyped views of the spiritual beliefs and practices of a particular group. To cite one widespread example, both mainstream media and the arts frequently romanticize Native Americans as inherently spiritual, as if to be born Native American necessarily makes one a kind of shaman or spiritual adept with special magical abilities, such as the power to talk to animals. John Feodorov, an American of mixed Navajo and Russian descent living in Seattle, takes a humorous look at such mythologizing in mixed-media works such as *Totem Teddies*, which feature toy bears decked out with consumer trinkets. Feodorov's 2000–2001 installation *The Office Shaman* included plastic dolls wearing business suits covered with feathers and beads and audible chants that, according to Lynn Herbert, "sound traditional—they have the right tone, the right ring—but as you listen, you realize that they are repeating motivational slogans often found posted in the workplace." ³⁰

Facing Death, Doom, and Destruction

Through history, spiritual teachings all over the world have dealt with the dark side of life, including sin, death, and destruction. These teachings often address the impermanence of life, by providing an explanation of what happens after death and prescribing behavior on earth that will help the individual be accepted into the unseen world of the spirits. Spiritual art gave visual form to fears about the transience of life and beliefs about an afterlife and supported rituals of mourning. Art historian Richard B. Woodward writes, "The ancient Greeks, however heroic, mourned the fragility of life. Hindu and Buddhist teachings explain that the things of this life are illusory and obscure the truth, the ultimate reality. The art of African cultures often focuses on the cycle of life and the transition from the world of the living to the realm of the ancestors." "11

The term *vanitas* refers to art intended to remind us that life and its pleasures are fleeting. Vanitas still-life paintings, which were especially popular in seventeenth-century Holland, depict objects such as skulls, decaying fruit, and hourglasses with the sand running out as symbols of the inescapability of death. Although the term is European, variations on the theme are found in artworks worldwide. John B. Ravenal, who curated a 2000 exhibition at the Virginia Museum of Art on this topic in contemporary art, writes,

"The theme of *vanitas* concerns one of life's fundamental tensions, between the enjoyment of earthly pleasures and accomplishments and the awareness of their inevitable loss. This bittersweet notion has long inspired some of Western civilization's most profound works of art and literature."³²

Vanitas and other themes related to death and destruction, including expressions of loss and mourning, are widespread in contemporary art. The ongoing nuclear threat, the AIDS epidemic, terrorism, wars, and ecological disasters have all influenced the production of art with apocalyptic content and a strong tone of elegy. For example, in a series of paintings called *Atmosphere*, American Ross Bleckner employs traditional symbols of death and mourning such as skeletons, candelabras, and urns full of flowers "as a direct means of expressing his pain and fury over AIDS, the atomic threat and the inescapability of death." In addition to using traditional vanitas motifs, today's artists use temporary forms such as installation and performance and materials that are ephemeral or fragile to evoke disease, mortality, decay, and death. American Zoe Leonard's *Strange Fruit* (for David) (1992–97), an installation of 295 pieces of fruit skins stitched back together, memorializes artist and gay rights activist David Wojnarowicz, who died of AIDS in 1992. While "strange fruit" is a reference to Wojnarowicz's homosexuality, the shriveled, sewn fruit skins recall religious relics and symbolize the notion of the body's decay. Mexican Gabriel Orozco uses an actual human skull in *Black Kites* (1997) [7-6] to

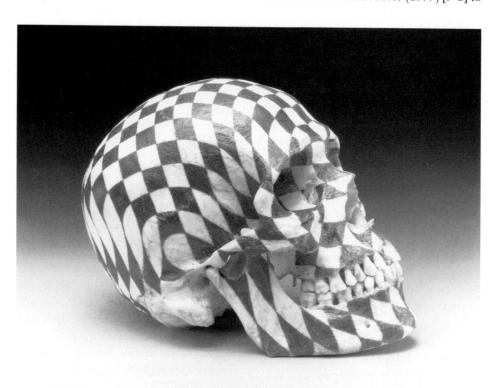

7-6 Gabriel Orozco

Black Kites, 1997

evoke death directly. Orozco also includes more-oblique symbols; for instance, his graphite drawing of black-and-white squares on the skull suggests a chessboard, "recalling that game's traditional symbolism of the conflict between dualities, including life and death."³⁴

Art dealing with death and destruction need not contain references to religion or spirituality, of course. American Frank Moore painted a post-nuclear landscape in Wizard (1994) that offers no vision of an afterlife; the mood of fear may reflect an absence of spiritual faith. American Lucinda Devlin has photographed a series of death chambers in prisons throughout the United States. She frames electric chairs, gas chambers, and lethal injection devices in a deadpan documentary manner that is in chilling contrast to the subject matter.

Mingling the Sacred and the Secular

As we have seen repeatedly, fine art and other arenas of visual and popular culture meet and mingle constantly in contemporary life. Art taking religion as its theme is no exception to this pattern. One manifestation of the intermingling of religion and secular culture occurs when artists borrow religious imagery for a decorative or frivolous purpose. Jeff Koons, for example, has appropriated and enlarged popular religious statuettes of saints and cherubs. Koons's *Ushering in Banality* (1988), for instance, is a five-foot-long carved and painted sculpture showing a pig flanked by two angels and a little boy. Koons does not use kitschy religious objects to convey religious or moral messages; instead, his use of these objects seems to be nostalgic (or perhaps ironic), In other cases artists place secular forms and icons from popular culture in a religious context. Ghanian artist Kane Kwei (1924–91) built whimsical fantasy coffins in the shapes of automobiles, airplanes, and animals [7-7] that represent the secular interests of the deceased. As Kwei's heartfelt art proves, not all art related to the rituals of death need be somber in tone.

The line between the religious and the secular, or the sacred and the profane, is not always clear-cut. Artists may deliberately transgress boundaries laid down by religious authorities in order to challenge their validity. It can be argued that Serrano and Ofili, both raised as Catholics, combined religious imagery (a crucifix and a Madonna) with profane elements (urine and dung) in part to challenge contemporary Catholic ideas about what is sacred and what is sacrilegious or taboo. From this perspective, Serrano and Ofili are advocating an extreme religious position that the Christian belief in incarnation—God made flesh—includes the idea that excrement is part of God's world. Eleanor Heartney argues that a Catholic perspective in particular lends itself to conflicting views about whether the human body is an ideal reflection of God or a profane vehicle of temptation, impurity, and sin. According to Heartney, "although by no means the exclusive domain of Catholics, such themes as the extremes of human sexual expression, the horrors of decaying flesh and death, and the forthright depiction of the body's excretions and physical processes are especially well-suited to the Catholic imagination." of the Catholic imagination."

Within this subtheme, a number of artists have borrowed liturgical forms of display to represent secular heroes, newsmakers, and cult figures from popular culture. For example, Chicana artist Amalia Mesa-Bains has made altarlike installations honoring Mexican women of the past, including the painter Frida Kahlo and the actress Delores del Rio. Elayne Goodman, from Mississippi, used dozens of images of Elvis Presley

7-7 Workshop of Kane Kwei Wood, cloth, and paint, 54 x 25 x 104 inches

Hen with Chicks Fantasy Coffin, 1988-91

Photo by Hadley Fruits

Collection of Children's Museum of Indianapolis. © Children's Museum of Indianapolis

as well as simulated relics (hair and fingernail clippings) to create her Altar to Elvis (1990) [7-8]. (The spontaneous altars of photographs, flowers, and texts that spring up in public places when a famous personality such as Princess Diana dies provide a vernacular version of this kind of artistic practice.) Similarly, Jeffrey Vallance, an artist born in California, has made fake replicas of the sweat-stained scarves that Presley ritualistically handed out to fans at his concerts.

The motives for appropriating religious forms and iconography may be straightforward. Mesa-Bains, for instance, sincerely wishes to honor the women who are the subjects of her altars. Goodman and Vallance, in contrast, appear to be gently mocking the cultlike devotion of many Elvis fans. They may be asking viewers to ponder the boundary between religious worship and secular idolatry. What are the consequences of the transfer of devotion from divine to human idols? What does it mean when a society's gods and heroes are personalities who exist in the material world?

Imagery that explores a mingling of the sacred and the secular is not necessarily concerned with popular culture. The Brazilian photographer Sebastião Salgado and the Israeli video artist Michal Rovner are among those contemporary artists who reveal a sense of the mystical in the most profane of human circumstances. The art critic Richard Cork ascribes a "biblical undertow" to Salgado's riveting photos of exhausted men laboring in Brazilian goldmines; the teeming scenes of workers climbing wooden ladders appear like events from the Old Testament. In our view, a similar description applies to

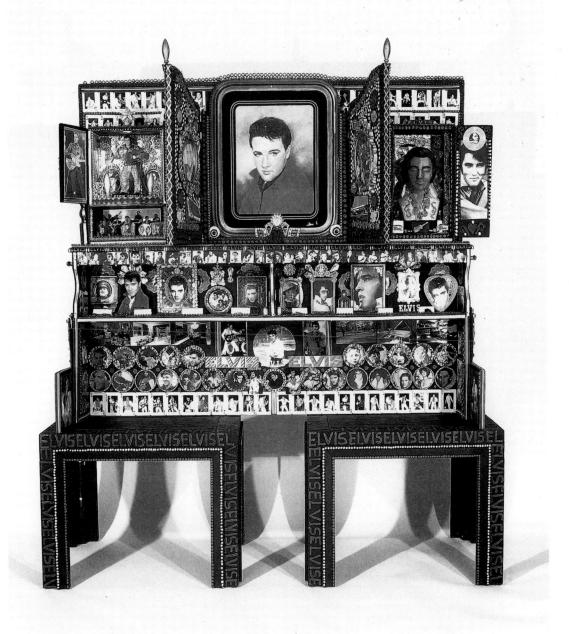

7-8 Elayne Goodman | Altar to Elvis, 1990

Wood construction with attachments, collage, Elvis collectibles, fake relics, posters and prints, buttons, braids, sequins, 74 x 66 x 22 inches Collection of the artist, Columbus, Miss.
Photo by Carlos Studios, Columbus, Miss.
Courtesy of Elayne Goodman

Rovner's friezes of out-of-focus, anonymous figures lined ghostlike along a distant, bleak horizon during wartime in the Middle East.

The critic Thierry de Duve argues that in contemporary secular societies "entertainment has replaced religion . . . but *religiousness* is still there." Humans now experience religious feelings such as devotion or awe in secular public domains such as museums, rock concerts, sports arenas, and shopping malls. Given this trend, some may wonder whether art will continue to have the power—and the audience—to speak profoundly about humanity's deepest concerns. In our view, contemporary artists in the next twenty-five years will continue, as they have for the preceding *twenty-five thousand* years, to create works that challenge us to rethink the world.

The graphic power of José Bedia's mixed-media drawings, paintings, and site-specific installations can be recognized in a glance. In many of his artworks, linear elements lock elongated figures within a pattern as eye-catching as a spider's web. Bedia often creates monumental wall drawings done primarily in black, accompanied by objects culled from either pop culture or nature, such as a toy boat or pair of antlers. To access the deeper symbolic associations contained in his imagery, however, viewers find it valuable to learn something of the influences the artist has embraced. José Bedia is Cuban; his heritage blends diverse ethnic traditions, including Hispanic, Native American, African, Afro-Cuban, and European. Early in his career, Bedia developed an interest in ethnographic studies, but since his maturation as an artist, his work flows primarily out of his internalization of ideas "concerning the relationship of human beings with the world, from Afro- and Indo-American viewpoints." ³⁷

A frequent motif in Bedia's art is the representation of a journey. A journey may be represented explicitly (by a boat or bridge, for instance), or a journey may be shown implicitly (with a labyrinth or passage of paint that appears to glow, thus marking an inner spiritual transformation). In Bedia's imagery, a mystical journey represents the process by which knowledge is gained. Gaining knowledge provides the opportunity for a metaphysical transformation; such a transformation is the dramatic center of many important works of art and literature of South and Central America.

Spiritual or transforming journeys are central to Bedia's art as well as to his own autobiographic experiences. Starting in the 1970s, as a teenager in Havana, he accompanied his mother on visits to a priest of Palo Monte. Palo Monte is a religious faith transposed to the Caribbean by black slaves brought from central Africa in the eighteenth and nineteenth centuries; as a religion Palo Monte claims a sacred connection between the world of humans and of animals. "The name of the faith refers to 'trees of the sacred forest,' for the classical Kongo religion of Central Africa focuses on special spirits or saints, *bisimbi*, and ancestors, *bakulu*, and both are believed to reside in the forests beyond the city."

Since his indoctrination into Palo Monte in the early 1980s, Bedia has devoted much of his art to a representation of reality as seen through the Palo Monte belief system. Words are incorporated frequently into his imagery in order to pinpoint the specific issues (such as the frailty of life) the artwork directs the viewer to consider. Words, inserted as titles or captions, are often snippets of Palo songs and expressions—mambos—some profoundly spiritual, others political and topical, often in reference to the challenges and injustices stemming from colonialism. In addition to incorporating Palo Monte words, Bedia's art may utilize ritual objects and altarpiece forms to evoke the religious practices of the Kongo brought to the New World by slaves. (In central Africa, altars can represent the face of the gods.)

The Palo Monte religion, an Afro-Cuban religion, contains "parallels with Native American cultures and religions such as the Nahuatl, Lakota, Sioux or Navajo." Bedia recognized these affinities intuitively, then confirmed them through research in anthropology texts. In 1985 the artist traveled to the Rosebud Sioux Reservation in South Dakota, where he lived with a shaman. Among the Sioux, immersed in a North American Plains Indian culture, Bedia intensely explored art and artifacts in which "every element, color, and image carries a specific symbolic reference." The shaman instructed Bedia in ritualistic practices, such as the sweat lodge in which spiritual regeneration occurs through self-purification. Bedia's own creative practice has since incorporated imagery (such as pipes for smoking and concentric patterns) derived from the cosmologies of the North American Plains Indians. An example of this influence is seen in *Mira*, *Mamita*, *Estoy Arriba*, *Arriba* (1991) [7-9]; the shape of this artwork, painted on a canvas adorned with found objects, echoes the dried leather hide, known as parfleche, on which Native American pictographs were drawn. The image itself

7-9 José Bedia | Mira, Mamita, Estoy Arriba, Arriba, 1991
Acrylic on canvas with found objects, 73 x 94 1/2 inches
Collection of the Bacardi Art Foundation

Courtesy of George Adams Gallery, New York

takes the triangular shape of a teepee. The entire work depicts a mysterious animal (a symbol of shamanistic power) anchoring an iconic forest; the silhouette of a man, small but significant, stands at the apex of the scene.

Immersing himself in other Native American traditions (including Aztec and Mayan traditions of Mexico), Bedia has found inspiration for his simplified, almost cartoonlike forms. Among these preliterate cultures the realms of people, animals, and nature interpenetrate on physical and metaphysical planes. In various artworks the artist has produced over the past two decades, figures often gesture to a void, eyes glow or stare at empty spaces, signifying the hidden dimensions that lie behind the facade of everyday existence.

The artist claims his use of symbolism is authentic, that his work is anchored in his own firsthand knowledge of actual traditions. In an interview published in 1999, the artist explained, "I don't invent anything. For example, the sand symbols. I learned what each thing represents from a medicine man in Montana." Drafted into the Cuban army in 1986, Bedia traveled to Africa; in Angola, he studied African religious beliefs that are ancestral to the Palo Monte and Santería traditions of Cuba. According to the artist, while he may duplicate an altar within the process of creating an artwork, the resulting artwork is not a sacred altar. The artwork cannot function in a truly spiritual way because the artist would never place "the sacred elements of his religion in a secular art installation." Such an artwork is never consecrated.

Among Bedia's most powerful artworks are those the artist has created by painting or drawing directly on gallery or museum walls, attaching or adding other materials to complete the installation. An example of this creative strategy, Las Cosas Que Me Arrastan (The Things That Drag Me Along) (1996) [7-10] includes a double-headed figure being "dragged" forward through the space of the gallery, attached by chains to a collection of found objects. Each head is defined by a jaw protruding in a way that is characteristic of many of Bedia's figures. On the enormous figure's chest are pasted photographs of an iron cauldron and sweat lodge, symbols of the Afro-Cuban and Plains Indian faiths, respectively. Pulling the figure are a "team" of altars, each representative of some aspect of the range of Bedia's knowledge of sacred rituals. At the front, a miniature bull marches forward on crutches; the animal is on a spiritual journey. The bull symbolizes the strength to cross boundaries in search of knowledge. Such a guest is the primary goal in all that the artist undertakes and all that his art represents. The entire artwork functions further as a collection of talismanic images and objects that may lead the viewer along the path of enlightenment as well.

Born in Havana in 1959, Bedia left Cuba permanently in 1990. The artist spent three years in Mexico, after which he migrated to the United States in 1993, where he settled in Miami, choosing that city for its close ties to Hispanic culture.

7-10 José Bedia | Las Cosas Que Me Arrastan (The Things That Drag Me Along), 1996 Wax, crayon, acrylic, found objects, approximately 10 x 20 x 30 feet Collection of the Bacardi Art Foundation

Courtesy of George Adams Gallery, New York

Notes

- 1. Gregory Volk, "Fred Tomaselli's Hybrid Sublime," in *Fred Tomaselli* (New York: James Cohan Gallery, 2000), p. 5. An exhibition catalog.
- 2. Susan Sollins, "Extending Vision," in art: 21—Art in the Twenty-First Century (New York: Harry N. Abrams, 2001), p. 9.
- 3. Andy Warhol's *Gold Marilyn Monroe* (1962), an image of Marilyn Monroe's head floating against a gold background, has been interpreted as an instance of the artist's coded religiosity.
- 4. See Maurice Tuchman, ed., *The Spiritual in Art: Abstract Painting*, 1890–1985 (New York: Abbeville Press, 1986). An exhibition catalog.
- 5. For an analysis of the controversy around Serrano's *Piss Christ*, see Linda Weintraub, *Art on the Edge and Over: Searching for Art's Meaning in Contemporary Society, 1970s–1990s* (Litchfield, Conn.: Arts Insights, 1996), pp. 159–64. For discussion of the Sensation show at the Brooklyn Museum, see David Halle, "The Controversy over the Show Sensation at the Brooklyn Museum, 1999–2000," in Alberta Arthurs and Glenn Wallach, eds., *Crossroads: Art and Religion in American Life* (New York: New Press, 2001), pp. 139–87.
- 6. Eleanor Heartney, "Art between Heaven and Earth," in Faith: The Impact of Judeo-Christian Religion on Art at the Millennium (Ridgefield, Conn.: Aldrich Museum of Contemporary Art, 2000), p. 57. An exhibition catalog.
 - 7. Suzi Gablik, The Reenchantment of Art (New York: Thames and Hudson, 1991), p. 12.
- 8. Anselm Kiefer, quoted in Axel Hecht, "Macht der Mythen," Art: Das Kunstmagazin, Wiesbaden, March 1984, p. 33; cited in Mark Rosenthal, Anselm Kiefer (Philadelphia: Philadelphia Museum of Art; Chicago: Art Institute of Chicago; Munich: Prestel Verlag, 1987), p. 27. An exhibition catalog.
- 9. David S. Rubin, *Contemporary Triptychs* (Claremont, Calif.: Pomona College, 1982). An exhibition catalog.
- 10. Clare Farrow, "Wolfgang Laib: More Than Myself," in *Parkett* 39 (March 1994): p. 78. Several articles in this issue of *Parkett* are devoted to Laib's work.
- 11. Anne Morgan, "Beyond Post Modernism: The Spiritual in Contemporary Art," *Art Papers* 26, no. 1 (January/February 2002): p. 32. Morgan is talking specifically about the site-specific installations of Ann Hamilton.
- 12. For a succinct summary of van Gennep's definition of a liminal state, see Stuart Morgan and Frances Morris, *Rites of Passage: Art for the End of the Century* (London: Tate Gallery, 1995), p. 12. An exhibition catalog.
- 13. The entire issue of CAA's *Art Journal* for spring 1998 was entitled "The Reception of Christian Devotional Art"; this publication included a range of examples of contemporary art that incorporated symbolic or metaphoric references to Christianity. For example, within the imagery of Derek Jarman's *The Garden*..., a pair of young male lovers *together* represents Christ. See *Art Journal* 57, no. 1 (Spring 1998): p. 73, and Derek Jarman's artist statement, p. 76.
 - 14. Morgan, "Beyond Post Modernism," p. 32.
 - 15. Tworkov quoted in ibid.
- 16. Kenneth Frampton, "Shirazeh Houshiary," in Richard Francis, ed., Negotiating Rapture (Chicago: Museum of Contemporary Art, 1996), p. 176. An exhibition catalog.
- 17. Shirazeh Houshiary, "From Form to Formlessness: A Conversation with Shirazeh Houshiary," by Anne Barclay Morgan in *Sculpture* 19, no. 6 (July/August 2000): p. 29.
- 18. Doreet LeVitte Harten, "Creating Heaven," in *Heaven* (Stuttgart, Germany: Hatje Cantz; New York: Distributed Art Publishers, 1999), p. 11. An exhibition catalog.
- 19. For a detailed analysis of Bailey's work, see Dorothy Desir-Davis, "Xenobia Bailey: Paradise under Construction," in Salah M. Hassan, ed., *The Art of Contemporary Africana Women Artists* (Trenton, N.J.: Africa World Press, 1997), pp. 19–26.
 - 20. Wendy Doniger, "Bruce Nauman," in Negotiating Rapture, p. 156.
 - 21. Harry Philbrick, "Creating Faith," in Faith, p. 15.

22. Dean Sobel, *Interventions: New Art in Unconventional Spaces* (Milwaukee: Milwaukee Art Museum, 2000), p. 13. An exhibition catalog. This installation is now broken up; one of the grates is in the collection of the Milwaukee Art Museum.

23. For examples of how this syncretism played out in one South American country, see the following exhibition catalog: Edward J. Sullivan, ed., *Brazil: Body and Soul* (New York:

Guggenheim Museum, 2001). An exhibition catalog.

24. Margo Machida, "Out of Asia: Negotiating Asian Identities in America," in *Asia/America: Identities in Contemporary Asian American Art* (New York: Asia Society Galleries and New Press, 1994), p. 76. An exhibition catalog.

25. Contemporary artists who express spiritual ideas in their art that draw from a variety of religions include Xenobia Bailey, Shahzia Sikander, Betye Saar, Alison Saar, Bill Viola, Pepón Osorio, Sonya Y. S. Clark, Ernesto Pujol, and Cao Guo-Qiang.

26. Quoted in Amei Wallach, "Art, Religion, and Spirituality: A Conversation with Artists,"

in Crossroads, p. 239.

- 27. For a discussion of Santería and its impact on the visual arts, see Arturo Lindsay, ed., Santería Aesthetics in Contemporary Latin American Art (Washington, D.C.: Smithsonian Institution Press, 1996).
 - 28. Ori Soltes, "Contexts: Jews and Art at the End of the Millennium," in Faith, p. 111.
- 29. See the exhibition catalog: Norman L. Kleeblatt, ed., *Too Jewish? Challenging Traditional Identities* (New York and New Brunswick, N.J.: Jewish Museum and Rutgers University Press, 1996). An exhibition catalog.

30. Lynn M. Herbert, "Regarding Spirituality," in art: 21, p. 88.

31. Richard B. Woodward, foreword to *Vanitas: Meditations on Life and Death in Contemporary Art*, by John B. Ravenal (Richmond: Virginia Museum of Fine Arts, 2000), p. 7. An exhibition catalog.

32. Ravenal, Vanitas, p. 13.

- 33. Burkhard Riemschneider and Uta Grosenick, eds., Art at the Turn of the Millennium (Köln: Taschen, 1999), p. 74.
 - 34. Ravenal, Vanitas, p. 15.
- 35. Eleanor Heartney, "Postmodern Heretics," in *Art in America* 85, no. 2 (February 1997): p. 37.
- 36. Thierry de Duve, "Come on, Humans, One More Stab at Becoming Post-Christians!" in *Heaven*, p. 74.
- 37. Arturo Lindsay, "The Presence of Africa in the Visual Art of Cuba," in Arturo Lindsay, ed., Santería Aesthetics in Contemporary Latin American Art (Washington, D.C., and London: Smithsonian Institution Press, 1996), p. 247.
 - 38. Robert Farris Thompson, "Sacred Silhouettes," Art in America 85 (July 1997): p. 66.
- 39. Cecilia Fajardo, "José Bedia: American Chronicles," Art Nexus 26 (October/December 1997): p. 105.
- 40. Louis Grachos, introduction: to *José Bedia: La Isla—el Cazador y la Presa (The Island—the Hunter and the Prey)* (Santa Fe: Site Santa Fe, 1997), p. 2. An exhibition catalog.
- 41. As quoted in Sherry Gaché, "José Bedia: Only the Most Valuable Things," *Sculpture* 18, no. 5 (June 1999): p. 48.
 - 42. Lindsay, "The Presence of Africa," p. 216.

Timeline

The Timeline covers the 25-year period from 1980 through 2004. Each year includes a sample of key events in three broad categories: World Events, Art, and Pop Culture. The events within any single year are not listed in strict chronological order, because so many of the events (such as the duration of a war or the run of a movie) overlap. Readers are invited to consider the interplay of historical forces that characterize the current era. Such influences are, of course, not one directional. World events and occurrences in popular culture strongly impact the work of visual artists, and, we believe, the achievements of artists also impact, in subtle and sometimes not-so-subtle ways, the development of culture and the course of history.

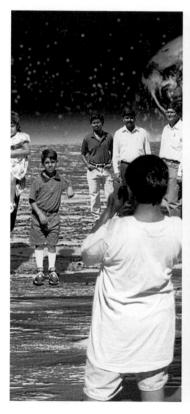

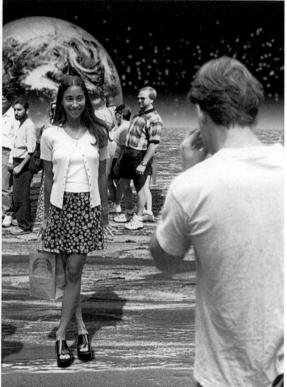

Detail of 1-2

POP CULTUR

ENT

EVI

ORLD

Anselm Kiefer and Georg Baselitz represent Germany at the Venice Biennale • Pablo Picasso: A Retrospective, Museum of Modern Art, New York • Women's Images of Men, Institute of Contemporary Arts, London • John Berger publishes About Looking • Keith Haring starts drawing on New York City subway station walls • French intellectual Roland Barthes dies • Death of Austrian Expressionist Oscar Kokoschka

Postmodernism begins to be applied as a concept to the visual arts in the U.S. • Thomas Ruff's first solo exhibition opens in Germany • Major German Neo-Expressionists are featured in gallery exhibits in New York • A New Spirit in Painting, Royal Academy of Arts, London • Death of International Style architect Marcel Lajos Breuer

Vietnam Veterans Memorial, designed by Maya Lin, dedicated in Washington, D.C. · Michael Graves designs the Humana Building in Louisville, Kentucky • Jenny Holzer exhibits her first Truisms work using LED in Messages to the Public. Times Square, New York • Transavantguardia Italia/America. Galleria Civica Modena • Extended Sensibilities: Homosexual Presence in Contemporary Art. New Museum of Contemporary Art, New York

1982

Philip Johnson's postmodern AT&T building, New York • Edward Larrabee Barnes's IBM building, New York • Whitney Biennial features fourteen women artists out of forty-six total • *Temporary Contemporary*, Museum of Contemporary Art, Los Angeles • Death of U.S. engineer and architect Buckminster Fuller • Death of Abstract and Surrealist painter Joan Miro

Jamie Uvs's The Gods Must Be Crazy . Martin Scorsese's Bull • Stanley Raging Kubrick's The Shining . George Lucas's Star Wars: Episode V-The Empire Strikes Back • Alfred Hitchcock, Hollywood's king of suspense, dies at age 80 • Ted Turner founds the Cable News Network (CNN) • John Lennon and Yoko Ono's Double Fantasy • December 8 John Lennon shot dead in New York City . South African novelist J. M. Coetzee publishes Waiting for the Barbarians . Death of French existentialist Jean-Paul Sartre • Nintendo's first electronic game introduces the Sony Walkman • Pac-Man launched

Hugh Hudson's Chariots of Fire • Peter Wier's Gallipoli · Steven Spielberg's Raiders of the Lost Ark . First MTV video airs: "Video Killed the Radio Star" by the Buggles . Prime time TV soap opera Dallas cliffhanger "Who shot J.R.?" . Death of Rastafarian reggae singer Bob Marley · Death of U.S. composer Samuel Barber • Death of songwriter Hoagy Carmichael • Toni Morrison's Tar Baby • Salman Rushdie's Midnight's Children • Prince Charles and Lady Diana Spencer wed · IBM introduces its first personal computer, the IBM PC

Ridley Scott's Blade Runner, an adaptation of Philip K. Dick's Do Androids Dream of Electric Sheep? • Steven Spielberg's E.T., the Extra-Terrestrial • Richard Gandhi • Attenborough's Sydney Pollack's Tootsie . Steven Lisberger's Tron • Comedian John Belushi dies of an overdose . Cheers TV sitcom debuts . Lifestyles of the Rich and Famous, hosted by Robin Leach, debuts . Death of jazz pianist Thelonius Monk • Alice Walker's The Color Purple • Gabriel Garcia Marquez's Chronicle of a Death Foretold Compact Disc (CD) audio system launched . Satellite TV introduced

Lawrence Kasdan's The Big Chill . Adrian Lyne's Flashdance • George Lucas's Star Wars: Episode VI-Return of the Jedi • James L. Brooks's film Terms of Endearment • Peter Weir's The Year of Living Dangerously . Popular TV programs include M*A*S*H and Magnum P.I. • Death American playwright Tennessee Williams . Michael Jackson's Thriller • Death of blues singer and songwriter Muddy Waters . Death of Russian-born U.S. choreographer George Balanchine • Death of American heavyweight boxer Jack Dempsey . Time magazine names the PC as "Man of the Year"

First automatic defibrillator is implanted into a human heart • U.S. space probe Voyager 1 reaches Saturn • May 18 Mount Saint Helens erupts . Former Hollywood actor Ronald Reagan wins election against incumbent Jimmy Carter • The Green Party forms in Germany . Shipyard strikes in Poland lead to the Solidarity trade union movement . Death of Yugoslavian president Joseph Tito • Iran-Iraq War begins when Iraqi armed forces invade western Iran . Deng Xiaoping takes power in China . Congress Party under Indira Gandhi wins Indian general elections • South Africa raids guerrilla bases in Angola

U.S. launches first space shuttle, Columbia . AIDS (acquired immune deficiency syndrome) identified • March 30 Assassination attempt on U.S. president Ronald Reagan • Sandra Day O'Connor becomes the first female U.S. Supreme Court justice • IRA hunger strikers in Northern Ireland's Maze Prison end their protest after 10 deaths . Socialist François Mitterand elected president in France . Assassination attempt on Pope John Paul II . Clashes between the PLO and Israel in Lebanon begin • Israeli air strike destroys nuclear reactor in Iraq • October 6 Egyptian president Anwar Sadat assassinated by a member of his own armed forces . China limits families to one child . World population reaches 4.5 billion

First permanent artificial heart, the Jarvik-7, is implanted . Insulin manufactured from bacteria becomes the first commercial product of genetic engineering • President Reagan declares war on drugs · 2,075 couples, members of the Unification Church ("Moonies"), wed in a mass ceremony in Madison Square Garden, New York • De Lorean motor plant in Northern Ireland closes . Falklands War between Britain and Argentina • Israel invades Lebanon . New government under Chancellor Helmut Kohl forms in West Germany • In Poland, the labor union Solidarity is outlawed . Soviet president Leonid Brezhnev dies

Sally Ride becomes the first woman in space • Human immunodeficiency virus (HIV) identified • First successful live human embryo is implanted • President Reagan calls the Soviet Union the "Evil Empire" and proposes the Strategic Defense Initiative (SDI), "Star Wars" • British prime minister Margaret Thatcher wins a second term . U.S. invades Granada · U.S.S.R. downs South Korean jet KAL 007, killing all passengers • Writer Arthur Koestler, proponent of voluntary euthanasia, takes his life . Oil tanker runs aground off Cape Town, South Africa, causing severe pollution . Blowout in the Nowruz oil field in the Persian Gulf spills an estimated 600,000 tons of oil

POP

CULTUR

WORLD

EVENTS

Primitivism in 20th Century Art: Affinities of the Tribal and the Modern, Museum of Modern Art, New York • Art and Ideology, New Museum Contemporary Art. New York . Robert Gober. Mona Hatoum, and Annette Lemieux are featured in their first solo exhibits in New York · Frederic Jameson's influential essay "Postmodernism, or The Cultural Logic of Late Capitalism" is published . French philosopher Michel Foucault dies . Death of U.S. photographer Ansel Adams

The Art of Memory/The Loss of History, New Museum of Contemporary Art, New York • The Saatchi Gallery opens in London • Katharina Fritsch's first solo exhibit opens in Cologne. Germany • Peter Halley, Alfredo Jaar, and the Starn Twins are featured in their first solo exhibits in New York . Rosalind Krauss publishes The Originality of the Avant-Garde and Other Modernist Myths . Death of Russian-born artist Marc Chagall . Death of French artist Jean Dubuffet, developer of Art Brut

The Spiritual in Art: Abstract Painting, 1890-1985, Los Angeles County Museum of Art . Arthur C. Danto publishes The Philosophical Disenfranchisement of Art • Andreas Huyssen publishes After the Great Divide: Modernism, Mass Culture. Postmodernism • Death of German sculptor and performance artist Joseph Beuys, at age 64 • Death of British sculptor Henry Moore • Death of U.S. painter Georgia O'Keeffe

The Museum of Women in the Arts is founded in Washington, D.C. . The NAMES Project AIDS Memorial Quilt is displayed in Washington. D.C., on the Mall . Similia/Dissimilia, Stadisches Kunsthalle. Dusseldorf • Barbara Kruger and Sherrie Levine become first female artists to join Mary Boone Gallery roster • Influential photographer Peter Hujar dies . King of Pop Andy Warhol dies at age 59 of a heart attack following a routine surgery

Sergio Leone's film Once Upon a Time in America . Wim Wenders's film Paris. Jarmusch's Texas • Jim Stranger Than Paradise . James Cameron's The Terminator, starring Arnold Schwarzenegger • Rob Reiner's mock documentary This Is Spinal Tap . (the artist formerly known as) Prince releases Purple Rain • Madonna releases Like a Virgin . Death of swing master Count Basie • Singer Marvin Gave is shot dead by his father in a violent argument . The term cyberspace is coined by William Gibson in Neuromancer • Czech novelist Milan Kundera publishes The Unbearable Lightness of Being . Death of writer Truman Capote

Robert Zemeckis's film Back the Future • Terry Gilliam's film Brazil . Akira Kurosawa's film Ran . Death of filmmaker and actor Orson Wells . Actor Rock Hudson dies from AIDS . Motion picture industry designs the new advisory rating PG-13 • Samplers begin to transform pop music production . Live Aid concert at Wembly Stadium, London, and in Philadelphia • Carlos Fuentes's The Old Gringo . Isabel Allende's The House of Spirits . Nintendo Entertainment System is introduced in the U.S. . The cellular telephone system is introduced in Britain • Microsoft Windows 1.0 released

Oliver Stone's film Platoon • James Cameron's film Aliens • David Lynch's film Blue Velvet . Spike Lee's She's Gotta Have It . Death of Cary actor Grant • The Oprah Winfrey Show is syndicated nationally . Death of clarinettist Benny Goodman Margaret Atwood publishes The Handmaid's Tale . John Irving publishes Cider House Rules • Art Spiegelman publishes Maus: A Survivor's Tale . Death of French author Simone de Beauvoir • Death of playwright Jean Genet • Apple's Macintosh introduces the mouse, windows, and onscreen icons to personal computers

Louis Malle's film Au Revoir Les Enfants . Gabriel Axel's film Babette's Feast . Adrian Lyne's film Fatal Attraction . John Boorman's Hope and Glory . Bernardo Bertolucci's The Last Emperor . Brian DePalma's film The Untouchables • Wim Wender's Wings of Desire . Death of comedian Jackie Gleason . "Good Night," the first "shorts" episode of The Simpsons airs • Michael Jackson releases Bad • Death of kitsch piano king Liberace • Reggae musician Peter Tosh is shot dead in Jamaica • Toni Morrison's Beloved • Tom Wolfe's The Bonfire of the Vanities . Disposable contact marketed

Genetic fingerprinting is developed • President Ronald Reagan wins another term in election against Walter Mondale: Geraldine Ferraro is the Democratic Partv's nominee for vice president . Miners' strike in Britain . British prime minister Margaret Thatcher agrees to return Hong Kong to China in 1997 • October 31 Prime minister of India Indira Gandhi is assassinated . December 3 Pesticide leak from Union Carbide factory at Bhopal, India, kills 2,500 · Archbishop Desmond Tutu is awarded the Nobel Peace Prize . Three million die of famine in Ethiopia

Scanning tunneling microscope is invented . Synthetic skin is introduced · Bifocal contact lens are marketed • British scientist Joe Farman publishes the discovery of an ozone hole over Antarctica . The wreck of the Titanic is found by underwater robotics . The Wall Street computer goes down . Israel withdraws from Lebanon • French government intelligence agents sink Greenpeace ship Rainbow Warrior in Aukland, New Zealand, harbor; the environmental group was protesting France's nuclear weapons tests in the Pacific • Mikhail Gorbachev comes to power in the U.S.S.R. · South Africa abolishes laws forbidding interracial marriage

January 28 The space shuttle Challenger explodes on takeoff, killing the entire crew, including teacher Christa McAuliffe . Core unit of the Mir space station launched . Six million participate in Hands Across America, a project to raise money for the homeless . U.S. bombs Libya • Iran-Contra Scandal surfaces: profits from illegal arms sales to Iran were given to Contra rebels fighting the elected Sandinista government in Nicaragua • Jacques Chirac is elected French prime minister; Socialists are defeated in elections • April 26 Chernobyl nuclear power plant disaster in the Ukraine when a reactor explodes . U.S. imposes sanctions on South Africa with the Anti-Apartheid Act . Desmond Tutu is appointed Anglican archbishop of South Africa

Glass fiber optic cable laid across the Atlantic . Construction of the Channel Tunnel between France and Britain begins • President Ronald Reagan uses the word AIDS in a public address . Senator and presidential candidate Gary Hart pulls out of election campaign after allegations of an affair with model Donna Rice • Lieutenant Colonel Oliver North testifies at the Iran-Contra congressional hearings in Washington, D.C. • October 19 Black Monday collapse of the stock markets of London and New York • Prime minister Margaret Thatcher wins a third consecutive term . U.S. and Soviet Union sign the Intermediate Nuclear Forces Treaty for reducing nuclear weapons ART

CULTURI

POP

Timeline

I.M. Pei's pyramid extension to the Louvre in Paris opens
• Griselda Pollock publishes Vision and Difference: Femininity, Feminism, and the Histories of Art • Jean-Michel Basquiat dies of a heroin overdose at age 27 • Death of Romare Bearden • Death of Italian car designer Enzo Ferrari • Death of sculptor Louise Nevelson • Death of abstract sculptor Isamu Noguchi

Andres Serrano's Piss Christ (1987) is debated by the U.S. Senate: a bill passed prohibits the National Endowment for the Arts from funding artworks deemed obscene • Robert Mapplethorpe: The Perfect Moment. Washington, D.C. . Magiciens de la Terre presents the subject of "globalism" at the Centre Georges Pompidou, Paris . Richard Serra's Tilted Arc is removed from the Federal Plaza in Lower Manhattan . Death of Spanish Surrealist Salvador Dali • Photographer Robert Mapplethorpe dies at age 42

High and Low: Modern Art and Popular Culture, the Museum of Modern Art, New York • The Decade Show: Frameworks of Identity in the 1980s is presented at the Museum of Contemporary Hispanic Art, the New Museum of Contemporary Art and the Studio Museum in Harlem • Jenny Holzer becomes the first woman to represent the U.S. at the Venice Biennale, where she wins the grand prize . Keith Haring dies from AIDS at age 31

Pleasure and Terrors Domestic Comfort presented at the Museum of Modern Art. New York . Dislocations is presented at the Museum of Modern Art, New York • Degenerate Art: The Fate of the Avant-Garde in Nazi Germany opens in Los Angeles • Sculptor Anish Kapoor wins the Turner Prize · Painter Carlos Alfonzo dies from AIDS at age 41 • Death of U.S. painter Robert Motherwell . Death of Swiss artist Jean Tinguely

Giuseppe Tornatore's film Cinema Paradiso . John Waters's film Hairspray . Barry Levinson's film Rain Man • Zhang Yimou's film Red Sorghum • Robert Zemeckis's film Who Framed Rabbit? . George Roger Michael releases Faith • Singer Roy Orbison dies of a heart attack at the age of 52 . Stephen Hawking publishes A Brief History of Time . Gabriel Garcia Marquez publishes Love in the Time of Cholera . Death of South African writer Alan Paton • U.S. track athlete Florence Griffith Joyner wins three gold medals at the Olympic Games in Seoul. Korea: Canadian Ben Johnson is disqualified for using steroids before the 100-meter race

Spike Lee's film Do the Right Thing . Bruce Beresford's film Driving Miss Daisy . Martin Scorsese's film The Last Temptation of Christ . Michael Moore's Roger and Me • Steven Soderbergh's sex, lies and videotapes . Rob Reiner's film When Harry Met Sally . Popular TV shows include Roseanne and The Wonder Years . Death of comedian Lucille Ball • Salman Rushdie publishes the novel The Satanic Verses; the Iranian government accuses him of blasphemy against Islam and issues a death sentence . Death of Irish dramatist and author Beckett . Nin-Samuel tendo's Game Boy is introduced

Kevin Costner's film Dances with Wolves . Francis Ford Coppola's film The Godfather Part III . Martin Scorsese's film GoodFellas . Stephen Frears's film The Grifters . Rob Reiner's film Misery • Beverly Hills 90210 debuts · Death of singer and entertainer Sammy Davis Jr. · American blues guitarist Stevie Ray Vaughan dies at the age of 35 in a helicopter crash . Poet Anthony E. Hecht publishes The Transparent Man • Naomi Wolf publishes The Beauty Myth . Baseball legend Pete Rose is banned from the game for gambling on professional sports . Tim Berners-Lee writes the first World Wide Web program

Oliver Stone's film JFK . Zhang Yimou's film Raise the Red Lantern • Jonathan Demme's film Silence of the Lambs • Ridley Scott's film Thelma and Louise • Nirvana's Nevermind . Queen's member Freddie Mercury dies from AIDS . Death of jazz musician Miles Davis . Douglas Coupland's Generation X: Tales for an Accelerated Culture • Milan Kundera publishes Immortality • Death of Theodor Geisel, creator of Dr. Seuss • Earvin "Magic" Johnson announces his retirement from the NBA after testing HIV positive . Norplant contraceptive implants are introduced in the U.S.

First transatlantic fiber-optic cable processes 40,000 phone calls simultaneously . DNA fingerprinting is used in forensics . Global warming fears increase: a UN resolution calls climate a "common concern of mankind" . George Bush wins the U.S. presidential election against Democratic candidate Michael Dukakis • Panamanian dictator Manuel Noriega is indicted on drug charges . Iran-Iraq War ends as the Iranian economy collapses . Mikhail Gorbachev becomes president of reformed Soviet government • Soviet troops withdraw from Afghanistan . Nelson Mandela's 70th birthday is marked by world protests over his continued imprisonment in South Africa First communications between commercial F-mail and Internet . U.S. launches the Magellan and Galileo probes to explore Venus and Jupiter; Vovager 2 reaches Neptune • March 24 Exxon Valdez oil tanker runs aground in Prince William Sound, Alaska, spilling 11 million gallons . October 17 Earthquake in San Francisco bay area, collapsing a double-tiered freeway bridge: the quake began at the start of the third World Series game, held at Candlestick Park • Serial killer Ted Bundy is executed · Panama declares war on 9 The U.S. • November Berlin Wall falls . Death of Iranian leader Ayatollah Khomeini . Death of Emperor Hirohito of Japan . June 3 Tiananmen Square massacre in Beijing, China . F. W. de Klerk becomes president of South Africa

The Hubble space telescope is sent into orbit . Beef products are banned in Britain over concern about Mad Cow disease, bovine spongiform encephalopathy (BSE) • Margaret Thatcher resigns as British prime minister; John Major takes office · Germany is reunited to form the Federal Republic of Germany, led by chancellor Helmut Kohl • Communist Slobodan Milosevic is elected president of Serbia . Conflict between Serbs and Albanians in Kosovo, Yugoslavia . Iraq invades Kuwait • Boris Yeltsin is elected president of Russia . Collapse of the U.S.S.R. • Mikhail Gorbachev is awarded the Nobel Peace Prize for his role in helping to end the Cold War . February 11 Nelson Mandela is released after 27 years' imprisonment

Precision-guided munitions, called "smart bombs," are used in the Persian Gulf War • President George Bush signs the Strategic Arms Reduction Treaty in Moscow . Anita Hill accuses U.S. Supreme Court nominee Clarence Thomas of sexual harassment • March Black motorist Rodney King is beaten by four white Los Angeles police officers; a witness' videotape of the incident prompts national debate on race and police brutality . Cholera outbreak hits Peru and spreads to Brazil . The Warsaw Pact is dissolved . Slovenia and Croatia declare independence from Yugoslavia · South African government announces repeal of apartheid laws . Civil war in Somalia . World population reaches 5.5 billion

Sexual

Queer Practice, University

Art Museum in Berkeley.

California • The Masculine

Masquerade, MIT List Visual

Arts Center • Africus 95 is

the first Johannesburg Bien-

nale . Sense and Sensibil-

Identity.

Culture,

ity: Women Artists and Minimalism in the Nineties, the Museum of Modern Art, New York • Longing and Belonging: From the Faraway Nearby, presented at SITE Santa Fe, explores issues of identity in global culture

Helter Skelter: LA Art in the 1990s is presented at the Temporary Contemporary of the Museum of Contemporary Art, Los Angeles . Mining the Museum, an installation by artist Fred Wilson, is presented at the Maryland Historical Society • Post Human, FAE Musée d'Art Contemporain, Pully/Lausanne . Death of British painter Francis Bacon • Death of artist and composer John Cage . Death of U.S. Joan Mitchell • David Wojnarowicz dies from AIDS at age 37

The U.S. Holocaust Memorial Museum, designed by James Ingo Freed, opens D.C. • The Washington, 1993 Biennial Exhibition. presented at the Whitney Museum of American Art, explores issues of race, class. and sexual identity . Roy Lichtenstein, Solomon R. Guggenheim Museum • The Return of the Cadavre Exquis, the Drawing Center, New York · Sculptor Rachel Whiteread wins the Turner Prize . Death of U.S. painter Richard Diebenkorn

opens in Pittsburgh • Michelangelo's restored Sistine Chapel frescoes are unveiled at the Vatican . Sculptor Antony Gormley wins the Turner Prize • Black Male: Representations of Masculinity in Contemporary American Art, Whitney Museum of American Art. New York • Andres Serrano, Works, 1983- 1993, Institute of Contemporary Art in Philadelphia • Death critic Clement Greenburg at age 85 • Death of U.S. sculptor Donald Judd Robert Zemeckis's Forrest

Stone's

Killers •

Gump • Oliver

Born

Quentin Tarantino's Pulp Fic-

tion • Frank Darabont's film

The Shawshank Redemption

King of pop Michael

Jackson weds Lisa Marie

Presley . Kurt Cobain, lead

singer of Nirvana, kills him-

self with a shotgun . Death

of U.S. jazz singer and band

leader Cab Calloway . The

Woodstock 25th anniversary

concert, Saugerties, New York

· Sherwin Nuland publishes

How We Die • At age 47,

George Foreman reclaims the

world heavyweight boxing

title by defeating 27-year-old

Michael Moorer . Death of

Jacqueline Kennedy Onassis

Natural

Idrissa Ouedraogo's Africa, My Africa • Ron Howard's Apollo 13 • Joel and Ethan Coen's Fargo . Mike Figgis's Leaving Las Vegas . Danny Boyle's Trainspotting • Superman star Christopher Reeve is paralyzed after falling from his horse . Death of Jerry Garcia of The Grateful Dead . Death of baseball great Mickey Mantle • The computer program Aaron, developed by Harold Cohen, produces the first "original" artworks, exhibited at the Boston Computer Museum • Tamagotchi virtual pets introduced in Japan

Neil Jordan's The Crying Game Wargnier's Indochine • Alfonso Arau's Like Water for Chocolate . Spike Lee's film Malcom X • Martin Brest's Scent of a Woman • Baz Luhrmann's Strictly Ballroom . Comedian Johnny Carson retires as host of The Tonight Show; he is replaced by Jay Leno . Francis Fukuyama publishes The End of History . Death of scifi writer Isaac Asimov . The term virtual reality is coined by Jaron Lanier • Maya Lin works with Thinking Machines Corporation on the design of the supercomputer CM-5 . The National Space and Air Museum opens an exhibit of Star Trek memorabilia, including the ears of Mr. Spock

Chen Kaige's film Farewell My Concubine • Steven Spielberg's Jurassic Park • Jonathan Demme's film Philadelphia • Jane Campion's The Piano . Tran Anh Hung's The Scent of Green Papaya • Steven Spielberg's Schindler's List • X-Files premieres . Death of actor Raymond Burr, known for his role as Perry Mason • Tony Kushner's Angels in America: A Gay Fantasia on National Themes opens on Broadway • Death of jazz trumpeter and bebop pioneer Dizzy Gillespie Alan Lightman publishes Einstein's Dreams • Poet A. R. Ammons publishes Garbage

February 26 The World Trade Center in New York is bombed, killing 6, injuring more than 1,000 • North America Free Trade Agreement (NAFTA) between Mexico, U.S., and Canada . The Brady Act, imposing slight gun control, passes in the U.S. . The Waco headquarters in Texas is stormed by federal agents; 82 people are killed in a fire . President Clinton orders the military to lift ban on homosexual servicemen • Homosexuality is decriminalized in Ireland • Oslo Peace Accord signed by Israel and the PLO . U.S. troops withdraw from Somalia . U.N. forms war crimes tribunal for genocide committed in the former Yugoslavia . Czechoslovakia becomes the separate Czech Republic and Slovakia

President Clinton investigated for his involvement with the Whitewater Development Corp in Arkansas . Death of former U.S. president Richard Nixon · O.J. Simpson is charged with the murders of Nicole Brown Simpson and Ronald Goldman • More than 20,000 Cubans leave for the U.S. when the Cuban government lifts restrictions on departure . Channel Tunnel connects Britain and France . Homosexual age of consent lowered to 18 in Britain . Britain and Ireland sign a declaration of peace . Russian forces invade Chechnva • Nelson Mandela is elected president of South Africa in the first fully democratic elections • Massacres in Rwanda's civil war

AIDS affects over 1 million worldwide . U.S. space shuttle Discovery docks with Russian space station Mir • April 19 Oklahoma City's Alfred P. Murrah Federal Building bombed • October 16 The Million Man March, led by Muslim leader Louis Farakhan, draws 400,000 African-American men to the Mall in Washington, D.C. • Referendum in Quebec narrowly votes to remain part of Canada • Jacques Chirac elected president of France . Dayton Peace Plan for Serbia. Croatia, and Bosnia . Assassination of Israeli prime minister Yitzhak Rabin • Aum Shinrikyo cult members release nerve gas in Tokyo subway trains, killing 12 and injuring over 5,000 • Thousands of Hutu refugees are killed by Tutsi forces in Rwanda • Ebola outbreak in Zaire

Vice president Dan Quayle cites the TV show Murphy Brown, in which Candice Bergen's character chooses to be a single mother, as an attack on family values . Democrat Bill Clinton wins presidency in election against Republican incumbents and billionaire independent candidate H. Ross Perot • April 29 Riots break out in Los Angeles after the four police officers charged for the Rodney King beating are acquitted . European community signs the Treaty of European Union • Boutros Boutros Ghali is appointed secretary general of the United Nations • Yugoslavia dissolves into independent republics; massacres Bosnia and Croatia . U.N. imposes sanctions on Serbia · U.S. military intervenes in

Somalia in an effort to dis-

tribute food supplies

POP CULTURE

231

Timeline

WORLD EVENTS

CULTUR

EVENT

WORLD

Timeline

Stelarc performs Ping Body, an "Internet Activated Performance," Art Space in Sydney, Australia: the audience participating via the Internet control the movements of the artist's body . The AIDS Memorial Quilt is displayed on the Mall in Washington, D.C. • Distemper: Dissonant Themes in the Art of the 1990s. Hirshhorn Museum Sculpture Garden, Washington, D.C. • Death of sculptor Dan Flavin • Felix Gonzalez Torres dies of AIDS at age 38

Edwardo Kac has an identification microchip implanted his his leg in "intracorporeal" artwork • The Basilica of Saint Francis of Assisi is damaged by an earthquake in Italy . Rrose is a Rrose is a Rrose: Gender Performance in Photography. Solomon R. Guggenheim Museum, New York . Documenta X, Kassel, Germany . Sensation, Royal Academy, London . Death of Willem de Kooning . Death of Roy Lichtenstein • Italian fashion designer Gianni Versace is shot dead

1997

Frank Gehry's Guggenheim Museum opens in Bilbao, Spain • The Art of the Motorcycle, Solomon R. Guggenheim Museum, New York • Mark Rothko, The National Gallery of Art, Washington, D.C. • Jackson Pollock, the Museum of Modern Art, New York • Painter Chris Ofili is awarded the Turner Prize • Death of designer Ferdinand Porsche

1998

Inside Out: New Chinese Art, San Francisco Museum of Modern Art and the Asian Art Museum of San Francisco . Regarding Beauty: A View of the Late Twentieth Cen-Hirshhorn Museum Sculpture Garden, and Washington, D.C. . William Kentridge is awarded the Carnegie Prize at Carnegie International, 1999/ 2000 • New York City mayor Rudolph Giuliani threatens sanctions against the Brooklyn Museum of Art's exhibition Sensation: Young British Artists from the Saatchi Collection

David Cronenberg's film Crash Anthony Minghella's film The English Patient Roland Emmerich's film Independence Day . Scott Hick's film Shine . Filmmaker Martin Scorsese is awarded the Wexner Prize . Popular TV shows include ER and Friends · The U.S. Congress requires television manufacturers to equip new sets with v-chips, hardware that allows parents block out violent programming • Prince Charles and Princess Diana divorce • Death of comedian George Burns . Death of jazz singer Ella Fitzgerald • Death of poet and essayist Joseph Brodsky

James L. Brooks's As Good As Gets • Paul Thomas Anderson's film Boogie Nights • Quentin Tarantino's Jackie Brown • James Cameron's film Titanic . Death of actor Jimmy Stewart . South Park debuts on cable TV . In an episode of the TV sitcom Ellen, actor Ellen DeGeneres becomes the first star in a prime time series to "come out" as a homosexual . September 6 Princess Diana's funeral becomes the mostwatched televised event in history • Death of singer John Denver • Death of beat poet Allen Ginsberg . Death of French oceanographer Jacques Cousteau • Volkswagen redesigns the Beetle · Intel launches the Pentium II chip

The Coen brothers' film The Big Lebowski • Shekhar Kapur's film Elizabeth . Peter Weir's The Truman Show . CBS airs footage of assisted suicide advocate Dr. Jack Kevorkian administering lethal drugs to a terminally ill Night patient • Saturday Live veteran Phil Hartman is shot to death by his wife . Pop singer George Michael comes out as a homosexual . Former singer and politician Sonny Bono dies in a skiing accident . Death of singer Frank Sinatra . Track legend Florence Griffith Joyner dies at age 38 • The FDA approves the use of Viagra for the treatment of male impotence

Sam Mendes's film American Beauty . Spike Jonze's film Being John Malkovich . Daniel Myrick and Eduardo Sanchez's Blair Witch Project · Stanley Kubrick's Eyes Wide Shut . David Fincher's film Fight Club . Andy and Larry Wachowski's film The Matrix . George Lucas's Star Wars: Episode I-The Phantom Menace • Spike Lee's Summer of Sam . Barbie makes her movie debut in the blockbuster Tov Story 2 . Death of film director Stanley Kubrick . Death of film critic Gene Siskel . Death of baseball legend Joe Dimaggio Japan's Pokemon cards and video games dominate the toy market

U.S. launches Pathfinder probe to explore Mars . President Clinton wins a second term, defeating opponent Dole • "Unabomber" Theodore Kaczynski arrested . Death of counterculture exponent Timothy Leary • Rally of nearly 200,000 school children at the Lincoln Memorial in Washington, D.C., in protest of Congress's cuts in social and educational programs . Yasser Arafat is elected president of Palestine • Benjamin Netanyahu is elected prime minister of Israel

Scottish geneticist Wilmut announces his successful cloning of a sheep; the clone is named Dolly . Timothy McVeigh is convicted of the Oklahoma City bombing and sentenced to death . Britain turns Hong Kong over to China . Tony Blair is elected British prime minister · BSE crisis in Britain; beef on the bone is banned . Taliban forces seize power in Afganistan . Death of Chinese Deng Xaioping • leader European Union bans tobacco ads . Death Mother Theresa of Calcutta . The World Trade Organization is established

The first component for the International Space Station is launched . NASA announces there is enough frozen water on the moon to support a colony • "Unabomber" Theodore Kaczynski is sentenced to life without parole; over 17 years, his mail bombs killed three people and injured 29 • U.S. Congress votes to impeach President Clinton on charges of perjury and obstruction of justice in the investigation of his alleged affair with White House intern Monica Lewinsky . The Euro currency is introduced by the European Union . Peace deal in Northern Ireland • Serb military offensive in Kosovo province · India and Pakistan each conduct nuclear arms tests . World's longest suspension bridge opens in Japan

Y2K: computer technicians anticipate failure of the twodigit date system . U.S. Senate acquits President Clinton of charges in the Lewinsky scandal . April 21 Teenagers Eric Harris and Dylan Klebold, armed with automatic weapons, enter Columbine High School in Littleton, Colorado, killing 13 students and teachers; the shooting forces debate on gun control and teen violence • November 20 Riots break out in Seattle, Washington, during the meeting of the World Trade Organization • U.S. turns over control of the Panama Canal to Panama . Vladimir Putin becomes Russian prime minister after Boris Yeltsin President resigns • Nelson Mandela steps down as the president of South Africa to be succeeded by Thabo Mbeki

Spectacular Bodies, Hayward Gallery, London . Alberto Giacometti, Museum of Modern Art. New York

Gerhard Richter is presented at the Museum of Modern Art. New York • Eva Hesse is presented at the Museum of Modern Art. New York • Death of celebrity photographer Herb Ritts . Death of painter Larry Rivers

The Lois and Richard Rosenthal Center for Contemporary Art, designed by Zaha Hadid, opens in Cincinnati . Philip Guston is presented at the San Francisco Museum of -Modern Art

Cameron Crowe's Almost Famous • Mary Harron's film Psycho • Julian American Schnabel's film Before Night Falls • Ang Lee's film Crouching Tiger, Hidden Dragon • Lars von Trier's film Dancer in the Dark . Wong Kar-wai's film In the Mood for Love • Steven Soderbergh's film Traffic • Napster, a leader in the digital media sharing industry, faces a legal battle over online copyrights . The "I Love You" computer virus, the most destructive in digital history, affects computer networks worldwide, including the British Parliament, the U.S. Central Intelligence Agency, and the Pentagon

Steven Spielberg's film A.I. Artificial Intelligence . Jean-Pierre Jeunet's film Amelie • Ron Howard's film A Beautiful Mind • John Cameron Mitchell's film Hedwig and the Angry Inch . Peter Jackson's adaptation of J. R. R. Tolkien's The Lord of the Rings: The Fellowship of the Ring . Baz Luhrmann's film Moulin Rouge . David Lynch's film Mulholland Drive · Danis Tanovic's film No Man's Land . Death of cartoon animator Bill Hanna . Death of Beatle George Harrison • Death of blues musician and performer Ron Taylor • Death of Hitchhiker's Guide to the Galaxy author Douglas Adams

Peter Jackson's film The Lord of the Rings: The Two Towers Steven Spielberg's film Minority Report • Michael Haneke's film The Piano Teacher • M. Night Shvamalan's film Signs • George Lucas's film Star Wars: Episode II-Attack of the Clones • Alexander Sokurov's Russian Ark • Hayao Miyazaki's Spirited Away . Discount chain Kmart files for Chapter 11 bankruptcy protection • Death of Queen Mother Elizabeth at age 101 . Death of Bugs Bunny and Porky Pig animator Chuck Jones

Peter Jackson's film The Lord of the Rings: The Return of the King . Sofia Coppola's film Lost in Translation • Jacques Perrin's film Winged Migration • Mike Nichols's adaptation of Tony Kushner's play Angels in America . Popular TV "reality" shows are American Idol and Survivor • Death of Fred Rogers, creator and host of the PBS children's show Mister Rogers' Neighborhood . Death of actor John Ritter. known for his role as Jack Tripper in the sitcom Three's Company • Michael Jackson is arrested on charges of child molestation

POP CULTURE

Timeline

Human DNA sequence established . U.S. District Court finds Microsoft in violation of antitrust laws . President Bill Clinton leaves office; in his eight-year term, he passed measures to protect 58 million acres of national forest and set aside eight million acres of land as new national monuments . The IRA disarms; Britain restores the Northern Ireland Parliament · The first-ever Concorde jet crashes near Paris, killing 113 people . Vojislav Kostunica is elected Yugoslav president, ousting Slobodan Milosevic • Russian nuclear sub Kursk sinks in the Sea, Barents killing 118 crew members • The 13th International AIDS Conference in Durban, South Africa, considers strategies for controlling surging AIDS rates in developing countries · World population exceeds 6 billion

November 18 Leonid Meteor Shower . George W. Bush is inaugurated president after a controversial election against Democrat Al Gore and Green candidate Ralph Nader • President Bush's energy plan calls for increased oil exploration and new construction of coal and nuclear power plants • September 11 Terrorists destroy the World Trade Center in New York City and damage the Pentagon in a coordinated hijack attack; an estimated 3,000 are killed · Government officials in Washington, D.C., New York, and Florida receive letters laced with deadly anthrax spores; the incidents lead to new fears of biological Enron files terrorism bankruptcy · Former Yugoslav president Slobodan Milosevic surrenders to Serbian authorities; he is tried by the UN war crimes tribunal at The Hague, charged with crimes against humanity in Croatia and Kosovo and genocide in Bosnia • U.S. bombs Afganistan • The Buddhas of Bamiyan are destroyed by the Taliban . Mad Cow disease spreads within Europe

Odyssey space probe maps the surface of Mars using thermal emission imaging; the probe identifies ice deposits • There are estimated 42 million AIDS cases worldwide . The Euro becomes the common currency in 12 European nations . Former Union President Jimmy Carter receives the Nobel Peace Prize • President Bush establishes the Homeland Security Department . A jury in Birmingham, Alabama, convicts former Ku Klux Klan member Bobby Frank Cherry of the 1963 murders of four girls at the 16th Street Baptist Church bombing • Yucca Mountain in Nevada is approved for use as a nuclear waste depository . American Taliban member John Walker Lindh is tried in the U.S. . The UN Security Council freezes the assets of alleged terrorists Osama bin Laden, Al-Qaida, and Taliban members • Hu Jintao replaces Jiang Zemin as general secretary of the Chinese Communist Party • North Korea confirms it developing nuclear arms, in violation of a 1994 international treaty

Scientists at the University of Illinois develop a copy of a human jaw joint with stem cells from rats . Dolly, the first cloned sheep, is euthanized at age six, at half her life expectancy • February 1 Space shuttle Columbia breaks apart re-entering the earth's atmosphere, killing all seven aboard, including Colonel Ilan Ramon, Israel's first astronaut • China launches its first manned spacecraft, the Shenzou 5 (Divine Vessel) . U.S. Senate outlaws partial birth abortion . Supreme Court ruling in Lawrence v. Texas overturns sodomy laws in 13 states, etablishing equal rights for homosexuals • March 19 U.S. leads massive air strikes against Iraq; international opponents stage demonstrations . August 14 Blackout of power grids in Ontario and eight Northeast and Midwestern states; it is the biggest power failure to hit North America . Arnold Schwarzenegger is elected governor of California . Iraqi leader Saddam Hussein is captured by U.S. forces . The deadly respiratory illness, Severe Acute Respiratory Syndrome (SARS), sweeps

WORLD EVENTS

	2004			
ART	Controversy over the Dia Art Foundation's proposed restoration of Robert Smithson's <i>Spiral Jetty</i> (1970) in the Great Salt Lake • Death of influential	theorist Jacques Derrida, best known for his "deconstruction theory"		
POP CULTURE	Clint Eastwood's film Mystic River • Mel Gibson's film The Passion of the Christ • Janet Jackson exposes her breast on live television during the half-time performance at the Superbowl; the incident	sparks a Federal Communications Commission investigation • Lifestyle expert Martha Stewart is convicted of obstructing justice in an investigation into the sale in 2001 of nearly 4,000 shares of	ImClone, a biotech company founded by Stewart's friend Sam Waksal • Death of actor Christopher Reeve, who became a campaigner for stem cell research after he was paralyzed	
WORLD EVENTS	Spirit rover transmits images of Mars surface • A new security system, the U.S. Visitor and Immigrant Status Indicator Technology (US-VISIT), requires international travelers to be photographed and fingerprinted • U.S. Central Intelligence Agency chief weapons inspector David Kay resigns in the face of an investigation of intelligence reports presented before the U.Sled war against Iraq; the agency found no evidence of chemical, biological, or nuclear weapons in Iraq •	Hundreds of gay and lesbian couples line up in front of San Francisco's City Hall Valentine's Day weekend to be married; the rush comes just before a delayed Superior Court hearing of two law suits opposing same-sex marriage • Violent demonstrations in Haiti call for the removal of President Jean-Bertrand Aristide • Afghanistan adopts a new constitution that establishes a presidential system and national assembly and gives equal rights to women • March 11 Terrorists bomb three train stations	in Madrid, killing 190, injuring more than 600 • Avian flu (Bird flu) spreads in Asia • September 1–3 At least 320 people are killed, many of them children, in a siege of a school in Beslan, Russia by Chechen separatists • The United Nations calls events in the Darfur region of the Sudan one of the world's worst humanitarian crises and puts the death toll at up to 50,000 from violence, hunger, and disease after twenty months of war • Estimated world population is 6.4 billion	

Selected Bibliography

Chapter One: The Art World Expands

Beyond the Future: The Third Asia-Pacific Triennial of Contemporary Art. South Brisbane, Australia: Queensland Art Gallery, 1999. An exhibition catalog.

Cork, Richard. Annus Mirabilis? Art in the Year 2000. New Haven: Yale University Press, 2003.

- ———. Breaking Down the Barriers: Art in the 1990s. New Haven: Yale University Press, 2003.
- ———. New Spirit, New Sculpture, New Money: Art in the 1980s. New Haven: Yale University Press, 2003.

Harris, Jonathan. The New Art History: A Critical Introduction. London and New York: Routledge, 2001.

Lovejoy, Margot. *Postmodern Currents: Art and Artists in the Age of Electronic Media.* Upper Saddle River, N. J.: Prentice Hall, 1997.

"The 1980s, Part One." Special issue, Artforum, March 2003.

"The 1980s, Part Two." Special issue, Artforum, April 2003.

Senie, Harriet, and Sally Webster, eds. Critical Issues in Public Art: Content, Context, and Controversy. New York: HarperCollins, 1992.

Stiles, Kristine, and Peter Selz, eds. *Theories and Documents of Contemporary Art: A Sourcebook of Artists' Writings*. Berkeley and Los Angeles: University of California Press, 1996.

Vitamin P: New Perspectives in Painting. London and New York: Phaidon, 2002.

Chapter Two: Time

Appel, Dora. Memory Effects: The Holocaust and the Art of Secondary Witnessing. New Brunswick, N.J.: Rutgers University Press, 2002.

Doubletake: Collective Memory and Current Art. London: South Bank Centre and Parkett Publishers, 1992. An exhibition catalog.

Friedel, Helmut, ed. Moments in Time: On Narration and Slowness. Stuttgart, Germany: Hatje Cantz; New York: Distributed Art Publishers, 1999.

Gangitano, Lia and Steven Nelson, eds. *New Histories*. Boston: Institute of Contemporary Art, 1996. An exhibition catalog.

Herkenhoff, Paulo, Roxana Marcoci, and Miriam Basilio. *Tempo*. New York: Museum of Modern Art, 2002. An exhibition catalog.

Hughes, Alex, and Andrea Noble. *Phototextualities: Intersections of Photography and Narrative*. Albuquerque: University of New Mexico Press, 2003.

Huyssen, Andreas. Twilight Memories: Marking Time in a Culture of Amnesia. New York: Routledge, 1995.

Kara Walker: Narratives of a Negress. Cambridge: MIT Press, 2003.

Kleeblatt, Norman L., ed. Mirroring Evil: Nazi Imagery / Recent Art. New York: Jewish Museum; New Brunswick, N.J.: Rutgers University Press, 2002. An exhibition catalog.

Making Time: Considering Time as a Material in Contemporary Video and Film. Lake Worth, Fla.: Palm Beach Institute of Contemporary Art, 2000. An exhibition catalog.

Rush, Michael. New Media in Late Twentieth-Century Art. New York: Thames & Hudson, 1999.

Toll, Nelly. When Memory Speaks: The Holocaust in Art. Westport, Conn.: Praeger Publishers, 1998.

Profile: Brian Tolle

Baudrillard, Jean. "The Hyper-realism of Simulation." A selection reprinted in Charles Harrison and Paul Wood, eds., Art in Theory: 1900–2000, pp. 1018–20. Malden, Mass.: Blackwell Publishing Ltd., 2003.

Blackwell, Josh. "Brian Tolle at Shoshana Wayne." Art Issues no. 63 (Summer 2000), p. 49.

Kaizen, William. "Brian Tolle." Bomb 77 (Summer 2001): pp. 56–63.

Owens, Craig. "The Allegorical Impulse: Towards a Theory of Postmodernism." In Charles Harrison and Paul Wood, eds., *Art in Theory: 1900–2000*, pp. 1025–32. Malden, Mass.: Blackwell Publishing Ltd., 2003.

Richardson, Lynda. "Like Potato Fields, His Memorial Lies Fallow." New York Times, May 14, 2003, p. B2.

Servetar, Stuart. "Ouverture: Brian Tolle." Flash Art 189 (Summer 1996): p. 124.

Weaver, Thomas. "Brian Tolle: Overmounted Interior." Sculpture 15 no. 7 (September 1996), pp. 64–65.

Chapter Three: Place

Bachelard, Gaston. The Poetics of Space. Boston: Beacon Press, 1969.

Bender, Susan, and Ian Berry. The World According to the Newest and Most Exact Observations: Mapping Art and Science. Saratoga Springs, N.Y.: Tang Teaching Museum and Art Gallery, Skidmore College, 2001.

Claustrophobia. Birmingham, United Kingdom: Ikon Gallery, 1998. An exhibition catalog.

Davies, Hugh. Blurring the Boundaries: Installation Art, 1969–1996. San Diego: Museum of Contemporary Art, 1996. An exhibition catalog.

Deitch, Jeffrey, and Dan Friedman, eds. *Artificial Nature*. Athens, Greece: Deste Foundation for Contemporary Art, 1990. An exhibition catalog.

De Oliveira, Nicolas, Nicola Oxley, and Michael Petry. *Installation Art*. London: Thames and Hudson, 1994.

Dunning, William V. Changing Images of Pictorial Space: A History of Spatial Illusion in Painting. Syracuse, N.Y.: Syracuse University Press, 1991.

Enwezor, Okwui. "A Question of Place: Revisions, Reassessments, Diaspora." In Mora J. Beauchamp-Byrd and M. Franklin Sirmans, eds., Transforming the Crown: African, Asian and Caribbean Artists in Britain, 1966–1996, 80–88. New York: African Diaspora Institute, 1997. An exhibition catalog.

Grynsztejn, Madeleine. About Place: Recent Art of the Americas. Chicago: Art Institute of Chicago, 1995. An exhibition catalog.

Kastner, Jeffrey, ed. Land and Environmental Art. London: Phaidon, 1998.

Klotz, Heinrich, ed. Postmodern Visions: Drawings, Paintings, and Models by Contemporary Architects. New York: Abbeville Press, 1985.

Kwon, Miwon. One Place after Another. Cambridge: MIT Press, 2002.

Lippard, Lucy. The Lure of the Local: Senses of Place in a Multicentered Society. New York: New Press, 1997.

Martin, Richard, ed. The New Urban Landscape. New York: Olympia and York Companies, 1989.

No Place (Like Home). Minneapolis: Walker Art Center; New York: Distributed Art Publishers, 1997.

O'Doherty, Brian. Inside the White Cube: The Ideology of the Gallery Space. San Francisco: Lapis Press, 1986.

Out of Site: Fictional Architectural Spaces. New York: New Museum of Contemporary Art, 2002. An exhibition catalog.

Ravenal, John B. Outer and Inner Space: Pipilotti Rist, Shirin Neshat, Jane and Louise Wilson, and the History of Video Art. Richmond: Virginia Museum of Fine Arts, 2002. An exhibition catalog.

Reiss, Julie H. From Margin to Center: The Spaces of Installation Art. Cambridge: MIT Press, 1999.

Rogoff, Irit. Terra Infirma: Geography's Visual Culture. London and New York: Routledge, 2000.

Rybczynski, Witold. Home: A Short History of an Idea. New York: Penguin Books, 1987.

Small World: Dioramas in Contemporary Art. San Diego: Museum of Contemporary Art, 2000. An exhibition catalog.

Storr, Robert. Mapping. New York: Museum of Modern Art, 1994.

Suderburg, Erika, ed. Space, Site, Intervention: Situating Installation Art. Minneapolis: University of Minnesota Press, 2000.

Vidler, Anthony. "Interpreting the Void: Architecture and Spatial Anxiety." In Mark A. Cheetham, Michael Ann Holly, and Keith Moxey, eds., The Subjects of Art History: Historical Objects in Contemporary Perspective, 288–307. Cambridge: Cambridge University Press, 1998.

Watkin, Mel. Terra Incognita: Contemporary Artists' Maps and Other Visual Organizing Systems. Saint Louis: Contemporary Art Museum, 2002. An exhibition brochure.

Profile: Janet Cardiff

Betsky, Aaron. "Janet Cardiff." In 010101: Art in Technological Times. San Francisco: San Francisco Museum of Modern Art, 2001, pp. 052–053. An exhibition catalog.

Cardiff, Janet. "Inexplicable Symbiosis: A Conversation with Janet Cardiff." By Carolee Thea. *Sculpture* 22, no. 1 (January/February 2003): pp. 52–57.

D'Souza, Aruna. "A World of Sound." Art in America 90, no. 4 (April 2002): pp. 110-115, and p. 161.

Kimmelman, Michael. "Janet Cardiff" in "Art in Review." New York Times, November 30, 2001, E36.

Lerner, Adam. "Janet Cardiff and George Bures Miller." In Jonathan P. Binstock, *The 47th Corcoran Biennial: Fantasy Underfoot*. Washington, D.C.: Corcoran Gallery of Art, 2002, pp. 42–45.

Chapter Four: Identity

Anderson, Walter Truett. The Truth about the Truth: De-confusing and Re-constructing the Postmodern World. New York: Putnam, 1995.

Asia/America: Identities in Contemporary Asian American Art. New York: Asia Society Galleries and New Press, 1994. An exhibition catalog.

Butler, Judith. Gender Trouble: Feminism and the Subversion of Identity. London and New York: Routledge, 1993.

Carson, Fiona, and Claire Pajaczkowska, eds. Feminist Visual Culture. New York: Routledge, 2001.

Comic Release: Negotiating Identity for a New Generation. New York: Distributed Art Publishers, 2002. An exhibition catalog.

Freestyle. New York: Studio Museum in Harlem, 2001. An exhibition catalog.

Hassan, Salah M., ed. *Gendered Visions: The Art of Contemporary Africana Women Artists*. Trenton, N.I., and Asmara, Eritrea: Africa World Press, 1997. An exhibition catalog.

- Kruger, Barbara. Barbara Kruger. Los Angeles: Museum of Contemporary Art; Cambridge, Mass.: MIT Press, 1999. An exhibition catalog.
- Lippard, Lucy R. Mixed Blessings: New Art in a Multicultural America. New York: Pantheon Books, 1990.
- Malik, Rohini, and Gavin Jantjes. A Fruitful Incoherence: Dialogues with Artists on Internationalism. London: Institute of International Visual Arts, 1998.
- Reckitt, Helena, ed. Art and Feminism. London and New York: Phaidon Press, 2001.
- Shohat, Ella, ed. *Talking Visions: Multicultural Feminism in a Transnational Age*. New York: New Museum of Contemporary Art; Cambridge: MIT Press, 1998.

Profile: Jaune Quick-to-See Smith

- Borum, Jenifer. "Jaune Quick-to-See Smith." Artforum 31, no. 5 (January 1993): pp. 87–88.
- Galligan, Gregory. "Jaune Quick-to-See Smith: Racing with the Moon." Arts Magazine 61 (January 1987): pp. 82–83.
- Guerrero, M.A. James. "Savage Hegemony: From 'Endangered Species' to Feminist Indiginism." In Ella Shohat, ed., *Talking Visions: Multicultural Feminism in a Transnational Age*. New York: New Museum of Contemporary Art; Cambridge: MIT Press, 1998, pp. 413–439.
- Valentino, Erin. "Coyote's Ransom: Jaune Quick-to-See Smith and the Language of Appropriation." Third Text 38 (Spring 1997): pp. 25–37.
- Zdanovics, Olga. "Jaune Quick-to-See Smith, Ted Garner." The New Art Examiner 22, no. 4 (December 1994); pp. 42–43.

Chapter Five: The Body

- Banes, Sally. "'A New Kind of Beauty': From Classicism to Karole Armitage's Early Ballets." In Peg Zeglin Brand, ed., Beauty Matters. Bloomington: Indiana University Press, 2000.
- Body. Melbourne and New South Wales, Australia: Bookman Schwartz and Art Gallery of New South Wales, 1997. An exhibition catalog.
- Brettle, Jane, and Sally Rice, eds. *Public Bodies–Private States: New Views on Photography, Representation and Gender.* Manchester and New York: Manchester University Press, 1994.
- Broude, Norma, and Mary D. Garrard, eds. *The Expanding Discourse: Feminism and Art History*. New York: HarperCollins, 1992.
- Carson, Fiona, and Claire Pajaczkowska, eds. Feminist Visual Culture. New York: Routledge, 2001.
- Cavallaro. Dani. The Body for Beginners. New York and London: Writers and Readers Limited, 1997.
- Deitch, Jeffrey. *Post Human*. Pully and Lausanne, Switzerland: FAE Musée d'Art Contemporain; New York: Distributed Art Publishers, 1992. An exhibition catalog.
- Hall, Donald. *Corporal Politics*. Cambridge: MIT List Visual Arts Center; Boston: Beacon Press, 1992. An exhibition catalog.
- Jones, Amelia, ed. Sexual Politics: Judy Chicago's "Dinner Party" in Feminist Art History. Los Angeles: UCLA/Armand Hammer Museum of Art and Cultural Center, in association with University of California Press, 1996. An exhibition catalog.
- Jones, Amelia. "Survey." In Tracey Warr, ed., The Artist's Body. London: Phaidon Press Limited, 2000.
- McDonald, Helen. Erotic Ambiguities: The Female Nude in Art. London and New York: Routledge, 2001.
- McEvilley, Thomas. Sculpture in the Age of Doubt. New York: Allworth Press, 1999.
- Mulvey, Laura. "Visual Pleasure and Narrative Cinema." Screen, Autumn 1975, and reprinted in Mulvey, Visual and Other Pleasures. Basingstroke, United Kingdom: Macmillan, 1989.
- Rogers, Sarah J. Body Mécanique: Artistic Explorations of Digital Realms. Columbus, Ohio: Wexner Center for the Arts, Ohio State University, 1998. An exhibition catalog.
- Warr, Tracey, ed. The Artist's Body. London: Phaidon Press, 2000.

Profile: Shirin Neshat

- Bailey, David A., and Gilane Tawadros, eds. Veil: Veiling, Representation and Contemporary Art. Cambridge: MIT Press, 2003.
- Neshat, Shirin. "Shirin Neshat: Interview." By Arthur C. Danto. Bomb 73 (Fall 2000): pp. 60–67.
- Shaw, Wendy Meryem K. "Ambiguity and Audience in the Films of Shirin Neshat." *Third Text* 57 (Winter 2001/02): pp. 43–52.
- Van Hoof, Marine. "Shirin Neshat: Veils in the Wind." Art Press 279 (May 2002): pp. 34–39.
- Wallach, Amei. "Shirin Neshat: Islamic Counterpoints." Art in America 89, no. 10 (October 2001): pp. 136–43, 189.
- Zabel, Igor. "Women in Black." Art Journal 60, no. 4 (Winter 2001): pp. 16-25.

Chapter Six: Language

- Bee, Susan, and Mira Schor, eds. M/E/A/N/I/N/G: An Anthology of Artists' Writings, Theory, and Criticism. Durham, N.C.: Duke University Press, 2000.
- Bowman, Russell. "Words and Images: A Persistent Paradox." Art Journal 45 (Winter 1985): pp. 335–43.
- Colpitt, Frances, and Phyllis Plous. *Knowledge: Aspects of Conceptual Art.* Santa Barbara, Calif.: University Art Museum, University of California, 1992. An exhibition catalog.
- Drucker, Johanna. The Century of Artists' Books. New York: Granary Books, 1995.
- A Forest of Signs: Art in the Crisis of Representation. Los Angeles: Museum of Contemporary Art; Cambridge: MIT Press, 1989. An exhibition catalog.
- Hapkemeyer, Andreas, and Peter Weiermair, eds. photo text text photo: The Synthesis of Photography and Text in Contemporary Art. Bozen, Italy: Museum für Moderne Kunst; Frankfurt am Main: Frankfurter Kunstverein, 1996. An exhibition catalog.
- Hughes, Alex, and Andrea Noble, eds. *Phototextualities: Intersections of Photography and Narrative*. Albuquerque: University of New Mexico Press, 2003.
- Lauf, Cornelia, and Clive Phillpot. Artist/Author: Contemporary Artists' Books. New York: American Federation of Arts and Distributed Art Publishers, 1998.
- Lyons, Joan, ed. Artists' Books: A Critical Anthology and Sourcebook. Rochester: Visual Studies Workshop Press, 1987.
- McDaniel, Craig, Matthew Brennan, and Renée Ramsey, eds. *Is Poetry a Visual Art?* Terre Haute: Indiana State University, Turman Art Gallery, 1993. An exhibition catalog.
- Perverted by Language. Greenvale, N.Y.: Hillwood Art Gallery, Long Island University/C. W. Post Campus, 1987. An exhibition catalog.
- Smith, Keith A. Text in the Book Format. Fairport, N.Y.: Sigma Foundation, 1989.
- Spector, Buzz, ed. Verbally Charged Images. Chicago: WhiteWalls: A Magazine of Writings by Artists 10/11 (Spring/Summer 1984).
- Stiles, Kristine. "Language and Concepts." In Kristine Stiles and Peter Selz, eds., *Theories and Documents of Contemporary Art: A Sourcebook of Artists' Writings*, pp. 804–16. Berkeley and Los Angeles: University of California Press, 1996.
- Temkin, Ann, and Hamza Walker, eds. Raymond Pettibon: A Reader. Philadelphia: Philadelphia Museum of Art, 1998.
- Word and Meaning: Six Contemporary Chinese Artists. Buffalo: University at Buffalo Art Gallery, 2000. An exhibition catalog.
- Words and #s. Dayton, Ohio: Museum of Contemporary Art, Wright State University, 1991. An exhibition catalog.
- Wye, Deborah. *Thinking Print: Books to Billboards, 1980*–95. New York: Museum of Modern Art, 1996. An exhibition catalog.

Profile: Ken Aptekar

Bryson, Norman. "The Viewer Speaks." Art in America 87, no. 2 (February 1999): pp. 98–101.

Kaplan, Janet. "Ken Aptekar." In "Give and Take Conversations." Art Journal 61, no. 2 (Summer 2002): pp. 71–74.

Sangster, Gary. "Ken Aptekar." In 43rd Biennial of Contemporary American Painting. Washington, D.C.: Corcoran Gallery of Art, 1993, pp. 34–35.

Chapter Seven: Spirituality

Apocalypse: Beauty and Horror in Contemporary Art. London: Royal Academy of Arts, 2000. An exhibition catalog.

Baldessari, John, and Meg Cranston. 100 Artists See God. New York: Independent Curators International, 2004. An exhibition catalog.

Faith: The Impact of Judeo-Christian Religion on Art at the Millennium. Ridgefield, Conn.: Aldrich Museum of Contemporary Art, 2000. An exhibit catalog.

Francis, Richard, ed. Negotiating Rapture: The Power of Art to Transform Lives. Chicago: Museum of Contemporary Art, 1996. An exhibition catalog.

Gablik, Suzi. The Reenchantment of Art. New York: Thames and Hudson, 1991.

Heartney, Eleanor. "Postmodern Heretics." Art in America 85, no. 2 (February 1997): pp. 32-39.

Herbert, Lynn M. "Regarding Spirituality." In art: 21—Art in the Twenty-First Century. New York: Harry N. Abrams, 2001.

Kandinsky, Wassily. Concerning the Spiritual in Art. Translated, with an introduction by M. T. H. Sadler. New York: Dover. 1977.

Kleeblatt, Norman L., ed. *Too Jewish? Challenging Traditional Identities*. New York: Jewish Museum; Brunswick, N.J.: Rutgers University Press, 1996. An exhibition catalog.

Lipsey, Roger. An Art of Our Own: The Spiritual in Twentieth-Century Art. Boston: Shambhala, 1988.

Morgan, Anne. "Beyond Post Modernism: The Spiritual in Contemporary Art." Art Papers 26, no. 1 (January/February 2002): pp. 30–36.

The Spiritual in Art: Abstract Painting, 1890–1985. Los Angeles: Los Angeles County Museum of Art; New York: Abbeville Press, 1986. An exhibition catalog.

Profile: José Bedia

Bettelheim, Judith. "Palo Monte Mayombe and Its Influence on Cuban Contemporary Art." African Arts 34, no. 2 (Summer 2001): pp. 36–49, 94–5.

Gaché, Sherry. "José Bedia: Only the Most Valuable Things." Sculpture 18, no. 5 (June 1999): pp. 42–49.

José Bedia: La Isla—el Cazadcor y la Presa (The Island—the Hunter and the Prey). Santa Fe: SITE Santa Fe, 1997.

Lindsay, Arturo, ed. Santería Aesthetics in Contemporary Latin American Art. Washington, D.C., and London: Smithsonian Institution Press, 1996.

Mosquera, Gerardo. "Juan Francisco Elso: Sacralisation and the 'Other' Postmodernity in New Cuban Art." Third Text 41 (Winter 1997–98): pp. 74–84.

Sullivan, Edward. "Fantastic Voyage: The Latin American Explosion." ARTnews 92, no. 6 (Summer 1993): pp. 134–37.

Thompson, Robert Farris. "Sacred Silhouettes." Art in America 85 (July 1997): pp. 64-71.

Index

Note: Italicized page numbers indicate illustrations. **Boldface** page numbers indicate initial occurrences of terms. References preceded by the word "color" indicate color plates.

"Abject" art, 27				
About Place: Recent Art of the				
Americas (exhibition), 72				
Abramovic, Marina, 205				
The House with the Ocean View,				
42, 52				
Abstract art				
sculpture in, 16				
as self-expression, 23-24				
semiotics and, 23-24				
spirituality in, 203, 208–209				
Abstract Expressionism				
body in, 131				
self-expression in, 23-24, 103				
semiotics and, 23-24				
Acconci, Vito, 77				
Courtyard in the Wind, 77				
Name Calling Chair, 178				
Notes on Language, 178				
Acconci Studio, 77				
ACME Novelty Library (Ware), 180				
ACT UP, 183				
Activist art, 109				
on AIDS, 14				
body in, 138–139				
definition of, 109, 123				
on discrimination, 109–110				
feminist, 26, 109–110				
identity in, 109-110, 123-125				
postcolonial, 26				
spirituality in, 213				
Adam and Eve, story of, 200				
Adams, Dennis, 77				
Advertising, language and, 189,				
197n.32				
Afghanistan				
burkas in, 135				

```
religious art in, 214
  Taliban in, 135, 214
  oral traditions of, language
       translation and, 187
  spiritual art of, 207
African American identity, 111,
       112, 121
Age identity, 108
Aguilar, Laura, 139
AIDS
  art about, 14, 142, 183, 184
  and body, mortality of, 141
Aldrich Museum of Contemporary Art
       (Ridgefield, Connecticut), 204
Ali, Laylah, 27, 37
Alice and Job (Tolle), 65
Alphabetic writing, 163, 174
Altar to Elvis (Goodman), 218, 219
Altars, 204, 221, 223
Alterity, 107
Amacher, Marvanne, 80
Amer, Ghada, 148, 149
  Love Grave, 178, 179
American Diary: October 16, 1942
       (Shimomura), 60
American Federation of Arts, 171
Anasazi people, 119
Anderson, Laurie, 176
Anderson, Walter Truett, 112
Animals, 125, 207
Anime, 27
Al-Anni, Jananne, 159n.35
Annunciation (Marden), 203
Antimonuments, 62
Antonakos, Stephen, The Blue Line
       Room, 208
```

```
Antoni, Janine
  body in works of, 137-138
  Eureka, 137
  Gnaw, 137
  Slumber, 137, 138
  spirituality in works of, 203
  To Draw a Line, 137-138, color-10
Aphorisms, 185
Apocalypse (exhibition), 199-200
Apollinaire, Guillaume, 163-164
Applebroog, Ida, 37, 93
Appropriation artists, 23, 31n.20, 39
Aptekar, Ken, 192-195
  Dad is showing me how to develop,
       192-193, color-14
  language in works of, 173, 192-195
  Pink Frick, 192, 193, 194
  spirituality in works of, 215
Araeen, Rasheed, 118
Arbus, Diane, 15
Architecture
  art tied to, 75
  liquid, 89
  of museums and galleries, 12, 76
Aries, Philippe, 91
Ark (Locke), 95
Art and Text (journal), 171
Art history
  body in, 131-133
  identity in, 106-107
  language in, 162-166
  overview of, 12-14
  place in, 72-77
  spirituality in, 201-204
  time in, 35-45
  timeline of, 227-234
Art Institute of Chicago, 72, 186
```

Art Journal, 171, 225n.13 The Art of Memory/The Loss of History (exhibition), 50 Artangel, 13 The Artifact Piece (Luna), 108, 109 Artificial bodies, 150-152 Artificial Nature (exhibition), 72 Artificial places, 84–89 Artist/Author: Contemporary Artists' Books (exhibition), 171 Artists of the Book: 1988 (exhibition), 171 Asia/America: Identities in Contemporary Asian American Art (exhibition), 105 Asia Society Galleries (New York), 105 Asian languages, written, 163, 187 At the End of the Day (Doherty), 56 Atheism, 210 Athey, Ron, 142, 205 Atmosphere (Bleckner), 216 Atmospheric perspective, in representations of place, 73 Austin, Alice, 65 Authority, language of, 185 AUTO-SCOPE (Baranowsky), 89-90 Azulejo, 57

Baby Fat (Pondick), 142, 143 Baca, Judy, The Great Wall of Los Angeles, 56-57 Bacon, Francis, 14, 106, 204-205 Bad Girls (exhibition), 105 Bahktin, Mikhail, 140 Bailey, Xenobia, Sistah Paradis Great Wall of Fire Revival Tent, 210, 211 Baker, Elizabeth, 56 Baldessari, John, 174 Banes, Sally, 141 Baranowsky, Heike, AUTO-SCOPE, 89-90 Barney, Matthew Cremaster 3, 117, 141, color-11 gaze and, 146 gender identity in works of, 117 Barth, Uta, 95 Barthes, Roland, 25, 107, 172, 194 Baselitz, Georg, 19, 133 Basquiat, Jean Michel, 184, 196n.27 Bates, David, 78 Bates, Sara, 205 Battery Park City (New York), 63 Baudrillard, Jean, 22, 23, 63, 168 Baumgarten, Lothar, 188 Baxter, Glen, 27 "Be-Lie-Ve" (Gerlovina and Gerlovin), 173 Bearden, Romare, 131 Beaubourg effect, 23, 31n.19 Beauty, of bodies, 139-142

Beauvoir, Simone de, 134

Beckmann, Max, 202, 204-205

Bedia, José, 221-223 Las Cosas Que Me Arrastan (The Things That Drag Me Along), 223, 224 Mira, Mamita, Estoy Arriba, Arriba, 222, 222-223 religious influences on, 214, 221-223 spirituality in works of, 221–223 Bedroom, privacy of, 93 Beecroft, Vanessa, Show, 140 Being and Having series (Opie), 116, 117 Benezra, Neal, 61, 62 Benjamin, Walter, 53 Bennet, Mark, 88-89 Bennett, Gordon, Notes to Basquiat, 188, 196n.27 Berger, John, 145, 195n.2 Bergson, Henri, 39 Berlind, Robert, 78 Bernstein, Charles, 191 Bertola, Carla, 164 Better Get Your Ass Some Protection (Ruscha), 178 Better Homes Better Gardens (Marshall), 73-74, 74 Beuys, Joseph, 14, 205 The End of the Twentieth Century, 26 Bhabha, Homi, 20, 26-27, 95, 111 Biblical stories, 199, 200 Bibliography, 241–246 La Bicicleta (Osorio), 105, 105-106 Bickerton, Ashley, 27, 168 Biennials, international, 20-22 Billboards, 29, 29 Binary code, 18 Binary pairs poststructural critique of, 25 sexual bodies and, 146 Binaural sound, 97 Biokinetic (exhibition), 87 Biotechnology, in posthuman bodies, 150 - 152Black identity, 111, 112, 121 Black Kites (Orozco), 216, 216-217 Black Male: Representations of Masculinity in Contemporary American Art (exhibition), 105 Black-paper silhouettes, 57 Blackwell, Josh, 65 Blake, William, 179 Bleckner, Ross, Atmosphere, 216 "The Blue Hour, New York City, 1982" (Meyerowitz), color-4 The Blue Line Room (Antonakos), 208 Body(ies), 129-157 in art history, 131-133 as battleground, 135 beauty of, 139-142 changing views of, 133-139 as cultural artifact, 130-131 diversity of, 139-140 as empty vessel, 129, 131

identity and, 105, 129 gender, 136-137 sexual, 133, 134 language of, 168 mortality of, 141-142 parts of, 140-141 as people, 137-139 posthuman, 150-152 sexuality of, 133, 134, 143-150 as sign, 135-137 soul in, 129 value of, 135-136 Body Art. 131-133 Body language, 168 Boltanski, Christian, 204 A Book from the Sky (Xu Bing), 187 Books art made with, 180-183 made by artists, 179-180 Bookworks, 179-180 Bootleg (Empire) (Gordon), 53 Border art, 119-120 Border Brujo (Gómez-Peña), 120 Born (Smith), 207, 207 Borofsky, Jonathan, 42-43 Bosch, Hieronymous, 86 Boston Athenæum, 171 Bottle of Notes (Oldenburg and Bruggen), 30 Bourgeois, Louise, 14 Bowers, Andrea, 45 Boy with Fish (Simpson), 44 Boyce, Sonia, 25, 118 Bramson, Phyllis, 114-115, 207, 212 Braque, Georges, 27 Breast cancer, 142 Brooklyn Museum, 203 Bruggen, Coosje van, Bottle of Notes, 30 Brunetti, John, 59 Buddhist art, 201 Built places, 79-80, 82-84 Burden, Chris, Other Vietnam Memorial, 62 Buren, Daniel, 77 Burgin, Victor, 49 Burkas, 135. See also Veils Burke, Edmund, 202 Burson, Nancy, 116, 120 Evolution II (Chimpanzee and Man), 120 Butler, Judith, 116 By Any Means Necessary—Nightmare (Tim Rollins + K.O.S.), 183 Byars, James Lee, 208 Byrne, David, 19

Cage, John, 53
Cai Guo-Qiang, 20
Cultural Melting Bath, 20, 21
Calder, Alexander, 42
California Institute of the Arts, 133
Calligraphy, **163**

Campbell, Jim, Untitled (for	Chia, Sandro, 19, 133	Comic books, 180
Heisenberg), 93	Chicago, Judy, 111, 133	boundaries between art and culture
Camptown Ladies (Walker), 57, 58	The Dinner Party, 13, 133	in, 27
Cancer, breast, 142	"Chicken" (Opie), 116, 117	language in, 179, 180, 183
Candyass, 27	Chin, Mel, 82	multi-episodic formats in, 37
Cannibalism, 57	China China	
		Comic strips, multi-episodic formats
Capitalism	calligraphy in, 163	in, 37
consumer, and international art	environmental restoration in, 82	Committed to Print: Social and Politica
market, 20	identity in, 110	Themes in Recent American
feminist/postcolonial critique of, 26	landscape painting in, 72-73	Printed Art (exhibition), 171
Cappellazzo, Amy, 33, 52	multi-episodic formats in, 37	Communications media, and public vs.
Captions, 174	words in art of, 164	private places, 91
Cardiff, Janet, 96–98		
	written language of, 163, 187	Computers. See Digital technologies;
Forty-Part Motet, 96–97	Chirico, Giorgio de, The Soothsayer's	Technology
The Paradise Institute, 97–98,	Recompense, 39	Conceptual Art
98, 99	Chomsky, Noam, 166	language in, 165, 168
Walks of, 96	Christian art	and theory, rise of, 22
Carnegie International Exhibition	figurative imagery in, 143–145	Concert for Anarchy (Horn), 42
(Pittsburgh), 45, 96	formats for, 204–205	Concrete poetry, 164, 178
Carnival, and treatment of body, 140	history of, 201–202	Connor, Maureen, 140
Carson, Fiona, 148		
The state of the s	iconography of, 201	Thinner Than You, 131, 132, 136, 133
Cartier-Bresson, Henri, 15	meanings in, 206–207	Consecrations: The Spiritual in Art in th
Cartography, and spatial	multi-episodic formats in, 37	Time of AIDS (exhibition), 204
representations, 74–75	Christo, Surrounded Islands, 77	Constitution, U.S., 202
Cartoons	Chronology	Construction
boundaries between art and culture	artists' manipulation of, 50–51	of identity, 110–114
in, 27	disadvantages of following, xii–xiii,	of place, 84–89
multi-episodic formats in, 37	0	
	3, 14	of sexuality, 148
Carvajal, Rina, 57	Cinematography, development of,	Consumer capitalism, and internationa
A Case for an Angel II (Gormley), 206	38–39. <i>See also</i> Film	art market, 20
Castle, Wendell, 43	Cities, places in	Consumer culture
Catholicism, 203, 205, 213, 214, 217	private vs. public, 91	beauty of body in, 140
Catlin, George, 122	protection of, 83–84	language in, 168
Cattelan, Maurizio, La Nona Ora (The	representations of built, 79–80	referenced in art, 27
Ninth Hour), 199–200	City Projects—Prague (Weiner), 172	
		Contemporary Triptychs
Cave paintings, 36	Civil rights movement, 19	(exhibition), 205
Cavemanman (Hirschhorn), 88	Cixous, Hélène, 134	Content
CAVS. See Center for Advanced Visual	Class identity, 108	body as, 131
Studies	Claustrophobia (exhibition), 72	vs. form, 11
Celmins, Vija, 78	Clegg, Michael, Open Library,	importance of, 11, 30
Censorship, power over language	182–183	politics as, 14
through, 186	Clemente, Francesco, 19, 106	
Centaurs, 151		spiritual and secular combined in,
	Cloaca (Delvoye), 142	217–220
Center for Advanced Visual Studies	Clocks, 43	Conversation pieces, 164
(CAVS), 42	Close, Chuck, 106	Coplans, John, 141
Centro Cultural de la Raza (San	Clyne, Brian, 64	Corcoran Gallery of Art (Washington,
Diego), 72	Coe, Sue, 93, 184	D.C.), 193–194
Ceremony, in spiritual art, 205	New Bedford Rape, 150	Cork, Richard, 14, 26, 218
Chadors, 118, 153-154, 156-157	Coffey, Susanna, 106	Cornell, Joseph, 86
Chadwick, Helen, 25, 134	Coleman, James, 53	
		Corporal Politics (exhibition), 141
Chagall, Marc, 203	Meanwhile Underneath the Oval	Corps étranger (Hatoum), 142, 144
Champaigne, Phillipe de, The Dead	Office, 59	Corridor (Kalpakjian), 68, 89, 90
Christ, 206	Colescott, Robert, 147	Las Cosas Que Me Arrastan (The
Chandler, John, 45	Knowledge of the Past Is the Key to	Things That Drag Me Along)
Chang, Patty, 149	the Future, 147	(Bedia), 223, 224
Change, and time, representations	Colescott, Warrington, 59	Cottingham, Robert, 165
of, 36		
	Collages	Counter memory, 56
Chaplin, Sarah, 152	as high art, 27	Courtyard in the Wind (Acconci), 77
Chapman, Dinos, 16, 141	language in, 164	Cox, Renée, 118, 149
Great Deeds against the Dead, 59	College Art Association, 171	Coyote, 125, 207
Hell, 199–200	Colonialism. See also Postcolonialism	Craft, Liz, Living Edge, 86
Chapman, Jake, 16, 141	hybridity from, 119–120	Cragg, Tony, 16
Great Deeds against the Dead, 59	language in, 188	_ 00 .
Hell, 199–200		Crary, Jonathan, 18, 22
11611, 199-200	Columbus, Christopher, 122	Creation stories, place in, 80

Cremaster 3 (Barney), 117, 141, color-11 Croak, James, 129 Decentered Skin, 130 Crop (Paine), 5-7, 6, 78 The Crossing (Viola), 205-206 Crowley, David, 197n.32 Cubism language in, 164 representations of time in, 39 Cucchi, Enzo, 19 Cultural Melting Bath (Cai), 20, 21 Cultural Negotiation (Xu Bing), 187 Culture(s) blending of (See Hybridity) boundaries between art and, 27-30 consumer, 27, 140, 168 ideal bodies in, 139 identity defined through, 103-105, 107-108 mass visual, 18-19, 30n.13 place transformed by, 70 pop, timeline of, 227-234 Culture wars, 13, 135, 203 Currin, John, 146 Cut Piece (Ono), 150 Cyborgs, 151 Cystic fibrosis, 142

Dad is showing me how to develop (Aptekar), 192-193, color-14 Daehnke, Nadja, Shop/Site/Shrine, 72 Dali, Salvador, 131, 202 The Persistence of Memory, 39 Damon, Betsy, The Living Water Garden, 82, 82 Davidson, Nancy, 140 Davies, Char, 89 Davis, Stuart, 165 De Kooning, Willem, 131 Deacon, Richard, 16 The Dead Christ (Champaigne), 206 Dean, Tacita, 53 Death, in spiritual art, 215-217 The Decade Show: Frameworks of Identity in the 1980s (exhibition), 104-105 Decentered Skin (Croak), 130 Declaration of Independence Desk: Thomas Jefferson (Tolle), 63 Decoding. See Deconstruction Decoding Advertisements (Williamson), 197n.32 Deconstruction, 24, 167 Degas, Edgar, 38 Deitch, Jeffrey, 84, 150 Déjà vu (Gordon), 54-55, 55 Del Rio, Delores, 217 Deleuze, Gilles, 56 Delvoye, Wim, 185 Cloaca, 142

Demand, Thomas, 87

Demo (Fasnacht), 33-35, 35

Demographics, world, 12

Democracy (Group Material), 186

Der Lauf der Dinge (The Way Things Go) (Fischli and Weiss), 33, 34, 45, 48, 52 Derrida, Jacques on deconstruction, 24 on identity construction, 110 on intertextuality, 25 on multiple interpretations, 24 Desert Cantos series (Misrach), 4, 81 Desire, sexual, 147-149 Deste Foundation for Contemporary Art (Athens), 72 Destruction, in spiritual art, 215-217 Devlin, Lucinda, 217 Dewan, Deepali, 94 Diagramming, in spatial representation, 75 Dialogue (Iwai), 186 Dialogue with Muself (Encounter) (Morimura), 115, 115-116 Diana, princess of Wales, 218 Diasporas definition of, 95 and displacement, 95 postcolonialism on, 25 Difference, 111 in bodies, 139-140 definition of, 111 hybridity and, 119 in identity, 111-114 Digital Landfill (Napier), 191 Digital technologies, 16-19 dissemination of art through, 18 in graphic design, 165 and identity, 120 and language, 189-191 and mass culture, 18-19, 30n.13 and paradigm shifts, 17-18 and photography, 17 and placeless spaces, 89-90 in posthuman bodies, 150–152 trends in, 16-19 The Dinner Party (Chicago), 13, 133 Dion, Mark, 86 Dioramas, as artificial places, 86 Disasters of War series (Goya), 59 Discobolus (The Discus Thrower) (Myron), 38 Discrimination, identity-based, and equal opportunity, 108-110 Displacement, 93-95 Distemper: Dissonant Themes in the Art of the 1990s (exhibition), 50 District Six (Cape Town), 71-72 Dittborn, Eugenio, 95 Diversity of bodies, 139-140 of identities, 111-114, 116-118 international, of artists, 19 D.O.A. (film), 55 Documenta 7 (exhibition), 174 Documentation, 165-166 Dodiva, Atul, 59 Doherty, Willy, 59, 95

At the End of the Day, 56

Dominion (Hamilton), 45 Doniger, Wendy, 210 Don't Look at Me (Oursler), 179 Doom, in spiritual art, 215-217 Doubletake: Collective Memory and Current Art (exhibition), 50 Doubt, in spiritual art, 210-213 Dream Temple (Mori), 199 **Dualities** feminist/postcolonial critique of, 26 poststructural critique of, 25 Duchamp, Marcel, 27, 94, 165 Dumas, Marlene, 126n.19, 148 Dung, elephant, 203, 205 Duration, of time, 53 Durham, Jimmie, 95, 108 Duve, Thierry de, 220 DVD recording technology, 16

Doig, Peter, 78

Earth art locations for, 29 site-specificity of, 76-77 Transcendentalism and, 202 Easy to Remember (Simpson), 175-176 Eckart, Christian, 208 Eco, Umberto, 22 Economy global, and international art market, U.S., impact on art activities, 12 Edelson, Mary Beth, 111 Edgerton, Harold, 38 Edmier, Keith, 62 Eggleston, William, 78 Egypt body as symbol in, 137 multi-episodic formats in, 37 The Eighth Day (Kac), 9 Einstein, Albert, 39 The Special Theory of Relativity, 48-49 Eisenman, Nicole, 116, 150 Eisenman, Peter, 12 El Camino de la Nostalgia (Road of Nostalgia) (Kcho), 94 Elephant dung, 203, 205 Elitism, postmodern critique of, 22, 23 Emerson, Ralph Waldo, 202 Emin, Tracey, Everyone I Have Ever Slept with 1963-1995, 59-60 Emotion place and, 71 time and, 48 Empire (Warhol), 53 The Empire of Lights (Magritte), 39 Enclosed and Enchanted (exhibition), 52 The End of the Twentieth Century (Beuvs), 26 Endlessness, 55-56 English language, alphabetic system of. 163

Entertainment, in boundaries between Figure, human. See Body(ies) A Funny Thing Happened art and culture, 29 (Williams), 150 Film(s) Environment. See also Nature development of techniques in, 38-39 Fusco, Coco, 118 protection and preservation of, 80-82 illusions of movement in, 39, 43 Futurism Epoch (Lovell), 41 time in posthuman bodies in, 151 Equal opportunity, for artists, 108-110 embodiment of, 39, 43-45 representations of time in, 39 Ernst, Max, 179 exhibitions about, 50 Eroticism, 147-149 real, 53 Essentialism, 111, 112 Finley, Karen, 135 Gablik, Suzi, 196n 28, 203 Estes, Richard, 165 Finster, Howard, 164, 208 Gabo, Naum, 42 Ethics, spirituality and, 212-213 Fischl. Eric. 15, 60 Galán, Julio, 51 Ethnic identity, 107-108 Fischli, Peter Galleries Eureka (Antoni), 137 Der Lauf der Dinge, 33, 34, 45, architecture of, 76 Eureka (Tolle), 64 artists' careers impacted by, 12 Everyone I Have Ever Slept with Room at the Hardturmstrasse, 88 video presentations in, 43 1963-1995 (Emin), 59-60 Flag, U.S., 186 Gandhi, Mohandas, 59 Evolution II (Chimpanzee and Man) Flanagan, Bob, 142 Ganson, Arthur, 43 Flaneur, 91 (Burson), 120 Garnier, Pierre, 164 Ex Voto (Self-Portrait with the Virgin Flashbacks, in video, 50-51 Gauguin, Paul, 146 of Guadalupe) (Zenil), 214 Flipbooks, 43 Gay artists, 19. See also Homosexuality Exhibitions Fluxus, 133 Gaze, 25, 145-146 about identity, 104-105 Fogle, Douglas, 49, 56, 59 definition of, 25, 145 about language, 161, 171 Foreign languages, 177 feminist analysis of, 25, 145, 146 about place, 72 translation of, 186-189 mortality and, 142 about spirituality, 199, 203, 204 A Forest of Signs: Art in the Crisis of sexual identity and, 117, 118 about time, 50 Representation (exhibition), 171 sexuality and, 145-146 Expressionism. See Abstract Form(s) voveurism of, 145-146 Expressionism: Neobody as, 131 Geerlinks, Margi, 151 Gehry, Frank, 12 Expressionism vs. content. 11 and meaning, 4 Gender identity, 107 and spirituality, 204-206 body and, 136-137 Faith, 210 Formalism, 11 sexual identity and, 116-118 in spiritual art, 210-213 limitations of, 11 Gender Trouble (Butler), 116 Faith: The Impact of Judeo-Christian place of art works and, 76 General Idea, 161, 184 Religion on Art at the Forty-Part Motet (Cardiff), 96-97 Gennep, Arnold van, 206 Millennium (exhibition), Foucault, Michel Gentileschi, Artemisia, 149 204, 210 on counter memory, 56 Geography = War (Jaar), 82–83, 83 Gerlovin, Valeriv, 173 Fantasy places, 84, 86 on gaze, 145 Farrow, Clare, 205 on identity construction, 110 "Be-Lie-Ve." 173 Fasnacht, Heide, 34-35 on language, power of, 185 Gerlovina, Rimma, 173 Demo, 33-35, 35 on multiple histories, 50 "Be-Lie-Ve," 173 Favela in Battery Park City: on socialization of space, 91–92 Germany, handwriting in, 163 Inside/Outside (Kawamata), 84 Found materials Ghazel, 159n.35 Feminism, 25-26 books as, 181 Giacometti, Alberto, 131 activist agenda of, 26, 109-110 and boundaries between art and The Palace at 4 A.M., 39 Gilardi, Piero, 86-87 backlash against, 26 culture, 27 and body, 133, 134, 138-139 in representations of time, 39-40 Inverosimile, 87 and eroticism, 148-149 Fraktur, 163 Gilbert and George, 42 on gaze, 25, 145, 146 Frampton, Kenneth, 209 Giuliani, Rudolph, 203, 205 and identity, 109-110, 111 Francis of Assisi, Saint, 205 Give and Take (exhibition), 194 on language, 167-168, 169 Frank, Robert, 15 Global positioning systems (GPS), 75 on patriarchy, 25 Frankfurter Kunstverein, 171 Gnaw (Antoni), 137 prominent thinkers in, 31n.23 Freilicher, Jane, 78 Gober, Robert theoretical influences on, 25-26, 167 Freud, Lucian, 106 body parts in works of, 141 and violence against women, Freud, Sigmund, 39 sexual identity and, 116 149-150 Fried, Nancy, 142 spirituality in works of, 203, 210-212 Feminist Art Program (California Friedman, Dan, 84 technique of, 16 Untitled, 210-212, 212, 213 Institute of the Arts), 133 Friedrich, Caspar David, 86 Fendrich, Laurie, 24 La Frontera/The Border: Art about the Goffman, Erving, 91 Feodorov, John Mexico/United States Border Gogh, Vincent van, 106, 192 The Office Shaman, 215 Experience (exhibition), 72 Starry Night, 200 Totem Teddies, 215 Frueh, Joanna, 139 Gold, in spiritual art, 205 Ferris, Alison, 136 Fuller, Peter, 158n.16 Goldberg, Vicki, 44 Golden, Thelma, 121, 183 Fervor (Neshat), 154, 156, 157 Fulton, Hamish, 168

Funding. See Public funding

Goldin, Nan, 15, 116

Fiennes, Ralph, 57

Goldsmith, Kenneth, 164 Gursky, Andreas Hirshhorn Museum and Sculpture Goldsworthy, Andy, 77 places in works of Garden (Washington, D.C.), 50 Gómez-Peña, Guillermo artificial, 84 Hirst Damien 207 body in works of, 140 people in, 80 Historical Portraits series "Shanghai," color-7 Border Brujo, 120 (Sherman), 115 place in works of, 95 Gutenberg, Johannes, 189 History, world. See also Art history syncretism and, 119-120 Guttmann, Martin, Oven Library, multiple versions of, 49-50 Gomringer, Eugen, 164 182-183 overview of 11-12 Gone with the Wind (Mitchell), 57 and place, 70, 71 Gonzalez-Torres, Felix representations of, changing views of AIDS and 141 Habitat displays, 86 past and, 49-50 billboards of, 29 Halley, Peter, 24 revisiting, 56-60 Hamilton, Ann place in works of, 95 timeline of, 227-234 spirituality in works of, 206 Dominion 45 truth in, 49 Untitled (Perfect Lovers), 43 mutable materials used by, 45 The History of Her Life Written across Goodman, Elavne, 217-218 Offerings, 45, 46 Her Face (Humphrey), 161 Altar to Elvis, 218, 219 place in works of, 77 History painting, 37-38 Goodman, Ionathan, 188-189 spiritual art of, 205 Hitchcock, Alfred, 54 Gordon, Douglas Hammons, David, 110 Hockney, David 24 Hour Psycho, 54, 54 Handwriting, 163, 174 The Scrabble Game, 52-53 Bootleg (Empire), 53 Hansen, Mark, Listening Post, 9 space in works of, 74 Déjà vu, 54-55, 55 Haring, Keith, 14, 184 time in works of, 52-53 time in works of, 53-55 Harmony, vs. duration, 53 Hodge, Roger, 117 Gormley, Anthony, A Case for an Harn Museum (Gainesville, Hollander, John, 164 Angel II. 206 Florida), 208 Holt, Nancy, 76 Gova, Francisco, Disasters of War Harnett, William, 164 The Holy Virgin Mary (Ofili), 203, 205 series, 59 Harriman, Job. 65 Holzer, Jenny GPS. See Global positioning systems Harris, Lyle Ashton Inflammatory Essays, 185 Graffiti art. 184 identity in works of, 112, 116, 146 language in works of, 29, 161, Graham, Robert, 139 "Memoirs of Hadrian #26," 183, 185 Graham, Rodney, Vexation Island, 112-114, 113 The Survival Series, 29 Harrison, Helen, 81 55-56 Truisms, 185 Gran Furv. 14, 183, 213 Harrison, Newton, 81 Home, privacy of, 91, 93 Grandfather clocks, 43 Harten, Doreet LeVitte, 210 Homosexuality Granet, Ilona, 168 Hatoum, Mona AIDS and, 14 Graphic design, language in, 165 body in works of, 142 Graves, Morris, 165 Corps étranger, 142, 144 as challenge, 145 Grav, Alex, 208 place in works of, 95 controversy over, 13 Gray, Spalding, Swimming to Present Tense, 75 in identity, 107-108 Cambodia, 170 sexual identity in works of, 118 visibility of, 19 Great Deeds against the Dead visibility of, 19 Hooks, bell, 111, 112, 118 (Chapman and Chapman), 59 Hawkinson, Tim, 43 Horn, Rebecca Hayward Gallery (London), 50 The Great Wall of Los Angeles (Baca), Concert for Anarchy, 42 56-57 Heap of Birds, Hachivi Edgar, 108, 188 Painting Machine, 150 Greeks, ancient, figurative art House (Whiteread), 13 Heartney, Eleanor, 81, 203, 217 of, 139 Hell (Chapman and Chapman), The House with the Ocean View Greenberg, Clement, 11 199-200 (Abramovic), 42, 52 Greiman, April, 165 Hen with Chicks Fantasy Coffin Houshiary, Shirazeh, 208-209 Griffin, Kojo, 37 Turning around the Centre, 209, 209 (Kwei), 218 Grigely, Joseph, 189 Henry Art Gallery (Seattle), 72 Hsieh, Tehching, 42, 139, 205 White Noise, 190 Herbert, Lynn, 215 Hudson River School, 73 Griswold, Charles, 61 Heridas de la Lengua (Wounds of the Hughes, Holly, 116 Groeneveld, Dirk, 191 Human figure. See Body(ies) Tongue) (Ocampo), 214 Grotesque body, 140, 141-142 Humor Heroin, 5-6 Group identity, 107-108, 111 Hieroglyphic writing, 163 in body, treatment of, 140 Group Material, 183 High art language and, 184-185 Democracy, 186 boundaries between low art and, 27 Humphrey, Margo, The History of Her Gu, Wenda, 19, 187 photography as, 15 Life Written across Her Face, 161 Guerrero, M. A. Jaimes, 118 Hillwood Art Gallery (Long Island), 171 Hung Liu Guerrilla Girls, 109-110, 183, 184 Hindu art, 143, 201 body in works of, 140 difference in works of, 114 Guggenheim Museum (Bilbao, Hiroshima Project (Wodiczko), 62 Hirsch, Faye, 80-81 Spain), 12 Judgment of Paris, 114, color-9 Guggenheim Museum (New York), 140

Hirschhorn, Thomas, Cavemanman, 88

place in works of, 95

Knots + Surfaces, Version #1 (Thater),

color-6

Huyssen, Andreas, 61 Jobling, Paul, 197n.32 Index, 40 Hybridity, 25 Johanson, Patricia, 82 Indiana, Robert, 165, 184 causes of, 119-120 John Wilkes Booth (Rosen), 176 Indianapolis Museum of Art, 178 definition of, 25, 119 Johnson, Larry, "Untitled (5 Buck Inflammatory Essays (Holzer), 185 Word)", 173 of human bodies and technology, 151 Infoglut (Rath), 151, 152 and identity, 118-120 Joke paintings, 184-185 Innerst, Mark, 78 postcolonialism on, 25 Jones, Amelia, 142 Installation art poststructuralism on, 25 Journals, 171 documentation of, 166 in religion, 214 Journeys, 221 painting overlapping with, 15 syncretism and, 119 Joyce, James, 39 place in, 77 Judgment of Paris (Hung Liu), 114, Hyperrealism, 63 site-specificity of, 77 color-9 spirituality in, 205-206 July, Miranda, 170 time embodied in, 40 I Am Not Tragically Colored The Swan Tool, 170, 170 Institute of Contemporary Art (Ligon), 184 (Boston), 50 Iconography, 5 Institutions in religious art, 201, 207 Kabakov, Ilya, 19, 77 artist critiques of, 13-14 Identity(ies), 103–126 Kac, Eduardo, The Eighth Day, 9 and public vs. private places, 93 in Abstract Expressionism, 103 Interconnectivity, 191 Kahlo, Frida, 106, 116, 131, 217 in art history, 106-107 Kalpakjian, Craig, Corridor, 68, 89, 90 International art market, 20-22 biology of, 110, 111 Kamps, Toby, 15, 86 International diversity, of artists, 19-20 body and, 105, 129, 133, 134, 136-137 Kandinsky, Wassily, 203 and language translation, 187 changing views of, 106-107, 110 Kapoor, Anish, 16, 208 Internationalism, new, 126-127n.19 communal/relational, 103-104, Internet. See Digital technologies Marsuas, 9, 10 107-110 Kass, Deborah, 215 Interpretations, multiple, xii, 4, 24. See construction of, 110-114 Katz, Alex, 106 also Meanings cultural, 103-105, 107-108 Kawamata, Tadashi, 77 Intertextuality, 25 declining interest in, 121 Favela in Battery Park City: Inverosimile (Gilardi), 87 difference and, 111-114 Iranian Revolution (1979), 153 Inside/Outside, 84 discrimination based on, 108-110 Kawara, On, 52 Irigary, Luce, 134 diversity of, 111-114, 116-118 Kcho (Alexis Leyva Machado), 94 Irish Hunger Memorial (Tolle), 63-64, exhibitions on, 104–105 El Camino de la Nostalgia (Road of color-5 group, 107-108, 111 Nostalgia), 94 Irony hybridity and, 118-120 Kelley, Mike, 27, 40, 129 identity and, 116 individual, 103, 107 Kelly, Mary, 134, 148 language and, 173, 184-185 Kentridge, William, 19, 45 malleability of, 114-116 Irwin, Robert, 77 multiple, 111-112 Kepes, Gyorgy, 42 Is Poetry a Visual Art? (exhibition), 171 politics of, 108-110 Khomeini, Ruhollah, 153 Islamic art reinvention of, 116, 120-121 Kids of Survival. See K.O.S. calligraphy in, 163 religious, 108, 213-215 Kiefer, Anselm figurative imagery in, 131, 163 Ikon Gallery (Birmingham, books made by, 179 history of, 201 England), 72 Itagaki, Yoshio, "Tourists on the Moon history in works of, 56 Illinois State University, 87 influence of, 15 #2." 17. 17. 88 Illnesses, art about, 142. See also AIDS place in works of, 70 Iwai, Shigeaki, Dialogue, 186 Illuminated manuscripts, 164 on spirituality, 204 visibility of, 19 Illusions of movement, time embodied in, 43 Jaar, Alfredo, 19 Kienholz, Ed, 73 The Rhinestone Beaver Peep of space Geography = War, 82-83, 83place represented in, 73 Jalaluddin Rumi, 205 Show, 146 time represented in, 37, 66n.4 Kienholz, Nancy, 73 James, Henry, 180 Immendorff, Jorg, 133 Jameson, Fredric, 167 The Rhinestone Beaver Peep Immersion environments, 89 Janowich, Ron, 208 Show, 146 Immigrant artists, 19, 20, 95 Jantjes, Gavin, 119, 126-127n.19, 161 Kinetic art, 42-43 Immigration Japan, comic and cartoon formats in, 27 embodiment of time in, 36, 42-43 displacement and, 95 Jeanne-Claude, Surrounded Islands, 77 history of, 42 hybridity from, 119-120 Jencks, Charles, 22 King, Ynestra, 139 Impressionism **Jewish** art Kinsey, Alfred C., 134 landscape painting in, 73 exhibitions on, 105, 215 Kitchen (Lou), 84, color-8 representations of time in, 38 figurative imagery in, 131 The Kitchen (New York), 171 "In the Garden (Karin in Grass)" Kitchen Table Series (Weems), 103, 104 history of, 201 (Schorr), 136, 136-137 Jewish Museum (New York), 50, Kitsch, 22, 23, 31n.18

105, 215

Jin Weihong, 110

Independent Curators Incorporated, 171

Independent Curators International, 204

Knowledge: Aspects of Conceptual Art (exhibition), 171 Knowledge of the Past Is the Key to the Future (Colescott), 147 Koch, Stephen, 14 Kollwitz, Käthe, 131 Komar, Vitaly, 19, 23, 56 Koons, Jeff body in works of, 129 Rabbit, 27, 28 spirituality in works of, 207, 217 Ushering in Banality, 217 Kopystiansky, Svetlana, 186 K.O.S. (Kids of Survival), 183 Kostelanetz, Richard, 164 Krauss, Rosalind, 48 Kristeva, Julia, 22, 134 Kruger, Barbara on bodies, 134, 135, 140 exhibition curated by, 171 identity in works of, 110 language in works of, 161, 185 poststructuralism and, 25 on violence against women, 150 Kuitca, Guillermo, 15 San Juan de la Cruz, 93 Terminal, 55 Kundera, Milan, 53 Kuspit, Donald, 123 Kwei, Kane, 217 Hen with Chicks Fantasy Coffin, 218

Labyrinths, 205 Lachowitz, Rachel, 24 Lacy, Suzanne, 138-139 Ladda, Justen, Romeo and Juliet, 82 Laib, Wolfgang, 205 Lam, Wildredo, 214 Land art. See Earth art Landscape painting, history of, 72–73 Language(s), 161-195 in art history, 162-166 about art vs. in art, 161 in books, 179-183 exhibitions on, 161, 171 form of, 174-183 in information age, 189-191 meaning and, 166, 167-168, 171-174 of place, 70-71 in poetry, 163-164 power of, 183-186, 187-188 reasons for using, 168-171 spoken, 174-179 structure of, 166-167, 173 theories of, 161-162, 166-168 of thoughts, 174 of time, 45-46 time taken by, 170 translation of, 186-189 written forms of, 174-183 history of, 162-164 Lantern slide shows, 43

Laqueur, Thomas, 135

Lawler, Louise, 185 Lawrence, Jacob, 111 Lederman, Stephanie Brody, Setting the Table for Romance, 172 The Legible City (Shaw), 189-191 Leibowitz, Cary, 215 Leonard, Zoe (Untitled), 146 Strange Fruit (for David), 216 Leonardo da Vinci, 42 Lesbian artists, 19. See also Homosexuality Lessing, Gotthold, 195n.7 Letinsky, Laura, 148 Lévi-Strauss, Claude, 195n.9 Levine, Sherrie, 23 Lewitt, Sol, 165 The Library (Wu Mali), 168 Lichtenstein, Roy, 14, 165 Light, in spiritual art, 208 Ligon, Glenn, 161 I Am Not Tragically Colored, 184 Liminal state, 206 Lin, Maya, Vietnam Veterans Memorial, 13, 61, 67n.30 Linear conceptions of time, 35, 36, 37, 46-47 Linear perspective in representations of place, 73, 86 in representations of time, 37 Linguistics, 166. See also Language Linker, Kate, 134 Lippard, Lucy, 45, 104, 108, 112, 147 Liquid architecture, 89 Listening Post (Hansen and Rubin), 9 Live art, embodiment of time in, 42 Live Oaks Friends Meeting House (Houston), 208 Living Edge (Craft), 86 The Living Water Garden (Damon), 82,82 Livre d'artiste, 179-180 Llano del Rio, 65 Lobe, Robert, 78 Locke, Hew, Ark, 95 London, public art in, 13 Long, Richard, 168 Planes of Vision, 168 Looping video, 55-56 Los Angeles County Museum of Art, 203 Lost (Prendergrast), 75 Lou, Liza, 84 Kitchen, 84, color-8 Love Grave (Amer), 178, 179 Lovell, Whitfield, 40 Epoch, 41 Low art, boundaries between high art and, 27 Lowe, Truman, Red Banks, 80, 81 Lucier, Mary, Wilderness, 51

Luhring Augustine Gallery (New

The Artifact Piece, 108, 109

York), 137

Luna, James, 108, 140

Lymphoma, 142 Lyotard, Jean-François, 22

Machado, Alexis Leyva. See Kcho Machida, Margo, 214 Magiciens de la Terre (Magicians of the Earth) (exhibition), 204 Magritte, René, 188 The Empire of Lights, 39 L'usage de la parole I (The Use of Words I), 196n.28 Making Time: Considering Time as a Material in Contemporary Video and Film (exhibition), 50 Malcolm X, 183 Malik, Rohini, 119 Manga comics, 27 Manglano-Ovalle, Inigo, Nocturne (tulipa obscura), 52 Manson, Charles, 180 Map(s), in representations of space, 74-75, 100n.5 Mapping the Studio (Fat Chance John Cage) (Nauman), 91 Mapplethorpe, Robert, 13, 117, 135 Marcaccio, Fabian, 15 Marclay, Christian, 188 Mixed Reviews, 188 Video Quartet, 19 Marden, Brice, Annunciation, 203 Marey, Etienne-Jules, 39 Mariani, Carlo Maria, 139 Market, art, international, 20-22 Marshall, Kerry James, 111 Better Homes Better Gardens, 73-74, 74 Marsyas (Kapoor), 9, 10 Martin, Agnes, 208 Marxism, 26 Maryland Historical Society, 185 Masaccio, 200 The Tribute Money, 37 Masks, Native American, time embodied in, 41, 42 Matee, Rudolph, 55 Materials and meaning, 4 mutable, in process art, 45 in sculpture, 16 in spiritual art, 205-206 Matisse, Henri, 131 Maus (Spiegelman), 183 McCarthy, Paul, Santa Claus, 116 McDonald, Helen, 146 McEvilley, Thomas, 129 McGee, Barry, 184 Meanings flexibility of, xii, 4 form and, 4 language and, 166, 167-168, 171-174 materials and, 4 of places, 69-71 of spirituality, 206-210 techniques and, 4

Meanwhile . . . Underneath the Oval Misrach, Richard, Desert Cantos series Museum für Moderne Kunst Office (Coleman), 59 by, 4, 81 (Bozen), 171 Meatyard, Ralph Eugene, 15 "Outdoor Dining, Bonneville Salt Museum of Contemporary Art Media, mass Flats, Utah" in, 4, 5, 6-7 (Chicago), 204 dissemination of art through, Miss, Mary, 77 Museum of Contemporary Art 18 - 19MIT List Visual Arts Center, 141 (Los Angeles), 171 poststructural critique of, 25 Mixed Blessings: New Art in a Museum of Contemporary Art (San uniformity of imagery in, 18-19, 49 Multicultural America Diego), 72 Media disciplines, 14-19 (Lippard), 104 Museum of Contemporary Hispanic multiple, artists engaging in, 16 Mixed Reviews (Marclay), 188 Art (New York), 104-105 organization of study by, xi Mobility Museum of Contemporary Religious trends in, 14-19 and displacement, 93-95 Art (St. Louis), 204 variety of, xii, 9-10 and identity, 120 Museum of Man (San Diego), 108 Mehretu, Julie, 74, 75 and language translation, 187 Museum of Modern Art (New York), Melamid, Aleksandr, 19, 23, 56 Modernism, place in, 73, 99n.2 50, 161, 171 Memento mori, 48 Moholy-Nagy, Laszlo, 42 Museum of Modern Art (Oxford, "Memoirs of Hadrian #26" (Harris), Mondrian, Piet, 24 England), 52 112-114, 113 Monet, Claude, 38, 62 Music Memorials, 60-62 Monk, Meredith, 97 duration in, 53 Montano, Linda, 42, 139, 205 Memory translation into language, 188 of art, reshuffling past and, 58-59 Monuments, 60-62 Mutable materials, in process art, 45 counter, 56 as records of events, 36 Muybridge, Eadweard, 39 historical, forms of conveying, time and, 60-62 Myron, Discobolus (The Discus 56, 57 Moods, time and, 48 Thrower), 38 in information age, 61 Moore, Frank, 80-81, 86 Mysticism, 201 place and, 70 Wizard, 217 standardization of, 49 Moore, Henry, 131 time and, 48, 49 Morality, spirituality and, 212-213 Name Calling Chair (Acconci), 178 Men, bodies of, objectification of, 146 Morgan, Anne, 206, 208 Naming Mendieta, Ana, 214 Mori, Mariko of places, 71 Mercer, Kobena, 118 Dream Temple, 199 power of, 187-188 Mesa-Bains, Amalia, 204, 217, 218 "Miko no Inori (Last Departure)," Napier, Mark, Digital Landfill, 191 Mestizaje, 214 151-152 Nara, Yoshitomo, 27 "Metalwork, 1723-1880" (Wilson), 185 placeless spaces of, 89 Narrative art Metaphor, language as, 171, 172 posthuman body in works of, film and video as, 44-45 Metonym, 137 151-152 language in, 171, 173 Meyerowitz, Joel, 62, 78 spirituality in works of, 199 multi-episodic format in, 37 "The Blue Hour, New York City, visibility of, 19 paintings as, 37-38 1982," color-4 Morimura, Yasumasa time in, 36-38, 44-45 "New York City, 1989," color-3 Dialogue with Myself (Encounter), Nash, David, 76 Meyers, B. E., 118 115, 115-116 National Endowment for the Arts Michals, Duane, 169, 173 identity in works of, 115-116 (NEA), 13, 203 "Necessary Things for Writing Fairy visibility of, 19 Native Americans Tunes," 169 Morse code, 174 identity of, 108, 122-125 Michelangelo, 75, 200 Mortality, of bodies, 141-142 languages of, 188 Michigan State University, 136 Motion (movement) spirituality of, 215 Microsoft PowerPoint software, 19 in embodiment of time, 40-45 time embodied in art of, 41 Mields, Rune, 174 in representations of time, 36, "Miko no Inori (Last Departure)" 38-39 in earth art, 76-77 (Mori), 151-152 Movements, classifying art into, xii-xiii vs. humans, 4 Millennium, and spirituality in art, 204 Mudimbe, Valentin Y., 187 pantheistic view of, 80 Miller, George Bures, 96, 98 Mullican, Matt, 168 protection and preservation of, 80-82 The Paradise Institute, 97–98, 98, 99 Mullins, Aimee, 141 as sacred, 80 Minh-ha, Trin T., 118 Multi-episodic formats, 37 in spiritual art, 205 Minimalism, 16 Multiculturalism, 112 in Transcendentalism, 202 Mining the Museum (Wilson), 185 declining interest in, 121 veneration of, as sublime, 202 Minorities and gaze, 146 Nature's Detail (Paha), 87 in history, 49-50 vs. internationalism, 126–127n.19 Nauman, Bruce, 53, 141 identity of, 107-108 Mulvey, Laura, 145 Mapping the Studio (Fat Chance participation in and influence on art Muñoz, Juan, 129 John Cage), 91 One Hundred Live and Die, 210 bv. 19 Murakami, Takashi, 27 Mira, Mamita, Estoy Arriba, Arriba Murphy, Gerald, 165 Navajo sand paintings, 41 (Bedia), 222, 222-223 Museum(s). See also specific museums The Nazis (Uklanski), 57 Mirroring Evil: Nazi Imagery / Recent NEA. See National Endowment for architecture of, 12

habitat displays in, 86

the Arts

Art (exhibition), 50

Ofili, Chris

The Holy Virgin Mary, 203, 205

spirituality in works of, 203, 217

The Paradise Institute (Cardiff and "Necessary Things for Writing Fairy Ohio State University, 12, 187 Tunes" (Michals), 169 Miller), 97-98, 98, 99 Oldenburg, Claes, Bottle of Notes, 30 Parkett (journal), 171 Negotiating Rapture (exhibition), 204 Older artists, 14 Neo-Expressionism 100 artists see God (exhibition), 204 Past. See also Time changing views of, 49-50 body in, 133-134 One Hundred Live and Die critics of, 15 (Nauman), 210 commemoration of, 60-62 historical past in, 56 Ono, Yoko, Cut Piece, 150 revisiting historical, 56–60 paintings in, 15 Pastiche, 23, 58 Opacity, 177 rise of, 12, 15 Open Library (Clegg and Guttmann), "Pathetic" art, 27 time as narrative in, 38 182 - 183Patriarchy, 25 Opie, Catherine, 116, 146 Patterning, in spiritual art, 208 U.S. attention to, 19 U.S. economy and, 12 Being and Having series, "Chicken" Pauline, Mark, 43 Nerdrum, Odd, 206 Peirce, Charles Sanders, 23, 195n.9 in, 116, 117 Neshat, Shirin, 153-157 Opportunity, equal, for artists, 108–110 Performance art, 42 body in, 133, 158n.6 body in works of, 140, 153-157 Orlan, 150 Fervor, 154, 156, 157 Orozco, Gabriel, 76 definition of, 42 Rapture, 154, 156 Black Kites, 216, 216-217 feminist, 133 religion in works of, 215 history of, 42 Osaka, Eriko, 186 sexual identity in works of, 118 Osorio, Pepón, 204 language in, 169-170 Turbulent, 154-156 La Bicicleta, 105, 105-106 spirituality in, 205-206 visibility of, 19, 154 "Other," 26, 112 time embodied in, 42-43 Women of Allah series, 154 "Permian Land" (Sugimoto), 86, 87 Other Vietnam Memorial (Burden), 62 The Persistence of Memory (Dali), 39 "Rebellious silence" in, 154, 155 Ouattara, 177 Netta, Irene, 43 Oursler, Tony, 178-179 Perverted by Language (exhibition), 171 Neue Galerie (Kassel, Germany), 146 Don't Look at Me, 179 Pettibon, Raymond, 27, 180 Tripping Corpse, 180 Out of Site: Fictional Architectural Nevelson, Louise, 14 New Bedford Rape (Coe), 150 Spaces (exhibition), 52 Untitled, 181 New Histories, 1996-97 (exhibition), 50 "Outdoor Dining, Bonneville Salt Flats, Phaophanit, Vong, 177 New Museum (New York), 72 Utah" (Misrach), 4, 5, 6-7 Untitled, color-13 New Museum of Contemporary Art Owens, Craig, 65, 134 Philadelphia (Tolle), 63 (New York), 104, 105 Philbrick, Harry, 210 New Museum of Modern Art (New Photo-realism, language in, 165 York), 50 Paha, Michael, Nature's Detail, 87 Photo text text photo (exhibition), 171 New York City, shifts in art activities Pahlsson, Sven, 89 Photoglyphs, 173 Paik, Nam June, 16, 43, 52 Photography "New York City, 1989" (Meyerowitz), Paine, Roxy of artificial places, 87-88 color-3 Crop, 5-7, 6, 78 darkroom manipulations in, Newman, Barnett, 203 Painter Dipper, 42 Nietzsche, Friedrich, 202 SCUMAK (Auto Sculpture Maker), documentation with, 165-166 Noble, Paul, 84 42, 150 as high art, 15 Nobspital, 85 site-specific art of, 76 identity in, malleability of, Nobspital (Noble), 85 Painter Dipper (Paine), 42 115-116 influence on other arts, 15 Nocturne (tulipa obscura) Painting(s) (Manglano-Ovalle), 52 abstract, 23-24 and place of art works, 76 Nomadism, 25 definition of, 15 staged, 17 La Nona Ora (The Ninth Hour) history, 37-38 subject matter of, 15-16 (Cattelan), 199-200 landscape, 72-73 in surveillance, 92 Nonobjective art, 203 narrative, 37-38 technological developments and, North Carolina Museum of Art, 188 Neo-Expressionist, 15 16 - 18Northwest Coast, Native Americans of, photography's influence on, 15 time in time in art of, 41, 42 time in, 37-38, 39, 52 motion representing, 38-39 Notes on Language (Acconci), 178 time spent viewing, 53 real, 52-53 rhythm of, 53 Notes to Basquiat (Bennett), 188, trends in, 15 196n.27 trends in, 15-16 words in, 164 Painting Machine (Horn), 150 truth factor in, 17 Physicality, of language, 178-179 Pajaczkowska, Claire, 103 Oboussier, Claire, 177 The Palace at 4 A.M. (Giacometti), 39 Picasso, Pablo, 27, 94, 106, 131 Ocampo, Manuel, 214 Paladino, Mimmo, 56, 133 Pictographs, 162-163 Heridas de la Lengua (Wounds of Palm Beach Institute of Contemporary Pictures and Promises (exhibition), 171 the Tongue), 214 Art (Florida), 50 Pink Frick (Aptekar), 192, 193, 194 Offerings (Hamilton), 45, 46 Palo Monte religion, 221-222 Piper, Adrian The Office Shaman (Feodorov), 215 Panopticon, 91-92 body in works of, 134, 137

Pantheism, 80

Paper Dolls for a Post Columbian

World (Smith), 124, 125

identity in works of, 108, 110, 118

What Will Become of Me?, 137

Piss Christ (Serrano), 13, 203

Place(s), 69–98	historical styles in, 58	Rape of the Sabine Women
in art history, 72–77	identity construction in, 110, 114	(Poussin), 149
art works existing in, 75-77	multiple styles of, 23	Raphael, 192
artificial, 84–89	Pop Art and, 11	Rapture (Neshat), 154, 156
built, 79-80, 82-84	poststructuralism and, 24, 25, 167	Rath, Alan, 151
constructed nature of, 84–89	tenets of, 22–23	
definitions of, 70, 83		Infoglut, 151, 152
	time in, fragmentation of, 51	Rauch, Neo, 39
displacement and, 93–95	Poststructuralism, 24–25	Ravenal, John B., 215–216
exhibitions on, 72	deconstruction in, 24, 167	Ray, Charles, Rotating Circle, 55
language used regarding, 70–71	definition of, 167	Raymond Pettibon: A Reader,
looking at specific, 78–80	feminism and postcolonialism	180, 181
meanings of, 69–71	influenced by, 25–26, 167	Reading, 178
naming of, 71	on language, 167	Reading Landscape (Xu Bing),
natural, 78, 80–82	postmodernism and, 24, 25, 167	188–189, color-14
protection and preservation of, 80-84	prominent thinkers in, 31n.22	Readymades, 27, 39
public vs. private, 90–93	tenets of, 24–25, 167	Reagan, Ronald, 57
sound and, 80, 96–98	Poussin, Nicolas, Rape of the Sabine	Real time, 52–53
in space, 73–75	Women, 149	
spaces without, 89–90		Realism, landscape painting in, 73
	PowerPoint software, 19	Reality
value of, 71–72	Prendergrast, Kathy, 75	poststructuralism on, 25
Planes of Vision (Long), 168	Lost, 75	virtual (See Virtual reality)
Plastic surgery, 150, 151	Present. See also Time	Reality television shows, 42, 52
Pleasure, sexual, 147–149	reframing, 59–60	"Rebellious silence" (Neshat), 154, 155
Poetry	as reshuffled past, 58	Red Banks (Lowe), 80, 81
concrete, 164, 178	views of, 49	The Reenchantment of Art (Gablik), 20
shaped, 163–164	Present Tense (Hatoum), 75	Reframing the Past (Sligh), 184
visual, 163-164	Presley, Elvis, 217–218	Reichek, Elaine, 167–168, 215
Politics	Prince, Richard, 184–185	Relics, in representations of time,
in content of art, 14	What a Kid I Was, 185	39, 40
identity, 108–110	Princenthal, Nancy, 34	Religion. See also Spirituality
and institutional critiques, 13–14	Private places, 90–93	
language in, 184		definition of, 200–201
	Process art, 45	vs. spirituality, 201
Polke, Sigmar, 45, 51	Profane, sacred combined with,	Religious art, 199–223. See also
Pollen, 205	217–218	Spirituality
Pollock, Griselda, 134	Proust, Marcel, 39	controversy over, 203
Pollock, Jackson, 23, 103, 131	Psychoanalysis, 26	figurative imagery in, 131, 143–145
Polymathicstyrene (Tse), 88	Public art. See also specific forms	government separation from, 202
Pompidou Center (Paris), 204	and boundaries between art and	history of, 200
Pondick, Rona, 142	culture, 29	Religious fundamentalism
Baby Fat, 142, 143	public opinion on, 13	in battles over body, 135
Pop Art	support for, 13	in Iran, 153
body in, 133	Public funding, controversy over, 13,	Religious identity, 108, 213–215
formalism and, 11	135, 203	Reliquary, 204
language in, 165	Public places, vs. private places, 90–93	Pombrondt 106 102 200
in 1980s, 14		Rembrandt, 106, 192, 200
	Publications, on language, 171	Representation(s)
Pop culture, timeline of, 227–240	Puipia, Chatchai, 39	definition of, 36
Poppies, 5–6	Pyramids, 205	of time, 36–40
Porter, Bern, 164		The Rhinestone Beaver Peep Show (Ed
Portraits, identity in, 106		Kienholz and Nancy Reddin
Posner, Helaine, 141	Queer theory, 116	Kienholz), 146
Post-black art, 121	Quinn, Marc, 141	Richter, Gerhard, 23, 78
Postcolonialism, 25–26	The Quintet of the Silent (Viola), 55,	Rickey, George, 42
activist agenda of, 26	color-1, color-2	Ringgold, Faith, 140
on gaze, 146	Qur'an, 163	Ritchie, Matthew, Self-Portrait in 2064
on hybridity, 25	Qui un, 100	47, 47
on language, 167–168		
poststructuralism and, 25–26, 167	D-1-1: (V) 27 20	Ritual, in spiritual art, 205, 206
	Rabbit (Koons), 27, 28	Rivera, Diego, 131
prominent thinkers in, 31n.23	Racial identity, 107–108	Robotics
on sexual identity, 118	sexual identity and, 117–118	in kinetic and performance art, 43
theoretical influences on, 25–26, 167	Rain, Steam and Speed (Turner), 38	and posthuman bodies, 150, 151
Posters, street, 183, 184	Rajchman, John, 23	Rockman, Alexis, 86
Posthuman bodies, 150–152	Ramos, Mel, 139	Roden Crater Project (Turrell), 208
Postmodernism, 22–23	Rand, Archie, 215	Rodgers, Richard, 176
body in, 129	Rape of the Daughters of Leucippus	Rollins, Tim, 183
decline of, 26	(Rubens), 149	Romeo and Juliet (Ladda), 82
		(2000), 02

Room at the Hardturmstrasse (Fischli sexual identity in works of, 116, Sight, See also Gaze 136-137, 146 identity revealed by, 129 and Weiss), 88 Rootlessness, 94 Schumann, Christian, 27, 58 privileging of, 145 Sigler, Hollis, 48, 142 Schütte, Thomas, 62 Rosen, Kav Sign language, 174 John Wilkes Booth, 176 Scott, Dread, 186 Signs, words as, 171-172. See also language in works of, 164, 176, 178 The Scrabble Game (Hockney), 52-53 Scrolls, Chinese Semiotics Sp-spit It Out, 176, 177 multi-episodic format in, 37 Sikander, Shahzia, 207 Rosenthal, Norman, 199 Uprooted Order I, color-16 Rosenthal, Rachel, 111 representations of space in, 74 "Silence=Death" posters (ACT UP), 183 Ross, Alex, 59 Sculpture Rotating Circle (Ray), 55 Silhouettes, black-paper, 57 materials for, 16 Rothko, Mark, 103, 200 painting overlapping with, 15 Simmons, Garv, 48 Rouault, Georges, 202 trends in, 16 Simpson, Bennett, 22 Simpson, Lorna Rovner, Michal, 218-220 SCUMAK (Auto Sculpture Maker) body in works of, 134, 140, 146, 168 Royal Academy of Arts (London), 199 (Paine), 42, 150 Rubens, Peter Paul, Rape of the Sean Kelly Gallery (New York), 42 Easy to Remember, 175-176 The Second Sex (Beauvoir), 134 gaze in works of, 146 Daughters of Leucippus, 149 Rubin, Ben, Listening Post, 9 Secularism, religion combined with, language in works of, 168, 175–176 217-220 poststructuralism and, 25 Rubin, David S., 205 Simpson, Tommy, 43 Rugoff, Ralph, 86 Security by Julia II (Scher), 92, 92 Boy with Fish, 44 Ruscha, Ed Self-Portrait in 2064 (Ritchie), 47, 47 Simulacra, 23 Self-portraits, identity in, 106 Better Get Your Ass Some Protection, 178 Semiotext(e) (journal), 171 Singer, Michael, 76 Semiotics, 23-24, 166 Singerman, Howard, 168 bookworks of, 180 Sistah Paradis Great Wall of Fire Sensation (exhibition), 203 Rush, Michael, 56 Rybczynski, Witold, 91 September 11, 2001, terrorist attacks monument commemorating, 62 Sistine Chapel (Rome), 75, 200 value of places targeted in, 71 Site-sensitive artworks, 100n.8 Saar, Alison, 207 Serra, Richard, 75 definition of, 76 Saar, Betve, 204, 214 Tilted Arc, 13 documentation of, 166 Saatchi Collection, 13 Serrano, Andres, 203, 217 forms of, 76-77 Sachs, Tom. 43 Piss Christ, 13, 203 Setting the Table for Romance trends in, 29 Sacred nature as, 80 (Lederman), 172 Sioo, Monica, 111 Sexual Behavior in the Human Female Skoglund, Sandy, 87 secular/profane combined with, Skyspace (Turrell), 208 217-218 (Kinsey), 134 Slick, Duane, 207 Said, Edward, 111 Sexual identity, 107-108 Salcedo, Doris, 48 body and, 133, 134 Slide shows, lantern, 43 diversity of, 116-118 Salgado, Sebastião, 218 Slumber (Antoni), 137, 138 Salle, David, 15 Sexual orientation. See Homosexuality Small Worlds: Dioramas in language in works of, 172–173 Sexuality Contemporary Art time in works of, 51, 58 battles over, 135 Samba, Chéri, 19, 187 of bodies, 133, 134, 143-150 (exhibition), 72 violence and, 149-150 Samizdat tradition, 173 animals in works of, 125, 207 San Juan de la Cruz (Kuitca), 93 Sexually explicit art, 135 "Shanghai" (Gursky), color-7 Sandler, Irving, 56 World, 124, 125 ShanghART (China), 110 Santa Claus (McCarthy), 116 Santería, 214 Shanshui, 72-73 syncretism in works of, 119 Shaped poetry, 163-164 São Paolo Biennial (1998), 96 Shaw, Jeffrey, The Legible City, Saunders, Raymond, 111

Saussure, Ferdinand de, 23, 167 Sava River, 81 Saville, Jenny, 139, 145 Schapiro, Miriam, 133 Scher, Julia, 52, 92, 145 Security by Julia II, 92, 92 Schnabel, Julian body in works of, 133 rise of, 12, 15 time in works of, 39 Schneemann, Carolee, 111, 133 Schorr, Collier "In the Garden (Karin in Grass)", 136, 136-137

189-191 Sherman, Cindy appropriation by, 23 body in works of, 134 Historical Portraits series, 115 identity in works of, 115, 116 Shimomura, Roger, 60 American Diary: October 16, 1942, 60 Shohat, Ella, 95, 118 Shop/Site/Shrine (Daehnke), 72 Shoshana Wayne gallery (New York), 65 Show (Beecroft), 140 Shrines, 204

Revival Tent (Bailey), 210, 211 Site-specific artworks, 76-77, 100n.8 Sligh, Clarissa, Reframing the Past, 184 Smith, Jaune Quick-to-See, 122-126 Paper Dolls for a Post Columbian Trade (Gifts for Trading Land with White People), 122-125, color-9 Smith, Kiki body in works of, 129, 141, 142 Born, 207, 207 spirituality in works of, 203, 207 Smithson, Robert, 100n.5 Snyder, Joan, 78 Sobel, Dean, 212 Sollins, Susan, 201 Soltes, Ori, 215 Sonfist, Alan, 76 Song Dong, 187 Sony Corporation, 43 The Soothsayer's Recompense (Chirico), 39

Soul, in bodies, 129	Subject matter, of art works	Texts
Sound art, place and, 80, 96–98	in photography, 15–16	definition of, 24, 162
Sp-spit It Out (Rosen), 176, 177	vs. theme, 5–6	interaction among, 25
Space. See also Place	Sublime, 202	poststructuralism on, 24
disjunctive representation of, 73–74	Submuloc Show: Columbus Wohs	Thater, Diana, 77
illusions of, time represented in, 37,	(exhibition), 125	Knots + Surfaces, Version #1, color-6
66n.4	Sufism, 208–209	Theater marquees, 29
without place, 89–90	Sugimoto, Hiroshi, 86	Thek, Paul, 204
places existing in, 73-75	"Permian Land," 86, 87	Themes, 3–4
time and	Superflat style, 27	definition of, 3
continuum of, 49	Surrealism, representations of time	multiple, works with, 6-7
in place, 69	in, 39	vs. subject matter, 5–6
Spatiality, of words, 178	Surrounded Islands (Christo and	in symbols, sets of, 4-5
The Special Theory of Relativity	Jeanne-Claude), 77	Theory(ies), 22-27. See also specific
(Einstein), 48–49	Surveillance, and public vs. private	types
Spector, Buzz, Toward a Theory of	places, 91, 92	emphasis on, vs. mechanics of art, 22
Universal Causality, 181, 182	Survival Research Laboratory	feminist, 25–26
Speed	(SRL), 43	influence of, 22–27
in representation of time, 38	The Survival Series (Holzer), 29	of language, 161-162, 166-168
of time passing, manipulation of,	Sutherland, Graham, 202	organization of study by, xii
53–55	The Swan Tool (July), 170, 170	postcolonial, 25–26
Spem in Alium (Tallis), 96	Swimming to Cambodia (Gray), 170	postmodern, 22–23
Spence, Jo, 139	Symbols	poststructural, 24–25, 31n.22
Spiegelman, Art, Maus, 183	books as, 180–181	semiotic, 23–24
Spillane, Mickey, 180	as indexes, 40	Thiebaud, Wayne, 79
The Spiritual in Art: Abstract Painting,	language of, 174, 177	THINGS PUSHED DOWN TO THE
1890–1985 (exhibition), 203	sets of, 4–5 (See also Iconography)	BOTTOM AND BROUGHT UP
Spirituality, 199–223	in spiritual art, 208	AGAIN (Weiner), 172
in art history, 201–204	Symmetry, in spiritual art, 208	Thinking, language of, 174
controversies over, 203, 204	Syncretism, 95. See also Hybridity	Thinking Print: Books to Billboards,
death and, 215–217	definition of, 95, 119	1980–95 (exhibition), 161, 171
definition of, 201	in-between places and, 95	Thinner Than You (Connor), 131, 132,
doubt and, 210–213	religious identity and, 214	136, 137
exhibitions on, 199, 203, 204	Sze, Sarah, 77	Thomas, Nicholas, 188
faith and, 210–213	220, 24141, 7,	Thoreau, Henry David, 202
formats and, 204–206		Thought, language of, 174
and identity, 108, 213–215	Tacha, Athena, 77	Tickner, Lisa, 134
materials and, 205–206	Tagg, John, 92	Tilted Arc (Serra), 13
meanings in, 206–210	Tagore, Rabindranath, 59	Tim Rollins + K.O.S. (Kids of
places tied to, protection of, 80	Taliban, 135, 214	Survival), 183
vs. religion, 201	Tallis, Thomas, 96	By Any Means Necessary—
secular content combined with,	Tanguy, Yves, 86	Nightmare, 183
217–220	Tansey, Mark, 171	Time, 33–66
Spivak, Gayatri Chakravorty, 111	Tappeti-natura, 86–87	in art history, 35–45
Sprinkle, Annie, 148	Tate Modern (London), 12	conceptions of, 45–50
SRL. See Survival Research Laboratory	Taylor-Wood, Sam, Still Life, 53	cyclical, 35, 36, 46–47
Starn, Doug, "Triple Christ," 206–207	Techniques, and meaning, 4	linear, 35, 36, 37, 46–47
Starn, Mike, "Triple Christ," 206–207	Technology. See also Digital	past in, 49–50
Starn Twins, 15	technologies	simultaneous, 35, 46–47
Starry Night (Gogh), 200	developments in, 11, 16	duration of, 53
Steinbach, Haim, 14, 27, 168	and identity, 120	embodiment of, 36, 40–45
Stelarc, 150	and new paradigms, 16–17	endlessness and, 55–56
Stiles, Kristine, 165, 186	and placeless spaces, 89–90	exhibitions on, 50
Still Life (Taylor-Wood), 53	in posthuman bodies, 150–152	fragmentation of, 51
Stop-action sculptures, 34–35	trends in, 16–19	freezing, 34–35, 37, 66n.4
Storytelling, 173	Television	for language in art, 170
Strange Fruit (for David) (Leonard), 216	artificial places based on, 88–89	language used regarding, 45–46
Streaming video, 52	bodies on, 136	in moving works, 36, 40–45
Structuralism, 167	reality shows on, 42, 52	in multi-episodic formats, 37
Studio Museum (New York), 104	time embodied in, 43	in paintings, 37–38, 39
Sturges, Jock, 139	Tempo (exhibition), 50	past
Styles	Tense, language markers of, 46	changing views of, 49–50
classifying art into, xii	Terminal (Kuitca), 55	commemoration of, 60–62
historical, popularity of, 58	Texte zur Kunst (journal), 171	revisiting, 56–60

Trompe-l'oeil paintings, 164

Truisms (Holzer), 185

Venus of Willendorf, 36 Time—continued Truth digital manipulation and, 18 Verbally Charged Images in photography, 38-39 (exhibition), 171 historical, 49 real, 52-53 representations of, 36-40 in photography, 17 Vermeer, Johannes, 100n.5 poststructuralism on, 25 Vexation Island (Graham), 55-56 found materials in, 39-40 Victoria and Albert Museum (London), Tse, Shirley, Polymathicstyrene, 88 motion in, 38-39 Tsong-zung, Chang, 163 141 194 narratives as, 36-38 Video, See also Film: Television Tuchman, Maurice, 203 rhythm of, 53-55 sequence of, 33, 37 Turbulent (Neshat), 154-156 accessibility of art of, 43 Turman Art Gallery (Indiana), 171 developments in, 16 space and continuum of, 49 Turner, I. M. W., 86 identity in, malleability of, 115, 116 Rain, Steam and Speed, 38 multiple projections of, 51 in place, 69 place in, artificial, 89–90 Turning around the Centre in static works, 35-40 popularity of, 43 structure of, 50-56 (Houshiary), 209, 209 Turrell, James, Skyspace, 208 time in in video, 40, 43-45, 50-56 embodiment of, 40, 43-45 24 Hour Psycho (Gordon), 54, 54 Time arts. 40, 50. See also Film: Twombly, Cv, 165 endlessness and, 55-56 Performance art: Video Tworkov, Helen, 208 exhibitions about, 50 Timeline, 227-234 Timepieces, 43 Type design, 189 fragmentation of, 50-51 real, 52-53 Tinguely, Jean, 42 rhythm of, 53-55 Tiravanija, Rirkrit, 95 Uelsmann, Jerry, 17 structure of 50-56 Titles, of works of art, 174 Video Quartet (Marclay), 19 Uklanski, Piotr, The Nazis, 57 To Draw a Line (Antoni), 137-138, color-10 Uniformity Vietnam Veterans Memorial (Lin), 13, Tolle, Brian, 63-66 of imagery in media, 18-19, 49 61, 67n 30 Viewers, definition of, 78 Alice and Job. 65 international art market and, 21-22 Declaration of Independence Desk: in views of past, 49 Viola, Bill University Art Museum (Santa Thomas lefferson, 63 Eureka 64 Barbara), 171 light in works of, 208 Untitled (Gober), 210-212, 212, 213 Irish Hunger Memorial, 63-64, color-5 Untitled (Pettibon), 181 color-2 Untitled (Phaophanit), color-13 Philadelphia, 63 (Untitled) (Leonard), 146 time in works of, 63-66 Virtual identities, 120 Tomaselli, Fred. 208 "Untitled (5 Buck Word)" (Johnson), 173 Virtual reality, 18 Untitled (Expulsion), 200, 204, color-15 Untitled (Expulsion) (Tomaselli), 200, definition of, 18 Too Jewish? Challenging Traditional 204, color-15 Untitled (for Heisenberg) Identities (exhibition), 105, 215 Toop, David, 89 (Campbell), 93 in games, as art, 18 Untitled (One day this kid. . .) Totem Teddies (Feodorov), 215 (Wojnarowicz), 161, 162 "Tourists on the Moon #2" (Itagaki), Untitled (Perfect Lovers) (Gonzalez-17, 17, 88 Torres), 43 Vision. See Sight Toward a Theory of Universal Viso, Olga, 61, 62 Causality (Spector), 181, 182 Uprooted Order I (Sikander), color-16 L'usage de la parole I (The Úse of Trade (Gifts for Trading Land with Vitacchio, Alberto, 164 Words I) (Magritte), 196n.28 White People) (Smith), Vitiello, Stephen, 97 122-125, color-9 Ushering in Banality (Koons), 217 Volk, Gregory, 200 Transcendence, 200 abstract art and, 203, 208-209 Voyeurism Transcendentalism, 202 Vallance, Jeffrey, 218 eroticism and, 149 Vanitas, 215-216 of gaze, 145-146 Translation, of foreign languages, Varejão, Adriana, 19, 57, 118 medical, 142 186 - 189Veils Translucency, of language, 175-177 Transparency, of language, 175-177, 178 artists focusing on, 156-157, 159n.35 and body as battleground, 135 Transvestism, 116 Travel, and displacement, 94 feminist views on, 118 Waiting (Bowers), 45 Neshat (Shirin) on, 118, 153-154, The Tribute Money (Masaccio), 37 "Triple Christ" (Starn and Starn), 156 - 157206-207 and sexual identity, 118, 156 Tripping Corpse (Pettibon), 180 Western views on, 118, 153-154, 156 Wall, Jeff, 15-16, 29 Velde, Willem Van de, the Younger, 193 Triptychs, 122, 204-205

Venice Biennial, 96, 168

Venus de Milo, 140, 158n.16

The Crossing, 205-206 The Ouintet of the Silent, 55, color-1, time in works of, 39, 53, 55 Violence, sex and, 149-150 boundaries blurred by, 18 dioramas compared to, 86 and placeless spaces, 89 and posthuman bodies, 151 Virtuality, definition of, 18 Visual culture, mass, 18-19, 30n.13 and public vs. private places, 91, 93 sexual identity and, 117-118 Walker, Kara, 57, 59, 118 Camptown Ladies, 57, 58 Wall paintings, ancient place in, 75 time in, 36, 37

Wallace, Michele, 146 Wang Guangyi, 19 Ware, Chris, ACME Novelty Library, 180 Warhol, Andy death of, 14 Empire, 53 identity in works of, 106 language in works of, 165 time in works of, 53 Watkin, Mel, 75 The Way Things Go (Fischli and Weiss), 33, 34, 45, 48, 52 Wearing, Gillian, 174 "Work Towards World Peace," 175 Weber, John S., 191 Webster, Meg, 76 Weems, Carrie Mae, 173 Kitchen Table Series, 103, 104 Weil, Benjamin, 29 Weiner, Lawrence, 165 City Projects—Prague, 172 Weintraub, Linda, 108 Weiss, David Der Lauf der Dinge, 33, 34, 45, 48, 52 Room at the Hardturmstrasse, 88 Welliver, Neil, 78 Wells, Liz, 78 Wexler, Allan, 215 Wexner Center (Columbus, Ohio), 45, 187 What a Kid I Was (Prince), 185 What Will Become of Me? (Piper), 137 White Noise (Grigely), 190 Whiteread, Rachel, 78, 108 House, 13 WhiteWalls (journal), 171 Whitney Biennial Exhibitions of 1993, identity in, 105 of 2000, Internet art in, 18 of 2002 commemorative art in, 62 site-specific art in, 76 sound art in, 97 Whitney Museum (New York), 105 Wigram, Max, 199 Wilderness protection and preservation of, 80-82

in Transcendentalism, 202

Wilderness (Lucier), 51 Wilke, Hannah, 133, 139, 142 Williams, Sue, A Funny Thing Happened, 150 Williamson, Judith, 197n.32 Wilson, Anne, 137 Wilson, Fred, 77, 185 "Metalwork, 1723-1880," 185 Wilson, Martha, 140 Witkin, Joel-Peter, 142, 203 Wittgenstein, Ludwig, 166 Wizard (Moore), 217 Wodiczko, Krzysztof, Hiroshima Project, 62 Wojnarowicz, David AIDS and, 14, 141 language in works of, 161 memorial for, 216 spirituality in works of, 203 *Untitled* (One day this kid. . .), 161, 162 Wolin, Jeff, 173 Womanhouse (exhibition), 133 Women bodies of, 134, 135-136, 138-139 body in art of, 133 equal opportunity for, 108-110 identity of, 109-110, 111 participation in and influence on art by, 19 sexual pleasure and desire of, 147-149 violence against, 149-150 Women of Allah series (Neshat), 154 Women's movement, 19 Wood, Denis, 79, 79-80 Woodrow, Bill, 114-115 Woodward, Richard B., 215 Wool, Christopher, 176 Words, in art. See also Language history of, 164-166 transparency and translucency of, 175-177 The Words and the Images

(exhibition), 171

"Work Towards World Peace"

(Wearing), 175

World Ant Farm (Yanagi), 95

World events, timeline of, 227-240.

See also History, world

World Trade Center (New York) installation art at, 84 monument commemorating, 62 September 11 terrorist attacks on, 62, 71 value of place, 71 Worldviews, poststructuralism on, 24-25 Worn materials, time represented by, 40 Written languages, 174-183 in books, 179-183 in calligraphy, 163 history of, 162-164 in information age, 189-191 media of, 174 translation of, 187 Wu Mali, The Library, 168 Wye, Deborah, 184

Xiaogang, Zhang, 106
XLP (Yuskavage), color-12
Xu Bing
A Book from the Sky, 187
Cultural Negotiation, 187
language in works of, 187
Reading Landscape, 188–189,
color-14
visibility of, 19

Yanagi, Yukinori, 19 World Ant Farm, 95 Yoruba religion, 214 Yourcenar, Marguerite, 112 Yuan, Li Tian, 9 Yugoslavia, former, 81 Yuskavage, Lisa, 146 XLP, color-12

Zenil, Nahum, 214 Ex Voto (Self-Portrait with the Virgin of Guadalupe), 214 Ziggurats, 205